Bollywood

T0374507

by Maaz Ali, Maaz Khan,
and Anum Hussain

for
dümmies®
A Wiley Brand

Bollywood For Dummies®

Published by: **John Wiley & Sons, Inc.,** 111 River Street, Hoboken, NJ 07030-5774, www.wiley.com

Copyright © 2021 by John Wiley & Sons, Inc., Hoboken, New Jersey

Published simultaneously in Canada

For general information on our other products and services, please contact our Customer Care Department within the U.S. at 877-762-2974, outside the U.S. at 317-572-3993, or fax 317-572-4002. For technical support, please visit https://hub.wiley.com/community/support/dummies.

Wiley publishes in a variety of print and electronic formats and by print-on-demand. Some material included with standard print versions of this book may not be included in e-books or in print-on-demand. If this book refers to media such as a CD or DVD that is not included in the version you purchased, you may download this material at http://booksupport.wiley.com. For more information about Wiley products, visit www.wiley.com.

Library of Congress Control Number: 2021934620

ISBN: 978-1-119-78067-0

ISBN: 978-1-119-78070-0 (ebk); ISBN: 978-1-119-78071-7 (ebk)

Manufactured in the United States of America

SKY10025785_032521

Contents at a Glance

Table of Contents

Introduction

More than likely, you've heard of an industry somewhere called Bollywood. You may have experienced the music through participating in a Bollywood wedding dance. Or perhaps you may have seen an actual Bollywood film with subtitles. But whether or not you've experienced a taste of Bollywood, have never been exposed, or are a die-hard fan, this book has something for you.

Bollywood is among the largest film industries in the world, with nearly a thousand films being released each year. The industry offers a diverse sampling of content, mixing various religious and regional influences of the Indian subcontinent to create films like no other. That said, most films are Hindi-language ones, but we explore the other flavors throughout this book.

The name Bollywood itself comes from merging "Bombay" and "Hollywood," given Bombay (now known as Mumbai) is where most Hindi films were historically produced. Now Hindi-language films are being shot all around the world, with London as a regular destination for making movies.

The Bollywood style itself is a delight to the eyes, full of expressive visuals and elaborate song and dance routines. And over the years, Bollywood has become an industry with diverse stories with global appeal. This book takes you from the genesis of the industry to the modern day production styles to every new innovation over the decades in between.

About This Book

Bollywood For Dummies is intended to be a handy reference, which means that you don't need to read the chapters in order or from beginning to end. We provide notes along the way, signaling you if there's another chapter with more detail on something you just read. That way, no matter how you read, you'll be easily guided on where to go next.

Of course, the Bollywood industry is constantly creating; we provide detail on everything until the time of publishing, but encourage you to follow along for updates on our podcast, Desi Standard Time.

Here is a brief snapshot of what we cover in this book:

>> An overview of one of the largest film industries in the world, including an inside look at the core Bollywood families that make up the industry and the endless talent occupying the Bollywood big screen.

>> The history of every decade of Bollywood from its inception to present day, including the Partition, which separated India and Pakistan, and the impact it had on overall entertainment industry.

>> The evolution of Bollywood music, its influence on the movies, and its impact for the Bollywood dance fanatics.

>> The fans and audiences that adore Bollywood worldwide.

>> How the entertainment industries in other South Asian countries have been impacted and impact Bollywood.

Foolish Assumptions

In this book, we make the following assumptions about you, our dear reader:

>> You have some interest in Bollywood, whether new to the industry or a lifelong fan.

>> You have access to any device that would allow you to watch, listen, or consume our various Bollywood recommendations.

>> You can read.

Icons Used in This Book

Icons in this book point out important tidbits for you to look at, remember, and absorb. Here we review the icons that we use throughout this book to guide you on your Bollywood journey.

TIP

The Tip icon points out helpful information that will help you more deeply understand the details of Bollywood.

REMEMBER

The Remember icon marks interesting or useful facts about Bollywood.

CULTURAL WISDOM

The Cultural Wisdom icon helps to point out key parts about the surrounding South Asian culture that influences various parts of the Bollywood industry.

Beyond the Book

A few of our podcast fans have already asked where they can turn to find out more. Beyond this book, we've put together some additional resources for those who need them:

>> **Cheat Sheet:** Go to www.dummies.com and search for "Bollywood Cheat Sheet" to find a handy reference guide for all things Bollywood. The online Cheat Sheet is particularly valuable for getting direct links to music videos or other fun Bollywood entertainment.

>> **Podcast:** We, the authors (Maaz Ali, Maaz Khan, and Anum Hussain), aren't employees of the Bollywood industry, but as long-time fans we host and produce a podcast called Desi Standard Time. Desi Standard Time's name itself is an ode to the people of South Asia and the long-standing trope poking fun at how South Asians are typically never on time, requiring their own "standard time."

Go to www.instagram.com/desistandard to enjoy our own posts, content, stories, and links to podcast episodes to continue being a part of the South Asian entertainment fan base. We also highlight podcast episodes.

Although this book serves as an educational reference guide, our podcast serves as a place to appreciate, study, and sometimes criticize the various aspects of the industry. Our episodes take a birds-eye look at themes that transcend the industry, such as the infamous hip-thrusting dance moves that have dominated endless Bollywood music videos or the evolution of rock music in Pakistan.

Where to Go from Here

If you're completely new to Bollywood, we suggest starting with Chapter 1 and 2 to get a basic breakdown of the industry as well its people, places, and history. If you've already been exposed to Bollywood and here to reminisce or explore a subject you're less aware of, peruse the Table of Contents or index to jump right to actors, music, or whichever category you deem worthy. If you're South Asian and are more intrigued by the greater diaspora, we dedicate the entire Part 5 to just that.

This book isn't linear, so ultimately you can start anywhere and then go where your inner Bollywood dancer takes you next.

1

Getting Started with Bollywood

Bite off your first taste and find out more about one of the largest film industries in the world.

Understand the fundamentals of Bollywood, covering what you need to know about the industry and the key people.

Get an inside look at the core Bollywood families and see how they influence and partake in the industry.

Begin your appreciation for the talent, on and off screen, who have become Bollywood legends.

Chapter **1**

Introducing Bollywood

As Bollywood stars begin to make waves outside India and bring the rich tradition of Indian filmmaking to other parts of the world, it has become impossible to not hear about Bollywood or see its influence worldwide. Though Bollywood is often characterized as an industry filled with musicals, corny dialogue, and over-the-top action scenes, it's so much more.

From its humble beginnings depicting the everyday struggles of Indian citizens after Partition to newer films that comment on polarizing subject matter, Bollywood has undergone a journey through time. Bollywood's true charm is the people that made it famous and continue to drive it forward today. From legendary directors, to homegrown actors, to modern-day media darlings, Bollywood has provided the world with a never-ending case of lovable characters. This chapter serves as your jumping off point into the world of Bollywood. Dive right in.

Addressing What Bollywood Is

Bollywood itself is a gigantic film industry that churns out hundreds of movies every year. The term "Bollywood" typically refers to movies made in Bombay (now Mumbai) studios, in the Hindi language. Figure 1-1 is a wall mural of a Bollywood film at one of their studios, evoking a similar feeling fans feel seeing movie posters as they drive past movie studios in Hollywood.

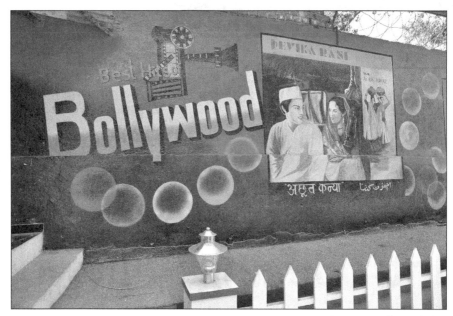

FIGURE 1-1:
Bollywood wall painting outside a film studio in Mumbai.

CULTURAL WISDOM

REMEMBER

Other film industries within India create movies in other languages (which we discuss more in Chapters 17), and although they're often remade or dubbed into Hindi films for Bollywood, their individual industries carry distinct and different names. Bollywood movies can be from a number of different genres, but they all carry a familiar formula and have several characteristics shared between the films.

A few of those notable characteristics, which we discuss in Chapter 7, include

>> **Musical aspect:** Nearly every Bollywood movie has at least one song and dance number where the main actors will cut away into a dream sequence and mesmerize the audience with a song. Some actors and actresses gain notoriety for their ability to dance, whereas the *playback singers* for the songs (the singers whose singing is pre-recorded and featured in Bollywood films) also grow famous for their vocal contributions. Though musicals are a bit less numerous in film industries around the world, the art of mixing storytelling with musical interludes is a defining aspect of Bollywood as an industry.

>> **Romance:** Regardless of the overarching theme of the movie, the gravity of its subject matter, or even the film's genre, Bollywood filmmakers nearly always find a way to include a romantic story arc within the plot of the film. As audiences continue to consume the romantic journeys with elated expectation, the filmmakers have no reason to stop. If you love a good love story, chances are you're going to love most Bollywood movies.

>> **Runtime:** A more dubious characteristic of Bollywood films is their runtime. Whereas many Western movies release their audiences after 1½ or 2 hours, Bollywood movies take great pride in enrapturing their audiences for several hours, sometimes as long as 4! Noting the lengthy time commitment that comes with any Bollywood movie, most Bollywood films also come with an intermission in the middle of the movie. Traditionally, when movies premier in theaters in India, the intermission of the movie allows moviegoers to stretch their legs, go to the bathroom, and buy snacks.

>> **Fashion:** Costume design is rarely an oversight in Bollywood films, often becoming the highlight of a movie. Whether the movie is a period piece that requires ornate, period dress, or a modern story set in the Western world, Bollywood movies don't hold back in decorating their characters in some of the trendiest and eye-catching of fashion. Moviegoers pay close attention to the dress of their favorite actors and actresses, and most Bollywood artists end up as international fashion icons as a result.

Identifying the Families of Bollywood

Bollywood movies share more than just similar characteristics between different films. A few legendary family have dominated Bollywood for nearly its entire history. Some of these families stick purely to acting, whereas others include directors, producers, and singers, occupying every part of the industry. Here are some of the most famous families you'll come across in your journey through Bollywood (we delve deeper into them in Chapter 2):

>> **Kapoors:** Spanning three generations, no family has had more influence on every aspect of Bollywood than the Kapoors. From some of the most iconic actors and actresses to a history of storied directors and producers, the Kapoors dominate the Bollywood scene. The Kapoor family is Indian royalty and truly a force to be reckoned with in the Bollywood industry.

>> **Bachchans:** Made particularly famous by the man who originally held the surname, Amitabh Bachchan, the Bachchan family continues to grow as it enters its third generation. Both Amitabh and his son, Abhishek, married revered actresses in their day, extending their influence across the industry and cementing their family as Bollywood royalty.

>> **Johars:** Known less for acting and more for the movies they have produced and directed over the years, the Johar family is often credited with some of the consensus best Bollywood films of all time. Family patriarch Yash Johar led the way and established the family name within the industry, and his son Karan Johar proudly carries the torch now.

>> **Bhatts:** A multitalented family, the Bhatts have contributed daring directors and incredible actors to the Bollywood industry. Today, this family is one of the most respected within the industry for its continuing contributions to the art of storytelling within Bollywood.

>> **Mukherjees:** A family that appeared in what seemed like every movie of the 1990s and early 2000s, the Mukherjees have carved their own name within the ranks of Bollywood. With esteemed actresses like Kajol and Rani Mukerji hailing from the renowned family, no doubt the Mukherjees are revered across Bollywood.

Looking at Bollywood's Evolution

Over the years, Bollywood has changed dramatically. Although each movie stays in line with the general characteristics we mention in the section, "Addressing What Bollywood Is," earlier in this chapter, each era of Bollywood had its own distinct feel, subject matters, and stylization. Comparing a movie from the 1960s to today would showcase the varying ways that Bollywood has progressed, while also exhibiting the characteristics that unite all Bollywood films together under one genre. Each era also brought with it a new parade of stars, bringing their singular talents to the screen in ways no one before them ever had. Here is a quick rundown of the different eras in Bollywood.

Focusing on the 1940s to the 1960s

The early years of Bollywood were a representation of the tumult that India was undergoing at the time. Freshly independent, India struggled to gain its footing in the early years after gaining its freedom from Great Britain and reeling from a bloody split with Pakistan. Many of the early films characterized the struggles of everyday people in India, connecting with the everyday man and woman.

This era of Bollywood film from the 1940s to the 1960s is often referred to as the Golden Era, because some of the most important and influential Indian movies were made during this time. At this time Bollywood was a direct reflection of its viewers and dealt with difficult socioeconomic conditions and class stratification in India in many of its films. However, as India began to lift itself out of the shambles that Partition had caused, the film industry also took a turn for the positive.

CULTURAL
WISDOM

The latter part of this era saw the introduction of romantic-themed movies that changed Bollywood cinema forever. In particular, a more whimsical, joyous cinema characterized movies in the 1960s. Iconic actors and actresses during this time period gave weight to the characters they played on screen and helped give

birth to what would become the largest movie industry in the world. To see how they did it, flip to Chapter 3.

Eyeing the 1970s and 1980s

By the late 1960s, Bollywood moviegoers were craving a bit of variety in their viewing experience. Enter the complicated and endlessly entertaining genre of action and crime movies. Using the rising underworld in India as a plot device, filmmakers re-invigorated audiences with complex plots, epic villains, and a whole new batch of actors.

One of these actors, Amitabh Bachchan, went on to define this era of Bollywood. Using his angry young man trope, Bachchan took over the Bollywood industry in the '70s and '80s and revolutionized the types of movies that Bollywood fans wanted to see. With intricate plots spanning generations, locales, and themes, he won the heart of a nation and helped to bring Bollywood to new heights. Chapter 4 discusses Bachchan and his rise to fame.

CULTURAL
WISDOM

The complexity of movies also increased, as filmmakers grew more and more emboldened to challenge audiences and explore bleaker themes. The emergence of highway bandits, or *dacoits*, spurred a separate genre during this time as well. Still a reflection of India in real life, Bollywood showcased this side of the quickly growing country while staying true to its roots. That's right, even underworld dons fancy a good love story.

Considering the 1990s and 2000s

One actor took over the film industry in India during the 1990s and never let go. Shah Rukh Khan's arrival into Bollywood was akin to a hurricane coming ashore, as he broke all records and established himself nearly overnight as the King of Bollywood. Appearing first as an anti-hero before evolving into a lovable romantic, Khan's screen presence and endearing personality defined a generation of Bollywood movies.

Of course, Khan wasn't the only talented actor in Bollywood during this time. The emergence of talented filmmakers and actors alike brought a period of great success to Bollywood during this era. Changing societal norms and the entrance of India onto the world stage catapulted Bollywood cinema into a new era where it explored more taboo subjects and experimented more and more with liberal displays of affection in film. That's right, Bollywood actors finally kissed on screen during this era — though not all global fans were happy about it, which you can read more about in Chapter 13.

With the Bollywood industry fully established and flourishing, the studios increased their budgets and often shot movies or portions of movies overseas. Indian audiences were enamored with the many locations shown on screen, and Bollywood's romanticized depictions of places around the world spurred a new generation of Indians to travel and share their culture around the globe. We explore some of the most iconic movies during this time in Chapter 5.

Arriving at the present day

Bollywood today continues to be a powerhouse film industry, making more movies than even Hollywood most years. Distributing worldwide and with fans all over the globe, Bollywood's influence can't be overstated. Although the stars of former years continue to appear in movies today, a new wave of actors and actresses have taken the helm and brought Bollywood into the next century. New filmmaking technology, the incorporation of social media, and a willingness to deal with difficult subjects have all led to a very different type of cinematic experience for Bollywood fans.

WHERE IN THE WORLD IS THE INDIAN SUBCONTINENT?

Also referred to as simply the *subcontinent,* this large body of land in South Asia encompasses the countries of India, Pakistan, Bangladesh, Sri Lanka, Nepal, the Maldives, and Bhutan. This book's focus is on Bollywood and India; however, it also touches upon the people living in these countries and abroad and the influence that the cinema has had on them. Here a few terms used to describe the subcontinent and its people:

- **Diaspora:** The dispersion of a people from their origin or homeland.

- *South Asian*: A people or culture hailing from South Asia; usually referring to countries from the subcontinent.

- **Hindustan:** The first century CE Persian word used to refer to the Indian subcontinent. The same name is used to describe the historic Republic of India.

- **Desi:** Any individual of South Asian descent. A term that is used heavily amongst the South Asian diaspora.

Nevertheless, many of the old faithful characteristics continue to shine through. Old songs are finding new listeners, as the wave of remakes applies not only to movies but to songs as well (refer to the chapters in Part 3 about music). Storylines that enamored audiences decades before are being adapted for modern-day depictions and once again packing theaters across the world. As a new era of Bollywood is ushered in, it will be entertaining to see how the old continues to mix with the new. For some quick recommendations from the modern era and to meet some of today's superstars in Bollywood, check out Chapter 6.

Grooving and Moving: Bollywood Incorporates Music and Dance

Perhaps no aspect of Indian cinema is as important to its success as the music that accompanies nearly every film. Bollywood soundtracks dominate the Indian music landscape and have fans all over the world. As singers, composers, and songwriters gain recognition across not just India but the entire Indian subcontinent, they inevitably find their way into Bollywood movie soundtracks.

The result is a beautiful harmony of various different styles, cultures, and sounds culminating in a crescendo of beautiful music featured throughout the world's largest film industry. The following sections provide a quick overview. Part 3 covers these types of music in greater detail.

Understanding the importance of the soundtrack

A Bollywood soundtrack closely follows the themes of its accompanying film. As the story evolves within the movie, the songs come in to elevate the characters and themes within the movie. Different from Hollywood soundtracks where the music is often played in the background during important scenes and sequences, Bollywood soundtrack songs are made specifically for the film they're featured in and are often picturized completely separately from the movie's events. Actors breaking out into song and dance isn't an uncommon sight in Bollywood productions.

In a Bollywood production the playback singers actually sing the songs, and the actors on screen lip sync the song. Many of these playback singers gain international fame and recognition from their appearance on a Bollywood soundtrack; such is the power of the Bollywood music industry. In fact, Bollywood movie soundtracks are the key tool that studios use to market movies. Releasing songs

ahead of a movie's release builds up anticipation and excitement as millions of Bollywood fans jam out to the new movie's songs before they have even seen the movie. Check out Chapter 7 for more information about soundtracks.

Recognizing the roles of different genres

A number of different musical genres encompass Bollywood music. You can see influences from all over the world throughout different eras in Bollywood. Understanding where each of these individual styles hail from is key to seeing the fabric that makes up Bollywood music as a whole. Here are some of the distinct styles that have influenced Bollywood:

» **Disco:** Classical Bollywood saw an influx of Western disco styles that moved everyone who listened to the dance floor for an entire decade. Pioneers like Biddu Appaiah and Bappi Lahiri brought a decidedly Western sound to Indian movies and introduced the Indian public to disco music that is still listened to today. Chapter 8 examines each of their stories and how they impacted the Bollywood music industry.

» **Sufi:** The soulful stylings of Sufi Muslim artists from across the subcontinent helped to incorporate styles like qawwali and ghazals into the Bollywood mainstream. Though originally used in religious contexts, the widespread popularity of soul music spurred Bollywood to incorporate it in many of its movies. Today, some of the most famous Bollywood songs fall in this genre of music. Read all about how this music took over the industry in Chapter 9.

» **Pop and rock:** The worldwide popularity of pop and rock music made it inevitable that they'd find their way into Bollywood music. The distinct sounds of both genres and the increased visibility for Western artists in India thanks to channels like MTV ensured that musicians in India were influenced heavily by their Western counterparts. Chapter 10 discusses pop and rock in greater detail.

» **Rap:** Similar to its meteoric rise in the United States and Europe, rap music in India started in underground scenes scattered throughout the country. A new wave of artists and feature films focusing on the genre has brought rap into the limelight, and it will be exciting to see how it evolves in the Indian music scene. Chapter 10 also explores rap.

» **Folk and Punjabi music:** A rich heritage of song and dance, an extremely proud cultural identity, and singular instruments help to define the Punjabi Folk music genre. Though it was formerly reserved for people of Punjabi origin, new artists and Bollywood features have thrust Punjabi music to the forefront of the Indian music industry, both in popular music and in Bollywood movie soundtracks, Punjabi music is everywhere you look in the modern day. Chapter 11 explores more about its history and evolution.

Shaking your groove thang: Dance in Bollywood

Dancing is also a significant part of the Indian film culture. Actors and actresses alike are praised and vaunted for their dancing abilities in movie songs. Hrithik Roshan, Madhuri Dixit, Govinda, Aishwarya Rai Bachchan, and Shahid Kapoor are examples of Bollywood stars who are known not only for their acting skills, but particularly for their dancing ability.

REMEMBER

The tradition of dance in Bollywood doesn't only live on screen, however. All across the world, talented Bollywood fans choreograph their own dances to Bollywood songs and post their creations to the ever-growing collection of Bollywood dance videos online. Soon the popularity spread with dance teams forming around Bollywood music. Dancers competed in cities and at universities around the globe.

CULTURAL WISDOM

Today, dancing is as much a part of the life of a Bollywood fan as any other aspect. Weddings, religious ceremonies, family gatherings, and cultural shows all include vibrant dance displays, often inspired by Bollywood songs or dance scenes. New platforms showcasing dance choreography have helped to spread the popularity of individual Indian music choreographers even more. Of course, as these dancers gain popularity, they come full circle and begin to be featured in Bollywood movies. Chapter 12 looks at these movers and shakers.

Appreciating Bollywood Worldwide

An industry as big as Bollywood could never be contained to just one country. As Bollywood has grown exponentially over the last several decades and Bollywood fans migrated to different parts of the world, Bollywood movies began to reach a global audience. Today Bollywood reigns as one of the world's largest film industry by number of movies made each year and worldwide revenue. With fans across all of the major continents, Bollywood has grown from its humble beginnings into a worldwide phenomenon. We discuss Bollywood's global reach and fandemonium in Chapter 13 and 14.

As the world continues to advance technologically and introduce new ways for people to interact, Bollywood fans across the globe have taken full advantage. From memes to social media, movie fans have gone online to share their love (or hate) for all things Bollywood. Not only casual fans, but famous members of the Bollywood industry, such as Karan Johar, have started talk shows to provide even more Bollywood coverage. These media moments only help to spread the culture of Bollywood around the world and introduce it to a wider and larger audience each year. Chapter 14 examines all the different ways Bollywood is making waves through various platforms around the world.

SAMPLING BOLLYWOOD MOVIES

As you venture out into the world of Bollywood, having a starting point is smart. Chapters 19 through 21 highlight some of the essentials you should view as you begin your Bolly-journey and give you some direction so you're not too overwhelmed. Here are some of the must-watch classics that will give an overall taste of Bollywood cinema and represent a good starting point for any new Bollywood fan:

- **3 Idiots:** What better way to step into the world of Bollywood than to watch a light-hearted modern comedy about three friends that also tackles a lot of societal issues plaguing India today? *3 Idiots* is an Aamir Khan blockbuster that left audiences and critics alike singing their praises. A fun watch that doesn't drag on too long, this is one of the best movies for new Bollywood fans dipping their toes into the water.

- *Deewar* **(The Wall):** If action is more your style, then *Deewaar* is a great introduction into the genre because it's a good example of Bollywood as well as Classical Bollywood films in general. Featuring none other than the great Amitabh Bachchan, *Deewaar* is an emotional family drama that has survived the test of time as one of Bachchan's most iconic roles. The movies explores a number of darker themes from 1970s India and will leave any viewer in awe of the star power of Bachchan and co-star Shashi Kapoor.

- *Karan Arjun*: This 1995 film features an ensemble cast including big names like Salman Khan, Kajol, and Amrish Puri, and was a huge hit at the box office. Chapter 20 sets out ten must-see Shah Rukh Khan movies; add this to the list as a bonus 11th suggestion to get a taste of Khan's early years when audiences were first falling in love with him.

- *Jab We Met* **(When We Met):** A film representative of the Bollywood romantic comedy genre, *Jab We Met* is a great love story with funny and emotional parts to it without getting too heavy. For a new Bollywood fan, it strikes the perfect balance between Bollywood cheesiness and a great viewing experience. Pairing Shahid Kapoor and Kareena Kapoor (not related in real life), it also showcases what can happen when two Kapoors light up the Bollywood big screen.

- *Bajirao Mastani* **(Warrior Lover):** This movie is a perfect introduction to the Bollywood historical drama. Epic movie sets, excellent costume design, star power, and dramatic dialogues abound in this classic story of separated lovers. Featuring the biggest power couple in Bollywood today, Ranveer Singh and Deepika Padukone, *Bajirao Mastani* is a tour de force from start to finish.

Of course, no film industry would be complete without honors and awards to hand out to its biggest stars. Bollywood is no exception. The industry hosts several major awards shows each year and doles out awards in all the major categories. Similar to Hollywood, some of these awards are looked at as benchmarks, whereas others are viewed as intriguing bellwethers to showcase specific works from that year. We look at the different awards shows and what they feature in Chapter 15.

Finally, Bollywood didn't become an international entertainment powerhouse without some help from its friends — namely, other film industries both inside and outside India. Though Bollywood has gained worldwide fame, many people don't know about the different regional cinemas that inspire many Bollywood movies and artists throughout the years. Aside from its neighboring industries, Bollywood also gets its inspiration from the other side of the world in Hollywood. Bollywood has become an expert industry at taking inspiration from another area and adapting it for its tried and true audience. Chapters 16 and 17 discuss all the industries that have shaped Bollywood into what it is today.

Chapter **2**

Focusing on Family Over Everything Else

B ollywood is an industry unlike any other. Though numerous stars have swept the hearts of audiences throughout the past century, interestingly enough, they often come from the same few families. Though it's never directly stated, nepotism plays a large part in casting. Though some Bollywood experts will ultimately deny any such influence, the seemingly never-ending trend of "keeping it in the family" throughout the industry shows no signs of stopping any time soon.

Whether in front of the camera or behind it, certain names repeatedly pop up in this book — especially last names. To help prevent confusion every time you run across the name Khan, Kapoor, or the like, this chapter maps out the most influential families of Bollywood, each family's most prolific members, and nepotism's influential role in the world of Bollywood. We describe the careers and accolades of several of these stars in later chapters; for now, we focus on their lineages. Get ready to take a further look to see who is who's daddy!

Introducing Kapoor and Sons

Arguably, the most popular family in Bollywood's long and illustrious history, the Kapoors have dominated the industry since the 1920s. The first Kapoor to act on film was Prithviraj Kapoor, also known as the patriarch of the Kapoor dynasty. He was the founder of Mumbai's *Prithvi Theatre,* where several of his future progeny established themselves. He also acted in silent films before being featured in Bollywood's first talkie, *Alam Ara* (Ornament of the World). Kapoor's most popular role to-date is Emperor Akbar, in one of Bollywood's most iconic films, *Mughal-E-Azam* (The Great Mughal), 1960; read more about this film in Chapter 19.

REMEMBER

"Bollywood" is often synonymous with "Hindi cinema" given Hindi is the primary language of Bollywood films. The other languages, such as Tamil language films, are given their own industry names. To read more about them all, turn to Part 5.

In his personal life, he married Ramsarni Mehra, a girl from his local community, in a marriage arranged by his parents. The two lived happily, and had 4 children that reached adulthood: three sons, Raj, Shammi, and Shashi, and a daughter, Urmila Sial.

The first generation of Kapoors

Prithviraj Kapoor's three sons, whom we discuss here, were successful filmmakers and actors in their own right. Figure 2-1 shows a clearer picture of the first generation Kapoor lineage. Overall, Prithviraj not only instilled a love for the film industry in his own progeny but also invited his cousin, Surinder, to do the same. Surinder Kapoor ended up having a career as a film producer and fathering, with his wife, Nirmal, four children — three of whom found success within Bollywood. His sons were named Boney, Anil, and Sanjay, and his daughter's name was Reena.

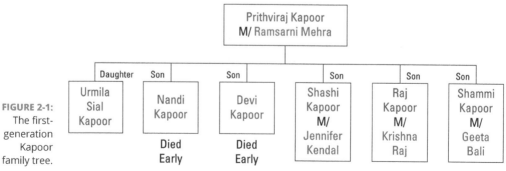

FIGURE 2-1: The first-generation Kapoor family tree.

© *John Wiley & Sons, Inc.*

Raj Kapoor

Prithviraj's first son was Raj Kapoor, one of the most iconic actors in Indian history. A winner of three National Film Awards and 11 Filmfare Awards, he was considered to be the "Charlie Chaplin of India," given that his roles were similar in style and essence. For more on Raj's career, check out Chapter 3. He had three sons (Randhir, Rishi, and Rajiv) and two daughters (Ritu and Rima). He passed away in 1988.

Shammi Kapoor

Raj Kapoor's younger brother, Shammi, lived for 79 years and made a reputation playing the fun-loving, lively playboy type in Bollywood films. He is best known for his award-winning performance in *Brahmachari* (Bachelor), and other blockbusters, such as *Junglee* (Wild), *Teesri Manzil* (Third Floor), and *Prince*. Shammi was wildly popular with audiences for his boyish, "Elvis-like" good looks, and offered a contrasting on-screen personality than his brother, Raj.

Shammi's first wife, of ten years, was Geeta Bali, who passed away in 1965. His second marriage came four years later, in 1969, to Neila Devi. With his first wife, he had a son, Aditya Raj Kapoor, and a daughter, Kanchan. Sadly, in 2011 Shammi passed away from kidney failure. His final film appearance was alongside his grand-nephew, Ranbir Kapoor, in the film *Rockstar*. (We discuss Ranbir Kapoor in depth in Chapter 6, which highlights the actors of present-day Bollywood, already giving you a sense of the Kapoor family legacy.)

Shashi Kapoor

Prithviraj's third son, Shashi, was a prominent actor from the late 1960s to 1980s. He was married to Jennifer Kendal and had two sons, Kunal and Karan, and a daughter, Sanjana. Though his kids pursued acting and modeling, they weren't prominent names in the industry. Shashi passed away in 2017, leaving behind a short but iconic Bollywood legacy. (To read more about Shashi Kapoor's life and career, check out Chapter 4.)

The second generation of Kapoors

Of the three brothers, Raj Kapoor's children grew most in popularity after being heavily involved in the film industry. Raj had three sons: Randhir, Rishi, and Rajiv. The middle child, Rishi, became the most beloved and successful actor from the trio. He ended up marrying his longtime costar, Neetu Singh, and fathered future superstar Ranbir Kapoor. For more on Rishi Kapoor's career, check out Chapter 4. Figure 2-2 shows the second generation of male Kapoors.

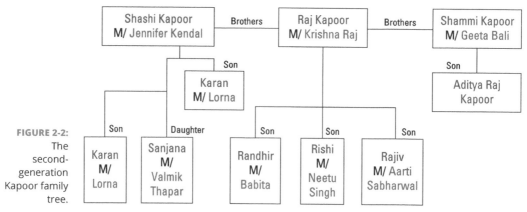

FIGURE 2-2:
The second-generation Kapoor family tree.

© John Wiley & Sons, Inc.

Prithviraj's younger cousin, Surinder, also had three sons that were successful contributors in Bollywood: Boney, Anil, and Sanjay. Figure 2-3 shows Surinder's offspring.

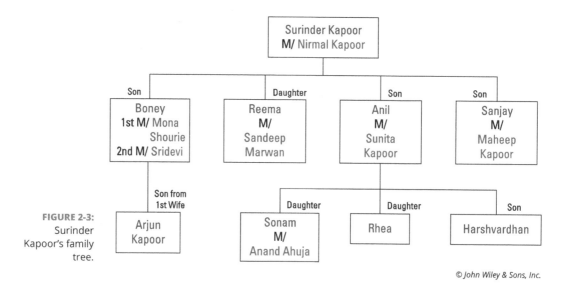

FIGURE 2-3:
Surinder Kapoor's family tree.

© John Wiley & Sons, Inc.

Randhir Kapoor

Randhir, the eldest of the Raj's sons, bore a striking resemblance to his father and had a prominent career in the 1970s. His career went on and off throughout the 1980s, until he finally was able to revive it temporarily, when he completed his father's vision with the film *Henna*, and was nominated for Best Director

at that year's Filmfare Awards (read more about various Bollywood awards in Chapter 15). He married actress Babita in 1971, and the couple had two daughters and the future hit actresses Karisma and Kareena Kapoor. Some of Kapoor's most notable acting roles were *Jeet* (Win), *Haath Ki Safai* (Skill of Hand), and *Kasme Vaade* (Sworn Promises).

Rishi Kapoor

The career of Rishi, the middle son of Raj, began with a cameo in his father's film *Shree 420* (1955). His official debut came in 1970, and from then until this passing in 2020, Rishi was on many Bollywood big screens. To read more about his career, turn to Chapter 4. We, the author team, also have a tribute where you can see Rishi in action in his famous Bollywood songs on our podcast page. Just go to www.instagram.com/stories/highlights/18102539962186591.

Rajiv Kapoor

The third son of Raj, Rajiv, had a career throughout the 1980s; however, he failed to find the same success as his big brothers. Rajiv resembled his uncle, Shammi, and some of his most popular movies were *Ek Jaan Hain Hum* (We Have One Life), *Aasman* (Sky), and *Zabardast* (Fantastic).

Boney Kapoor

Then there's Boney Kapoor, Surinder Kapoor's eldest son and a prominent Bollywood producer. Some of his more notable titles are *Mr. India, Judaai* (Separation), *Shakti* (Power), and *No Entry*. He has two children from his first marriage, with Mona Kapoor: present-day Bollywood star Arjun Kapoor and daughter Anshula Kapoor. He later separated from Mona Kapoor, and in 1996 wed actress Sridevi, with whom he had two children, including rising Bollywood star Janhvi Kapoor.

Anil Kapoor

Surinder's middle son, Anil, ended up becoming the most successful of the siblings. His career transcended Bollywood as he found himself in a major Hollywood role for the production of *Slumdog Millionaire*. To read more about his career, flip to Chapter 4. He married a costume designer named Sunita Bhavnani, and has three kids with her. His daughters are Rhea Kapoor and Bollywood star Sonam Kapoor, and his son is Harshvardhan Kapoor.

Sanjay Kapoor

Sanjay Kapoor, the younger brother after Anil, was also an actor featured in films during the 1990s and 2000s. His notable work includes *Raja* (an Indian name that

also means "prince"), *Shakti* (Power), and *LOC Kargil.* Many fans remember Anil Kapoor dancing with his costar, Madhuri Dixit, in the hit song "Akhiyaan Milaoon Kabhi" (When the Eyes Meet) from the film *Raja.*

The third generation of Kapoors

Clearly, Kapoors often come in threes (Figure 2-4 shows this generation's lineage). Entering the modern-day, the three latest Kapoor kids who found resounding success were the daughters of Randhir Kapoor, and the son of Rishi Kapoor.

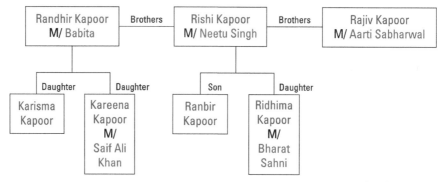

FIGURE 2-4: The third-generation Kapoor family tree.

© *John Wiley & Sons, Inc.*

Karisma Kapoor

The eldest daughter of Babita and Randhir, Karisma got her start in the early 1990s and had a career starring alongside the likes of Shah Rukh Khan, Madhuri Dixit, Salman Khan, and Govinda, all of whom we discuss in Chapter 5. She was known for having a vibrant personality on-screen, and the green eyes she inherited from her father and grandfather became a trademark of her look. Karisma was married to industrialist Sunjay Kapur, and had a daughter and son with him. The two later divorced in 2016.

Kareena Kapoor

Karisma's sister, Kareena, made her debut at the turn of the millennium, in 2000, alongside Abhishek Bachchan, a star debuting from the Bachchan family; we mention him a little later in this chapter. Kareena Kapoor's most iconic role to-date is that of Poo, from *Kabhi Khushi Kabhie Gham. . .* (Sometimes Happy, Sometimes Sad). She's now married to actor Saif Ali Khan, and they have a son, Taimur Ali Khan. Check out Chapter 5 for more about the Kapoor sisters.

Ranbir Kapoor

Ranbir Kapoor, cousin to Karisma and Kareena, is arguably one of the best, if not *the* best, Bollywood actors today. Ranbir's distant family members Arjun Kapoor and Sonam Kapoor are also part of the current younger generation of Kapoor actors. As we mention earlier in this chapter, Arjun is the son of producer Boney Kapoor, and Sonam is the daughter of actor legend Anil Kapoor. Refer to Chapter 6 to read more about their careers.

Building the Bachchan Family

Family ties and lineage foster amazing talent and successful careers in Bollywood. What's interesting, though, is that, historically speaking, some of the most popular generational stars were self-made stars. Here's a look at one of them, and Amitabh Bachchan's family who followed. Figure 2-5 shows the Bachchan lineage.

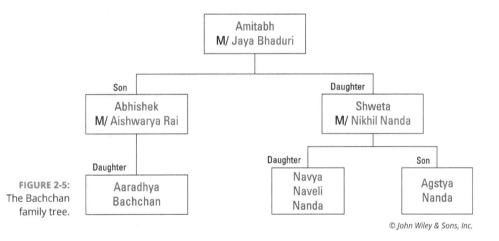

FIGURE 2-5: The Bachchan family tree.

© *John Wiley & Sons, Inc.*

Contending to be the GOAT: Amitabh and his wife, Jaya Bachchan

Known as the Shahenshah of Bollywood (King of Bollywood), and also nicknamed the Big B, Amitabh Bachchan is widely regarded as one of the greatest, if not *the* greatest, Bollywood actor of all time. Bachchan fell in love with acting thanks to his mother, who had dreams and aspirations of becoming a star herself. After bursting onto the scene with films such as *Saat Hindustani* (Seven Indians), and

Parwana (Moth), audiences and critics alike took notice of this "angry" newcomer who brought a new flare to the Bollywood landscape with action-packed movies, as opposed to the norm of romantic dramas at the time.

His first megahit was *Zanjeer* (Chain), which accentuated his signature as an "angry young Indian man." Bachchan won several awards for this signature style, and that ultimately led him to the iconic role of Jai in one of Bollywood's highest-grossing films of all time, *Sholay* (Embers).

Bachchan exceled not only as an action star but in comedic roles as well. With the rise of masala films (films that mixed multiple genres into one) in the 1970s, Bachchan dominated the industry for a long time, starring in classics like *Amar Akbar Anthony*, *Don*, 1978, *Silsila* (Affair), *Laawaris* (Orphan), and *Namak Halaal* (Loyal Servant). His versatility — combined with his deep voice, height, and over-all charismatic presence — made him second to none.

Masala films are films that mix together several genres — for example, comedy, romance, action, and drama. The name itself comes from the term *masala*, which is a mixture of spices in South Asian cuisine. These films, which are most often musicals, have quickly become a popular genre of Indian cinema.

Seemingly Bachchan had it all, so it's only natural that he was able to attract actress Jaya Bhaduri along the way. Bhaduri was a prodigy of sorts and was landing roles when she was in her teens. She appeared in several Bengali films during this time before starring in career-defining Bollywood films, such as *Uphaar* (Above) and *Koshish* (Effort). She was partially responsible for kick-starting Bachchan's rise to superstardom when she costarred with him in *Zanjeer* — even after so many accredited actresses were worried it would be another one of Bachchan's many flops, and had refused to take on the role themselves. The two got married in 1973 and costarred together again in Salim-Javed's (Salim Khan and Javed Akhtar) *Sholay* in 1975. After costarring once more with her husband in *Silsila*, Bhaduri took a step back from her acting career and focused on raising her kids, Abhishek and Shweta.

Both Amitabh and Jaya Bachchan began starring in prominent roles again from 2000 onward. They both costarred in Karan Johar's superhit *Kabhi Khushi Kabhie Gham. . .* (Sometimes Happy, Sometimes Sad), reestablishing themselves as seasoned veterans while transitioning into more fitting roles, given their age and stature. Here are some of the more notable films from Amitabh's later years:

» *Mohabbatein* (Love Stories)

» *Baghban* (Gardener)

» *Black*

> » *Paa*

> » *The Great Gatsby*

> » *Piku*

And Jaya's:

> » *Hazaar Chaurasi Ki Maa* (The Mother of 1084)

> » *Fiza*

> » *Kal Ho Naa Ho* (Tomorrow May Never Come)

Abhishek and Aishwarya Rai Bachchan

Abhishek Bachchan, the son of the great Amitabh Bachchan, definitely attracted all the hype in the world leading to his debut film, *Refugee,* in 2000. Even though it was difficult for him to reach the same level of superstardom as his father, Amitabh, Abhishek was nonetheless able to have a respectable career. After struggling to have a successful hit in the early 2000s, Abhishek started finding success in films like *Yuva* (Youth), *Dhoom* (Blast), and *Bunty Aur Babli* (Bunty and Babli). After pairing with his father in *Kabhi Alvida Naa Kehna* (Never Say Goodbye), and having breakthrough performances in *Guru* and *Dostana,* Abhishek finally proved to be not only a lovable, snarky, and sarcastic protagonist but also an actor who's able to handle varying roles with substance. His other popular films include *Bluffmaster!*, *Paa,* and *Happy New Year.*

Bachchan's *Guru* costar, and future wife, was undoubtedly considered to be a superstar long before she entered the Bachchan family. Aishwarya Rai was, and still is, considered to be one of the most beautiful and powerful women in the world. Rai, also known as Ash by her loyal fan base, was a pageant darling in her early days and was crowned Miss World in 1994 (read more about her career in Chapter 4). After transitioning from modeling to acting, Rai quickly became a bona fide superstar and starred in hits like *Hum Dil De Chuke Sanam* (I've Given My Heart, Beloved), *Taal* (Rhythm), and *Josh* (Zeal).

CULTURAL WISDOM

Even before joining the Bachchan family, Rai was an unstoppable force who gained the world's attention from not just her beauty but also her stellar acting and dancing abilities. After playing Paro in the all-time classic, *Devdas,* she gained international acclaim by starring in *Bride and Prejudice* in 2004. To read more about her legacy, turn to Chapter 5.

Rai married Abhishek in 2007. The blue-eyed beauty continued to make appearances and work in films such as *Dhoom 2* (Blast 2), *Jodhaa Akbar, Guzaarish* (Request), and *Ae Dil Hai Mushkil* (The Heart Is Difficult). The pair have a daughter together.

Keeping Up with the Khans

Similar to the Kapoors, multiple stars throughout Bollywood history have shared the last name Khan. However, unlike the Kapoors, they didn't all stem from the same family. Instead, the common last name Khan has led to more than enough actors who have been, and still are, beloved by fans worldwide, creating lasting legacies for themselves and anyone associated with the name.

The most popular Khans were four actors who made their debuts all around the same time within the industry. Three of them came from familial ties within the industry, and one was a self-made man who ended up becoming a generational icon. This section is a preview of four unrelated Khans: Shah Rukh Khan, Saif Ali Khan, Aamir Khan, and Salman Khan, all of whom we discuss in more depth in Chapter 5.

Bollywood's king: Shah Rukh Khan

Similar to Amitabh Bachchan, Shah Rukh Khan is considered by many to be the greatest Bollywood actor of all time. Also known lovingly by his fans as King Khan, S. R. Khan began acting on television serials before slowly transitioning his way toward the big screen, a trend not often seen in Bollywood, unlike Hollywood, where stars transition from TV to film and vice versa quite regularly. S. R. Khan was told by so-called advisers that he wouldn't make it as a leading man, saying he wasn't as handsome as other leads at the time. So Khan gained critical acclaim by taking on dark, sociopathic roles that gained the approval of audiences worldwide. This strategy opened the door for him to then become the charming lead in the wildly popular *Dilwale Dulhania Le Jayenge* (The Big-Hearted Will Take the Bride), where he grabbed the proverbial Bollywood brass ring overnight.

King Khan was first interested in pursuing athletics, until a shoulder injury sidelined him from playing any longer. He then turned his attention to theater acting and quickly became popular for his imitations of famous Bollywood stars, such as Dilip Kumar and Amitabh Bachchan.

S.R. Khan's rise in Bollywood led to a series of epic films that gained global fandom. For a list of his best works, turn to Chapter 20 for ten films worth watching.

Saif Ali Khan

Of the four Khans hailing from the 1990s, Saif Ali Khan was the youngest, and correspondingly took on roles of goofy, carefree, and hormonal characters. S. A. Khan was the eldest of three to an Indian cricket-captain father, Mansoor Ali Khan, and actress mother, Sharmila Tagore. His sisters are Saba Ali Khan, a jewelry designer, and Soha Ali Khan, who is also a Bollywood actress and is married to Bollywood actor Kunal Khemu.

S. A. Khan has been married twice, with his first marriage, with actress Amrita Singh, lasting 13 years. The couple had two children, one of which is Sara Ali Khan, who is now an established actress herself (read more in Chapter 6), and their aspiring actor son, Ibrahim Ali Khan. After divorcing in 2004, S. A. Khan embedded himself into the Kapoor family by marrying actress Kareena Kapoor; the pair have a baby son named Taimur Ali Khan Pataudi.

Aamir Khan

Aamir Khan is best known for making films that pushed the envelope and made audiences and critics alike think outside the box, with hits like *3 Idiots* and *PK*. Aamir Khan has always been quite astute in his film selections, perhaps because he was influenced by his elder relatives who worked as directors and producers of Bollywood films. His father, Tahir Hussain Khan, was a movie producer, and his uncle, Nasir Hussain, was a director and producer. After spending time in theater circuits, Aamir Khan became an assistant director and shadowed his uncle and son, as well as cousin Mansoor Khan, in the mid-1980s. From there, Aamir Khan made his debut in his cousin Mansoor's film *Qayamat se Qayamat Tak* (From Doomsday until Doomsday) in 1988.

Aamir Khan has since created his own production company, Aamir Khan Productions and has been successful in his occasional directorial pursuits. Khan's nephew, Imran, made his debut in *Jaane Tu . . . Ya Jaane Na* (Whether You Know or Not) and had a steady acting career until he stepped away from acting in 2015.

Salman Khan

Another child who was born into the industry, Salman Khan is considered to be the on- and off-screen bad boy of the four Khans. He is the eldest son of screenwriter Salim Khan and Salma Khan, and is also the stepson of actress Helen. Salim

Khan often helped Helen get cast in roles throughout the 1970s, and the two married in 1981. Salman Khan's brothers, Arbaaz and Sohail, are also actors, who were often seen acting alongside Salman; however, their careers were less successful than Salman's, who officially made his debut in 1988.

Though Salman has faced legal troubles and controversy over the years, he has still had a successful career that continues even today. Given his longstanding career, he has become a mentor and a source of inspiration for many Bollywood actors. His trademark look was being shirtless for his sculpted physique, and setting a high bar for future actors, like Hrithik Roshan and mentee Arjun Kapoor. Other mentees of Salman Khan were Varun Dhawan and Aditya Roy Kapur.

The forgotten Khans

Bollywood has seen a wide array of Khans who have left a mark on the industry. They range from acting and directing to everything in between, which you can see in these sections.

REMEMBER

The Khans listed here aren't related, but share the same last name. "Khan" is actually one of the most common surnames in the world and shared by more than 12 million people.

Amjad Khan

Most famous for his role as Gabbar Singh in *Sholay*, Amjad Khan created his own legacy by often playing the role of a notorious dacoit or villain alongside the likes of Amitabh Bachchan, Vinod Khanna, and Rishi Kapoor. His father, Jayant, was also an actor, who worked steadily from the 1930s into the 1970s. Unfortunately, Khan passed away when he was only 51 years old from heart failure in 1992. His portrayal of Gabbar Singh is still highly revered, because he's considered to be one of the greatest screen villains in Bollywood history.

Feroz Khan

One of the earlier Khans, and one of the more famous actors and directors of his generation, Feroz Khan made a name for himself by acting in thrillers throughout the 1960s and 1970s. He's called by some the Clint Eastwood of India, thanks to his on-screen roles, and is most famous for his good looks and immense sense of style. He's best known for films such as *Aadmi Aur Insaan* (Man and Mankind), *Khote Sikkay* (Fake Coins), and *Qurbani* (Sacrifice). His son, Fardeen, later became an actor, finding moderate success of his own before marrying the daughter of a popular actress from the 1970s, Mumtaz, named Natasha Madhvani. Fardeen Khan is known for roles such as *Jungle*, *Fida* (Infatuated), and *No Entry*. Khan grew popular with fans for his comedic roles.

Kader Khan

A renaissance man of sorts — given that he was an actor, a screenwriter, and a comedian — Kader Khan appeared in more than 300 films and wrote for about another 200 films. He made his acting debut in 1973 in *Daag: A Poem of Love* alongside Rajesh Khanna, and was also featured in films such as *Muqaddar Ka Sikandar* (Conqueror of Destiny), *Mr. Natwarwal*, and *Bade Miyan Chote Miyan* (Big Mister, Little Mister). Though he was mostly known for his comedic chops, he showed great range and partook in dramas, romance, and sociopolitical plots. He continued writing and acting into his 1970s, until he passed away in 2018.

Yusuf Khan, better known as Dilip Kumar

Though he wasn't widely known as a Khan, Dilip Kumar's real name is Yusuf Khan. He grew up in the same neighborhood with childhood friend Raj Kapoor and decided to change his name to something more "filmy," like the other actors of that era, in the hope of landing more work. He then became known as Dilip Kumar and went on to have a legendary career, becoming another generational icon much like his successors, Amitabh Bachchan and Shah Rukh Khan. His dominant performances reigned supreme from the 1940s through the 1960s, and he's widely regarded as another one of the greatest actors in Indian history. Incredibly dedicated to his craft, Kumar was known to use the method approach to his roles and would often find it difficult to separate from his characters.

He is best known for his performances in *Andaz* (Style), *Devdas* (1955), *Azaad* (Free), *Mughal-E-Azam*, and *Kohinoor* (Mountain of Light), to name just a few. He holds the record for the most Filmfare Awards for Best Actor at eight wins, a record that was later matched by none other than Shah Rukh Khan (read more about Bollywood Awards in Chapter 15). S.R. Khan has always cited Kumar as his acting idol, and Kumar went on to say that if he had a son, he would look just like S.R. Khan. S. R. Khan, perhaps in honor of Kumar and for the role, took the method approach when he did his own take on *Devdas* in the 2002 reboot.

In his personal life, Kumar had a heavily publicized relationship with another popular actress at the time, Madhubala. He later married actress Saira Banu in 1966, who was 22 years younger than he. Unfortunately for the couple, they faced complications when attempting to have their first child, and afterward decided not to try again, for they believed it was God's will.

Irrfan Khan

The late Irrfan Khan was a grounded actor, which allowed him to cross over into Hollywood roles. He cites Rajesh Khanna as his acting idol and gives career credit to his uncle who was involved in theater. He began acting in stage performances and was soon cast for a minor role in *Salaam Bombay!*, which was nominated in the

international film category at the 61st Oscars. He married Sutapa Sikdar, a writer from his alma mater, and had two sons, Babil and Ayan.

CULTURAL WISDOM

Irrfan's career is one of the few so strongly celebrated in both Hollywood and Bollywood. Both industries mourned his death in 2020 when he passed away from complications of a neuroendocrine tumor. To read more about his work in Hollywood, turn to Chapter 21.

Farah Khan

A notable figure in the industry is Farah Khan, who started as a choreographer (see Chapter 12 for all things dance and choreography), and then later began to produce and direct films. Her father, Kamran Khan, was a stuntman and film-maker. She's also the niece of famous poet and screenwriter Javed Akhtar. Farah first met S.R. Khan on the set of *Kabhi Haan Kabhie Naa. . .* (Sometimes Happy, Sometimes Sad), and the two remained good friends.

Sharmila Tagore

The mother of Saif Ali Khan, Sharmila Tagore, was a popular and successful actress in her own right. Debuting in the 1959 film *Apu Sansar* (The World of Apu), Tagore became somewhat of a sex icon in the 1960s and was a heavily sought-after heroine in both Bollywood and Tollywood (the Bengali film cinema, which we discuss in Chapter 17). Before marrying Mansoor Ali Khan Pataudi, Tagore converted to Islam and changed her name to Ayesha Sultana Khan, but was known as Ayesha Begum, for short.

Meeting the Johars

You can turn your attention now to a family who made a name for themselves working behind the camera more so than being in the limelight, at least at the start of some of their careers! These sections examine the infamous Johars. Refer to the later section, "Examining the Chopras: More than Priyanka," for a family tree that includes the Johars.

Yash Johar

The forefather of Dharma Productions, Yash Johar was a producer who worked for the production company of Bollywood great Dev Anand before launching his own company. His brother, Inderjeet Sen Johar, was an actor who worked from

the 1950s well into the 1980s until his untimely passing in 1984. Yash was married to Hiroo Chopra, the sister of Bollywood figure Yash Raj Chopra. Johar and his production company are responsible for producing movies like *Dostana* (Friendship), *Kuch Kuch Hota Hai* (Something Happens), *Kal Ho Naa Ho* (There May Not Be a Tomorrow), *Yeh Jawani Hai Deewani* (This Youth Is Crazy) and *Kapoor and Sons* (the last two of which were released posthumously), just to name a few. Johar is also the father of Bollywood personality and director Karan Johar. Unfortunately, in 2004, Johar passed away from a chest infection that was a result of his long-time battle with cancer.

Karan Johar

Following the untimely death of his father in 2004, Karan Johar took over as head of Dharma Productions. Karan started his career as an actor, but then decided that he's better off directing, after taking on the role of assistant director for Aditya Chopra's film *Dilwale Dulhania Le Jayenge* (The Big-Hearted Will Take the Bride). Karan then made his own directorial debut with *Kuch Kuch Hota Hai* (Something Happens) in 1998 and went on to have a successful career as not only a film director but also a media personality, after debuting his own talk show, *Koffee with Karan,* in 2004. For more on this, check out the in-depth breakdown of the show in Chapter 14.

Although people have a lot of ongoing debates about Karan's sexual orientation, he himself has never officially commented on it, though he has said that the conservative climate of India makes it difficult for anyone to do so. In February 2017, he became the father to a set of twins, a boy and a girl, through surrogacy. His son was named after his father, Yash, and his daughter was named Roohi, which is a rearrangement of his mother's name, Hiroo.

Bhatt-ing their Way Into Bollywood

Another Bollywood family known for producing and directing are the Bhatts, whom we discuss here. A family with a slightly more tumultuous background and upbringing, the Bhatts have never shied away from being bold in their artistry and theatrics. Figure 2-6 takes a closer look at the Bhatt lineage.

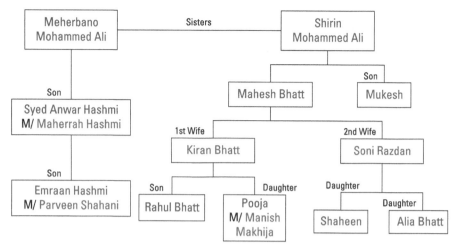

FIGURE 2-6:
The Bhatt
family tree.

© John Wiley & Sons, Inc.

Mahesh Bhatt

Mahesh Bhatt is a film producer, director, and screenwriter. His father, Nanabhai Bhatt, was also an Indian film director, and his brother, Mukesh, is also a film producer. Mahesh first wed Lorraine Bright at the age of 20, who changed her name to Kiran. The couple had two kids: future actress Pooja Bhatt and a son named Rahul. Unfortunately, the marriage ended when he had an affair with popular actress Parveen Babi; however, that relationship didn't last long. Several years after the affair, Mahesh married British Indian actress and director Soni Razdan. In this marriage, he fathered two more daughters: Shaheen and superstar actress Alia.

He's known for working alongside established director Raj Khosla and his film projects. Bhatt's most notable projects are *Aashiqui* (Lover), *Hum Hain Rahi Pyaar Ke* (We Are Travelers on the Path of Love), *Zakhm* (Wound), *Jism* (Skin), and *Murder*. Mahesh has developed a reputation for his bold film style, which is often considered promiscuous.

Alia Bhatt

Mahesh Bhatt's youngest daughter, Alia, has made a name for herself in recent years and has become a bona fide star in Bollywood. Making her debut as a child actor in her father's production, *Sangharsh* (Struggle), Alia went on to make her official debut in *Student of the Year* in 2012. She is a three-time winner of the Film-fare Award for Best Actress. Read more about her career in Chapter 6.

Emraan Hashmi

Also known as the "serial kisser" among Bollywood fans, Emraan Hashmi is the cousin of actress Alia Bhatt and the nephew of director Mahesh Bhatt. Hashmi developed a reputation and notoriety within the industry for his bold kissing scenes in films, donning the serial kisser nickname when intimacy on film was considered taboo within Bollywood. He worked alongside his uncles, Mahesh and Mukesh Bhatt, and has starred in many of their films, including *Murder*, *Gangster*, *Murder 2*, and *Jannat 2* (Heaven 2). In 2006, Hashmi married Parveen Shahani and has a son named Ayaan.

CULTURAL WISDOM

Hashmi is an actor this author team particularly enjoys and has mentioned in many comedic references throughout our podcast. Check out our podcast, Desi Standard Time, to spot all the times we've his work.

Examining the Chopras: More than Priyanka

Especially now that Priyanka Chopra has made her way to Hollywood, she might be the most famous Chopra in the world today. However, most Bollywood enthusiasts think about the one-and-only Yash Raj Chopra, and his family, as the most notable Chopras in the industry (Figure 2-7 lays out the Chopra lineage).

FIGURE 2-7: The Chopra (and Johar) family tree, who became one family after Yash Johar married Yash Chopra's sister.

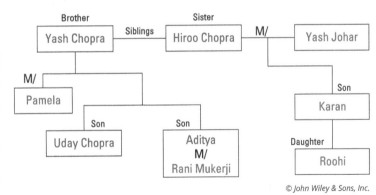

© John Wiley & Sons, Inc.

REMEMBER

Yash Raj Chopra's family isn't related to Priyanka Chopra, but all Chopras in Bollywood, which we look at here, have a significant stamp on the industry today.

Yash Chopra

One of the most prominent figures and directors in Bollywood history, Yash Raj Chopra was the founding chairman of Yash Raj Films and directed several blockbusters throughout Bollywood history. Early in his career, he shadowed and assisted his brother, director Baldev Raj Chopra, and brother-in-law, Inder Sen Johar, the brother of Yash Johar. As he worked alongside them, Yash was able to rub shoulders with Bollywood greats such as Sunil Dutt, Sharmila Tagore, Shashi Kapoor, Amitabh Bachchan, Waheeda Rehman, and Shah Rukh Khan. His notable films are *Deewaar* (Wall), *Darr* (Fear), *Dil To Pagal Hai* (The Heart Is Crazy), and *Veer Zaara*. He has won eight Filmfare Awards and seven National Film Awards over the course of his career.

Yash married Pamela Singh in 1970 and had two sons, by the names of Aditya and Uday. During the filming of his final film, *Jab Tak Hai Jaan* (As Long As I Live), Chopra grew severely ill and passed away a month before the release of the film. His legacy (as well as the reins of Yash Raj Films) lives on through his sons.

Aditya Chopra

The elder son of Yash Chopra, Aditya is a prominent film director in Bollywood. He is the chairman and managing director of Yash Raj Films, and the older brother of Uday Chopra. He started his early years as an assistant director working alongside his father and made his directorial debut with the super blockbuster *Dilwale Dulhania Le Jayenge* (The Big-Hearted Will Take the Bride). Soon after, he was the directing genius behind many blockbuster Bollywood hits, and he had a huge hand in furthering Yash Raj Films by working closely with his first wife, Payal Khanna, on establishing its studio and music distribution sector. He returned to directing with the release of *Befikre* (Carefree). He wed actress Rani Mukerji in 2014, and the two have a daughter named Adira.

Uday Chopra

The younger son of Yash Chopra, Uday Chopra worked behind the scenes as a producer and assistant director to his father and elder brother. Fans and audiences may be more familiar with Uday than Aditya because Uday also transitioned to working in front of the camera as an actor. He made his debut in *Mohabbatein* (Love Stories) and continued working in Yash Raj-produced films, such as the *Dhoom* franchise (Blast trilogy), and *Mujhe Dosti Karoge!* (Will You Be My Friend) to name just a few.

Priyanka Chopra

Though Priyanka Chopra doesn't belong to the aforementioned Chopra lineage, she is a daughter of doctors, and in many ways is a self-made woman who had no familial ties within the industry. If anything, she is now the head of her own Chopra family because her younger cousins — Parineeti, Meera, and Mannara Chopra — are all working actresses in India now. For more on Priyanka, you can read about her career in Chapter 6 and Chapter 21.

Navigating the Roshans

Family is definitely everything for the Roshan family, and they're most likely seen working alongside one another in their endeavors. The Roshans have never been afraid to take a stab at introducing new genres to the Bollywood landscape, and for that reason they've found success. They may not produce the same volume of work as their contemporaries, but the Roshans (Figure 2-8 shows how the Roshans are related) are well known for their professionalism and for dedicating their time to their projects, as we explain here.

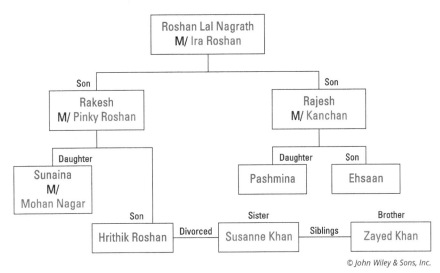

FIGURE 2-8: The Roshan family tree.

© John Wiley & Sons, Inc.

Rakesh Roshan

Rakesh Roshan was fathered by Roshan Lal Nagrath, an Indian music director who directed many films throughout Bollywood's Golden Era. Originally seen

alongside the likes of Rajesh Khanna, Shashi Kapoor, Randhir Kapoor, and Vinod Khanna, Roshan was in many films as a supporting actor. He also played roles in which the focus was primarily on the heroines of the film. Even though he was in only a few films where he was the stand-alone lead hero, he was still respected and beloved within the industry, which enabled him to successfully transition to a director. Roshan received many accolades directing films from the 1980s though the modern day with his production company, Filmkraft. He is best known for directing *Karan Arjun*), *Koyla* (Coal), and the *Krrish* franchise (short for the name *Krishna*). Roshan is also best known for introducing the world to his son, Hrithik, in his film *Kaho Naa . . . Pyaar Hai* (Say It's Love).

Rajesh Roshan

Rajesh Roshan is the younger brother of Rakesh and the uncle to Hrithik Roshan. Similarly to his father, Roshanlal Nagrath, Rajesh ended up becoming a music director, who has often been paired up with his brother's productions at Filmkraft. Before these brotherly collaborations took place, Rajesh had a successful career winning, and being nominated for, the Filmfare Award for Best Music Director ten times since the 1970s. He won the award for *Julie*, and *Kaho Naa . . . Pyaar Hai*. Roshan has a son, Eshaan, and daughter, Pashmina, a theater actress who has her sights set on making her Bollywood debut soon.

Hrithik Roshan

One of the highest-paid actors in Bollywood today, Hrithik Roshan made a rock-star-like debut in the aforementioned *Kaho Naa . . . Pyaar Hai* by blowing away audiences with his versatile acting and incredible dancing abilities. His ability to dance set a new bar for future male actors in Indian cinema and is still one of his most renowned and praised talents. Aside from dancing, he's known for his range in character work and larger-than-life roles. Hrithik has two sons with his former wife, Sussanne Khan, who is the niece of 1970s actor Feroz Khan, and the elder sister of actor Zayed Khan. For more on Hrithik Roshan's career, check out Chapter 5.

Zayed Khan

Hrithik Roshan's brother-in-law, Zayed Khan, is the son of actor, director, and producer of Sanjay Khan and first cousins with actor Fardeen Khan, the son of Feroz Khan. Zayed got his start in the early 2000s, similar to Hrithik Roshan, and is most famous for his role as Lucky in *Main Hoon Na* (I Am Here). After having a lukewarm career as an actor, Zayed started his own production company with friend and actress Dia Mirza called Born Free Entertainment. Since then he has transitioned to acting on television. He has two sons with his high school sweetheart, Malaika Parekh.

There's Something about Mukherjee

The Mukherjee family begins with two brothers, Sashadhar Mukherjee and Subodh Mukerji, who were respected filmmakers and producers of Hindi cinema (Bollywood). Don't be fooled by the different spellings of their last names — they're definitely related! Sashadhar married Sati Rani Ganguly, who was the sister of actors Kishore and Ashok Kumar. Collectively, the Mukherjees have cultivated household names every generation and remain as some of the most memorable personalities in Indian cinema.

Ranging over several decades, the Mukerjee/Mukerji family has become one of the most recognizable and revered names in Bollywood. Here are the main characters who have helped to make it a household name. Figure 2-9 helps you see everyone in the family.

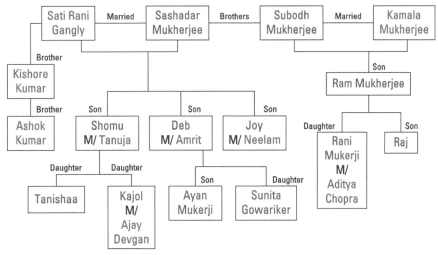

FIGURE 2-9: The Mukherjee/ Mukerji family tree.

© John Wiley & Sons, Inc.

Kishore Kumar

Kishore Kumar is considered to be one of the most successful and popular playback singers in Bollywood history. Earlier in his career, he was a popular comedic actor who worked throughout the 1950s and 1960s before fully committing to playback singing. He was the youngest of four children to lawyer Kunjalal Ganguly and Gouri Devi. His elder brother Ashok became an actor when he was still a child, and Kumar was able to leverage Ashok's connections and immerse himself into the Bollywood scene as well. Kumar was married four times; the most popular

marriage was his second, with actress Madhubala. To read more about Kumar's career, see Chapter 3.

Kajol

Shomu Mukherjee was one of three sons to Sashadhar Mukerjee and Sati Rani Ganguly. Shomu was a director himself, and his brothers Joy and Deb were successful actors from the 1960s and 1970s. He married an actress by the name of Tanuja, and the couple had two daughters, Kajol and Tanisha Mukherjee. Kajol become one of the more successful actresses from the Mukherjee family, had a thriving Bollywood career, and is now married to actor Ajay Devgn. For more on Kajol's career and legacy, see Chapter 5.

Rani Mukerji

This hazel-eyed beauty is the daughter of film director and founder of Filmalaya Studios, Ram Mukherjee, and playback singer Krishna Mukherjee. Her father is the son of film producer Ravindramohan Mukherjee. Rani Mukherjee (see her in Figure 2-8), too, has had a successful career as a Bollywood actress throughout the late 1990s and into the mid- to late-2000s, and was seen on-screen with contemporaries like Shah Rukh Khan, Saif Ali Khan, and Preity Zinta. In 2014 she married film director Aditya Chopra and has a daughter with him as well. For more on the career of Rani Mukerji, see Chapter 5.

Ajay Devgn

This actor has appeared in several blockbusters hits of his own in supporting roles, but is still considered to be a highly respectable actor in Bollywood even today. Ajay Devgn is the son of stunt choreographer and film director Veeru Devgan and film producer Veena. His acting career began in *Phool aur Kaante* (Flowers and Thorns), and he has starred in several hit films, such as *Hum Dil De Chuke Sanam* (I Have Given My Heart, Beloved), *Deewangee* (Obsession), *Once Upon a Time in Mumbaai,* and *Simmba\.* As he depicted several times in his films, Devgan is known for having a quiet and stoic personality and often calls his marriage with Kajol the "unlikely pair," given their contrasting personalities. His late brother, Anil Devgan, was a screenwriter in Bollywood.

2

Bollywood through the Years

Take a trip back in time and examine every decade of Bollywood from its inception to present day.

Find out more about the Partition that separated India and Pakistan, with the major impact on the each country's film industry.

Glimpse the evolution of Bollywood's film styles, from genres to all out musical productions.

Meet the famous actors and actresses of each generation, including their blockbuster films of the time.

Build your list of must-see Bollywood movies with recommendations from every era of the industry.

Introduce yourself to the man considered to be the biggest legend of Bollywood today.

Jump into where the industry is today with contemporary Bollywood actors and actresses.

Chapter **3**

Looking at the Golden Age, from the 1940s to the 1960s

To understand Bollywood fully, first you need to look to its humble beginnings and often tumultuous past. During British rule, India's film-and-music industry thrived in various parts of the subcontinent, including Bombay (renamed to Mumbai as of 1995), Calcutta (renamed to Kolkata as of 2001), and Lahore (in present-day Pakistan), which all emerged as cultural centers where artists and producers of movies all resided. However, the term *Bollywood* didn't yet exist, because Bombay wasn't yet the centralized beating heart of the industry.

However, 1947 brought a host of changes to not only the film industry but also the subcontinent itself. As India gained independence from British rule, two states were subsequently formed within itself, into what would become present-day India and Pakistan. This bloody split of the two countries, referred to as *Partition*, created a political and cultural divide between the two countries that persists even today.

Partition itself has become a subject of many Bollywood movies. An extremely violent and tragic episode in the subcontinent's history, Partition claimed the lives of as many as two million people as they scrambled to move to either India or Pakistan from their respective homes, spurred on by religious and ethnic divides within the subcontinent. Among those traveling were several recognizable names within the film-and-music industries, hoping to start anew when they reached their new homes.

In this chapter, we walk you through the separation from Britain that led to one of the world's largest film industries. We explore how Bollywood was born and start exploring the earliest generation of Bollywood actors to appear on the silver screen. We also discuss the beginning of a genre that would dominate Bollywood for years to come: romance.

Parting Ways: The Effect on Indian Cinema

India's independence from Great Britain led to the birth of one of the world's largest film industries — and a Golden Era of progress and filmmaking in the country. The violent split the country endured, however, played a significant role in the movies that came from this period.

REMEMBER

The original separation of India and Pakistan came to be known as *Partition,* a bloody dislocation of millions of families on either side of the border. As people migrated to the side that they were told they belonged on, violent outbursts throughout the region led to an immeasurable loss of life. This bloody period served as the backdrop for stories told in Bollywood for generations to come.

The obvious initial effect of Partition would be the migration of artists from one side of the new border to the other. Because Lahore (now in Pakistan) was a cultural center for many Indian films until this point, artists such as Noor Jehan, Dilip Kumar, Dev Anand, and Mohammed Rafi all migrated to Bombay, which was the new hub of Indian cinema.

Lahore continued to have its own film-and-music industry (we discuss more about Pakistan's role in Chapter 16) and served as the cultural and artistic center of Pakistan for many years. Indeed, the film industry of Pakistan is still referred to as Lollywood, combining *L*ahore and H*ollywood.* However, the exodus of talent from Lahore was significant, and Lollywood has been overshadowed by its big brother, Bollywood, ever since. Conversely, the consolidation of talent into one place led to the flourishing of Bollywood, and it would enjoy a period of progress, popularity, and success over the next several decades.

INDIA ACHIEVES INDEPENDENCE

Originally establishing trade posts and merchant centers within the subcontinent, the British Empire eventually had sovereign control for more than 300 years over all of India, which at the time included the modern-day nations of Pakistan and Bangladesh.

India was an important part of the British Empire and was fiercely held on to as such. As time passed, more power was given to local factions, leading to some self-governance within the subcontinent, though the British rulers reigned supreme. However, this structure eventually led to many internal power struggles and calls for further autonomy within the country by its leading elite.

By the early 1900s, Indian leaders had made it clear to the British Raj (the name of the British rule of the subcontinent from 1857 to its last days) that they wanted independence. Separation talks stalled over the next several decades, as Indians even fought alongside British soldiers in both world wars.

Following these tumultuous times and while Britain was reeling from losses from the Second World War, Indian leaders demanded a separation from British rule, which the Raj eventually granted in 1947. At the same time, the conflicts within the region between the Muslim and Hindu elite led to a further split of the subcontinent into a Muslim-majority state (Pakistan) and a Hindu-majority one (India). The subcontinent continued to face political strife over the next few decades, as Bangladesh also become a sovereign country in 1971.

This period after Partition, which became known as Bollywood's *Golden Era*, included some of the most iconic Indian movies of all time. It set the tone for decades to come in terms of style, fashion, and acting method. In many ways, modern-day Bollywood still draws from this era of filmmaking in terms of format.

First Some Sour, Then Some Sweet: Realist Cinema Giving Way to Romance

Perhaps because of the strife during the world wars and India's own independence and Partition, Indians in the 1950s were yearning for happier times. Bollywood first reflected the state of the people before answering their call in the 1960s, giving people the release they craved. As the following sections discuss, the earlier films during this period commented on social themes and explored the various socioeconomic conditions of people in the new country. The latter part of this era

saw the emergence of the type of film that went on to dominate Indian cinema for decades to come: romance.

A sign of the times: Indian social realism

The social, political, and economic ramifications of splitting a country in two sent most of India reeling in the late 1940s and early 1950s. Families were separated, entire city economies had to be rebuilt, and India was dealing with the challenge of governing itself for the first time in hundreds of years.

Bollywood films during this era were a reflection of the state of the Indian people:

>> *Pyaasa* (Wistful) and *Shree 420* (Sri 420) tells stories of working-class or poor individuals struggling to break ranks and rub shoulders with the richer social elite.

>> *Awaara* (The Vagabond) shows the struggle of moving to cities in search of work and the troubles that befell those who dared to make the leap.

This genre of movie was important not just at the time but historically as well because it faithfully depicted the struggles of a post-Partition India. Audiences immediately connected with the plight of the characters; the filmmakers themselves could draw on their personal experiences when making the movies. This period culminated with the everlasting classic *Mother India*, which became the first Indian film to be nominated for an Academy Award.

The subsequent dominance of romance

As India recovered from the Partition and found more solid footing economically, the mood surrounding Bollywood also changed. A more hopeful genre began to emerge in the 1960s — one that remains the most prevalent, even in today's Bollywood.

Suddenly, theaters were filled with moviegoers who delighted in viewing musical romances, and a new genre was born. Movies like *Mughal-E-Azam* (The Great Mughal), shown in Figure 3-1, and *Chaudhvin Ka Chand* (Full Moon) brought a softer tone into the Indian cinema landscape, one that was centered around a love story rather than a social struggle.

Actors such as Shammi Kapoor began to break out of the normal, serious roles into more whimsical ones. Kapoor's character in *Junglee* (Wild) remains iconic for its lesson of not taking life too seriously and enjoying the simpler moments that it has to offer. Its title song, which went on to become one of the most popular and iconic songs of all time, represented the changing mood in India at the time.

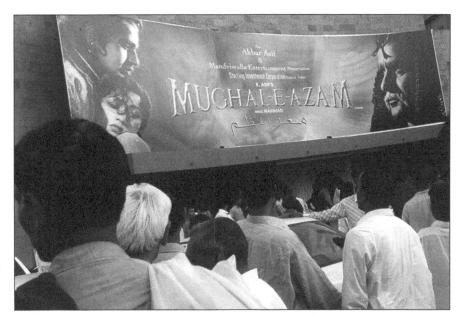

FIGURE 3-1:
Pakistani
cinema-goers
gather for
tickets to see
the Indian
classic
Mughal-E-Azam
in Lahore in
2006.

Of course, Partition and India's independence weren't completely forgotten. They remained in the backdrop of nearly every movie made during this time. Some movies, like *Waqt* (Time) used metaphors, such as an earthquake, to represent the struggles of Partition. Others were less subtle, using the blatant fallout from India's independence to epitomize the struggles of the main characters as they navigated a newly independent India.

BOLLYWOOD MOVIES FROM THE GOLDEN ERA WORTH WATCHING

You can learn as much as enjoy from the movies of this era. Each movie is a depiction of the struggles of common men and women in India during this difficult time in its history. From unforgettable performances to heart-wrenching storylines, some of the best movies ever made come from the Golden Era in Indian cinema. For starters, here are some of the most important from that time:

- *Anari* **(Amateur):** This 1959 comedy starring Raj Kapoor, *Anari* follows the journey of a hard-working and honest man as he tries to make a living. Depicting the struggles of the common man around that time, *Anari* took a more lighthearted approach and offered a more comedic take on the plight of the city man.

(continued)

(continued)

- **Babul (Father's House):** Directed by S.U. Sunny, *Babul* starred Dilip Kumar, Munawar Sultana, and Nargis in leading roles. Centered around a rich man and a poor woman vying for his affections, this 1950 film explores the stratification of wealth and the pitfalls of jealousy. At the time of its release, it was a major success, becoming the second-highest-grossing film of 1950.

- **Barsaat Ki Raat (Rainy Night):** Known for its soundtrack, which featured qawwali-style music, *Barsaat Ki Raat* was a major box office success in 1960. It explored the struggles of loving someone your family disapproved of in India, as well as the struggles of trying to make a living in the city. Known also for its depiction of girls singing in a public setting (a practice that was frowned upon in India), it's credited with promoting a diverse perspective on women in India at the time.

- **Chhalia:** *Chhalia* is a dramatic film, directed by Manmohan Desai and starring Raj Kapoor in the titular role. Centered around Partition, this 1960 film follows the plight of a young woman who is married just before the Partition is created and the various troubles that arise from the separation of families during that time.

- **Devdas:** One of the most remade films in Indian cinema, this 1955 iteration of *Devdas* was directed by Bimal Roy and stars Dilip Kumar, Suchitra Sen, and Vyjayanthimala. Based off Sarat Chandra Chattopadhyay's 1917 novel, it's regarded by many as one of the greatest Bollywood movies of all time. The love story of the main characters Devdas and Paro is one of the most beloved and well-known in India, as the film also explores issues of caste and social custom in India in the early 1900s.

- **Madhumati:** Another Bimal Roy film, *Madhumati* has also been remade several times after its initial success. Reuniting stars Dilip Kumar and Vyjayanthimala, this 1958 film broke several box office and awards records, walking away with nine Filmfare Awards, including the one for best picture. The movie's plot centers around a love story and the Hindu belief in reincarnation.

- **Manzil (Destination):** Starring the popular duo of Dev Anand and Nutan Samarth, *Manzil* is another movie that has been remade in recent years. Centered around the story of a struggling musician and his family's unwillingness to accept his musical career, this 1960 film wasn't successful during its release. However, it has in later years earned itself a cult following and remains a classic.

- **Mother India:** Widely regarded as one of the best and most iconic movies in Indian cinema, *Mother India* was directed by Mehboob Khan and had a star-studded cast that included Nargis, Sunil Dutt, and Rajendra Kumar in 1957. The classic story of a poor woman struggling to make ends meet and raise her children remains one of the most beloved and esteemed films in Bollywood. Still one of the biggest box office successes in Bollywood history, it won five Filmfare Awards and was the first Indian film to be nominated for an Academy Award.

- *Mr. and Mrs. 55*: A romantic comedy starring Guru Dutt (who also directed) and Madhubala, *Mr. and Mrs. 55* follows the mess that characters create for themselves while facing challenges laid out by the female protagonist's family. This 1955 film was successful at the time of its release and remains one of the best comedies to emerge from 1950s Bollywood.

- *Mughal-E-Azam* **(The Great Mughal):** Another all-time great film, *Mughal-E-Azam* stars Madhubala and Dilip Kumar in the main protagonist roles. The famed story is of a forbidden love between a prince and his father's court dancer; the problematic couple eventually leads to a full-out war between the prince and his father. One of the first successful epic films made in India (in 1960), *Mughal-E-Azam* smashed box office records and won multiple accolades, including three Filmfare Awards.

- *Padosan* **(Neighbor):** A romantic musical starring Sunil Dutt, Saira Banu, and Kishore Kumar, *Padosan* is a roller-coaster ride of antics and hilarious situations. One of the great romantic comedies of its time (1968), the movie hilariously portrays the main protagonist going to great lengths to win the love of his female neighbor.

Meeting the Evergreen Actors

The Golden Era of Bollywood was known for its iconic films and hard-hitting storylines. However, the actors and actresses of the time are legends in their own right, doing justice to the demanding roles they played in the films. Here are some of the biggest names in Bollywood, who are nothing short of legendary figures in Indian cinema.

Master of mannerisms: Dev Anand

A multitalented star who remained in the Bollywood industry for several decades, Dev Anand, born as Dharamdev Pishorimal Anand, is widely considered one of the greatest and most iconic Indian actors of all time. Easily recognizable by his vivacious personality and his habit of nodding his head while talking, he appeared in more than 100 Bollywood films. He also wrote, directed, and produced films, some of which debuted as late as 1991.

Anand — who has often been compared to the great American actor Gregory Peck — is perhaps best known as the evergreen hero. Anand appeared in several films as the main protagonist despite being 60 years and older in his later years. His long list of successful movies include such titles as *Ziddi* (Stubborn), *Kala Pani* (Black Water), *Johny Mera Naam* (My Name Is Johnny), and *Guide*. His final film, *Chargesheet*, in where he acted, directed, and produced was released in 2011.

Award winner: Dilip Kumar

Another actor whose career spanned multiple decades, Dilip Kumar (shown in Figure 3-2) is best known for his methodical approach to acting. Born as Yusuf Khan, he later changed his name to something more "filmy" and took on the name of Dilip Kumar. From then on he often appeared in more tragic or serious roles, earning acclaim as one of the best actors of his time. The last living actor of the Golden Era, Kumar has often been called the Tragedy King for his various roles dealing with somber themes in India. He has also served as a member of Indian Parliament from 2000 to 2006.

FIGURE 3-2: Married couple Dilip Kumar (left) and actress Saira Banu (right).

Dinodia Photos/Alamy Stock Photo

Kumar is also famous for being the first recipient of the Filmfare Best Actor award, which he won for *Daag* (The Stain). Kumar, who went on to win seven more Film-fare Best Actor awards, is tied with Shah Rukh Khan for the most Best Actor wins in his lifetime. (Refer to Chapter 15 for more about Bollywood's specific award shows.) He has played a wide variety of roles and can be seen in these classics:

» *Deedar* (Glance)

» *Aan* (Pride)

- » *Devdas*

- » *Gunga Jumna*

- » *Mughal-E-Azam* (The Great Mughal)

- » *Madhumati*

The singing actor: Kishore Kumar

Born Abhas Kumar Ganguly, Kishore Kumar is one of the most legendary singers and actors in all of Indian cinema. A speaker of more than ten languages, Kumar remains revered as one of the best Bollywood playback singers of all time. The brother of another actor, Ashok Kumar, Kishore Kumar appeared in several films during the late 1940s and early 1980s, including lead roles in commercially successful films such as *Naukari* (Occupation) and *Padosan* (Neighbor).

Kishore Kumar may forever be remembered most fondly for his soft voice and melodious love songs, but his mark on the Golden Era of Bollywood is undeniable. Though he gained an infamous reputation for missing shoots and skipping call times, he remained one of the most beloved singers and actors of his time.

Introducing the Classic Gentlemen

Hindi cinema during this era, much like Hollywood, was beaming with classy and sophisticated male personalities. Performances by the likes of John Wayne and Rock Hudson enamored American audiences, while Indian audiences were kept captivated by charismatic, charming, and strong leading men with star powers to match. We take a look at a few of Bollywood's extraordinary gentlemen.

The multitalented star: Raj Kapoor

Hailing from the famous Kapoor family, Raj Kapoor was born into a family of movie icons. His brothers, Shammi and Shashi, had successful careers of their own in Bollywood. However, Raj is undoubtedly the most successful Kapoor of his time; in fact, he's often regarded by many as the most successful Bollywood actor of all time.

Compared favorably to such other greats as Clark Gable and Charlie Chaplin, Raj Kapoor (see Figure 3-3) began appearing in Bollywood films when he was only 10 years old. He went on to receive multiple accolades, including two Filmfare

Best Actor awards. His career spanned almost 50 years, in which he was an actor, a producer, and a director. His greatest films include the extremely successful *Awaara* (The Vagabond), *Shree 420* (Sri 420), and *Sangam* (Confluence).

FIGURE 3-3: Indian actor Raj Kapoor in 1988.

Raj Kapoor's children carried on his legacy within Bollywood — most notably, his late son Rishi Kapoor, who became a Bollywood icon in his own right in the 1980s and 1990s. Refer to Chapter 4 for more about Rishi.

The first superstar: Rajesh Khanna

A singular personality born by the name of Jatin Khanna, Rajesh Khanna is widely regarded as India's first superstar. Khanna received a favorable review of the vast majority of his films. At his peak, he appeared in 15 consecutive solo films that were considered hits, a record that remains unbroken.

An actor of the later 1960s, Khanna burst onto the scene after winning a national talent competition. As part of his prize, he appeared in his first Bollywood movie, *Akhri Khat* (The Last Letter), which was an instant success and launched his career. He went on to win three Filmfare Best Actor awards and even served in India's Parliament. He married actress Dimple Kapadia, and his daughters, Twinkle and Rinkle, also emerged as Bollywood actresses.

Overcoming adversity: Sunil Dutt

Born Balraj Dutt, Sunil Dutt had a tumultuous childhood. After his father passed away early in his life, his entire family was saved by one of his father's friends during Partition. Dutt became a radio host for Radio Ceylon and was discovered by director Ramesh Saigal. It would take a couple of years, but Dutt would shoot to stardom in his role in *Mother India*, which was an instant classic and one of the greatest Bollywood movies ever made.

Dutt went on to have an extremely successful career as a Bollywood actor, appearing in a number of films in the late 1950s, 1960s, and well into the 1990s, including these classic titles:

>> *Padosan* (Neighbor)

>> *Waqt* (Time)

>> *Hamraaz* (Confidant)

>> *Insaan Jaag Utha* (Mankind Has Awoken)

Shining the Spotlight on Leading Ladies

Though the men of the Golden Era established themselves as legends, the women were equally, if not more, revered for their abilities on the screen and their timeless beauty. These sections identify a few notable women in Bollywood.

International beauty: Madhubala

One of the first Indian film stars to break into the international scene, Madhubala has been recognized as one of the most beautiful, accomplished, and influential actresses in Bollywood cinema history. Born as Mumtaz Jehan Begum Dehlavi and debuting as a child artist, Madhubala (refer to Figure 3-4) later went on to take several lead roles, including perhaps her most famous performance, in the epic *Mughal-E-Azam*.

Madhubala was later featured in *Life* magazine and gained international fame as a result. Her untimely death at the age of just 36, her incredible beauty, and her iconic status often lead to comparisons between her and Marilyn Monroe. She was survived by her husband and fellow actor Kishore Kumar.

FIGURE 3-4:
Indian actress
Madhubala's
wax figure, at
Madame
Tussaud's in
New Delhi.

Xinhua/Alamy Stock Photo

Dancer turned star: Waheeda Rehman

Widely regarded as one of the most accomplished actresses ever in Indian cinema, Waheeda Rehman is still one of the most recognized names and faces on the Indian subcontinent. Known as both an incredible actress and a dancer, Rehman began her career dancing in item numbers, before cementing herself as a leading star for her performance as a prostitute in the widely acclaimed *Pyaasa* (Wistful). She continued to garner praise and acclaim for such classic movies as these:

>> *Chaudhvin Ka Chaand* (Full Moon)

>> *Kaaghaz Ke Phool* (Paper Flowers)

>> *Guide*

>> *Khamoshi* (Silence)

Among her accolades are two wins for Filmfare Best Actress (you can read all about the Filmfare Awards in Chapter 15), as well as a number of other national awards. In recent years, she has appeared in successful movies as a mother or grandmother figure, and is a recognized philanthropist.

Presenting All Things Grace and Presence

Although the Golden Era presented several powerful leading ladies, two actresses in particular stood out so much that they were each regarded as the national treasures of their home countries, India and Pakistan, respectively. Each woman's body of work had social significance that's recognized even today. Their legacies are forever tied with their homeland and helped instill a great deal of pride and prestige to their fellow people.

Beloved beauty: Nargis

Born Fatima Rashid, Nargis was another actor to grace the screen from an early age, making her early debut at the young age of 6. Known for her incredible chemistry with Raj Kapoor onscreen, with whom she appeared in a number of her films, Nargis cemented her legacy as an incredible actress with her lead performance in *Mother India*, still considered to be one of the greatest Bollywood films ever.

Nargis (shown in Figure 3-5) started her career strongly, appearing in the blockbusters *Andaz* (Style) and *Barsaat* (Rain). After a few down years, she reemerged as a household name after appearing in *Shree 420* (Sri 420) before her legendary performance in the national breakthrough film, *Mother India*. (You can read more about this film and its unique history in Chapter 19.) Nargis ended her career early to spend time with her family despite many viewing her as the best actress of her time. She famously died just days before the acting debut of her son, Sanjay Dutt, succumbing to a short battle with pancreatic cancer.

FIGURE 3-5:
Nargis, in 1980.

Dinodia Photos/Getty Images

Pakistani princess: Noor Jehan

One of the few actresses to move from India to Pakistan during the Partition, Noor Jehan was one of the most successful Indian actresses before Partition. Like Kishore Kumar, she is remembered now more for her playback singing, holding the record for most female playback songs in Pakistan — having lent her voice to more than 20,000 numbers.

From 1945 to 1947, Jehan was one of the most popular actresses in British India, appearing in commercially successful movies such as *Badi Maa* (Elder Mother), *Zeenat* (Gorgeous, also a female name), and *Jugnu* (Firefly) just before Partition. Even after Partition, she remained a mainstay in Pakistani cinema and is now revered by fans from both sides of the border as one of the most influential actresses from the subcontinent at large.

Chapter **4**

Spotlighting Classical Bollywood in the 1970s and 1980s

As the social and political scene in India changed as the country recovered from its independence and Partition (refer to Chapter 3), so too did the arts. Movies, music, and television all began to reflect the changing moods and conditions of the country. The population within India began to boom in the 1970s and with that came additional challenges. Slums, especially within large cities, became much more numerous. The economic struggles of many became the main focus of conversation during this time, and more people even began turning to crime to solve their problems.

In this chapter, we help you explore how Bollywood begins creating films outside the romance genre, meet arguably one of the legends of Bollywood acting, and find out about films that would define a generation.

Going Beyond Musical Romance Films

Although musical romances had dominated the 1960s and continued in the 1970s and beyond, the public started finding the lack of originality and change of pace to be rather disappointing. The romance genre was quickly turning stale, and as the actors from the previous generation grew older, a new wave of actors would take the helm and secure leading roles. As the talent pool diversified, so too did the types of characters that appeared on-screen.

The leading ladies from the 1950s and 1960s made way for a new wave of leading ladies, who wowed audiences with incredible dance moves, shocking good looks, and personalities to match. Their characters saw a similar evolution, as they were written with more colorful personalities and more dialogue than prior years, despite often remaining in supporting roles.

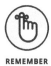

REMEMBER

A big part of these changes was a successful shift in writing. Rather than simple plots focused on one large, overbearing problem, the stories that writers spun in this era often had complex storylines, multiple parallel stories, surprise twists, and numerous antagonizing elements. Two writers in particular who began to emerge during this period worked to revolutionize the industry: Salim Khan and Javed Akhtar.

The duo, referred to commonly as Salim-Akhtar in screenwriting credits, shaped much of the Bollywood cinema landscape in the 1970s. (You can see them in Figure 4-1, at a promotional event for their 1975 film *Sholay*, which was rereleased in 3D in 2013.) By popularizing action and darker themes in movie plots, they gave rise to a different kind of hero, facing extremely different issues from the ones during the Golden Era. Indeed, the pair can be given much of the credit for discovering and vaulting superstar Amitabh Bachchan (see the later section "Dominating the Industry: The Killer 'B'") into fame. Were it not for their writing and darker themes, the "angry young man" persona that defined actors like Bachchan and Vinod Khanna may never have come to exist. This paradigm shift led the way to new categories and darker themes in movies.

STRDEL/Getty Images

FIGURE 4-1:
Javed Akhtar
(left) and Salim
Khan (right).

Ramping Up the Action

Although highway robbers and bandits, or *dacoits,* were prevalent in the Indian countryside since the British Raj, they became even more infamous during this period. Ultimately, they found their way on the silver screen, appearing in movies regularly and spawning the dacoit genre of Bollywood movies. Alternatively, for each dacoit villain, a similar hero was on-screen to play the good guy. And as the countryside turned violent, so too did the content of Bollywood movies.

Actors therefore saw a complete reversal in roles. Gone were the days of whimsical romancers; the men of the 1970s came in as verifiable tough guys who faced formidable henchmen and evil antagonists. This time also saw an ever-increasing number of bad guys wreaking havoc for the hero and heroine. Furthermore, the advent of organized crime grew in the 1970s, leading to more and more movies that explored the dark underworld of cities. Indeed, some of the best-known movies during this time, such as *Deewar,* centered on the main characters' navigating the rigors of the criminal underworld.

CULTURAL
WISDOM

Of course, romance wasn't dead during this time. Plenty of romantic films still became popular during this era. Though fresh faces abound, new pairings were also made, and audiences clamored to learn more about the interesting new couples who were gracing the screen. This era of Bollywood was an exciting time of moviemaking that saw a host of new faces, plots, characters, and conflicts.

CONSIDERING SOME MUST-SEE CLASSIC MOVIES

The 1970s were the first decade where Amitabh Bachchan (see the later section "Dominating the Industry: The Killer 'B'") began to leave his mark on Bollywood. Appearing in many of the blockbusters of this era, he cemented himself as a superstar in India and abroad. A number of the films during this time featured many of his colleagues in lead roles alongside him, and the plots of 1970s films similarly touched on many different points in spinning their tales. Here are some of the best movies from this decade:

- *Amar Akbar Anthony*: A timeless classic studded with star power, *Amar Akbar Anthony* stars Vinod Khanna, Amitabh Bachchan, and Rishi Kapoor in titular roles. As if that weren't enough, the female cast includes Parveen Babi, Neetu Singh, and Shabana Azmi. The story of three brothers separated at birth and adopted into families of three different faiths, this 1977 movie continues to be quoted, referenced, and revered in modern times.

- *Bobby:* Directed by Bollywood legend Raj Kapoor, *Bobby* marked the debut of his son Rishi Kapoor as well as Dimple Kapadia. A lighthearted film centered around teenage romance, this 1973 movie was an instant hit and set the trend for young love in movies with class difference as a central conflict, a plotline that is used in Bollywood even today. The movie launched the careers of both of its debuting actors, Kapoor and Kapadia.

- *Don:* Starring Amitabh Bachchan in a dual role, *Don* was so successful in 1978 that it became a full-fledged Bollywood franchise as well as remakes in several other languages. Heralded as a classic and one of Bachchan's most iconic roles, *Don* showcases the grimy Bombay underworld of the 1970s as its backdrop and weaves an intricate plot with memorable characters and dialogue around it.

- *Laila Majnu* **(Laila and The Madman):** An epic love story that has been made into film several times, perhaps no iteration is as famous as the 1976 version starring Rishi Kapoor and Ranjeeta Kaur. Based on an old Arabic tale, the story of star-crossed lovers is well known on the Indian subcontinent. Rishi Kapoor gives a memorable performance as a lover driven to madness, and the movie's soundtrack is an evergreen classic showcasing the voices of Lata Mangeshkar and Mohammad Rafi.

- *Muqaddar Ka Sikandar* **(Conqueror of Destiny):** One of nine films that teamed Director Prakash Mehra with Amitabh Bachchan, *Muqaddar Ka Sikandar* weaves an intricate plot around several important characters. With a star-studded supporting cast that includes Rekha, Raakhee, Vinod Khanna, and Amjad Khan, this 1978 movie has a little bit of everything. One of the biggest commercial and critical successes of its time, *Muqaddar* is three hours of pure entertainment and emotion.

- *Sholay* **(Embers):** Widely considered to be one of the best Bollywood films of all time, *Sholay* is another multistarrer that has perhaps the most memorable dialogues and characters of any film from this era. Easily the most famous dacoit film from Bollywood, Sholay is a 3½-hour tour de force with one of the greatest villains in Bollywood history, Gabbar Singh, who is based on a real-life bandit.

- *Suhaag* **(Husband):** Yet another Bachchan starrer, *Suhaag* also featured Shashi Kapoor, Rekha, and Parveen Babi in leading roles. This 1979 movie centers around a separation of siblings, roles that Bachchan and Kapoor have appeared in together numerous times. With a convoluted plot and twists and turns aplenty, this movie is another crime film that guarantees to keep audiences on their toes.

Dominating the Industry: The Killer "B"

The action-packed films that dominated this era demanded big, strong men who could play the part. One man — Amitabh Bachchan — separated himself from the rest of the pack early on and went on to become the most famous man in Bollywood, universally regarded as one of the most, if not *the* most, beloved actors of all time as we discuss in these sections.

Recognizing Bachchan's legacy in Bollywood

Known by many nicknames over the course of his career, Bachchan was born with the name Inquilaab Srivastava to a poet father and a social activist mother. With striking physical features, including being taller than six feet, which was a rarity in this industry at the time, and possessing a deep, immediately recognizable voice, Bachchan (see Figure 4-2) is a formidable presence on- and off-screen throughout his career.

Bachchan appeared in a few films in the early 1970s in various roles, with his performances in *Anand* and *Bombay to Goa* gaining recognition. However, by 1973 he was already older than 30 and a largely unsuccessful actor in Bollywood. His fortunes were to change drastically in the next year when he was cast in *Zanjeer* (Shackles) by director Prakash Mehra. *Zanjeer* went on to become one of the most successful movies of all time and launched the career of Bachchan in the process, establishing him as an angry young man in Bollywood, as opposed to the joyful romantic actors who were his peers.

CULTURAL WISDOM

Bachchan was so successful that he was even pulled into small roles in Hollywood. To read more about his work and other Bollywood actors in Hollywood, flip to Chapter 21.

FIGURE 4-2:
Portrait of
Indian actor
Amitabh
Bachchan
in 1987.

Dinodia Photos/Getty Images

Writers Salim Khan and Javed Akhtar deserve much of the credit for discovering Bachchan, and his career arc aligned closely with the two writers as well as directors Prakash Mehra, Manmohan Desai, and Yash Chopra. Bachchan became the actor of choice for these directors and essentially came to dominate the 1970s, appearing in blockbuster after blockbuster and establishing himself as a superstar. He appeared in some of the most highly regarded films in Bollywood history, including these megahits:

>> *Deewar* (Wall)

>> *Sholay* (Embers)

>> *Kabhie* (Sometimes)

>> *Don*

>> *Amar Akbar Anthony*

>> *Muqaddar Ka Sikandar* (Conqueror of Destiny)

Indeed, Bachchan appeared in more hits than any other actor in the 1970s. Not only was he found in every hit movie, but nearly every movie he was in also became a guaranteed hit.

Moving beyond Bachchan's star status

As Bachchan's success grew, he also grew as an actor. From the angry-young-man persona that had originally made him famous, Bachchan began to appear in various other genres and roles. From comedy to romance to drunkard, he began to do it all, opening up even more opportunities to him. He even began to take on double roles, playing two different characters within the same film — most famously in his blockbuster hit *Don*.

Bachchan continued to be a superstar in the early 1980s before taking a respite from films to enter politics. His career after politics was a bit rockier, but he reestablished himself as a household name and an excellent actor in the late 1990s and early 2000s, appearing as older characters alongside leading stars such as Shah Rukh Khan (see Chapter 5 for more).

CULTURAL WISDOM

Bachchan married his fellow actress Jaya Bhaduri in 1973, and the two often starred in films together. The couple has two children, one of which is Bollywood actor Abhishek Bachchan. Amitabh continues to act today and remains a major public figure in India. Aside from his movie acting, he's also an ambassador for several brands and has hosted television shows in India as well.

THE '80S, BABY!

The 1980s continued the trend of the decade before it and sprinkled plenty of action in its movie plots. However, Bachchan was no longer seemingly the only actor available for parts, and other actors began to emerge in more diverse, interesting roles. The 1980s, which featured some epic debuts of artists, has some of the most memorable films made in Bollywood. Here's a short list to get you started:

- *Coolie* (**Porter**): Starring none other than Bachchan in the titular role, *Coolie* is another film with a complicated plot set up by heartless men, distorted pasts, and separation of siblings. A smashing box office success in 1983, *Coolie* is another in a long line of memorable roles that Bachchan delivered in the 1970s and 1980s.

- *Kranti* (**Revolution**): Directed by Manoj Kumar in 1981 and marking the return of Dilip Kumar after a short hiatus in the late 1970s, *Kranti* has an ensemble cast featuring Shashi Kapoor, Hema Malini, and Parveen Babi. The story of Indian freedom fighters struggling to gain independence from Britain in the late 1800s, *Kranti* was a commercial success at the time of its release and continues to be regarded as one of the best films of its time.

(continued)

(continued)

- ***Maine Pyaar Kya* (I Have Loved):** Salman Khan's first movie in a lead role, *Maine Pyaar Kiya* is a certified classic of Indian cinema, earning six Filmfare Awards at the time of its release, including Best Film honors. As its title suggest, this 1989 movie is a love story between the main characters who overcome obstacles in pursuit of their joint happiness. The film also has one of the most recognizable soundtracks of all time, including several tracks featuring Lata Mangeshkar as a playback singer.

- ***Mard* (Man):** Firmly in the action genre, *Mard* stars Bachchan in a lead role and as part of another twisted-and-turning plot. Barbaric at times and heartfelt at others, *Mard* is another chapter in the legend of Bachchan as a tough guy with a heart of gold.

- ***Naseeb* (Destiny):** Bachchan leads an ensemble cast that experiences several ups and downs throughout the course of this 1981 movie. A winning lottery ticket sets off a chain of events involving several characters and multiple generations, as was customary of movie plots of this time. Themes of friendship, love, deceit, and revenge are explored in this blockbuster film that features multiple music hits from its soundtrack.

- ***Ram Lakhan:*** One of Anil Kapoor's most memorable films, *Ram Lakhan* also stars Jackie Shroff, Dimple Kapadia, and Madhuri Dixit in lead roles. Yet another story involving siblings, *Ram Lakhan* is a fan favorite and was another 1980s hit from director Subhash Ghai. The story revolves around titular brothers Ram and Lakhan as they navigate greedy antagonists in their search for justice and revenge in this 1989 movie.

- ***Ram Teri Ganga Maili* (Ram, Your Ganga Is Tainted):** A controversial movie at the time of its release (1985), *Ram Teri Ganga Maili* is one of the few movies during this decade to feature a woman as the protagonist, with nearly all other characters acting as supporting cast. This movie was also Raj Kapoor's last as a director, allowing him to finish his directorial career on a high note — because the film was the highest-grossing Bollywood film of 1985.

- ***Tridev* (Trinity):** An action-packed thriller featuring Jackie Shroff, Sunny Deol, and Naseeruddin Shah as the titular trinity, *Tridev* was a critical and commercial success in 1989. The movie, which won two Filmfare Awards, is another memorable installment in the dacoit genre of Bollywood.

- ***Tezaab* (Acid):** Another movie featuring the classic pairing of Anil Kapoor and Madhuri Dixit, this 1988 movie is best known for cementing its two leads as certifiable stars. Madhuri became something of an overnight success when her dancing abilities and addicting smile turned the song "Ek Do Teen" (One Two Three) into a national sensation. The film was also critically successful and won multiple awards at Filmfare.

- ***Vidhaata* (Creator):** The highest-grossing movie of 1982, *Vidhaata* is an action movie spanning multiple generations with crime and betrayal at its epicenter. Directed by Subhash Ghai, the movie stars legend Dilip Kumar alongside Shammi Kapoor and Sanjay Dutt, among others. The film was remade into several other languages and earned Shammi Kapoor a Filmfare Award for Best Supporting Actor.

For Richer or Kapoor-er: The Kapoors

Much like any era of Bollywood, actors with the Kapoor surname went on to have highly successful careers. On many occasions they ended up hailing from the major Kapoor clan (see Chapter 2), other times they're distantly related, and very rarely they might've made it big with no familial relation. In the case of the 1970s and 1980s, you can see all three scenarios. So many Kapoors, so little time.

The remake king: Jeetendra Kapoor

A close friend of Rajesh Khanna's, Jeetendra Kapoor (born Ravi Kapoor) grew in prominence during the 1980s for appearing in remakes of South Indian films for Bollywood. All in all, he starred in more than 200 films, many of which were extremely commercially successful. He was often cast alongside actresses Sridevi and Jaya Prada, and their pairings remained hugely popular throughout his career.

Although Kapoor had been acting since the late 1960s, he didn't begin experiencing widespread success until the 1970s and '80s such as *Khushboo* (Aroma) and *Himmatwala* (Brave Man). He became known especially for his dancing abilities and charismatic lip-syncing in movie songs. Kapoor now chairs Balaji Telefilms, which is run alongside his wife, Shobha, and daughter Ekta, and produces television soap operas, game shows, reality shows, and other television programs. His son Tusshar Kapoor is also an actor, who has appeared in movies throughout the 2000s.

The ageless actor: Anil Kapoor

An actor who seemingly refuses to age, Anil Kapoor has been a Bollywood veteran for more than four decades. He rose to prominence in the 1980s, first in South Indian films and finally in Bollywood films. He began to earn critical praise and established himself as a great actor with his roles in popular films like *Tezaab* (Acid) and *Beta* (Son), both of which earned him Filmfare Best Actor honors.

Anil Kapoor (see Figure 4-3) went on to star in many more commercially successful films in the 1980s, perhaps most famously in *Mr. India* and *Ram Lakhan*. Kapoor continued to find success throughout the next few decades as well. His iconic mustache and warm smile won over audiences far and wide, and he eventually appeared in international roles as well, including popular films like *Slumdog Millionaire* and *Mission Impossible — Ghost Protocol* (read more about his Hollywood career in Chapter 21).

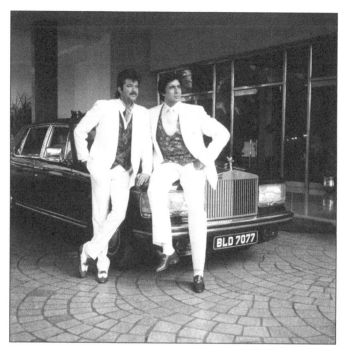

FIGURE 4-3:
Anil Kapoor
(left) and
Amitabh
Bachchan
(right) in 1990.

Dinodia Photos/Getty Images

**CULTURAL
WISDOM**

Even though Jeetendra and Anil have the Kapoor last name, they aren't immediate family members of the long-standing Kapoor generation in Bollywood that starts with Rishi Kapoor, who we introduce in the next section.

Boy wonder: Rishi Kapoor

Exploding on the scene as both a child and adult, first in *Mera Naam Joker* (My Name Is Joker) and later in *Bobby* (Figure 4-4 shows Kapoor with Dimple Kapadia in the 1973 hit), Rishi Kapoor quickly established himself as a household name and one of the best actors of his time. The son of legendary actor Raj Kapoor, Rishi Kapoor quickly became a romantic hero with his sweet smile, soft voice, and boyish charm. Though he appeared in many movies from the 1970s to the 2000s, he's best known for the blockbusters he starred in during the 1980s, including his iconic role in *Karz* (Debt) and the popular romantic drama *Saagar* (Sea).

Kapoor continued to act well into the 2000s and began to appear in supporting roles as a character actor. His work in these roles earned him several Filmfare Awards nominations, and he even won awards for his work in later movies like *Kapoor and Sons* (read more about this film in Chapter 6). Kapoor was a beloved movie icon in the Bollywood industry, and his passing from leukemia in April 2020 was met with worldwide mourning. He is survived by his wife, actress Neetu Singh, as well as two children, including popular actor Ranbir Kapoor.

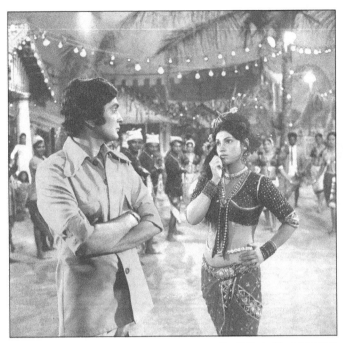

FIGURE 4-4:
Rishi Kapoor
(left) and
Dimple
Kapadia.

Dinodia Photos/Alamy Stock Photo

Identifying the Original Gangsters

As Amitabh Bachchan popularized the angry young man during the 1970s and 1980s, more actors were cut from the same cloth as the standards for the male lead suddenly changed. The tough, no nonsense, machismo male archetype was all the rage during this era, which lead to a few stand out talents that really benefitted from this phenomenon.

Tall and tough: Jackie Shroff

A veteran of more than 200 films in 13 different languages, Jackie Shroff (Figure 4-5 shows him at Sanjay Dutt's 60th birthday party in 2019) rose to prominence in the 1980s and became popular in gritty action roles. A six-foot-tall actor with a formidable mustache, Shroff espoused the tough-guy role and played it to great reviews in films such as *Ram Lakhan*, *Tridev* (Trinity), and *Parinda* (Bird). Over the course of his career, he has won four Filmfare Awards, and has starred in many different kinds of projects, including hosting television shows and appearing in short films.

FIGURE 4-5:
Manisha
Koirala (left),
Jackie Shroff
(center), and
Sanjay Dutt
(right).

Sujit Jaiswal/Getty Images

**CULTURAL
WISDOM**

Shroff's son, Tiger Shroff, debuted in Bollywood in the late 2010s and has gained prominence as well. To read more about Tiger, turn to Chapter 6.

The roller coaster career: Sanjay Dutt

Perhaps no actor has had as much of a roller coaster career as Sanjay Dutt, the son of famed Bollywood actors Sunil and Nargis Dutt. Born into a Bollywood family, his debut film was the Sunil Dutt–directed *Rocky*, which went on to become a huge hit at the box office. Just four days prior to the movie's premiere, Dutt (refer to Figure 4-5) lost his mother to cancer.

Although he'd have a long and illustrious career, with many box office hits and several accolades, his personal life would be the subject of intense scrutiny because he would make headlines for drug abuse, underworld connections, and run-ins with the law. Eventually serving a stint in jail, Dutt was the real-life version of many of the bad-boy characters he played in films. These are some of his best-known works:

>> *Saajan* (Beloved)

>> *Khal Nayak* (Villain)

>> *Vaastav* (The Reality)

>> *Munna Bhai, M.B.B.S.* (Brother Munna, M.B.B.S.)

CULTURAL WISDOM

Dutt's own life would become the subject of film in the biopic *Sanju*, starring Ranbir Kapoor and featuring a guest appearance from Dutt himself. The Indian public's fascination with him continues even today, as the movie did well at the box office and garnered good reviews from critics as well.

Villain and hero: Vinod Khanna

Another certified tough guy, Vinod Khanna started his career by appearing in villainous roles and smaller supporting roles. However, he quickly adopted a similar persona as Amitabh Bachchan's angry young man and was cast in leading roles throughout the 1980s, often opposite the big B, as Amitabh is fondly nicknamed. Over time, he became known as one of the best-looking and most talented actors of his time and went on to have a successful career in both Bollywood and politics.

Meeting the Method Men

Similar to some Hollywood stars, Bollywood has also had its fair share of method actors who were able to dive deep into their character assignments. Dilip Kumar was a notable method actor from Bollywood's Golden Era (refer to Chapter 3), and the 1970s and 1980s definitely added a few more into that mix. The dedication to their crafts paid major dividends as these stars are still talked about today.

Disco King: Mithun Chakraborty

A truly multitalented individual, Mithun Chakraborty is perhaps best known for his ability to immerse himself in any given role and deliver incredible performances in his movies. Debuting in an art house film — an unlikely path for a Bollywood actor in the 1970s — called *Mrigayaa* (The Royal Hunt), Chakraborty quickly became a critical darling and earned accolades for his performance.

He followed this debut with the internationally renowned *Disco Dancer*, for which he received praise and was recognized as an excellent dancer for years to come. His career would span more than 350 films, in more than eight languages! Besides acting, Chakraborty is also an established politician, philanthropist, entrepreneur, and television presenter. As in the variety of roles he has played in his lifetime, he has shown over the course of time that he really can do it all.

The Theatric: Shashi Kapoor

Known perhaps for delivering some of the most iconic dialogues opposite Amitabh Bachchan, Shashi Kapoor was a force to be reckoned with in the 1970s and 1980s. Born into the famed Kapoor family, Kapoor (see him on set for the movie *Siddhartha* in 1972 in Figure 4-6) was the youngest brother of legend Raj Kapoor and established himself as an actor in his own right. He appeared in multiple films alongside other great actors of his time and was often cast in romantic films alongside the leading actresses of his day.

FIGURE 4-6: Shashi Kapoor on set.

Michael Ochs Archives/Getty Images

Because Kapoor came from a prominent film family, he naturally began acting at a young age. He made a name for himself as a child actor at Mumbai's esteemed Prithvi Theatre working in his father's plays. He was often seen playing the younger version of his eldest brother, Raj, and continued his work as the theater's stage manager even when he started transitioning to films. On the theater circuit he met his eventual wife, Jennifer Kendal, who similarly was managing her father's Shakespearean theater in Mumbai. The pair married in 1958 and acted together in American movies, specifically for Merchant Ivory Productions.

Some of Kapoor's best work came alongside Bachchan, as the two starred in multiple hits together, including *Kabhie Kabhie* (Sometimes) and *Suhaag* (Husband). However, his most memorable role is often cited as the one he played in *Deewar* (Wall), in which he delivers the impassioned line "Mere paas maa hai" ("I have our mother") to a stunned Bachchan. The line, which has become iconic, is still referenced in Indian pop culture.

Stranger than Fiction: Feroz Khan

In a world of often categorizable actors, being an individual and standing out from time to time is important. Feroz Khan took this ideal to heart and became one of the most singular personalities in the entire Bollywood industry. Besides acting, producing, and directing numerous successful films, Khan was well-known for his fashion and eccentric lifestyle. His appearance in Western-style films often earned him a comparison to American actor Clint Eastwood.

Although he began his career in low-budget films, Khan would eventually make it big in Bollywood and be the lead actor in hits such as *Khotte Sikkay* (Fake Coins) and *Kala Sona* (Black Gold). He continued to direct and even appeared in films until his death in 2007; he's survived in the industry by his children including his son, actor Fardeen Khan.

Appreciating the Divine Divas

Although the men of the 1970s and 1980s were tough, they were no match for the beauties that erupted onto the scene who often stole the show and wrapped both the audiences and the lead actors around their fingers. Here are some of the wonderful ladies who graced the screen during that period.

Sex symbol: Mumtaz

An audience favorite opposite Rajesh Khanna, Mumtaz was widely regarded as a sex symbol and one of the prettiest actresses of her time. Because of her excellent dancing ability and willingness to take on diverse roles, she became known for her versatility and ability to excel, no matter the part given to her.

Mumtaz gained notoriety opposite Feroz Khan and Rajesh Khanna; audiences especially loved this latter pairing. She also won a Filmfare Award for Best Actress for her work in *Khilona* (Toy).

CULTURAL WISDOM

Unlike the male actors of this generation that often still appear in films, the same trend hasn't continued for actresses. Female actors in Bollywood often work during a set generation, but in recent years a growing trend began to recast the female legends of yesterday into films of today.

Eyes to die for: Sridevi

Often regarded as the first female superstar of the Bollywood industry, Sridevi was one of the most recognized and celebrated actresses in the history of Indian cinema. She enjoyed a successful career in both South Indian cinema and Bollywood, appearing in multiple successful films in both industries. Her rise to fame in Bollywood came particularly in the mid-1980s, when she starred in multiple big hits, such as *Mr. India*, *Chandni* (Moonlight), and *Khuda Gawah* (Lord As Witness).

Known especially for her incredible dance moves and expressive eyes, Sridevi was a beauty and fashion icon. Many later actresses have cited her as their main influence, and she continued to be a darling of the public eye until her unfortunate death in 2018. She had begun her comeback into film just before her death.

The versatile vixen: Rekha

Celebrated as one of the best actresses of all time throughout her career, Rekha's career has spanned several decades, and she has appeared in more than 180 films. From megahit blockbusters to art house films, Rekha (check out Figure 4-7 for Rekha at an awards show in 2018) has proven herself to be one of the most versatile and talented actresses of her generation, and she continually earns praise for reinventing herself to adapt to the times and roles that she is offered.

FIGURE 4-7: Indian actresses Rekha (left) and Zeenat Aman (right).

SOPA Images Limited/Alamy Stock Photo

These are her best performances:

- ❯❯ *Silsila* (Affair)
- ❯❯ *Khoobsurat* (Beautiful)
- ❯❯ *Umrao Jaan*
- ❯❯ *Muqaddar ka Sikandar* (Conqueror of Destiny)

Rekha worked with all the leading men of the 1970s and 1980s, but her pairing with Bachchan garnered the most attention. Interestingly, while tabloids painted a picture of the two of them being involved romantically while Bachchan was married, the two of them appeared in the movie *Silsila* (Affair) alongside Jaya Bachchan, with an extremely similar plot. As a result of this negative media attention during her career, Rekha has always kept her personal life private.

The dream girl: Hema Malini

Known for her fast dialogue delivery and animated expressions lending herself to comedy, Hema Malini (refer to the section, "Unconventional yet refined: Dimple Kapadia," later for a photo of Malini) was a dream girl for many during this era. This label, which was pushed by studio executives early in her career, eventually led to her playing the titular role in the move *Dream Girl*, opposite her future husband, Dharmendra.

Malini and Dharmendra ended up acting in 28 films together, including their iconic pairing in the all-time classic *Sholay* (Embers). Malini's likable personality and relatable goofs in movies endeared her to many fans and made her one of the most popular actresses of her time. Check out Chapter 19 about her work in the film *Sholay*.

Breaking Stereotypes: Actresses Stepping Out of the Box

As Bollywood continued to modernize with bigger and badder plots during the 1970s, the leading ladies of this era too were beginning to break out of the norms and showcase more nuance in their performances. Here are the ladies that captured the hearts of moviegoers worldwide.

Stereotype shatterer: Parveen Babi

The most recognizable actress of the 1970s, Parveen Babi dominated the box office like few women before or after her during this period. She appeared in numerous commercial and critical hits and shot into stardom for her role in *Deewar* (Wall). A model-turned-actress, Babi was world renowned, and became the first Indian to grace the cover of *TIME* magazine.

She was especially known for breaking stereotypes and portraying strong, independent women. Due to her western attire and accent, Babi (see her in Figure 4-8) challenged the typical Indian woman stereotype that was thrust on actresses during the 1980s. She paved the way for normalizing what was then perceived as sexual behavior, such as wearing cropped tops and having a well-sculpted body. Babi's mannerisms, attitude, and screen presence forever changed the perception of Indian actresses, and she paved the way for many of the actresses who followed her.

FIGURE 4-8: Couple and actors Kabir Bedi (left) and Parveen Babi (right) in Rome in 1976.

Mondadori Portfolio/Getty Images

Unconventional yet refined: Dimple Kapadia

Thrust into the limelight after the immense success of her first film, *Bobby*, Dimple Kapadia (see Figure 4-9) rarely looked back and has remained a Bollywood icon for several decades since. After winning a Filmfare Best Actress award for *Bobby*, Kapadia starred in some hits before taking a brief respite from acting after

marrying fellow actor Rajesh Khanna. However, when the two divorced, Kapadia reentered the industry right where she left off, winning another Filmfare Awards Best Actress nod for her role in *Saagar* (Sea).

FIGURE 4-9: Dimple Kapadia (left) and Hema Malini (right) in 1984.

Dinodia Photos/Getty Images

TIP

A number of Bollywood Award Shows have come and again to recognize Hindi film talent. To read more about these shows, their significance, and corresponding performances, turn to Chapter 15.

Kapadia has continued to work in movies ever since and has avoided limiting herself to only lead roles. She has earned high praise for appearing in unconventional roles, such as that of a middle-aged wife in the English language film *Leela*, or for her role as an older woman involved with a younger man in *Dil Chahta Hai* (The Heart Wants). She continues to take on new, interesting roles, even appearing in Christopher Nolan's sci-fi drama *Tenet* in 2020.

Tackling tough subjects: Shabana Azmi

Shabana Azmi is the type of actress who arrives only once in every generation, breaking from the norm and exploring themes and roles that few around her would venture into. Born into an artistic family, and eventually marrying famed screenwriter Javed Akhtar, Azmi's achievements stand on their own and position her as one of the best and most decorated actresses in Bollywood history.

Known especially for her roles and involvement in India's *parallel cinema* movement — cinema outside the mainstream that focused on more realistic and serious themes — Azmi appeared in roles that dealt with serious issues and portrayed the often darker and more forgotten side of India. Her hard-hitting roles have been met with universal praise, and she has won five Filmfare Awards along with a record five National Film Awards for Best Actress, to cement her legacy as one of the best Indian actresses of all time.

Azmi is still quite an active public figure and is known especially for her social and political activism, particularly in the defense of people who died from complications to AIDS.

Staying consistent with Queen Zeenat Aman

A legend with more than 80 films to her credit, Zeenat Aman (refer to Figure 4-7) remains one of the most popular actresses from 1970s Bollywood. An actress of extraordinary consistency, Zeenat has been nominated for numerous awards in her lifetime, including a win for Best Supporting Actress at Filmfare for her work in *Hare Ram Hare Krishna* (Praise Ram, Praise Krishna).

Seen as a trailblazer, Aman often took on unconventional roles that required her to be more than a simple love interest of the lead actor. She paved the way for stronger female characters to be written into plots, and her success has had a lasting effect on Bollywood because she continues to be a primary influence on young actresses who aspire to be more than eye candy on the big screen.

Lifelong Devotee: Neetu Singh

The esteemed Neetu Singh entered the Bollywood landscape at the young age of 8 and has never looked back. Debuting as an adult actress at the age of 20, Singh continued to star in lead roles throughout movies in the 1970s and 1980s. Appearing in multiple hits across various genres, she worked with all the top talent within the industry and eventually formed a successful pairing with Rishi Kapoor. She later married him and then decided to take a hiatus from acting for several years, though at the time she was at the top of the industry and was one of its most sought-after stars.

Singh made a comeback in the late 2000s, starring opposite her husband in *Love Aaj Kal* (Love These Days), and appearing in other movies through 2013. One of her two children, her son Ranbir, is also a Bollywood star himself.

Chapter **5**

Going Contemporary: Bollywood in the 1990s and Early 2000s

The 1990s brought a host of changes to Bollywood: a new generation of fans, a more liberal social climate, and, perhaps most importantly, the influx of fresh talent as classic Bollywood actors aged and no longer played leading roles in movies. The liberalization of India's economy, the advent of new technology, and easier access to cinema led to an even greater demand for movies, songs, characters, and memorable storylines, and Bollywood answered the call — in epic fashion.

This decade began with a fresh exploration of a different kind of man: the romantic. Audiences yearned to connect with their on-screen heroes, and Bollywood delivered just that. Powerful leading men delivering endlessly dramatic dialogues were replaced by roles for relatable, scrawny 20-somethings who were shy and nervous when speaking to a girl. The backdrop changed from rural parts of the homeland to majestic Swiss landscapes and recognizable European landmarks. And although familial conflict often dominated the plotlines of classic Bollywood, contemporary Bollywood focused on one thing: How will the boy get the girl?

Of course, if the movies of this era were to have a host of charming young men, they needed equally vivacious and desirable actresses to play the counterparts. In this chapter, we review how the recognizable Bollywood families contributed several names to the big screen during this time. However, a new trend also emerged simultaneously: Models and former pageant winners were finding success in movies while garnering critical acclaim for their performances, establishing themselves as true double threats.

DEFINING A GENERATION OF FILM

The 1990s and 2000s brought a host of new and interesting personalities into the Bollywood mix. Though a few actors and actresses dominated the screen, every new face got its day in the sun, and audiences were able to enjoy the singular talents of each of these individuals. If you want to watch these folks in action, tune in to our picks for the best movies from the 1990s to acquaint yourself with these contemporary Bollywood stars:

- *Darr* (Fear): Directed and produced by Yash Chopra, *Darr* is an Indian psychological romantic thriller film from 1990. It stars many actors we discuss from the 1990s, including Sunny Deol, Juhi Chawla, and Shah Rukh Khan. This film, which received ten nominations at the 39th Filmfare Awards, is known for putting King Shah Rukh on the map.

- *Khal Nayak* (Villain): *Khal Nayak* is a crime thriller produced and directed by Subhash Ghai and featuring Sanjay Dutt, Madhuri Dixit, and Jackie Shroff. This 1993 film is known for its more suggestive song "Choli Ke Peeche Kya Hai" (What's Behind Your Blouse?). The movie's soundtrack itself became one of the year's best-selling Bollywood soundtracks, with 10 million copies. Female singers for the song, Alka Yagnik and Ila Arun, whom we discuss more in Part 3, scored the film and won the Filmfare Award for best female playback singer.

- *Dilwale Dulhania Le Jayenge* (The Big-Hearted Will Take the Bride): Written and directed by Aditya Chopra, this iconic musical stars Shah Rukh Khan and Kajol as nonresident Indians (NRIs) who fall in love and must win over their more traditional family members. DDLJ, as it is fondly known, set the record for most Filmfare awards by winning ten and has played in theaters for more than 24 continuous years. This 1994 film also started the trend of Indian filmmakers making movies to appeal to the NRI audience.

- *Hum Aapke Hain Koun..!* (Who Am I To You?): Written and directed by Sooraj Barjatya, this romantic drama from 1994 stars Madhuri Dixit and Salman Khan and focuses on two key themes of Indian film and culture: weddings and family. It's recognized as an influence in the switch to less violent storylines in the Bollywood industry. It won five Filmfare Awards. For more on this defining film, see Chapter 18.

- *Raja Hindustani* **(The Indian King):** Directed by Dharmesh Darshan, this romantic drama stars Karisma Kapoor and Aamir Khan and was inspired by the 1965 film *Jab Jab Phool Khile* (Whenever the Flowers Bloomed), starring classic Bollywood actors Shashi Kapoor and Nanda. This 1996 film became the fourth-highest-grossing film of the 1990s.

- *Dil To Pagal Hai* **(The Heart Is Crazy):** A romantic musical, this 1997 film is another Yash Chopra classic and went on to become the highest-grossing Bollywood film of the year. It features a classic 1990s cast: Shah Rukh Khan, Madhuri Dixit, Karisma Kapoor, and Akshay Kumar. Made on a budget of just over $1 million, the film went on to gross more than $8 million worldwide.

- *Dil Se..* **(From the Heart):** Written and directed by Mani Ratnam, *Dil Se..* is a romantic thriller set against the backdrop of the insurgency in Northeast India. This 1998 film stars, of course, Shah Rukh Khan alongside Manisha Koirala. It's also known as the debut film for Preity Zinta and went on to win awards for cinematography, audiography, choreography, and music. The soundtrack is known for its work by A. R. Rahman, whom we discuss in Part 3.

- *Kuch Kuch Hota Hai* **(Something Happens):** Known for the directorial debut of the one and only Karan Johar, this romantic drama features the iconic duo again: Shah Rukh Khan and Kajol, with a supporting role by Rani Mukerji. Johar's goal for this 1998 movie was to set a new standard for Indian cinema, which he accomplished by having it become the highest-grossing film in India ever — until Johar broke his own record in 2001 with *Khabi Khushi Khabie Gham*.

- *Hum Dil De Chuke Sanam* **(I've Given My Heart Away, Beloved):** Described as a loose adaption of the Bengali novel *Na Hanyate, by Maitreyi Devi*, this 1998 romantic drama is one of many classic love triangles found in Bollywood. It stars Aishwarya Rai Bachchan, Salman Khan, and Ajay Devgn, who is now Kajol's real-life husband. The movie is directed and produced by Sanjay Leela Bhansali.

- *Taal* **(Rhythm):** Another romantic drama from 1999, this time directed by Subhash Ghai, *Taal* actually premiered in the United States at the Chicago International Film Festival. Starring Anil Kapoor, Aishwarya Rai Bachchan, and Akshaye Khanna, it's another incredible A.R. Rahman soundtrack and was the first Indian movie to be listed on *Variety*'s Top 20 box office list.

Never-Ending Rom-Khans: Shah Rukh and the Other Khans

The 1990s came to be defined by a few individuals who came from seemingly nowhere — actors and actresses who weren't associated with one of the well-known families found fame and glory as audiences became fascinated by relatable

people who could do extraordinary things. Specifically, four different Khans made a huge impact, which we discuss in the following sections.

As Shah Rukh Khan was ascending to his throne, other actors were gaining recognition. Curiously, though they aren't related, three other Khans were dominating headlines in the 1990s: Salman Khan's boyish charm, Aamir Khan's piercing glare, and Saif Ali Khan's goofy antics ushered in the era of the Khans. Three of the four Khans — Shah Rukh, Aamir, and Salman — together dominated the Indian box office for nearly three decades.

King Khan: Shah Rukh Khan

One man rose from relative anonymity and was crowned the Badshah (meaning "king") of Bollywood in the '90s and created a wave of popularity that only Amitabh Bachchan had generated before him (read about Bachchan's legacy in Chapter 4). This man is Shah Rukh Khan.

The story begins like any other: A young boy from a middle-class family in Delhi aspires to be an actor. Though he excels in other areas of life, including sports, those around him notice that he has a knack for imitations and acting, and they encourage him to pursue acting full-time. Though reluctant at first, he finally succumbs and lands his first roles in television until working his way to the top of the largest movie industry in the world.

Shah Rukh Khan, a man from humble beginnings, went on to become one of the most influential and popular celebrities in the world. He appeared in multiple blockbusters that cemented his legacy forever, first playing an *antihero,* a male protagonist who the audience knew possessed a fatal flaw — but couldn't help but love. Khan is known particularly for his puppy dog eyes (check out Figure 5-1), which drew in audiences — even when his character in *Baazigar* (Juggler) was throwing a woman off a roof in cold blood!

CULTURAL WISDOM

Directors quickly noted Khan's quirky personality, fast dialogue delivery, and those same puppy dog eyes, leading him to appear in more traditional romantic films that went on to become some of the highest-grossing Indian films of their time, such as

>> *Dilwale Dulhaniya Le Jayenge* (The Big-Hearted Will Take the Bride)

>> *Dil to Pagal Hai* (The Heart Is Crazy)

>> *Kuch Kuch Hota Hai* (Something Happens)

>> *Mohabbatein* (Love Stories)

>> *Kabhi Khushi Kabhie Gham* (Sometimes Happy, Sometimes Sad)

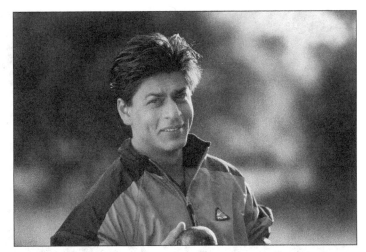

FIGURE 5-1:
Shah Rukh
Khan in 1998.

Dinodia Photos/Getty Images

REMEMBER

This stretch beginning in the 1990s is truly what shot Khan to stardom, when nearly any and every movie he appeared in became a blockbuster hit. Some of these movies remain regarded even today as some of the best classics of Bollywood cinema. Chapter 20 goes into detail about his ten must-see films.

The critically acclaimed Khan: Aamir Khan

No diehard Bollywood fan can argue Aamir Khan's influence and popularity during the same period. Appearing in the following classics, Aamir (see Figure 5-2) established himself early on as a versatile actor who could play a variety of roles *really* well:

>> *Dil* (Heart)

>> *Rangeela* (Colorful)

>> *Jo Jeeta Wohi Sikander* (Whoever Wins Will Be King)

>> *Raja Hindustani* (The Indian King)

TIP

Aamir went on to establish his own production company, which later produced *Lagaan* (Tax), a movie that would forever cement his legacy as both an actor and a filmmaker. Released in 2001, *Lagaan* is a movie about prerevolution Indian villagers playing a game of cricket for their lives. It captivated audiences worldwide and was nominated for best foreign language film at the 74th Academy Awards. Read all about *Lagaan* in Chapter 19.

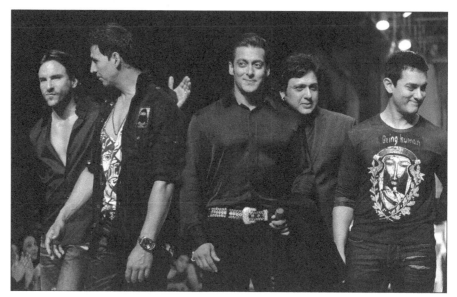

FIGURE 5-2:
From left to right, Saif Ali Khan, Akshay Kumar, Salman Khan, Govinda, and Aamir Khan.

He has continued to make socially conscious films; his name has become synonymous with critically acclaimed movies that tackle difficult subject matter in India, such as racial and religious divisiveness, mental health, divorce, and government corruption.

Macho man Khan: Salman Khan

Another Khan to grace the Bollywood big screen in the 1990s was Salman Khan. First appearing in the late 1980s as a fun-loving goofball who used his boyish charm to woo women, he (refer to Figure 5-2) went on to become one of the first actors in Bollywood to place an emphasis on bodybuilding and physique. His rise in fame came from such family dramas as *Maine Pyar Kiya* (I Have Loved), *Hum Saath Saath Hain* (We All Are Together), *Hum Aapke Hain Koun..!* (Who Am I to You?) Particularly, the last of these became a massive hit and remains a verifiable classic in Bollywood film history.

CULTURAL
WISDOM

Salman altered his physique in the late 1990s and packed on pounds of muscle, becoming a heartthrob throughout the industry. His roles changed accordingly, as he started to appear in more serious, action-packed roles as he grew older. People commonly joked in the 1990s about Salman taking his shirt off every chance he could in order to show off his chiseled physique.

The fun-loving Khan: Saif Ali Khan

If Aamir was the thoughtful Khan and Salman was the macho Khan, Saif Ali Khan was definitely the jokester Khan of the 1990s. His infectious smile and comedic personality endeared him to audiences, and he rode that affinity to become a hugely successful Bollywood actor in his own right. The son of a famous cricketer as well as Bollywood actress Sharmila Tagore, Saif Ali (refer to Figure 5-2) was exposed to the limelight and film industry early in his life. He began acting in major movies when he was only 21 years old.

Although he appeared in a number of movies in the 1990s that were fairly unsuccessful, he rose to prominence following his critically acclaimed performance in *Dil Chahta Hai* (The Heart Is Yearning), for which he won several awards. He delivered yet another memorable performance just a couple of years later, alongside Shah Rukh Khan in *Kal Ho Naa Ho* (Tomorrow May Never Come), and he never looked back. As his career progressed, he turned away from comedic roles to take on more serious work and continues to make successful movies today. In 2020, he continued his jokester reputation with the film *Jawaani Jaaneman* (Youthful Lover) on Amazon Prime, playing a 40-year-old playboy.

CULTURAL WISDOM

Khan is married to actress Kareena Kapoor (see the section, "The Kapoor Sisters: Karisma and Kareena," later in this chapter), and his daughter from a previous marriage, Sara Ali Khan (see Chapter 6), is also a well-known actress within the Bollywood industry.

Laughing with the Comedy King: Govinda Ahuja

Other actors certainly held their own during this time. Perhaps one of the funniest and most iconic of these was Govinda Ahuja, who achieved the prestigious one-name-only status over the course of his career, lovingly referred to as just Govinda.

Known for his endless comedic ability, fantastic expression control, and quirky dance moves, Govinda (refer to Figure 5-2) was one of the original funnymen-turned-heroes to grace the Bollywood screen.

From his comedic presence to his dancing skills, he received 12 Filmfare Award nominations, including best comedian (read about these awards in Chapter 15). He appeared in more than 165 Hindi films in his entertainment career and later moved on to a political career, becoming a member of parliament in Mumbai North from 2004 to 2009.

As the Khans and Govinda brought laughter, love, and cheeriness to the big screen, other stars were packing a different kind of punch, literally. The 1990s brought some of Bollywood's most famous action heroes, which we discuss in the next section.

High Octane and High Energy: The Action Stars

No film industry is complete without its dose of testosterone and high-flying stuntmen. Two men, whom we discuss here, stood out during this era in this genre and continue to be mainstays: Akshay Kumar and Sunil Shetty.

The stuntman: Akshay Kumar

Akshay Kumar has remained one of the most recognizable and sought-after actors in Bollywood, playing a wide range of roles, from comedy to drama to action. He's known particularly for doing many of his own stunts in his films, for which he has been nicknamed by some as the Indian Jackie Chan. In fact, his stunt work led him to an American audience in 2020 with a special appearance in an episode of *National Geographic*'s *Into the Wild with Bear Grylls*.

Because of his impressive range and ability to take on different types of roles, Kumar has starred in more than 100 Bollywood films and is one of the most commercially successful actors of all time. Kumar (refer to Figure 5-2) is married to former Bollywood actress Twinkle Khanna, with whom he has two children.

Perennial tough guy: Sunil Shetty

Perhaps no one exuded the tough-guy vibes in Bollywood quite like Sunil Shetty. Appearing in more than 100 films, Shetty appeared in numerous action movies in the 1990s, many of which were commercial successes. Known for his recognizable voice, unmistakable swagger, and epic action roles, Shetty remains one of Bollywood's most beloved action stars even today. He now owns his own production house, Popcorn Entertainment Private Limited.

Coming of Age: Sons of Industry

One of the enduring talent pools from which Bollywood finds fresh faces is within the families that have already traversed the big screen. The sons of former actors and industry regulars, they grew up around the limelight and worked their way in as they came of age. As actors age and reprise their leading roles for supporting ones, their children often are brought into the limelight with high expectations and the age-old question: Will they be as good on-screen as their parents? These sections discuss three actors who had parents in the biz.

Killer B's son: Abhishek Bachchan

The actor with perhaps the biggest shoes to fill in the early 2000s was none other than Amitabh Bachchan's son, Abhishek Bachchan. Similarly tall and handsome like his father, Abhishek exploded onto the movie scene with his debut in *Refugee* (alongside another famous daughter debut: Kareena Kapoor), though his career is less illustrious than Amitabh's.

Nevertheless, Abhishek carved a niche for himself within the industry and appeared in a few memorable roles. After marrying Bollywood star Aishwarya Rai, he has appeared in only a handful of movies on the big screen, though he does continue to act and produce within the industry. He was the main actor in the three-film action series *Dhoom* (Blast).

REMEMBER

As we discuss in Chapter 2, the Bachchan family is one of Bollywood's most famous Bollywood families. In 2007, two members — Amitabh Bachchan and daughter-in-law Ashwarya Rai — were on the list, compiled by the *Times of India*, of the most influential Indians.

Dancing into the limelight: Hrithik Roshan

Hrithik Roshan also burst onto the scene in his 2000 debut, *Kaho Naa . . . Pyaar Hai* (Say It . . . You're in Love), an instant classic that shot him into stardom overnight. The movie was directed by none other than Roshan's father, Rakesh Roshan, who is also a Bollywood actor, producer, director, and screenwriter.

Though more one-dimensional than his father, Hrithik (refer to Figure 5-3) continues to be a Bollywood mainstay and versatile actor. He's known especially for his incredible dance moves and bulging biceps, which are both showcased aplenty in his movies. His dancing led him to both performances and a role as the judge on *Just Dance*, an Indian dance-reality television series that made him the highest-paid movie star on Indian television.

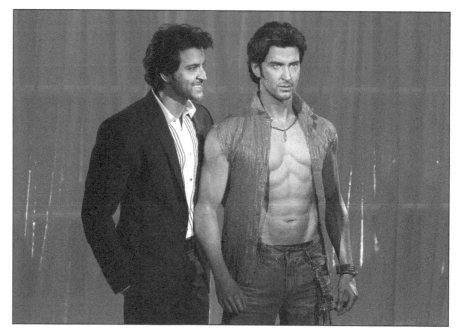

Matt Crossick/Alamy Stock Photo

The serial kisser: Emraan Hashmi

Part of the illustrious Bhatt family, Emraan Hashmi certainly isn't the most conventional actor. Note here that Bollywood, unlike, for example, Hollywood, has been traditionally a conservative medium. Bringing a bold approach to most of his roles, Hashmi has made a name for himself in the industry for his steamy on-screen kisses (a rarity in Bollywood film before the 2000s) and unconventional roles. A divisive character for many, he remains a household name within the industry. He took on roles many shied away from because of their audacious nature, such as *The Dirty Picture* and the *Raaz* (Secret) series.

Meeting the Method Actors

Though Bollywood has a reputation for dance numbers and overly dramatic acting, some artists within the industry have made a name for themselves with their heartfelt and often gut-wrenching performances over the years. The following list discusses two method actors in detail:

>> **Nana Patekar:** Nana Patekar is a longtime method actor who began appearing in mainstream Bollywood cinema in the early 1990s and quickly gained a reputation as a fantastic actor who could take on some of the toughest roles

the industry had to offer. From protagonist to villain, Patekar tackled a broad range of roles, and he remains the only Bollywood actor to win a Filmfare Award in the Best Actor, Best Supporting Actor, and Best Villain categories (Chapter 15 discusses Bollywood award shows).

>> **Irrfan Khan:** The late Irrfan Khan was similarly known for his ability to immerse himself in any role he played. He enjoyed a career that spanned multiple generations, though he first made his debut in the late 1990s. He served as a great ambassador for Bollywood, taking on acclaimed Hollywood films during his career and establishing himself as a bridge between the two industries (see Chapter 18).

His work in Bollywood earned him numerous accolades in India, and American audiences got to see him in action in films such as *Jurassic World*, *Life of Pi*, and *Slumdog Millionaire*. By 2017, his films had grossed more than $3.6 billion at the worldwide box office, a sign of his global impact. (Chapter 21 reviews his unforgettable legacy, his work in Hollywood, and the impact he left on the American entertainment industry.)

Posing with Models-Turned-Actors

The 1990s and early 2000s saw another emerging trend: Pageant winners and models were increasingly recruited into the industry to act. Some, such as Dino Morea, were never truly able to find the same success in the movie industry as they enjoyed in the modeling industry. However, others, whom we examine here, became much more popular as they completed the transition.

Voice (and muscles) of stone: Arjun Rampal

Model-turned-actor Arjun Rampal (see Figure 5-4, which shows Rampal with actress Preity Zinta at HDIL Couture Fashion Week in Mumbai in 2017) is one such example of a successful model turned actor, who appeared as the lead in several romantic films in the early 2000s. He first gained fame for his deep, recognizable voice, and for his roles in *Dil Ka Rishta* (The Relationship of the Heart), *Aankhen* (Eyes), and *Om Shanti Om* (The Mantra of Peace).

Rampal went on to also be a critical darling, winning the Filmfare Award for Best Supporting Actor in 2009 for his role in *Rock On!* In recent years, he has remained a popular figure in media and has branched out to screenwriting, producing, and hosting television shows.

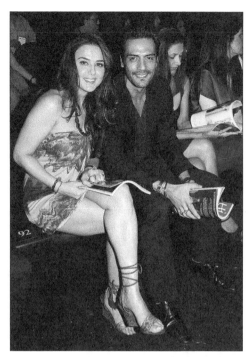

Mail Today/Getty Images

Heartthrob heaven: John Abraham

Another male model who found success in Bollywood is John Abraham. He made a big splash with his debut in *Jism* (Body), a steamy erotic thriller that shot him and his costar, Bipasha Basu (see Basu and Abraham pose for the release of the soundtrack for their movie *Aetbaar* in 2003 in Figure 5-5), to the front of the exciting newcomer line in Bollywood.

He didn't disappoint expectations, as he went on to appear in a number of commercial and critically successful films, including *Dhoom* (Blast), *Zinda* (Alive), *Dostana* (Friendship), and *Baabul* (Father's House). In the last one, he was nominated for a Filmfare Award. He also tried his hand at producing, and his first production, *Vicky Donor*, was also a commercial and critical success. Abraham continues to be a Bollywood mainstay and appears in both villainous and lead roles.

Dancing Backup to the Leading Man: Shahid Kapoor

Perhaps one of Bollywood's most heartwarming success stories is that of Shahid Kapoor. After appearing as a backup dancer for multiple songs in the 1990s, Shahid was noticed by Bollywood directors and eventually cast in the 2003 movie *Ishq Vishk* (Love, Shmove) by director Ramesh Taurani.

CULTURAL WISDOM

The name *Ishq Vishk* highlights a cultural quirk you may often hear from the South Asian community: A love for rhyming. Oftentimes, conversations include a made-up word that rhymed with the last spoken word for comedic effect or to simply emphasize. Examples include "joke shoke" or "cook shook." The concept is similar to the American phrase "tomato tomahto."

After the film did better than expected and Kapoor received the Filmfare Award for best male debut, he was cast in other leading roles in films that eventually became commercial and critical successes:

>> *Jab We Met* (When We Met)

>> *Haider*

>> *Udta Punjab* (Punjab Is High)

>> *Kabir Singh*

Many of his later roles — including those in *Haider, Udta Punjab,* and *Kabir Singh* — were met with controversy because of the subject matter of the movie and the roles that Kapoor would play in them — for example, playing a drug-abusing singer. However, he was also praised for his portrayal of the characters in each of these movies and his ability to immerse himself into those roles. For both *Haider* and *Udta Punjab*, Kapoor won Filmfare Awards for his performances, and he was also nominated for an award for his role in *Kabir Singh*.

CULTURAL WISDOM

Known for his exquisite dancing abilities and chiseled physique, Kapoor continues to appear in Bollywood movies in leading roles. Aside from acting, Kapoor is a known philanthropist and occasional host and judge on television shows, including an appearance as a talent judge on the Indian show *Jhalak Dikhhla Jaa Reloaded* (Give Me a Glimpse of What You Have).

Buzzing with the Queen Bee: The Inimitable Madhuri Dixit

Bollywood actresses made it to the contemporary Bollywood big screens via similar routes as the men, such as by way of their major families. One woman rose to fame over others. Widely regarded as one of the most popular Bollywood actresses of all time, Madhuri Dixit ruled the big screen during the 1990s and into the early 2000s.

Her dance moves became legendary even early in her career; security often had to be tightened at her movies because of crowds going into frenzies when she danced! Playing a wide range of roles throughout her career, Dixit has appeared in more than 70 Bollywood films and has been cast alongside nearly every other famous actor of the 1990s and early 2000s. In fact, a number of the Khans' greatest hits had Dixit playing the lead actress.

TIP

Dixit is most often praised for her acting abilities in the films *Tezaab* (Acid), *Parinda* (Birdie), *Khal Nayak* (Villian), *Beta* (Son), and *Lajja* (Shame). She also went on a spree of hits in the 1990s, similar to Shah Rukh Khan, and often as his costar. The following films were incredibly successful at the box office, worth watching, and served to establish Dixit as one of the most popular actresses in Bollywood:

» *Dil* (Heart)

» *Anjaam* (The Result)

» *Dil To Pagal Hai* (The Heart Is Crazy)

» *Hum Aapke Hain Koun..!* (Who Am I to You?)

Even as a supporting actress in movies such as the 1990s remake of *Devdas*, Dixit would have memorable performances and often would land a Filmfare Awards nomination for her work. Though she has appeared in fewer films in recent years, she continues to appear in Bollywood films in minor roles or as a guest appearing in song-and-dance numbers (read all about Bollywood's music industry in Part 3.

Keeping It in the Family

Multigenerational families in Bollywood have produced stars for seemingly every decade, and the contemporary era is no different. Here we examine some of the talented ladies whose lineage also hails deep within Bollywood's storied history.

The Kapoor sisters: Karisma and Kareena

The Kapoor family has spanned multiple generations across Bollywood, with a new star in nearly every decade since they began appearing in films. The 1990s were no different, as the older of two sisters, Karisma, saw her Bollywood debut and rise in popularity, while the early 2000s saw the growing success of the younger Kareena.

Known for her expressive eyes and warm smile, Karisma had a hard time finding success early in her career, appearing in mediocre films and often having only minor roles next to her male counterparts. However, she reversed her fortunes dramatically after her role in *Raja Hindustani* (Indian King) in 1996, for which she won a Filmfare Award. After this performance, her career began to take off, and she went on to win multiple Filmfare Awards for iconic movies such as these:

» *Dil To Pagal Hai* (The Heart Is Crazy)

» *Fiza*

» *Zubeidaa*

Since the mid-2000s, Karisma has taken a break from acting, but continues to maintain a public following and is extremely popular even today as a media personality.

Kareena followed closely in Karisma's footsteps in the early 2000s, and even surpassed her in popularity in the following years. Kareena starred in the same movie that debuted another famous acting child, Abhishek Bachchan (refer to the section "The Killer B's son: Abhishek Bachchan," earlier in this chapter) as they both starred in *Refugee*. She followed up her debut with one of her most memorable roles in *Kabhi Khushi Kabhie Gham* (Sometimes Happy, Sometimes Sad), in which

she plays the kindhearted socialite Pooja, or, as all her friends and a wealth of Internet memes call her, Poo. Read more about this film in Chapter 20. Subsequently, Kapoor has appeared in a number of successful films, including *Jab We Met* (When We Met), *3 Idiots*, and *Bajrangi Bhaijaan* (Brother Bajrangi).

CULTURAL WISDOM

Kareena's career transcends the Bollywood screen, as she has become a popular figure on social media and in the press in recent years. A fashion icon in India, she married actor Saif Ali Khan in 2012 (read about "the jokester Khan" earlier in this chapter), establishing the pair as a true power couple in Bollywood. Beyond starting her own fashion and cosmetic lines, she is an outspoken advocate for a variety of social issues and causes in India.

The Mukherjee cousins: Kajol and Rani

The Mukherjee-Samarth family also has generations of family members in Bollywood in all aspects of production. Two of the most famous Mukherjees made their mark on Bollywood during the 1990s and continue to be household names even now. The first is one of the most recognizable faces in all of Bollywood, Kajol (she also achieved one-name-only status) has been a mainstay since her acting debut in 1992.

REMEMBER

Often paired with King Khan himself, Shah Rukh Khan, Kajol Mukherjee enjoyed a run of extremely successful movies throughout the 1990s, and won over audiences' hearts with her passionate dialogue and extremely quick deliveries. Her most famous roles are

>> *Baazigar* (Gambler)

>> *Kuch Kuch Hota Hai* (Something Happens)

>> *Dilwale Dulhania Le Jayenge* (The Big-Hearted Will Take the Bride)

>> *Kabhi Khushi Kabhie Gham* (Sometimes Happy, Sometimes Sad)

>> *Gupt* (Secret)

Her illustrious career includes five Filmfare Awards in the best actress category. She continues to be a public figure via social activism and occasional acting appearances. Read more about a few of these films in Chapter 20.

Kajol Mukherjee's cousin, Rani Mukerji (they're in the same family but spell their last names differently), also had a successful career in Bollywood. Her early films, such as *Ghulam* (Servant) and a small role alongside her cousin in *Kuch Kuch Hota Hai* (Something Happens) — Figure 5-6 show her with costars during the 20th anniversary of *Kuch Kuch Hota Hai* — gave her a quick start into the industry, though it wasn't until the early 2000s that Mukerji found her groove. Following the success of *Saathiya* (Companion) in 2001, she went on to star in multiple

successful movies, including *Veer-Zaara*, *Hum Tum* (Me and You), and *Kabhi Alvida Naa Kehna* (Never Say Goodbye). In addition to acting, Mukerji is a vocal social activist as well as a host of television reality shows.

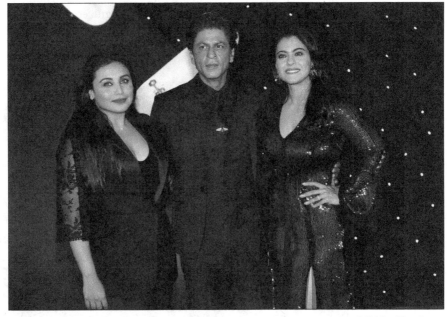

Sujit Jaiswal/Getty Images

FIGURE 5-6: Rani Mukerji (left), Shah Rukh Khan (center), and Kajol (right) in 2018.

Identifying the Pageant Winners

The extremely talented pageant winners coming into international notoriety from India sparked a trend in the 1990s. The following sections examine these beautiful, talented women who also acted as well.

Sweet and wholesome: Juhi Chawla

Perhaps one of the earliest to transition from beauty pageants to the silver screen was Juhi Chawla, who won the 1984 Miss India pageant. A mainstay in the 1990s, Juhi appeared in a number of successful films, many of them opposite Shah Rukh Khan. Though she appeared in fewer films in the late 1990s, Chawla continues to be a producer on Bollywood films and also appears from time to time to host television reality shows.

Renowned beauty: Aishwarya Rai Bachchan

Perhaps the most famous pageant-winner-turned-actress is Aishwarya Rai Bachchan, who won the Miss World crown in 1994. Quickly taking India and the Bollywood industry by storm after her crowning, Bachchan (see Figure 5-7) went on to become one of the most popular, recognized, and influential actresses that Bollywood has ever seen. She's often been referred to as the most beautiful woman in the world.

FIGURE 5-7: Aishwarya Rai Bachchan.

Dinodia Photos/Getty Images

TIP

Besides being stunningly beautiful, Ash, as she is commonly referred to, brought excellent acting skills to the screen. A classically trained dancer, she commanded a screen presence that few others have. Here are her blockbuster performances to prioritize watching:

>> *Hum Dil De Chuke Sanam* (I Have Lost My Heart to You)

>> *Devdas*

>> *Taal* (Rhythm)

>> *Josh* (Passion)

>> *Mohabbatein* (Love Stories)

>> *Guzaarish* (Request)

Bachchan established herself as one of the best of her generation, and proved to many that models could be successful actresses as well. After marrying Abhishek Bachchan in 2007, she appeared in fewer movies than before. However, she continues to be a popular figure internationally and acts in occasional roles on screen. She is also involved in many charities and serves as a goodwill ambassador for the Joint United Nations Programme on AIDS (UNAIDS). In 2003, she became the first Indian actress to be a jury member at the Cannes Film Festival in France.

International star: Priyanka Chopra

Another famed pageant winner from this era is Priyanka Chopra Jonas, winner of the Miss World pageant in 2000. She has gained notoriety for not only being a successful Bollywood actress but also crossing over and working in American television shows. After gaining popularity and critical acclaim for her work in movies like *Fashion*, *Bajirao Mastani*, and *Barfi* (Milk Dessert), She starred in the U.S. television show *Quantico* from 2015 to 2018. She also gained a following as a recording artist, putting out three singles that amassed hundreds of millions of views on YouTube alone. In 2018, she married American singer Nick Jonas. We discuss her more in Chapter 18.

Identifying Critically Acclaimed Darlings

Every Bollywood era seems to have a few actors who end up being remembered purely for their craft. Although this era had many leading ladies who sought after large box office numbers and commercial success, some actresses only took on roles that challenged their artistry. Here we look at the ladies who were adored by the critics.

Multi-award winner: Tabassum Hashmi

Few women have had the critical acclaim in their Bollywood career that Tabassum Hashmi, commonly referred to as Tabu, has had over the years.

A multilanguage actress, Tabu has appeared in Telugu movies and even in Hollywood films in addition to her Bollywood screen appearances. Indeed, she's a highly decorated actress in Bollywood alone: Tabu has six Filmfare Awards, including a record four for Best Actress. Though she has had a rocky career at the box office, her performances often garner critical acclaim and recognition.

Tabu has repeatedly taken on difficult roles, especially those addressing a woman's role in Indian society. These are some of her iconic movies:

>> *Virasat* (Inheritance)

>> *Chandni Bar* (Moonlight Bar)

>> *Astitva* (Identity)

>> *Hum Saath Saath Hain* (We Are All Together)

>> *Haider*

In addition to these hits, Tabu can be seen in the notable Hollywood films *The Namesake* and *Life of Pi*, both of which garnered positive reviews from critics (read more about Bollywood actors in Hollywood in Chapter 21). Tabu has kept her personal life private from the Indian media; she continues to appear in Bollywood films as well as films made in other languages.

Powerhouse performer: Manisha Koirala

Often, the evolution of actors and actresses in Bollywood makes for incredible stories in and of themselves. Manisha Koirala, the daughter of a Nepalese political family, aspired initially to become a doctor. However, she soon found herself acting in high-profile roles within Bollywood after the commercial success of her early films. Koirala established herself critically in *1942: A Love Story,* for which she was heavily praised, though the film didn't do well commercially.

TIP

Koirala then followed up with a powerhouse performance in the Tamil-language film *Bombay*, which made waves in the Bollywood circles as well after being dubbed in Hindi and winning awards at the Filmfare Awards that year. From these two films, Koirala emerged as one of the best actresses of her time, and continued to make excellent movies over the years:

>> *Dil Se..*(From the Heart)

>> *Mann* (Mind)

>> *Khamoshi: The Musical* (Silence: The Musical)

In recent years, Koirala has branched into television acting, South Indian cinema, and smaller roles in Bollywood. Notably, she was featured in the Netflix anthology series *Lust Stories*, which garnered critical acclaim.

Recognizing the Leggy Leading Ladies

Many different characteristics set Bollywood actresses apart from one another, whether it's dancing ability, fashion, or incredibly good looks. Each generation in Bollywood also had at least one leading lady who possessed another striking physical characteristic: being very tall relative to their male costars. These sections identify two such women who stand out.

Reality-star-turned-actress: Shilpa Shetty

Although she was a successful Bollywood actress, Shilpa Shetty garnered international recognition by participating in and eventually winning the UK reality television show *Celebrity Big Brother*. She went on to host and judge a variety of competition shows in India. Shetty continues her career today as an outspoken activist for women's rights and animal rights, a social media influencer, and a spokesperson for many well-known brands in India.

Item number specialist: Katrina Kaif

Katrina Kaif has been able to tower over the competition from the 2000s and beyond. Originally a model in the UK, Kaif was discovered during a talent search in London by Indian filmmaker Kaizad Gustad, who cast her in the commercially unsuccessful *Boom*. However, the role allowed her to break into the Indian modeling-and-acting scene and eventually land successful roles in Bollywood films. To do this, she had to learn to speak proper Hindi, the dominant language spoken in Bollywood movies. Her devotion to learning the language endeared her to both critics and fans in India, and she has been cast in some of the biggest roles as a result.

TIP

Often standing taller than her male counterparts at 5' 6", Kaif is also praised for her exceptional height and is called on to perform in item numbers regularly. Her best works in a lead role include these movies to check out:

>> *Ek Tha Tiger* (There Was a Tiger)

>> *Mere Brother Ki Dulhan* (My Brother's Bride)

>> *New York*

>> *Zindagi Na Milegi Dobara* (Life Does Not Come Again)

Smiling with the Sweethearts

The 1990s had a number of interesting personalities, but perhaps few were as universally loved and adored as Raveena Tandon and Preity Zinta, whom we discuss in greater detail here.

The mast-mast girl: Raveena Tandon

Often paired with Govinda in comedic dramas, Raveena Tandon established herself as a lovable, quirky personality on-screen who fit well with Govinda's eccentric personality and acting. Some of Bollywood's most iconic songs feature Tandon as the female lead, including the extremely famous *Tu Cheez Badi Hai Mast Mast* (You Are an Awesome Thing), which led to her being dubbed the mast-mast girl. Throughout her career, Tandon has taken sabbaticals from film in order to concentrate on her personal life, but her legacy is unquestionable — she remains a mast-mast — watch for anyone diving into 1990s Bollywood.

Dimpled sweetheart: Preity Zinta

The early 2000s saw a sweetheart of its own emerge, in Preity Zinta. Her infectious smile and pronounced dimples won over the hearts of many after her performances in blockbusters like *Dil Se..* (From the Heart) and *Kal Ho Naa Ho* (Tomorrow May Never Come). Read more about this latter film in Chapter 20.

Zinta quickly established herself as more than a cute face, however. She took on a number of challenging roles during her career, often upending the conventional Indian female stereotype. She's often credited with changing the types of roles that women could portray in Bollywood and leading to an evolution in the characteristics of heroines within Bollywood film. Though early in her career she was typecast as a cute-and-quirky female lead, Zinta (refer to Figure 5-4) has challenged that convention and been outspoken about the types of roles that women should play in film.

CULTURAL
WISDOM

Though Zinta is well-known for her on-screen work, she's equally celebrated for her penchant for speaking freely in the press, for her social activism, and for winning the Godfrey Phillips National Bravery Award, which was for being the only witness to not retract her testimony against the Indian mafia during the highly publicized 2003 Bharat Shah case. She has also worked in Canadian film, earning a silver Hugo Award for best actress, for her role in *Heaven on Earth*.

The Sex Icon: Bipasha Basu

Because of its traditionally conservative nature, Bollywood for years had no counterpart for Marilyn Monroe. However, all that changed in the early 2000s, when Bipasha Basu stormed onto the scene.

Basu captivated audiences with her thrilling and provocative performances. Initially gaining fame for the horror flick *Raaz* (Secret), she established herself as a sex symbol in the media for her portrayal of an erotic seductress in *Jism* (Body).

TIP

Basu followed up these roles with numerous successful performances worth watching:

>> *Corporate*

>> *Race*

>> *Bachna Ae Haseeno* (Beware, Ladies)

Though she is best-known for her work in thriller and horror films, Basu has covered a wide range of roles in her career. She remains a cultural icon, and she appears in several item numbers and as a fitness personality. As a woman of Bengali descent, she's also outspoken against the colorism that she has faced and that still prevails within the Bollywood industry.

REMEMBER

An *item number* in Indian cinema is a musical number inserted into a film, regardless of whether it contributes to the plot, to help market the film and attract viewers. The song is typically catchy, upbeat, and often involves sexually provocative dance moves.

Chapter **6**

Good As New: Bollywood from the Mid-2000s to the Present Day

In this chapter, we arrive at modern-day Bollywood, a hodgepodge of old traditions meeting new trends and striking a balance between the two. Bollywood is now experiencing a resurgence; much like the 1970s, when Bollywood audiences demanded fresh content, the 2000s Bollywood began to feel a little stale, and even movies featuring superstars began to flop. However, unlike the writers of yore who sought new and original plots to refresh the industry, current filmmakers are turning to the past to draw their inspiration.

As the earlier generation of Bollywood fans grows older and reminisces on days past, the industry is benefitting from the interest of younger fans, who haven't heard or seen the classics. This situation has led to a resurgence of old songs and movies being remade for modern audiences — sometimes with a modern twist and sometimes as nearly exact replicas.

REMEMBER

Bollywood has traditionally been a conservative industry, focusing on similar romantic storylines, even when action is involved. Chapters 3–5 touch on these themes and the families that have dominated the Indian film screens.

The era may have changed, but one thing remains the same: Strong, talented women continue to push the envelope in Bollywood. The continued evolution of female roles in Bollywood is spurred on by these accomplished women who refuse to conform to many of the gender roles that women before them had to adhere to. From daughters of famed stars to beauty queens, the women of today's Bollywood are paving only one path: their own.

In this chapter, we explore how the industry has begun changing. Classic Bollywood is being remade for the new generation, and new trends call for progressive storylines leading to a new era of Bollywood plots. Despite the change, actors rising from the ranks of their family's history in the industry only grew stronger as these roles demanded newfound range and versatility.

Recycling Old Plots: What's Old Is New Again

As Bollywood exhausted most of the genres of movies through the early 2000s (see Chapter 5), the question often was, "What next?" As moviegoers craved new experiences different from the age-old story of boy-meets-girl, Bollywood executives searched far and wide to find plotlines that would keep audiences engaged and coming to the theater.

Often, that meant borrowing plots and movie ideas from other film industries. Industries like Hollywood began to be a common source of inspiration for Bollywood, and movies in foreign languages were commonly adapted for the Bollywood screen. Even these movies began to dry up, however, as an industry that churns out more movies per year than any other was left wondering how it would ever have enough content to satisfy its *billions* of viewers.

The answer: Look within. As a new generation of moviegoers began to emerge, one that was too young to appreciate the Dilip Kumars and even the Amitabh Bachchans of the world (refer to Chapters 3 and 4), Bollywood made a stark realization. These new Bollywood fans had only an inkling of the stories and movies that made Bollywood famous — why not remake some of these films and adapt them with modern filmmaking techniques for a modern audience? And thus the Bollywood remake genre was born. Applied to not only movies but music as well, the 2000s and beyond have seen a resurgence of Bollywood classics featuring modern-day actors reprising the lead roles.

Of course, these remakes can't quite be *exact* copies. Many of the issues that dominated and drove plots in classic Bollywood would be moot now; the advent of technology such as the Internet and cell phones made obsolete such concepts as missing love letters. Still, by using the general theme of a movie as a baseline, filmmakers can adapt the stories of old for a younger, more tech-savvy audience. Much like Hollywood adapted Shakespearean plays (*10 Things I Hate About You* and *Taming of the Shrew* are two examples), Bollywood retained the main points but swapped out the details to keep up with the times. And, for the new generation of viewers, of course, a new generation of actors also kept things interesting.

Keeping It in the Family: Children of Famous Actors

Although families such as the Kapoor family have always had members in the movie industry (refer to Chapter 2), no era of Bollywood has had as many children or relatives of former Bollywood industry leaders than the present one. Sure, there are still those actors and actresses who have risen to stardom in the past few years out of seeming anonymity, and some models continue to find themselves starring in movies. However, more than ever before, familial ties have brought newcomers into the limelight.

We aren't talking about blind nepotism, however. Many of the actors and actresses in today's Bollywood have been able to witness the careers of their family elders and learn the trade. And these new faces come supplied with a pleasant surprise: undeniable acting ability. Sure, having a superstar parent or two never hurts when climbing the ranks of stardom, but these actors and actresses have proven again and again that they belong in the spotlight and not just for their names.

Identifying the Newest Kapoors

When discussing families in Bollywood and their respective influences, one family name reigns supreme: Kapoor. No other family has as many entries in the Bollywood landscape since its inception. And the current roster of Kapoor kids in the industry ensures that this era of Bollywood will be no different. Though we have left out several other Kapoors in the industry, these next few actors we discuss have cemented their place in Bollywood as stars for years to come.

Charming and varied: Ranbir Kapoor

Being Rishi Kapoor's son means, inarguably, having some huge shoes to fill, but Ranbir Kapoor has stepped up to the challenge with fervor (refer to Chapter 4 for more about the late Rishi Kapoor). Already one of the most successful actors of his generation, Ranbir Kapoor made his debut in *Saawariya* (My Love) in 2007. Though the movie wasn't a success, his work in it was positively received, and he received a Filmfare Best Male Debut award for the film.

Initially appearing as a lovable charmer, he has taken on several challenging roles in his career and become a critical darling at an early stage in his career. Thanks to hits like *Wake Up Sid* and *Barfi!*, Ranbir has already earned the reputation of a capable and talented Bollywood star. He has already won three Filmfare awards for Best Actor, for his movies *Rockstar*, *Barfi!*, and the Sanjay Dutt biopic *Sanju*.

Household name: Arjun Kapoor

The son of famous Bollywood film producers Boney Kapoor and Mona Shourie Kapoor, Arjun Kapoor (Figure 6-1 shows Arjun with Aditya Roy Kapur and Parineeti Chopra at a Diwali party in 2017) began his career on the production side, serving as an assistant director to Nikhil Advani, notably on the superhit *Kal Ho Naa Ho* (Tomorrow May Never Come). He was then cast to debut in the successful film *Ishaqzaade* (Love Couple), which helped to launch his career.

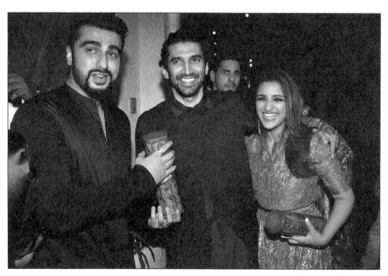

FIGURE 6-1: Arjun Kapoor (left), Aditya Roy Kapur (center), and Parineeti Chopra (right).

Azhar Khan/Alamy Stock Photo

Though Arjun's career has been tumultuous thus far, he has made a name for himself in the industry within a short period. Most notably, his performances in the films 2 *States* and *Half Girlfriend* were met with praise, and both movies did well commercially.

Winning smile: Aditya Roy Kapur

Technically part of a different Kapoor family, Aditya Roy Kapur is one of three brothers who are all involved in Bollywood. Aditya Kapur's brother Siddarth has carved out an indelible name for himself by producing some of the biggest movies of the 2000s, and their brother Kunaal has also appeared in a number of Bollywood films. However, Aditya Kapur (you can see his winning smile in Figure 6-1) has established himself as the brother to beat, at least on-screen.

Gaining fame for his roles in hits like *Aashiqui 2* (Romance 2) and *Yeh Jawaani hai Deewani* (This Youth Is Wild), he has won over audiences with his winning smile and relatable personality. Still at the beginning of his career, Aditya Roy is already a household name and a popular actor in young Bollywood. In 2020, he appeared in the Netflix original Hindi-language film *Ludo* alongside contemporary actor Abhishek Bachchan (you can read about him in Chapter 5).

CULTURAL WISDOM

Ludo is a strategy game originating in India as far back as 3300 BC but officially introduced as a board game in 1896. The game has become a staple of South Asian culture, played by two to four people as a race from start to finish based on the rolls of a single die. The 2020 Netflix film took this concept as a backdrop for the film showcasing how four lives were all intertwined.

Aching in Heartthrob Haven

A few stars have been able to make their way into the limelight without having any familial ties in the industry. Their incomparable charisma, heart-stopping performances, and admiration for the greats before them have continued to win them over with the masses. As students of the game, here are the male leads who are doing their best to fill in the big shoes of their idols.

The new king of Bollywood: Ranveer Singh

Although not hailing from a traditional Bollywood family, Ranveer Singh has quickly stolen the heart of a nation and established himself as one of the brightest new stars in Bollywood. Making a splash in his debut alongside Anushka Sharma

(refer to the later section "Recognizing the Challengers of the Norm") in *Band Baaja Baaraat* (Band, Music, and Revelry), Singh was an overnight success.

He went on to collaborate frequently with famed director Sanjay Leela Bhansali, appearing in several of Bhansali's blockbuster films:

» *Goliyon Ki Raasleela: Ram Leela* (A Dance of Bullets: Ram Leela)

» *Bajirao Mastani* (Warrior Lover)

» *Padmaavat*

Falling in line with most of Bhansali's work, these films, based on epic stories and poems, cemented Singh as an outstanding actor with verifiable star power. He can also be easily spotted as often the most colorful and fashion-daring man at events. (Figure 6-2 shows Singh at a photo-call for *Gully Boy* before being screened at the International Film Festival in 2019.)

FIGURE 6-2:
Ranveer Singh.

dpa picture alliance/Alamy Stock Photo

CULTURAL WISDOM

In 2018, Singh married his costar in each of the Bhansali films, Deepika Padukone (you can read about her later in this chapter, in the section "Crowning a Queen: Deepika Padukone"), leading many to label them as India's premier power couple and the royal family of Bollywood.

Besides appearing in epic films, Singh has garnered praise for taking on different roles, including that of a criminal in *Gunday* (Outlaws) as well as a rapper in Bombay's underground scene in *Gully Boy* (you can read more in Chapter 10). To date,

Singh has already won two Filmfare Best Actor awards, for the aforementioned *Bajirao Mastani* and *Gully Boy*.

Tall and talented: Sidharth Malhotra

A former model, Sidharth Malhotra was cast in the teen romantic comedy *Student of the Year* in 2012 and instantly became a fan favorite. After a number of moderate successes, Malhotra firmly planted himself as part of the new generation of Bollywood stars. Known for his tall stature, good looks, and dancing abilities, Malhotra has often drawn comparisons to a young Amitabh Bachchan. (Figure 6-3 shows Malhotra with Alia Bhatt and Pakistani actor Fawad Khan at the launch of *Kapoor and Sons* in 2016.)

FIGURE 6-3: Sidharth Malhotra (left) with Alia Bhatt (center) and Fawad Khan (right).

Dinodia Photos/Alamy Stock Photo

Meanwhile, Malhotra has also played a variety of roles, from romantic or action-packed to his best critical performance, in the social drama *Kapoor and Sons* (you can read more about this film in the sidebar "Five fantastic movies from the late 2000s to the present day"). Malhotra has been nominated and won in a variety of categories for different awards, but as of 2020 had yet to win a major award for acting.

Building Bodies in Bollywood

A few notable actors from Chapter 5 created such a buzz around their particular attributes that having those attributes became the absolute norm for future male leads there on out. For example, Salman Khan leveraged his scenes so that he would be able to display his muscular physique, and Hrithik Roshan wowed audiences with his ability to dance to any tune. This new generation of actors have that and sometimes even more, but a few specifically really became known for these particular traits.

Tragic star: Sushant Singh Rajput

One of the more heartbreaking tales in Bollywood is that of the late Sushant Singh Rajput, a promising young actor who passed away suddenly in June of 2020. Known universally for his kind smile and sculpted body, SSR as he was known wowed audiences with hits such as *M.S. Dhoni: The Untold Story*, *Kedarnath*, and *Chhichhore* (Uncivilized). Though his future seemed bright, Sushant took his own life in 2020; his death spurred a nationwide conversation about mental health and the treatment of young actors in Bollywood.

The martial artist: Tiger Shroff

The son of legendary actor Jackie Shroff (you can read about him in Chapter 4), Tiger Shroff is an accomplished martial artist who has made a name for himself in the Bollywood industry as an action star. With high-flying stunts and rock-hard abs as his staple, Shroff has quickly become a fan favorite, starring in the *Baaghi* (Rebel) movie series as well as the commercially successful *War*, opposite Hrithik Roshan (a Bollywood star who we discuss in Chapter 5).

Besides earning universal praise for his ability to pull off daring stunts and acrobatic action sequences, Shroff (Figure 6-4 shows him with Shraddha Kapoor at a Fitbit launch event in India in 2015) has also established himself as one of the best dancers in Bollywood. After creating a frenzy by appearing alongside Roshan, another accomplished dancer, Shroff was then cast as the star of *Student of the Year 2*.

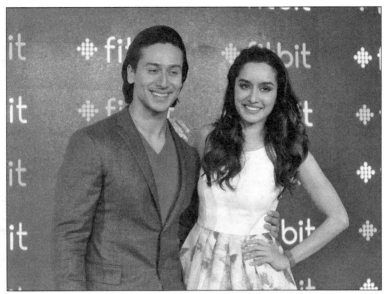

FIGURE 6-4:
Tiger Shroff
and Shraddha
Kapoor.

Romantic hero: Varun Dhawan

Another actor who got his start from the first *Student of the Year* film, Varun Dhawan quickly took over the role of romantic hero in Bollywood with a number of hit movies that included these:

>> *Humpty Sharma ki Dulhania* (Humpty Sharma's Bride)

>> *Main Tera Hero* (I'm Your Hero)

>> *Badrinath ki Dulhania* (Badrinath's Bride)

Often appearing alongside actress Alia Bhatt (refer to the section, "The Descendants: Women from Bollywood Families," later in this chapter), Dhawan has established himself as a charming star in romance and comedy films. Also a good dancer, he has appeared in the dance-centric films *ABCD 2* and *Street Dancer 3D*.

Crowning a Queen: Deepika Padukone

Every generation has its unanimous queen bee, and for the current generation, Deepika Padukone (see Figure 6-5) has run away with the title. Appearing initially in the Shah Rukh Khan starrer *Om Shanti Om*, Padukone quickly became a fan favorite, thanks to her stunning good looks, praiseworthy acting, and excellent dance moves.

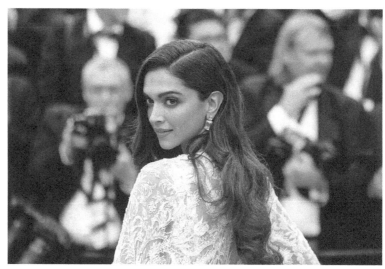

FIGURE 6-5: Deepika Padukone.

Not originally from a Bollywood family, Padukone made a name for herself as a model before being cast in *Om Shanti Om*. After her breakthrough, her movies initially flopped at the box office and earned lukewarm reviews from critics, before she turned the corner in 2012 and established herself as Bollywood's premier leading lady. Like her current husband, Ranveer Singh (we discuss in the section, "The new king of Bollywood: Ranveer Singh," earlier in this chapter), Padukone found success collaborating with director Sanjay Leela Bhansali, in productions like *Goliyon Ki Rasleela: Ram-Leela* and *Bajirao Mastani*.

Once established as a star, Padukone took on more challenging roles, such as a headstrong architect in *Piku* and as an acid attack survivor in *Chhapaak* (Splash). She also appeared in the Hollywood film *XXX: Return of Xander Cage*. Chapter 21 discusses her presence in Hollywood in more detail.

A prominent public figure in India, Padukone is also outspoken about social issues such as women's rights and mental health.

The Descendants: Women from Bollywood Families

Naturally, expectations are high when stars are the children of famed and successful parents. Comparisons to them are always made making it all the more difficult for the offspring to carve a legacy for themselves. However these leading ladies

have all exceeded expectations by pushing the envelope and revolutionizing the roles for women in Bollywood. The quintessential damsel in distress is long gone thanks to these modern heroines.

Acclaimed at an early age: Alia Bhatt

Alongside the aforementioned actors Varun Dhawan and Sidharth Malhotra, Alia Bhatt became an overnight sensation due to the success of their debut film, *Student of the Year*. The daughter of famed director Mahesh Bhatt, Alia has made a name for herself in the industry for taking on tough, unconventional roles (read more about her family legacy in Chapter 2). She has not only challenged herself with these roles but also received almost universal praise for her acting abilities in most of her films. Here are some of her successes:

» *Badrinath ki Dulhania* (Badrinath's Bride)

» *Dear Zindagi* (Dear Life)

» *Udta Punjab* (Punjab Is High)

» *Highway*

» *Raazi* (Willing)

» *Gully Boy*

Appearing in a variety of films and roles, Bhatt (refer to Figure 6-3) has already cemented herself as one of the best actresses of her generation and a leading lady for years to come. Aside from acting, Bhatt is also a talented singer and entrepreneur.

Body image hero: Sara Ali Khan

The daughter of Saif Ali Khan (see Chapter 5), Sara Ali Khan has just started to make her mark on Bollywood. Both of her first two films, *Kedarnath* and *Simmba*, were commercial successes, with the former earning her a Filmfare award in 2018 for Best Female Debut (refer to Chapter 15). In addition to acting, Khan is a celebrity endorser for various brands and products. Because she went through an incredible weight loss journey of her own, Khan is also outspoken about health and body image positivity.

Variety queen: Shraddha Kapoor

A multitalented star and the daughter of Bollywood great Shakti Kapoor, Shraddha Kapoor has taken the Bollywood industry by storm in just a few short years. Appearing in a variety of roles — including romance, dancing, and

action — Shraddha (refer to Figure 6-3) has established herself as a versatile actress with a personality and good looks to boot.

In addition to acting, Kapoor sings many of her own songs. Outside of the film industry, she's one of the most followed celebrities in India on social media, a model who regularly graces magazine covers and catwalks, a fashion icon, and an entrepreneur. Though her acting career has started off with both ups and downs, she has already earned a spot at the table with Bollywood's elite.

The fashion icon: Sonam Kapoor

Perhaps no modern actress is as polarizing among fans as Sonam Kapoor. Because she's the daughter of the inimitable Anil Kapoor (see Chapter 4), expectations were high as she entered the Bollywood film industry. After experiencing mild success with romantic comedies such as *I Hate Luv Storys* and *Aisha*, Sonam Kapoor acted in poorly reviewed films that were also flops at the box office.

However, she later bounced back with supporting roles in the commercially and critically successful biopics *Neerja*, *Bhaag Milka Bhaag* (Run, Milka, Run), and *Sanju*. Critics have been split on her performances; Sonam nevertheless has earned her place in Bollywood as an actress, a fashion icon, a model, and an outspoken media personality.

The royal debutante: Sonakshi Sinha

Although she's Bollywood royalty, the daughter of famed actor Shatrughan Sinha, Sonakshi Sinha earned her keep in the film industry by first working as a costume designer. She made her debut in the successful *Dabangg* (Fearless) action film, alongside none other than Salman Khan (see Chapter 5).

Often playing the love interest of her male costars, Sonakshi has been criticized at times for playing one-dimensional characters. However, she has also earned positive reviews for some of her roles, including that of a woman battling tuberculosis in *Lootera* (Robber).

Recognizing the Challengers of the Norm

As roles for women continue to diversify, more talented and independent actresses have stepped forward. These women have changed the Bollywood landscape by being the leads in female-centric movies and sometimes even stealing the show in male dominated films. Not only are they confident in their abilities, but they also don't shy away from letting you know it either.

The strong personality: Anushka Sharma

One of the most popular actresses in India, Anushka Sharma began her career alongside Shah Rukh Khan in *Rab Ne Bana Di Jodi* (A Match Made by God) before joining fellow newcomer Ranveer Singh in *Band Baaja Baaraat* (Band, Music, and Revelry). Much like her costar in the latter film, she became an overnight sensation upon the film's release, and has never looked back.

Sharma (pictured in Figure 6-6 with Varun Dhavan at their 2018 launch of the film *Sui Dhaaga* [Needle and Thread]) has made it a point in her career to portray strong-willed, independent women, for which she has gained recognition from fans, peers, and critics alike. In addition to being a successful actress in Bollywood, she's also a brand ambassador and an outspoken social activist for a number of causes.

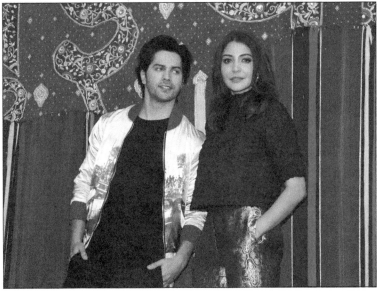

FIGURE 6-6:
Varun Dhavan
and Anushka
Sharma.

ZUMA Press, Inc./Alamy Stock Photo

Critical darling: Parineeti Chopra

Another Bollywood star who has been able to hold her own is Parineeti Chopra (refer to Figure 6-1) has been wowing audiences and critics alike throughout the 2010s. After gaining acclaim for her supporting role in *Ladies vs. Ricky Bahl*, a remake of the Hollywood film *John Tucker Must Die*, Chopra scored a leading role opposite Arjun Kapoor in *Ishaqzaade* (Love Couple).

CULTURAL WISDOM

It's actually common for Bollywood to remake popular Hollywood films. In some cases, remakes are done more subtly, and other times the remakes can be a clear scene-by-scene replica. This has spurred international copyright conversations with business school case studies dedicated to the concept of creative ownership. Other examples include *Hum Tum* (You and Me), considered a remake of *When Harry Met Sally* and *Dostana* (Friendship), considered a remake of *Now I Pronounce You Chuck and Larry.*

After receiving positive reviews for her performance in a leading role, Chopra continued to be cast as a lead heroine and strengthened her place as a leading lady. Known for her vivacious personality, particularly in romantic comedy roles, Chopra looks to be a Bollywood mainstay for years to come. She is also the cousin of actress Priyanka Chopra (see Chapter 5).

Taking her own stance: Kangana Ranaut

No actress in recent times has been as outspoken as Kangana Ranaut. Making a strong debut in the film *Gangster,* Ranaut quickly gained a reputation for portraying intense characters and choosing to do more unconventional films, which eventually caught the eye of critics. Though she struggled to consistently find success after her debut, she had a few breakthrough performances in films like *Fashion, Once Upon A Time in Mumbaai,* and *Tanu Weds Manu* before reaching a turning point in her career with *Queen.*

As Ranaut consistently secured awards and accolades, she was also frequently going viral for her hot takes on Bollywood. Considered as an outsider herself, she has been highly critical of the industry for continuously pushing forward nepotism as opposed to rewarding individuals for their talent and merit. Speaking of talent, Ranaut has never shied away from applauding her own talents and bodies of work elevating herself above the likes of Meryl Streep and Tom Cruise. This self-praise and interest in holding the unconventional opinion has landed her in trouble, especially in 2021, when she began shaming international stars such as Rihanna for bringing awareness to agriculture issues within India. Many found Ranaut's words, mainly in her social media posts, to be so harmful and suggestive of violence that petitions were started to ban her from Twitter altogether.

CULTURAL WISDOM

Many Bollywood producers and actors, including Ranaut, have been criticized in the 21st century for their political views and positions. Although some fans praise them for standing proudly with their country, many fans, especially those abroad, feel that Bollywood actors have become government talking heads versus a voice of the people.

FIVE FANTASTIC MOVIES FROM THE LATE 2000S TO NOW

Even though nothing beats Bollywood classics, the latest generation of Bollywood has pushed the norm and started conversations beyond romance and country relations. Movies of late have dug into modern-day problems, complex relationships, and progressive ideals. Here are some films that are changing the norm of what has traditionally been seen on Bollywood screens:

- **Kapoor and Sons:** A prime example of a modern-day Bollywood film, *Kapoor and Sons* was one of the first Bollywood movies to touch on (spoiler alert) homosexuality in an Indian household. Though it's not the main premise of the plot, this 2016 movie also digs into other sensitive and progressive topics, such as bad blood and familial deceit. A critically acclaimed film, *Kapoor and Sons* features mature storytelling and is appropriately lovable and gut-wrenching throughout.

- **Gully Boy:** Director Zoya Akhtar leads the pack in this critically acclaimed picture from 2019, which touches on India's ever-evolving hip-hop scene. The story follows hip-hop enthusiast Murad (Ranveer Singh) as he rises through the ranks of underground rap and becomes dubbed Gully Boy. This film touches on domestic abuse, life in a city slum, and dreams that can become reality for anyone — no matter where they're from.

- **Queen**: A star-making performance by Kangana Ranaut helps this 2013 film follow the journey of a simple Delhi girl, Rani, as she embarks on a "solo-moon" after her wedding is unexpectedly called off. *Queen* is a groundbreakingly feminist film, as director Vikas Bahl showcases Rani expanding her horizons through travel, befriending strangers, and realizing that she isn't defined by any man.

- **Dear Zindagi**: *Dear Zindagi* takes a giant leap toward progressive discussion about mental health in 2016. Actress Alia Bhatt plays Kaira, a filmmaker in the midst of a failing career and a failed relationship. Because nothing is going her way, she moves back in with her parents and seeks therapy with psychologist Dr. Jehangir (Shah Rukh Khan) to conquer her personal demons and improve her relationship with her parents.

- **Piku:** At some point in life, you suddenly may find yourself parenting your own parents. This 2015 film, from director Shoojit Sircar, gives a lighthearted (yet at times dismal) take on Piku (actress Deepika Padukone), her aging father (Amitabh Bachchan), and life's practical difficulties with aging parents. The late Irrfan Khan plays a taxi driver who takes the father-daughter combo to Kolkata and comes to aid them.

3

The Sound of (Bollywood) Music

Resist the urge to dance with a deep-dive into all things Bollywood music.

Discover the technical aspects of Bollywood music, from style to format to length and more.

Understand where the music originated with special spotlights on famous composers.

Watch the evolution of Bollywood music because it took influences from disco, rock, pop, and more over time.

Find out more about the varying fashion and costumes used in Bollywood music video production.

Appreciate the artistic influences from neighboring Pakistan and Sufi spirituality.

Inspect what's needed to become a Bollywood dancing star.

Chapter **7**

Not a Sprint, but a (Musical) Marathon

No medium in the world today is as dynamic and effectual as music. The beats, rhythms, and lyrics can take you on an emotional roller-coaster, ranging from happiness to sadness and sometimes even to anger in just a matter of minutes. Music is art, as is film, and when the two come together, they're undeniably powerful — they can even inspire social dialogue and eventual policy change.

REMEMBER

In Bollywood, music is everything. In fact, music, at times, can be even more significant than the films themselves, whereas at other times, music interests you in seeing the movie. In Bollywood, the actor usually lip-synchs the song as opposed to the artist singing it.

If you're intrigued, this chapter is for you. Here we discuss the significance of music in Bollywood, dive into the unique nuances of the industry, and see how music and movies are connected.

Respecting the Soundtrack

Soundtracks, or the musical companions of movies, are often anticipated for major Hollywood blockbusters. Meanwhile, musicals come complete with singing and dancing as an essential component of the film. In Bollywood, every movie is a musical, and musical numbers themselves have been a part of Indian cinema since the industry's first-ever movie *Alam Ara* (Ornament of the World) in 1931.

Since then, Bollywood in particular has ensured that each and every film has an original musical score, complete with performances, costumes, and sometimes even extravagant sets. Because the theatrics of the songs were so highly entertaining and often united the nation, Bollywood kept this musical formula going. In fact, Bollywood realized the importance of the soundtrack and began to use the music of movies to promote and popularize the movies before they were even released. We cover exactly how Bollywood did that is here.

Nodding at movie soundtracks

The collaborative relationship between song and film has become the hallmark of Bollywood and the greater Indian cinema at large. Unlike American musicals, where the actor casted is often considered for their singing ability as well, actors in Bollywood films aren't expected to have their own pipes. Though some actors sing their own tracks, most often the songs featured in a Bollywood movie are simply mouthed by the film's characters or protagonists.

As a result, the production and filming of each song is on a much larger scale in comparison to any in Hollywood. Rather than simply showing the actor singing along, these songs are often filmed in exotic locations, with extremely high production value. The end result are songs with videos that can stand alone, similar to music videos. The difference, of course, is that you're being treated to this music video in the middle of a feature-length film.

For example, consider the 2018 *Black Panther* soundtrack, which was one of the most anticipated and popular in recent Hollywood memory. Although not a musical, the background music of this film includes The Weeknd's song "Pray for Me." As the song plays, lead actor Chadwick Boseman's character, T'Challa, enters a casino in search of one of the film's antagonists, Klaue, to seize a dangerous and illegal arms exchange.

In contrast, consider the 2015 Bollywood film *Bajirao Mastani,* which features the song "Malhari." It takes place after the protagonist, Peshwa Bajirao, conquers all of India. In true Hindi film fashion, Bajirao (played by Ranveer Singh) sings and dances in celebration with the rest of his comrades. The sets on these music videos

tend to be not only quite expensive but also, as in the case of "Malhari," built specifically for that song alone!

Focusing on the actual songs

Songs on Bollywood soundtracks are direct representations of the movies themselves. As each film hits its emotional highs and lows, so too will the songs that accompany each portion of the movie. From the soundtrack alone, audiences can decipher the range of emotions they'll experience while watching the film. Furthermore, songs and their accompanying videos often have some key, uniform characteristics.

Considering the types of songs on soundtracks

Here are some important characteristics about the types of songs that usually appear on Bollywood soundtracks:

>> **To show no public displays of affection:** Bollywood traditionally has a conservative approach to entertainment (which often helped its growth in international markets — see Chapter 13). Even movie songs minimized any display of intimacy, such as kissing, sex scenes, and nudity. It was nearly the turn of the millennium when more provocative scenes began appearing.

>> **To replace intimate moments:** Doing so allows Bollywood to continue to appeal to families and conservative demographics without dealing with explicit sex scenes.

>> **To provide interior motifs:** Songs often outline an underlying story within the film that previously wasn't evident. Most commonly, songs show a budding romance or clue audiences in to a character's feelings through the song lyrics rather than showing these motifs explicitly through plot points.

>> **To add commentary on a scene or theme:** Songs can often serve as background music for a montage during a film or accentuate a character's plight or feelings that may not have been easily evident from just dialogue or plot movement.

>> **To heighten a mood or scene:** Typically, a movie soundtrack contains a mixture of themes and moods, ranging from romance to sadder moods to uplifting dance or party songs. The songs therefore help to heighten the emotions audiences feel during any given point in a film.

Eyeing the length of soundtracks

Here are some additional characteristics about the length of Bollywood soundtracks:

>> Each contains anywhere from five to six original songs, if not more.

>> Each song ranges anywhere from three to eight minutes long. Yes, eight minutes (for even longer songs, turn to Chapter 9 for more about qawwali songs). Even for longer songs, though, when showcased in the film, they're usually around five minutes long.

>> Almost always, a main title track incorporates the film's name or tagline.

Marketing movies: How songs do it

Bollywood marketers use the soundtracks to pique Bollywood fans' interest in a film. Given that a lot of music in India is consumed through its film industries, Bollywood movies are responsible for supplying people with new songs to jam out to, whether it's part of commute playlist or to boogie down to at the next South Asian wedding! The anticipation for these new songs is high, and the ensuing excitement ends up being a perfect way to promote a forthcoming movie.

Bollywood fans now listen to their favorite music via streaming apps, such as Spotify and iTunes, as well as a few Bollywood-exclusive streaming apps that include JioSaavn and Gaana. YouTube is also an extremely popular way for fans to watch and listen.

Here are some ways Bollywood markets movies with soundtracks:

Hyping movies with new songs

When a release date for a film is set, the film executives spend the months leading up to it releasing songs every few weeks, driving up anticipation and hype. Often, the songs themselves end up performing better than the film itself. Each new song can showcase a new scene in a movie, or even different characters and stars who are to be featured in it — though sometimes the soundtrack becomes memorable without listeners ever even watching its accompanying film.

REMEMBER

Sometimes the famous stars make a cameo in just one song of the film, which is referred to as an *item number*. The spotlighted actor in the item number, also known as the *item*, may have nothing to do with the film's plot other than filling in as lead for that specific song. This addition of star power helps to create even more buzz surrounding a film, which can hopefully translate into more ticket sales.

Introducing new dance moves

Because Bollywood movies appeal to multiple audiences and demographics, another helpful way to market a movie is to include a catchy song that incorporates new and hip dance moves, typically targeted to families and younger demographics.

For example, Salman Khan has capitalized on this phenomenon with such fun and upbeat songs as "Dhinka Chika" (sound effect for music beats) from the 2011 movie *Ready* in which he places his hands in the pockets of his loose pants and begins moving them vigorously side to side — a simple yet fun dance move that was emulated by many people. Khan (whom we discuss more in Chapter 5) incorporates a catchy dance move in almost every one of his recent films, knowing that it also falls in line with the traditional movies across all of India; as a result, his movies are consistently some of the highest grossing movies in a given year.

Fans often watch Bollywood videos like this one on YouTube to master the dance moves. Aside from promoting the film further, these dance moves become iconic over time and are recreated at weddings, dance competitions, and cultural shows around the world (we discuss this phenomenon at length in Chapter 11).

Hosting music shows

Even before streaming became popular, independent production companies from around the world began hosting music shows to market their songs. These shows always played the top Bollywood songs of the time while providing some novel Bollywood news, much the way MTV has done.

CULTURAL WISDOM

Some notable shows were even based in and/or targeted to Western audiences, including *Namaste America, Showbiz India,* and *India Waves.* These shows in particular, which would air Saturday mornings, were an excellent way for the diaspora to keep up with the recent hits dominating the airwaves in India. Refer to the nearby sidebar for other musical shows in India.

Making songs easily accessible

Bollywood also marketed soundtracks globally in local Indian convenience stores in the United States, the United Kingdom, Canada, and any of Bollywood's international audiences. In addition to Indian spices, food, and produce, you could often find a home video section where you could rent Bollywood films (on VHS, DVD, or Blu-ray). In the earlier days, these came in video CDs (VCDs), often in a set of three due to the length of Bollywood films. Bollywood films could also be found on VHS, DVD, or Blu-ray.

This easy accessibility was particularly exciting for the music diehards because specific song ensemble packages were created by independent companies as well. For example, complete VHS tapes were available with titles such as "The Best of Shah Rukh Khan," which played only the corresponding music videos from his hit films (see Chapter 20).

DO-RE-MI-FA-SO MUCH MUSIC

It's no secret that Bollywood has a rich song, dance, and music history. As obsessed as the United States is with its talent shows — such as *American Idol, The X Factor,* or *America's Got Talent* — so is India. As stars' hair turns grayer by the day, the public is always on the lookout for fresh young faces to root for — while contributing to the ever-so-popular movie industry that is Bollywood. Here are some shows (some original, some spin-offs) that help crown a potential future Bollywood music star.

- *India's Got Talent:* Stemming from the *Britain's Got Talent* franchise, *India's Got Talent* premiered in 2009. The show has the same format as any other *Got Talent* spin-off with many Indian personalities hosting and judging the competition. The hosts have changed over time — the roster included several comedians and past winners of the show. Meanwhile, the judges have included Bollywood big names such as Karan Johar (director), Farah Khan (director), Dharmendra (actor), Sajid Khan (director), Kirron Kher (actress), and Sonali Bendre (actress).

- *Indian Idol:* One of the longer-running music talent shows on Indian television, *Indian Idol* is a staple reality show that is similar to its predecessor, *American Idol.* Many special appearances throughout the seasons are by Indian actors, actresses, singers, or film directors. The show's hosts are typically previous winners, up-and-coming actors, models, and comedians. Winners are crowned every season; however, a few competitors either become memorable or go on to find more success than even some of the winners do, just like in *American Idol.* Notable singers who came from *Indian Idol* are Neha Kakkar, Monali Thakur, and Nakash Aziz.

- *The Indian Notes: Sa Re Ga Ma Pa:* Probably the biggest and longest-running reality singing competition show in India is *Sa Re Ga Ma Pa.* Named after the standard octave notes of classical Indian music (similar to do-re-mi-fa-so in English), this current show started in 1995. Though the show has seen several hosts, the longer-running ones are established singers like Sonu Nigam, Shaan, and Aditya Narayan.

 One of the more notable signers to come out of this competition as a bona fide star is Shreya Ghoshal. After her appearance on the show, Sanjay Leela Bhansali caught note of the innocence in her voice and thought it would be perfect for Aishwarya Rai's free-spirited and beautiful character Paro for his movie *Devdas* in 2002. After she sang hits for the movie such as "Bairi Piya" (Cruel Beloved) and "Dola re Dola" (I Swayed and Circled), her career in Bollywood was officially made.

- *Boogie-Woogie:* We've seen a lot of competition shows with an emphasis on singing. Bollywood musical scores aren't just about singing — they're also about the dancing. Spearheaded by the Jaffrey brothers, Naved and Javed, *Boogie Woogie* was introduced in 1996. The show was highly entertaining to watch not only because viewers had the pleasure of watching contestants dance to famous songs, but also because the audience members would dance along in their seats. The light-hearted approach to honoring the dance craft was contagious and was a major reason that the show was so popular. Chapter 12 looks more closely at dance in Bollywood.

Recognizing the Importance of the Score

For the greater part of its history, Bollywood was responsible for the majority of music consumption to the Indian public. (Only in recent times has an independent music scene started to thrive outside the industrial juggernaut known as Bollywood.) As a result, many professionals work to make that happen behind the scenes. The following sections identify the team members needed to create a mind-bogglingly high volume of chart-topping soundtracks.

Orchestrating everything: Music directors

A designated music director compiles the soundtrack. In addition, the music director is responsible for being not only the composer but also the producer and the coordinator of the playback singers, lyricists, themes, and the band — all while working in collaboration with the director of the film.

Typically, most music directors gained tutelage by learning to sing or play an instrument at a young age. They often revive that talent in their own projects. For example, Rahul Dev (R. D.) Burman directed the soundtrack to *Sholay* (Embers), which we discuss in depth in Chapter 19, and he sang the iconic song "Mehbooba" (Beloved, Beloved).

Music directors are also usually the ones who are responsible for cultivating and bringing forth new genres and styles to Bollywood's musical stratosphere. For example, Bappi Lahiri is known for being the self-proclaimed disco king and fully merging Western disco sounds with classic Bollywood (refer to Chapter 8). Oscar winner A.R. Rahman is known for not only being able to cross into other industries but also incorporating traditional Sufi soul in his wide array of styles borrowed from cultures within India and around the world.

Here's a list of the more notable music directors:

>> A. R. Rahman

>> R. D. Burman

>> Shankar-Ehsaan-Loy (Shankar Mahadevan, Ehsaan Noorani, Loy Mendonsa)

>> Anu Malik

>> Ismail Darbar

>> Bappi Lahiri

>> Madan Mohan

>> Rajesh Roshan

Bringing the lyrics to life: Singers

The second most popular players are the singers. Known as *playback singers,* their timeless voices actually are responsible for creating world-class hits. At times, famous worldwide singers and artists are also invited to sing a song or two for a movie.

CULTURAL
WISDOM

A notable example is American singer Akon, who sang "Chammak Chalo" (collo-quial for Flashy Girl) from the 2011 film *Ra One.* In one of the stranger, yet interest-ing phenomena that Bollywood is known for, fans typically associate these said songs with the actors onscreen who are lip-syncing and dancing to them, even though everyone is well aware that these aren't their actual voices.

Furthermore, the plotlines of Bollywood films are intended for the actors on-screen who are "singing" the songs for viewers, and so they're often the ones who end up being recognized, because audiences associate them with bringing the songs to life. Not to be mistaken, the playback singers are still highly respected and credited for their body of work and have huge followings of their own.

Famous playback singer-and-actor pairings who have consistently worked together include singer Kishore Kumar with actor Amitabh Bachchan (though Bachchan has also been known to sing some of his own songs) and singer Udit Narayan with actor Shah Rukh Khan.

Here are some of the more notable playback singers in history:

>> Mohammed Rafi

>> Lata Mangeshkar

- >> Kishore Kumar

- >> Asha Bhosle

- >> Mukesh

- >> Udit Narayan

- >> Alka Yagnik

- >> Sonu Nigam

- >> Neha Kakkar

- >> Arijit Singh

- >> Shreya Ghoshal

Writing the songs: Lyricists

The lyricists are also considered to be poets, more or less. The origination of Bollywood music came from traditional Urdu poetry, better known as *ghazals*, and this lasted for several decades, until other music genres from around the world started influencing Bollywood.

Songs are typically written in Urdu and Hindi, and may even incorporate some English. For more on ghazals and all things soul-and-poetry in Bollywood, check out Chapter 9. These are some notable Bollywood lyricists:

- >> Javed Akhtar

- >> Gulzar

- >> Anand Bakshi

- >> Kausar Munir

- >> Amitabh Bhattacharya

Sequencing videos: Sets and locations

The locations where songs take place are just as important as the songs themselves. Songs sometimes require a set of their own, and they can take place anywhere the storyline takes the protagonists of the film (such as their home or workplace), whereas background actors can act normally or can get in on the action.

Bollywood showcases a wide variety of natural scenic wonders of the world as backgrounds to songs. Here are a couple examples of love ballads in natural scenery:

>> **"Dekha Ek Khwab" (Saw a Dream):** The 1981 movie *Silsila* (Affair) had actor Amitabh Bachchan and Rekha "sing" to each other in a giant, multicolored flower field.

>> **"Tujhe Dekha Toh" (When I See You):** The iconic song in the 1995 movie *Dilwale Dulhania Le Jayenge* (The Big-Hearted Will Take the Bride) features Shah Rukh Khan and Kajol expressing their love in a mustard field (see Figure 7-1).

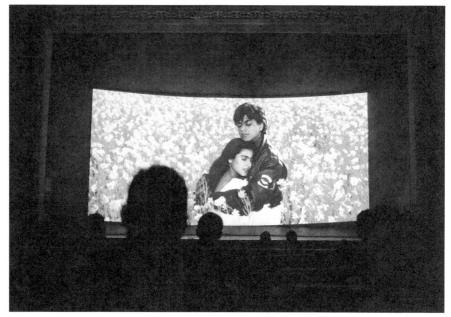

FIGURE 7-1: The movie *Dilwale Dulhania Le Jayenge* features a clip from "Tujhe Dekha Toh."

Source: Alamy

In fact, songs have been shot in famous wonders of the world, such as the Pyramids of Giza or Christ the Redeemer in Rio de Janeiro, Brazil. In modern times, dance and party songs have been reserved for more elaborate and colorful stages, often which resemble the setting at a nightclub.

Many of those revered songs also have the most elaborate settings with a team investing heavily in the location for the song — even if it doesn't flow with the natural progression of the film and is instead a one-off scene purely for musical effect. For example, "Chaiyya Chaiyya" from *Dil Se..* (From the Heart) takes place on top of the moving Nilgiri Mountain Railway train in Tamil Nadu.

Other sets have become so iconic that they've been repeatedly used in film over generations. For example, the set of the 1981 song "Jahan Teri Yeh Nazar Hai" in the film *Kaalia* can be seen again in the 1982 song "Jawani Janeman" in the film *Namak Halaal* (Loyal Servant). It was then seen again, three decades later, in the song "Zindagi Meri Dance Dance" from the 2017 film *Daddy* in a tribute to Bappi Lahiri.

Wherever the locations of the songs are shot, it still ties in with the film's plotline.

SOME OF THE MOST EXPENSIVE SONGS EVER MADE IN BOLLYWOOD

Bollywood songs are clearly vital to a film's success, and having at least one audience hit is the key. Even more important is how that hit song is presented and performed in the film, which is often extracted and posted as a stand-alone music video for fans to enjoy over and over again. Just how much do these music videos alone cost? Take a look at some songs that were quite steep investments:

- **"Malang," 50 million Indian rupees (INR) (more than $675,000):** "Malang" was a song in the third installment in the *Dhoom* (Blast) franchise, starring actors Aamir Khan and Katrina Kaif. Created by Yash Raj Films, the company invested 50 million Indian rupees (which is more than $675,000) in the music video in order to fly American dancers to Mumbai and set up a special training camp for 20 days. In addition, custom outfits were made for each of the 200 gymnasts who performed in the song.

- **"Dola Re Dola," 25 million INR (more than $300,000):** "Dola Re Dola" is a blockbuster song from the 2002 iteration of *Devdas,* with an iconic performance by actresses, and renowned Bollywood dancers, Madhuri Dixit and Aishwarya Rai Bachchan. The film's director, Sanjay Leela Bhansali, is known for his enchanting sets in his extended collection of work, and he didn't spare a dime when it came to this number. See Chapter 12 for more about this song.

- **"Azeem O Shaan Shahenshah," 25 million INR (more than $300,000):** "Azeem O Shaan Shahenshah," from the 2008 film *Jodhaa Akbar*, stayed true to its historical story line, which was based in the Mughal Empire period (1555–1857), by investing in its video production. The song featured more than 400 trained dancers and 2,000 other artists. These dancers traveled to Karjat from Mumbai daily for more than two weeks to complete shooting.

- **"Pyar Kiya Toh Darna Kya," more than 1 million INR (more than $13,000):** Varying reports state that this song cost anywhere from 1 to 10 million INR to make! That $13,000 might not sound like a lot, but this song was filmed in 1960, which made it the most expensive song of its time and would cost nine times that amount today. In fact, the cost even led to financial problems at the time, ultimately taking the makers 12 years to complete shooting.

Getting into Costume

When a new Bollywood film hits theaters, fans worldwide swarm the cinemas in order to catch a glimpse of their favorite actors on-screen, sing and dance along to the new tunes, and be moved by their untouchable performances. The other huge draw, especially to the more iconic Bollywood films? It's the costume design and fashion that is on full display during the song and dance numbers.

Whether the film is based in the present day or is a period piece, the featured wardrobes for men and women are quite different and have even been reflective of the era and the social norms that the country is experiencing at the time. Although the actors and actresses wear everyday clothes reflective of the era throughout the film, the song videos give the chance for actors to show a little flair. These sections discuss some of the most iconic styles and types of clothing that appear in Bollywood songs. Overall, Bollywood has excelled in showcasing India's many cultures and their corresponding fashion through its music.

Eyeing the cuts and wraps of women's clothing

Probably the most popular female adornment on the Indian subcontinent is the sari. Spanning anywhere from three to nine yards long, it's first wrapped around the waist before being draped over the shoulders in various styles. Given that saris are considered traditional clothing, characters in Bollywood films with more conservative values often wear these fabrics in every style, cut, and flavor they've been made in over the years. Some of Bollywood's most famous songs, like "Dola re Dola" from *Devdas* features actresses in saris. (Figure 7-2 shows Indian model and actress Nikkesha wearing a sari from Kamal Sood. The sari consists of the blouse [as seen in the right photo] with roughly seven yards of fabric wrapped around the waist [as seen in the center photo] and then draped over the shoulder [as seen in the left photo].)

We describe a few other styles of clothing in Bollywood songs:

>> **Women's Shalwar kameez** is a combination dress that includes trousers (shalwar) that are baggy and wide except from the waist and cuffed bottom. The kameez is a long shirt top in which the rear can reach the knees. Another traditional variation on the trousers is a *churidar,* which is tightly fitted to the legs with extra fabric that gathers at the hems to create the illusion of bangles around the ankle.

FIGURE 7-2:
Nikkesha
modeling
a sari.

Source: Kamal Sood

>> **Lehenga** is an ankle-length blouse and skirt combination that often has a thick embroidery toward the bottom of the skirt. Many variations of the lehenga have emerged, such as ghagra, which is more pleated. Many women, especially for dances, also flock to two-legged innovations to the traditional skirts, including shararas, which are wide-legged trousers that can sometimes be heavily embroidered, and ghararas, which are fitted from the waist to the knees before forming the wide-legged look from knees to ankle.

>> **Dupatta** is a scarf or shawl that can be made in different materials and accompanies any South Asian outfit. The dupatta has become an iconic symbol of love and attachment in Bollywood films, such as in *Om Shanti Om* (universal sound for Peace), where Deepika Padukone's dupatta gets caught in Shah Rukh Khan's sleeve cuff, or when Hrithik Roshan chases a free-falling dupatta because it reminds him of his love interest, played by Amisha Patel, in *Kaho Naa . . . Pyaar Hai* (Say . . . It's Love).

The 1970s and '80s brought about a change in women's clothing. Though actresses were still mostly playing the roles of damsels in distress, some were stronger sex symbols and their wardrobe followed suit. Given that the 1970s was dominated by disco (see Chapter 8), women also wore bell bottoms, frayed jeans, knee-highs, and large sunglasses. Trends of every decade were followed, and once we entered the mid-to-late 2000s, mainstream Bollywood movies had actresses wearing mostly modern, Westernized clothing. The song videos got more modern at the same time, and more and more Western designer brands began to make appearances in songs.

Given that South Asian fashion is so loved by South Asians themselves, it's occasionally also used to market the release of specific films. Movies like *Mughal-E-Azam*, 1960, *Jodha Akbar*, 2008, and *Bajirao Mastani*, 2015, are all period pieces that highlighted the royal styles of the Mughal empire and historic India. These gaudy-yet-regal adornments are cherished and emulated by many as they became fashion muses for formal attire as well as South Asian weddings worldwide.

Much like the rest of the world, the Indian subcontinent has also progressed and has become a bit more liberal when it comes to its values and styles of clothing. India, as well as the rest of South Asia, is still considered to be more traditional than perhaps the West; however, Bollywood has always pushed forward liberal ideas — even if they are subject to a culture clash with the mainstream.

Appreciating the simplicity and tradition of men's clothing

Men's attire tends to be simpler, even in song; men often can get away with dawning a simple Shalwar kameez and calling it a day. Men also wore Western styles of clothing much sooner than women did, reflective of the types of roles they also had. Here are some of the traditional garments you can see men wearing:

» **Men's Shalwar kameez** is a style similar to a women's Shalwar kameez, but you can also find this fit topped off with an Indian vest, also known as the *koti*.

» **Lungi** is an unstitched garment like a sarong that is wrapped solely around the waist and covers the greater part of the lower extremities. It's particularly popular throughout India as well as in Sri Lanka, Bangladesh, and Nepal. In song, it appears most famously in "Lungi dance," which features the garment as its main subject.

» **Sherwani,** worn in more formal gatherings, is a long, fitted coat jacket with exposed buttons (see Figure 7-3). The fabric typically extends below the knees, but in recent times, varying lengths have ridden a bit higher, along the thigh. This style of clothing has been borrowed by other cultures, including the West; most notably, in the 2003 film *The Matrix Reloaded,* where Neo (played by Keanu Reeves) wears a custom Sherwani that drapes lower, to his ankles. Sherwanis are typically accompanied by churidar bottoms.

FIGURE 7-3: Maaz Khan (left) and Maaz Ali (right) wearing sherwanis while attending a wedding in 2019.

Source: High Dynamic Photography

All that said is not to say that men haven't had iconic looks in Bollywood. There have definitely been experiments with men's looks, from period pieces where men are accessorized with excessive jewelry to club scenes where mesh or ripped shirts are often styled in various ways. Shah Rukh Khan famously wore a see-through mesh shirt in the megahit song "Suraj Hua Maddham" from *Kabhi Khushi Kabhi Gham...* (Sometimes Happy, Sometimes Sad).

Chapter **8**

Getting Funky with Disco

D isco first emerged in the 1970s around the world, but took its time reaching Bollywood. After disco arrived in the 1980s, Bollywood added — in addition to its funky, hippie, and mirror ball styles — its own magic to the metallic flares and Technicolor-flashing dance floors.

This entire period of disco-inspired Bollywood music saw new variations in styles as directors tried to embrace this new, foreign rhythm within the traditions of a Bollywood song or movie. Slowly but surely, Bollywood began to get into the groove and embrace disco full-on.

This chapter shares how disco made its way to India and evolved throughout the 1980. You meet some of the key figures in this movement, the astounding musicians who adapted a very Western trend for Bollywood audiences; ultimately, the disco trend in Bollywood in the 1980s led to the rise of other similar genres and continues to be romanticized and celebrated by Bollywood music in the modern era.

Disco Dancing through Bollywood: How Filmi Disco Made an Impact

Though the 1960s rock and roll remained a popular music genre and spilled into the 1970s, the tides began to shift toward the latter part of the decade, as American disco movies such as *Saturday Night Fever* and the music of the Bee Gees garnered international attention.

These influences crept into Bollywood, leading to what is now better known as *filmi disco,* or disco music that would appear in movies on the big screen. Filmi disco became particularly important as the music producers who pioneered this movement created a legacy that is recognized even today.

When Bollywood's disco era was all said and done, there was something about its vibrance and popularity that was so unapologetically bold, which made it so revered in modern times. For one, Bollywood's spectacular and vivid take on life seemed to blend particularly well with disco music. It also piqued when actor Amitabh Bachchan, who was one of, if not, the biggest Bollywood box office attraction featured in several filmi disco hits, was the reigning king of the industry. The industry's popularity was at an all-time high, and Bollywood disco is one of the major reasons why. This chapter examines the phenomena of this music trend.

Everybody was BIDDU fighting

Biddu Appaiah (pronounced "uh-PIE-uh") (see Figure 8-1) is considered a pioneer of disco and pop worldwide. Born in Bangalore, India, Appaiah eventually made his way to England and is currently ranked number 34 on the British magazine *NME*'s list of "The 50 Greatest Producers Ever."

FIGURE 8-1:
Anglo-Indian
producer
Biddu Appaiah
in February
1975.

Michael Putland/Getty Images

Appaiah's breakthrough came in 1974 with Carl Douglas's "Kung Fu Fighting," which became one of the best-selling singles of all time and garnered him international acclaim as a highly sought-after dance music producer. He continued to make a name for himself in the West and worked with the likes of The Tigers, Tina Charles, The Buggles, Trevor Horn, and Geoff Downes.

As the 1980s began, disco was starting to fade out for good in the West. However, Appaiah saw an opportunity to transport it to South Asia, where the boogie-woogie had yet to catch on. Though he originally had no interest in working for Hindi films, a few events ultimately motivated him to change his mind:

>> Appaiah went on record saying that he wanted to make his Indian mother, who still lived in India, proud by working for Bollywood.

>> Bollywood superstar Feroz Khan paid him an unlikely visit at his home in England and pitched the idea for a catchy song for Khan's upcoming film *Qurbani* (Sacrifice).

>> Khan had also simultaneously discovered a 15-year-old Pakistani girl named Nazia Hassan at a party in London and asked Appaiah to listen to her wonderfully unique voice in an audition. Appaiah obliged and, after signing Hassan to a contract, proceeded to produce this future iconic song for the film.

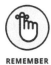

REMEMBER

The new duo of Appaiah and Hassan created the song "Aap Jaisa Koi" (Someone Like You) in a relatively short time. The tune and composition of the song were similar to Tina Charles's "Dance Little Lady Dance," which Appaiah had also worked on in 1976. "Aap Jaisa Koi" was released in 1980 to promote what would become a film's eventual release in 1980. The song, which can be found on YouTube, did so well on its own that its promotion filled the seats of theaters nationwide when the film was released, and *Qurbani* crushed the box office.

Appreciating the Hassan phenomenon

Nazia Hassan was a talented teen from a middle-class Pakistani family in London. The eldest of three (followed by her brother, Zoheb, and baby sister, Zahra), Hassan started as a child artist singing on several shows on Pakistan TV (PTV) throughout the early 1970s. After becoming a bona fide star, thanks to "Aap Jaisa Koi," Hassan and her brother were signed by Appaiah; he also produced their first album, in 1981, titled *Disco Deewane* (Crazy for Disco), which contained ten original tracks. Appaiah envisioned the siblings as South Asia's very own version of the famous American musical duo The Carpenters, and they gained tremendous notoriety and success as a result.

The brother-sister duo, better known as The Hassans, went on to release their second studio album, *Boom Boom,* which also happened to be the soundtrack of the 1982 movie *Star.* Appaiah had offered the opportunity for them both to act in a film, but they declined and stuck to doing what they did best: sing!

CULTURAL WISDOM

Pakistan is a country in the Indian subcontinent with its own entertainment industry: Lollywood. The Hassans were among the select few artists to make musical history in India's entertainment industry during the disco era. Check out Chapter 16 for more about Lollywood and how it impacted Bollywood.

After reaching legendary status with two smash hit albums, The Hassans' groundbreaking third album, *Young Tarang* (Young Wave or the New Wave — a play on words), furthered their legacy when the album became the first in history to feature music videos in Pakistan. Selling 40 million albums worldwide, they were officially icons of South Asia. Fittingly enough, Nazia became the host of the first-ever pop music stage show Music '89.

As The Hassans continued to release their fourth album, *Hotline* (1987), and their fifth, *Camera Camera* (1991), Nazia unfortunately grew seriously ill. She wasn't able to promote her final album because of her health issues, so it didn't find much success. Deciding that she needed to focus on her health, she abandoned her singing career and focused on her personal life. Zoheb later revealed that his sister had kept the illness a secret from their family and the public and resumed life normally. Her untimely death, from lung cancer, occurred on August 13, 2000, in London. Her legacy lives on now as the youngest (at 16) Filmfare Award winner for female playback singer. She was heavily involved in philanthropic work, most notably as the cultural ambassador for United Nations Children's Fund (UNICEF) in 1991 commemorated by the Nazia Hassan Foundation, which was founded by her parents after Nazia's death.

Grooving with the Self-Proclaimed Disco King: Bappi Lahiri

Bollywood films are typically known for celebrating a colorful, vivacious, and embellished take on life. Although the disco tunes of Appaiah and Nazia Hassan took India by storm (see the section, "Appreciating the Hassan phenomenon," earlier in this chapter), no one embodied the spirit of Bollywood disco quite like Bappi Lahiri (refer to Figure 8-2).

FIGURE 8-2:
Bappi Lahiri
in his home
in 2011.

Hindustan Times/Getty Images

Like Biddu Appaiah, Lahiri introduced the synthesizer and other disco sounds to India's film industry; Lahiri's execution, however, was a bit different. He delivered a more extravagant disco sound that matched Bollywood's overall bold gaudiness in contrast to Appaiah's softer interpretation, which also was a closer match to his work out West.

Lahiri's strategy of "Bollywood-izing" disco music for Indian audiences worked; he went on to become one of the most famous and successful music producers in Bollywood history. The following sections examine that influence in greater detail.

Kickstarting the disco trend in India

Born to classical singers Aparesh and Bansari, Bappi Lahiri was trained to play the *tabla* (twin hand drums) by the age of three and to sing classical *Shyama sangeet* (a subgenre of Bengali devotional songs to the Hindu goddess Shyama or Kali). As the nephew of the wildly prominent and multitalented Kishore Kumar, Lahiri had a flamboyant personality and early dedication to his craft, and from an early age was undoubtedly destined for success.

Under the tutelage of his family and his own musical training, Lahiri was able to land gigs within Bollywood as a musical composer, as well as playback singing as early as age 21. Some of those notable movies are *Nannha Shikari* (Young Hunter), *Zakhmee* (Wounded), and *Chalte Chalte* (On the Way).

Hitting the dance floor: Lahiri's influence

Lahiri was a major contributor to the heavy influx of disco movies and songs in the early part of the 1980s. His notable work includes *Armaan* (Desire), *Disco Dancer*, *Namak Halaal* (Loyal Servant), and *Sharaabi* (Alcoholic). The self-proclaimed disco king was recorded in the *Guinness Book of World Records* (now known as Guinness World Records) in 1986 for recording 180 songs for 33 films — all occurring in that same year! To this day, he has recorded more than 5,000 songs in 500 movies across eight languages.

Truly worthy of the moniker disco king, Lahiri ventured into newer mediums to continue his legacy even in the current generation, including becoming a host on India's singing-talent show *Sa Re Ga Ma Pa* (Do Re Mi Fa So). Lahiri remains now as a legend in the industry, and he continues to work on new up-and-coming films.

Digging the Psychedelic: R. D. Burman and Asha Bhosle

One song style to emerge from the 1960s was *psychedelia,* a musical genre made popular in the West by the growing subculture that sought to use music to enhance the effect of psychedelic drugs. In India, no one had quite grasped this genre more than Rahul Dev (R.D.) Burman and Asha Bhosle. Although their smash hit "Dum Maro Dum" (a colloquial expression for "Keep Smoking") was technically a rock song, the duo used it to introduce the psychedelic sound to India. The song over-shadowed the film it appeared in, *Hare Rama Hare Krishna* (Praise Lords Rama and Krishna) and had a distinct Woodstock-esque feel. With the incorporation of a traditional Hindi section, this song proved to be an inspiration for their future disco hits.

The following sections take a deeper dive into these two artists and how they made an impact in Bollywood.

Master of mixing genres: R.D. Burman

R.D. Burman was known for fusing western styles with Indian music, and he would continue to find the happy middle ground between the popularized disco of the 1980s and traditional Bollywood music.

The son of musical director Sachin Dev Burman and lyricist Meera Dev Burman, R.D. was raised in a talented and musically inclined family (much like Bappi Lahiri, whom we discuss in the section, "Grooving with the Self-Claimed Disco King: Bappi Lahiri," earlier in this chapter) and was exposed to music at a young age.

Burman grew up learning classical Hindi musical technique. He notably gained tutelage from some famous mentors:

» **Ustad Ali Akbar Khan:** Ustad ("teacher") Khan taught Burman to play the Indian string instrument *sarod*.

» **Samta Prasad:** Samta taught him to play the tabla.

» **Salil Chowdhury:** Salil mentored him in composition.

Burman gained his initial successes by befriending these and other established figures within the industry. He'd eventually go on to have a successful career in Bollywood film music production, gaining popularity during the 1960s. He was particularly known for drawing from multiple genres, musical instruments, and international styles. The heavy influence of electronic instruments (popular in Western music) as well as the soothing tones of Western psychedelic music often found their way into his productions.

When disco took over as all the rage in the 1980s, Burman again mixed sounds from the growing trend with his own style. He finished the decade with recognition for his mellower, eclectic sound that was halfway between disco and psychedelia. In order to do so, he'd need a partner to pull it off.

The versatile playback singer: Asha Bhosle

As Burman perfected the use of various sounds, instruments, and styles for his music production, he needed a voice that could adapt to the various mixes he was creating. Asha Bhosle fit this mold perfectly, and the pair made history as an extremely successful musical couple.

Known for her range and versatility, Bhosle is one of the most decorated playback singers in Bollywood history. She had been singing since the 1940s and began collaborating with Burman in the 1960s. One of their collaborations, "Dum Maaro Dum," was a gigantic hit in India and came to be the defining song of the psychedelic Indian music movement. Bhosle's wonderful range and versatility lent themselves to Burman's eccentric style, and a musical power couple was born.

Burman and Bhosle married in 1980 and found further success for more than the next two decades because they'd almost always guarantee a standout movie soundtrack. Their work together helped to modernize Bollywood music and assimilate Western influences, like disco, into the fold.

TIP

Along with "Dum Maaro Dum," their famous musical collaborations include the following, which we recommend finding and listening to:

>> "Piya Tu Ab To Aaja" (Come to Me Now, My Love)

>> "Chura Liya Hai Tumne Jo Dil Ko" (As You Have Stolen This Heart)

>> "O Haseena Zulfon Wali Jaane Jahan" (O Beautiful Haired Girl)

>> "Jawaani Jaaneman" (Youthful Lover)

Bhosle (Figure 8-3 shows her performing at her "75 Years of Asha" concert in 2008) came from a musical family as well — most notably, as the younger sister of the great Lata Mangeshkar. The public couldn't help but compare the two. Mangeshkar, who is known as the "nightingale of India," entranced the nation with her ability to create soft, modest beauty with her voice. Bhosle held her own with her sultry, sexy, and sensual numbers. And, with Burman's heavy brass and alternating singing sections, the duo became famous for their psychedelic take on Indian disco.

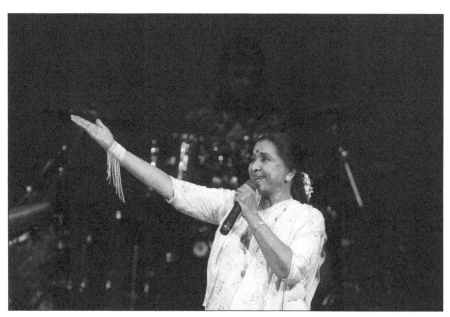

FIGURE 8-3:
Asha Bhosle.

Jack Vartoogian/Getty Images

OUR RECOMMENDATIONS: BOLLYWOOD DISCO SONGS TO ADD TO YOUR PLAYLIST

Of course, you can't just read about the disco era — you have to boogie to it, too! We recommend these songs, which can be heard online, either on YouTube or Spotify:

- **"Aap Jaisa Koi" (Someone Like You):** Nazia Hassan's iconic 1980 song kickstarted disco in Bollywood. Hassan's youthful voice, coupled with xylophone beats, is sure to get your booty moving. Visually, this song's music video has it all: body paint, headbands, knee-highs, and a rainbow kaleidoscope filter throughout that will make you feel like you never left the 1980s. And, of course, there's India's Marilyn Monroe, front and center and hypnotizing everyone — actress Zeenat Aman.

- **"Om Shanti Om" (The Universal Sound of Peace):** "Om Shanti Om" bridges the gap between East and West as traditional Sufi hymns meet all things disco. Kishore Kumar's vocals fill you with glee as actor Rishi Kapoor thrills you by dancing atop a giant, spinning a vinyl record in this incredibly energetic and nostalgic number.

- **"Jawaani Jaaneman" (Youthful Lover):** Gold, glitz, and glam dominate everything in this song, from the edgy stage designs to actress Parveen Babi's mesmerizing costumes and dance moves. Bappi Lahiri intoxicates you with the use of synthesizers and brass work, and Asha Bhosle seduces you with her sultry vocals. From the movie *Namak Halaal* (Loyal Servant) in 1982, this number is guaranteed to leave you completely entranced. Quite literally, it's filmi disco's gold standard.

- **"Jimmy Jimmy Jimmy Aaja" (Come Back, Jimmy), 1982:** Quite frankly, Lahiri's entire soundtrack to the movie *Disco Dancer* should be on this list, but if you were to choose one song, it would have to be this one. Sung by Parvati Khan, this fun-loving and flirty song has violins, a funky bass, and a catchy chorus with a tinge of psychedelia. Actors Mithun Chakraborty and Kim were an overnight hit, and *Disco Dancer* was the highest-grossing Indian film worldwide until *Hum Aapke Hain Koun* (Who Am I to You?) in 1994 largely in part because of its musical score.

 In popular culture, this song was featured in Adam Sandler's *You Don't Mess with the Zohan* in 2008 and was a cover to singer M.I.A.'s song "Jimmy" in 2007.

- **"Ooe Ooe Chori Chori Bate Ho" (Secret Chatter):** From Nazia and Zoheb Hassan's second studio album, *Boom Boom,* this breakout hit was featured in the movie *Star.* With the help of funky guitar and electric keyboard, Zoheb's voice makes you fall head over heels with young love once again. Also for the visualist in you, nothing screams 1980s Bollywood louder than actor Kumar Gaurav dancing alongside a giant Rubik's cube.

(continued)

(continued)

- **"Udi Baba" (colloquial expression Oh, My God):** This song was composed by another famous music-directing duo, Kalyanji-Anandji, and became the hit song from their film *Vidhaata* (Creator), in 1982. This star-studded ballad is an absolute must-listen because the sights and sounds straddle the line of being superhip yet completely ridiculous.

 If you have any doubt, just know that actress Padmini Kolhapure is shot out of a giant golden six-shooter and comedian Jagdeep dawns a knockoff Superman costume as he sings and prances atop a Technicolor stage while also providing subtext to the scene. The vocals are provided by Asha Bhosle, and this number also includes a youthful Sanjay Dutt in disguise, a graying Dilip Kumar, and the bespectacled Amrish Puri, among others.

Mixing It Up: A Little Boogie, a Little Sufi

The final chapter of the disco age of Bollywood drew inspiration from *Sufism*, a dimension of Islam focused on mysticism. Bollywood already saw interpretations of Sufism, through the poetic forms of ghazals and Qawwali, which we discuss in detail in Chapter 9. Giving these forms a disco spin had yet to be initiated.

To continue innovating, music producers sought to mix the disco genre with other classical genres. Soon, they turned to the religious and spiritual side of music, adapting different traditional sounds to meet the requests of a new type of listener, which we discuss in these sections.

Blending religious motifs

Another interpretation on filmi disco was the incorporation of traditional Sufi and religious tunes. As we mention in Chapter 4, a *ghazal* is a poetry form devoted to love, religion, and the Divine — originating from Arab traditions. The ghazal served as another blueprint for many Bollywood songs; however, until this point, it hadn't been quite "disco-fied" yet.

Trying to catch up with the rest of the disco scene in the industry, Indian composers Laxmikant Kudalkar and Pyarelal Sharma mixed traditional and Sufi motifs to create a new variety of song for the soundtrack to the movie *Karz* (Debt) in 1980. The most popular song to come from that soundtrack was "Om Shanti Om."

CULTURAL WISDOM

"Om shanti om" is the known mantra of peace. *Shanti* is the word for peace, and *om* is recognized universally as its sacred sound.

Composing disco music: Laxmikant Kudalkar and Pyarelal Sharma

Laxmikant Kudalkar and Pyarelal Sharma became a successful and popular Indian composer duo that also impacted disco in Bollywood. The two met at Sureel Kala Kendra, an esteemed music academy for youth that was governed by the Mangeshkar family — a prominent Indian family that included the famous Indian playback singer Lata Mangeshkar. Both Kudalkar and Sharma came from poor backgrounds, but as soon as Mangeshkar found out about their financial backgrounds, she put them in touch with music directors Naushad, C. Ramchandra, and R.D. Burman's father, Sachin. Together, they assisted the Burman family in music composition with Sachin's film *Ziddi* (Stubborn) in 1964 and R.D.'s *Chhote Nawab* (Little King) in 1961.

Kudalkar and Sharma used their connection to many A-list singers in Bollywood, including Lata Mangeshkar, Mohammad Rafi, and Kishore Kumar, to find work alongside them, even on low budgets. As a result of their tenacity, the duo finally struck gold and scored their first Filmfare Award for the 1964 movie *Dosti* ("Friendship"). From this time, the duo began dominating the music scene with their ghazals and Qawwali, (another devotional form and style of Islamic Sufi songs from Pakistan and India), but still left quite the mark in disco as their later songs were heavily influenced by the likes of "Om Shanti Om" and this era in general. This combination of disco sounds with a more spiritual context and instrumentation created its own wave and was extremely popular in India. Disco had seen its full integration at this point, combining with all aspects of traditional Bollywood music.

PAYING HOMAGE TO BOLLYWOOD'S DISCO DAYS

The disco era of Bollywood was an experimental time for the industry as directors incorporated disco styles without losing the true essence of Bollywood. Today, the filmi disco age is met with nostalgia and remembrance, with some people even paying homage by sampling the music or attempting to remake the songs for contemporary Bollywood.

Here's a short list of newer songs that aren't disco tunes themselves but do play homage to the disco days:

- "It's the Time to Disco," from the movie *Kal Ho Naa Ho*

- "Dard-e-Disco" (Pain of the Disco) from the movie *Om Shanti Om*

- "The Disco Song," from the movie *Student of the Year*

Chapter **9**

Feeding the Soul: Bollywood's Music Origins and Soul Music

Soul music usually incorporates elements of rhythm and blues, jazz, and a few religious undertones. For example, in the United States, soul music was inspired by African American gospel. Similarly, out East, Bollywood was heavily influenced by Muslim Sufi poetry during its infancy.

Sufism is a form of Islamic mysticism that focuses on becoming spiritually closer to God. This introspective practice comes in many forms, such as prayer, chanting, poetry, singing, and even dancing. Note, however, that it isn't exclusively reserved for Muslims — and it is in turn a broader form of worship that draws an individual's attention inward.

CULTURAL
WISDOM

Given that Islam started in Saudi Arabia, early Sufi poetry hailed from there before slowly branching out into the Middle East and South Asia. Thematically, the poems expressed one's devotion and love for Allah (God) and the Prophet Muhammad (Islam's Holy Prophet) and grew popular for not only their content but also their structure, composition, and delivery. Eventually, ghazals gained popularity as a more modern iteration of Sufi poetry, and their introduction into Bollywood movies transitioned them into a representation of romance.

In this chapter, we uncover the beginnings of Bollywood music, examine how Sufism influenced the industry for years, and meet some famous singers who have left their mark.

Examining the Genesis of Bollywood Music

Like most international film industries, Bollywood movies started out as silent pictures. As technology advanced and sound was introduced to film, Bollywood filmmakers quickly found that incorporating Indian traditions and music garnered praise and popularity for their films. As a result, music and Bollywood movies began to go hand-in-hand and continue to do so even today.

The 1931 movie *Alam Ara* (Ornament of the World) is widely regarded as the first Indian sound film. Directed and pioneered by Ardeshir Irani, the film as an instant hit. This film was revolutionary not only because all earlier movies were silent films but also the movie's dialogue had about seven original musical tracks. Much to the dismay of local musical theater performers, Bollywood music had officially arrived on the big screen. This was during a time when rural and folk theatre had started to reemerge throughout different villages on the subcontinent, and with the influx of debuting *filmi* (a term describing the dramatics of Bollywood films) songs in new movies, it nearly obliterated the live theatre medium, because people were racing to film theaters instead.

Here's a fun fact: The Indian Constitution identifies 22 official languages spoken in India, which needless to say is a lot. *Alam Ara* was filmed in Hindi and went on to inspire many other language films to be made that year in India. India suddenly saw speaking films, or, as the industry liked to call them, *talkies*, in languages such as Bengali, Tamil, Telegu, Marathi, and Gujarati.

CULTURAL
WISDOM

One reason that songs remained hugely popular in Indian cinema is that singing and music were viewed as a higher form of communication. You can likely imagine that across 22 languages a little overlap in language might occur here and there — though music seems to be the most unifying form of entertainment that brings people together. Although *Alam Ara* featured only Hindi songs, people across several regions and cities and in many different languages shared and celebrated the film.

After *Alam Ara* established the standard for sound in Bollywood movies, film-makers looked to India's rich culture and plethora of artists to inspire the actual music that would be included in the movies. The directors and producers of early Bollywood found easy inspiration in the poetry and religious customs of Islamic artists from the region.

The emergence of Urdu poetry in India through ghazals

As songs in India, and by extension, Bollywood, are typically in some form of poetic structure (as opposed to open prose), it only made sense to derive inspiration for early music from poetry in the region. As some of the most famous poets from the subcontinent were of Muslim origin, their traditions and poem formats were the early inspiration for Bollywood music.

REMEMBER

A *ghazal* is a form of poetry that originated in Arabic literature. Ghazals were rooted in the longing and separation of love and its beauty, and they quickly flourished throughout neighboring countries, like Turkey, Iran, Uzbekistan, and Afghanistan. As ghazals made their way to South Asia, they were first recorded in Urdu, which would make sense because Urdu (one of those 22 languages spoken in India — and the national language of Pakistan) is written using the Arabic alphabet.

CULTURAL
WISDOM

Given that ghazals are rooted in Islam, they were typically performed in Islamic high sultanate courts where they were revered as a sophisticated literary art form. Structurally, a ghazal consists of 5 to 15 rhyming couplets and, thematically, is about spiritual love. Ghazals' content omitted mentions of sexual content. The general concept was that love is a feeling that humans ultimately need and desire, and loving more only further elevates one's rank and station in life. In earlier centuries, this level of advanced poetry was part of the educational curriculum of most countries in the East, though its removal from classrooms took place more toward the end of the 20th century.

These Urdu-based ghazals were what first inspired Bollywood music. To this day, romantic Bollywood ballads are still composed using the original ghazal structure. Madan Mohan was a music director who became famous from the 1950s through 1970s by making ghazals fit for the Indian silver screen. He worked with the most popular singers of that era, including the likes of Mohammed Rafi, Lata Mangeshkar, Asha Bhosle, Kishore Kumar, and Talat Mahmood.

Alongside Madan was the great Jagjit Singh (Figure 9-1 shows him performing at a 2011 concert in celebration of his 70th birthday). Among the masses, he's known as the Ghazal King because he revived and popularized the ghazal medium throughout the 1970s and beyond. He not only collaborated with Bollywood film-makers but was also heavily revered for his own albums. Singh has a stellar array of classics and hits, including "Tum Ko Dekha to Yeh Khayal Aaya" (When I Saw You, This Thought Came to Me), "Jhuki Jhuki Si Nazar" (Eyes Gazed Down), and "Tumne Dil ki Baat Keh Di" (You've Spoken the Heart's Language). Despite Singh's passing in 2011, his legacy remains — he spearheaded singing in such a way that focused more on the lyrics than on the accompanying music and beats. As a result, he's revered by the old and new generations alike.

FIGURE 9-1:
Ghazal King
Jagjit Singh.

Source: Getty Images

Filmi ghazal revival in the 1990s

With the simultaneous rise of newer playback singers and newly established actors, filmi ghazals saw a resurgence throughout the 1990s. The likes of Kumar Sanu, Alka Yagnik (Figure 9-2 shows Sanu and Yagnik in 2015), S. P. Balasubramanyam, and Udit Narayan helped spearhead this movement as the popularity of 1990s actors such as Shah Rukh Khan, Madhuri Dixit, and Salman Khan skyrocketed them to superstardom (refer to Chapter 5).

The collaborations between all these stars resulted in movies such as *Saajan* (Beloved), *Dilwale Dulhania Le Jayenge* (The Big-Hearted One Will Get the Bride), *Kuch Kuch Hota Hai* (Something Happens), and *Hum Aapke Hain Koun..!* (Who Am I to You?).

PROMINENT GHAZAL SONGS

Though the inspiration for ghazal music in Bollywood is centuries-old, ghazal songs continue to be a mainstay in Bollywood soundtracks even today. Here are some of the most powerfully emotional and famous ghazal songs in Bollywood's history:

- **"Pyaar Kiya To Darna Kya" (Why Should I Be Afraid to Be in Love?):** This powerful-yet-delicate ballad was one of the standout hits from the all-time classic movie *Mughal E Azam,* in 1960. With legendary actress Madhubala front and center, coupled with Lata Mangeshkar's timeless voice, you can easily see why this song is revered by so many generations.

- **"Dil Cheez Kya Hai" (colloquial, Forget My Heart):** From the 1981 movie *Umrao Jaan,* this movie is an ode to 19th century India and an onscreen interpretation of the 1905 novel *Umrao Jaan Ada* (The Story of Umrao Jaan). The movie tells the story of a Lucknow-based courtesan's rise to fame. Every song in this feature's soundtrack is considered to be a ghazal; however, this song has remained one of the most popular — to this day. Legendary actress Rekha performs this number as Umrao Jaan and is assisted vocally by the extremely popular Asha Bhosle (see Chapter 8 for more about Bhosle).

(continued)

(continued)

> • **"Tere Dar Pe Aaya Hoon" (I've Come to Your Doorstep):** This song is from the 1976 movie soundtrack of *Laila Majnu,* starring actors Rishi Kapoor and Ranjeeta Kaur. Every song from this score, composed by Madan Mohan, was considered to be a hit, especially considering that every number was sung by the iconic Mohammed Rafi and Lata Mangeshkar. The historic love story of Laila and Majnu (who were more or less the Romeo and Juliet of the East) only elevates the songs further.

Appreciating the Preachy, Powerful, and Poetic: Qawwalis

Other forms of traditional music and poetry took a more devotional route and offered some variety in early Bollywood music. This alternative genre of music is heavily inspired by Sufi Muslim mysticism and tradition, and also maintains a significant hold in today's Bollywood music scene.

Structurally speaking, Bollywood ghazals were performed with slower tempos and in a more traditional song format as the previous section discusses. Even though they were performed using Indian instruments and percussion, they matched the mood and feel of slow Western love ballads in the 1950s. Sufi poetry inspired a wholly different type of music, which was similar to the ghazal in theme but was performed quite differently: qawwalis.

Qawwali songs are structured very particularly and follow a distinct pattern. As an early form of music that experienced widespread popularity in the subcontinent and Bollywood, qawwali songs are an integral part of early Bollywood music evolution. The following sections break down how qawwali songs are composed and from where they're derived.

Looking closer at qawwali songs

Qawwali is a devout form of music that speaks about love as well as the separation from, and longing for, the Divine. A single qawwali song can last anywhere from 10 to 30 minutes. Given the content of these songs, qawwali performances were traditionally a more intimate affair, known as "Mehfil-e-Sama" (a festive gathering for Sufi music, often shortened to Mehfil).

CULTURAL WISDOM

A typical mehfil took place in the evening and lasted until dusk, and it was accompanied by other meditations and religious Sufi chants. Initially, mehfils were exclusively religious in tone, but modern-day qawwali songs started becoming more secular and at times hedonistic, often expanding into romance. Initially,

only male singers were allowed, given its conservative nature, though women were present at the mehfil. Among women who carry the tradition of qawwali forward, Abida Parveen (see Figure 9-3) is an iconic trailblazer in paving a road for future female qawwali artists.

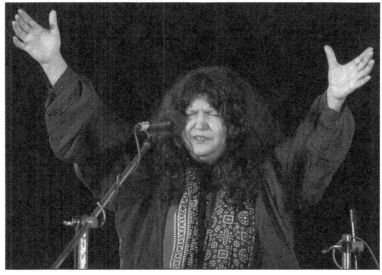

FIGURE 9-3: Abida Parveen performs.

When it comes to the musicality of the qawwali, each instrumental and vocal section is incredibly elongated. Typically, the preliminary section starts with softer instrumentals that slowly build into faster melodies, proving to be hypnotizing to listeners. Much like how a jazz musician may riff with a saxophone or trombone, the qawwali introduction provides an opportunity for each instrument player to improvise different variations of the melody. This section is followed by the *Ustad* — an honorable name given to an expert or highly skilled musician — riffing lyrics that are thematically in line with the song and putting on a grand display of their vocal range. The main song and lyrics then begin and are never improvised. Many qawwali songs are renditions of old Sufi poetry and so, out of respect, they try to stay true to them, to the best of their ability.

Vocally, qawwali songs create a sound unique from anything else. Although lyrics can be sung harmoniously and beautifully, in some sections, singers can sound louder and more guttural. Much like the music, vocals start low and slow and then end up high and fast throughout. It's not uncommon to hear a slow, powerful vocal last in one drawn-out note for several *minutes* before the rest of the song even begins. Several times throughout the song, the *Ustad* will say a line that is then repeated back by his backup vocalists. In other sections, you might see a

back-and-forth "riff-off" between the *Ustad* and his student as they try to outdo one another, much to the audience's pleasure.

CULTURAL WISDOM

A band of *qawwals* (qawwali singers) consists of about eight to ten men who are all seated cross-legged on the floor and playing various roles. The main singer, better known as the *Ustad* (master, or maestro) is typically front and center and accompanied by his harmonium (a keyboard instrument that's also a pump organ) performers on either side. The percussion "section" usually consists of one person playing a *dholak* (a two-headed hand drum) and one playing the tabla (twin hand drums of variant sizes) who are seated in the back row with the other members of the qawwals. The others who aren't playing an instrument (usually, the students of the *Ustad*) are either providing backup vocals to the *Ustad* or clapping their hands to the beat — or both.

Religious devotion from Sufi music

Just as the format of qawwali songs remains unchanged from song to song, the subject matter of most qawwali songs is very consistent as well. Nearly all of them include some form of religious devotion in verse. Bollywood's adoption of qawwali songs didn't change these aspects — no matter the placement of the qawwali song in the movie, the religious subject matter persisted.

For the most part, qawwali songs are still considered to be closer in similarity to Muslim Sufi poetry, in the sense that they stay true to singing about love, separation, and longing for the Almighty — a belief rooted in the religious origins of this musical style. Even in recent times, when modern-day qawwali songs have been more focused on romance than religion, there is still mention of Allah, often to juxtapose a character's love with the struggles and stories of notable religious figures. This sort of expression has remained a way to show just how infatuated the singer is with their lover.

Like many other mediums, qawwali songs started gaining mainstream attention in the late 20th century. Now famous artists such as Nusrat Fateh Ali Khan (Figure 9-4 pictures him with his group, Party, at a World Music Institute concert in New York in 1995), the Sabri Brothers, and Aziz Mian have gained international fame, thanks in part to Peter Gabriel and his Real World record label. Qawwali songs were performed in intimate gatherings among fewer people, but as their popularity grew substantially, qawwali performers started selling out stadium-size venues. Qawwali songs gained listenership even outside South Asia, including the United States. People throughout the world were entranced by the hypnotic melodies and yearned for more. If you ever happen to attend a qawwali concert now, you may be surprised to see the diversity of the crowd in attendance.

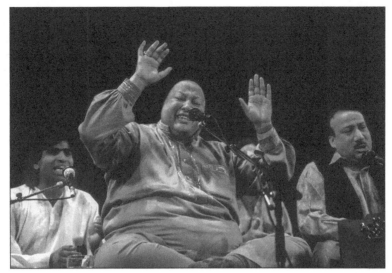

FIGURE 9-4:
Pakistani
qawwal Nusrat
Fateh Ali Khan
with his group,
Party.

Influencing Bollywood: The subgenre of filmi qawwali

With the universal rise of qawwali songs, music directors started incorporating them in motion pictures more regularly. They'd be shortened for the sake of the film and would revolve around the movie's plot and characters while still incorporating Sufi undertones. The wardrobe and sets for Bollywood qawwali would be much more glamorous with brighter colors and tones, and gaudy in comparison to the more modest and simple outfits worn typically at a mehfil.

Bollywood qawwali songs, better known as *filmi qawwali* songs, were more common throughout the golden and classic eras of the industry (1950s–1980s). One of the more popular songs came, in 1977, from the movie *Amar Akbar Anthony* (which we explore more fully in Chapter 19), called "Pardah hai Pardah" (There's a Veil). In it, actor Rishi Kapoor's character, Akbar, tries to persuade his love interest in the crowd to remove her burqa (a traditional Muslim veil that covers a woman's face) so that she can illuminate the mehfil with her beauty.

A few movies that incorporated qawwali songs were talking solely about God and are still applicable to the film's story line. For example, the qawwali "Piya Haji Ali" from the movie *Fiza*, talks about the 14th century Sufi saint Pir Haji Ali Shah Bukhari, better known as Baba Haji Ali. Ali was an Uzbeki man who came from a wealthy merchant family and spread the message of Islam when he migrated to India. Highly knowledgeable, he was known to have performed many miracles and acts of faith. In one particular act of faith, he decided to give away all his

belongings and wealth as he set out to sea with the intent to perform Hajj (an Islamic pilgrimage to Mecca). He grew ill and passed away on his journey there, and as a result, in Mumbai he has been immortalized with a shrine in his honor on an islet off the coast of Bombay. The song praises his actions and paints him as a holy servant of God who is worthy of adoration. As the qawwali singers are performing this song for the film, actress Jaya Bachchan's character, Nishatbi, sits as an emotional spectator as she resonates with the lyrics about pure intentions and desire, and is reminded of her beloved son, who recently went missing.

In *Bajrangi Bhaijaan* (Brother Bajrangi), you see a modernized rendition of the 1972 Sabri Brothers' classic, "Bhar do Jholi Meri, Ya Muhammad" (Fulfill My Needs, Oh Prophet Muhammad). Reprised by singer Adnan Sami, the song is a supplication to Islam's Holy Prophet, where the singer begs for Muhammad's intercession to Allah in the hope of ultimate salvation. Keep that much in mind when you consider that the plot of the movie is about an Indian man, nicknamed Bajrangi, who tries to escort a mute Pakistani girl named Munni back to her family and their home in Pakistan (you can read more about Pakistan's presence in Bollywood in Chapter 16).

Bajrangi is also a name derived from a nickname for a Hindi God, Lord Hanuman.

Given the unfortunate tensions between the two countries, government reps are tracking down Bajrangi because they think he's an Indian spy. At one point during this exhausting journey, Bajrangi and Munni break to listen to this qawwali alongside other onlookers. Though he is Hindu, Bajrangi can't help but be moved to tears as he relates to the Islamic song lyrics, hoping to find salvation for both himself and Munni.

Nowadays, anytime a qawwali is incorporated in a movie, it's typically one of the more popular songs on that film's soundtrack. Because it's a more traditional art form, it naturally appeals heavily to older viewership, but also to younger viewers, by way of performances by modern-day artists. A qawwali is a fantastic way to pay homage to the yesteryears of art and entertainment while further bridging the gap between old and new.

Going techno

A fusion with Western instruments and influences started showing up toward the 21st century. Later known as *techno-qawwali*, this niche brand of qawwali music was more dance-oriented, and as a result became hugely popular with the newer generation of moviegoers. One of the more famous techno-qawwali numbers is "Kajra Re" (Dark Kohl) from the movie *Bunty aur Babli* (Bunty and Babli). This trend continued, with many independent DJs remixing qawwali classics such as "Mast Qalandar" (Jubilant Saint) and "Mere Rashke Qamar" (Oh My Beloved).

FIVE FAMOUS USTADS

Qawwali singers have made their mark on not only Bollywood, but the entire world. As the genre has evolved and grown over time, the Ustads that showcase the art of the qawwali remain the most important reason why. Here are some of the most renowned qawwali Ustads and how they have contributed to the genre, Bollywood, and music at large:

- **Nusrat Fateh Ali Khan:** The most famous qawwali singer of all time, Nusrat Fateh Ali Khan, is responsible for the meteoric rise of qawwali music worldwide in the '80s and '90s. Dubbed Shahenshah-e-Qawwali (King of Kings of Qawwali), he came from a Pakistani Punjabi family who had a heavy qawwali tradition, and he was soon anointed the head Ustad of his family, following the death in 1971 of his uncle and his family's original Ustad, Mubarak Ali Khan. Known for his hits such as "Dam Mast Qalandar" (a song honoring the Sufi saint Lal Shahbaz Qalandar) and "Mere Rashke Qamar" (Envy of the Moon), he'd sell out stadiums worldwide and compose music for industries across Pakistan, Japan, Europe, the United States, and of course, India.

 After Nusrat did work for Bollywood, he scored hits such as "Tere bin Nahin Lagda" (I'm Restless without You) and "Koi Jane Koi na Jane" (Some Know and Some Don't) for the movie *Aur Pyar Ho Gaya* (And Love Happened). On several occasions, however, Nusrat's songs were plagiarized by Bollywood directors — the most famous was, notably, "Tu Cheez Badi Hai Mast" (colloquial, You are an Awesome Thing), from the movie *Mohra* (Pawn), which was derived from Khan's song "Dam Mast Qalandar." Unfortunately, Nusrat passed away from a sudden cardiac arrest at only 48 years old. His legacy inspired many musicians, such as A. R. Rahman, Nadia Ali, Zayn Malik, Eddie Vedder, Dave Navarro, and Peter Gabriel. Given that he was a musical juggernaut, he was admired by many of his contemporaries, including Mick Jagger, Amitabh Bachchan, Susan Sarandon, Sean Penn, and Tim Robbins.

- **Sabri Brothers:** The duo consisting of Maqbool Ahmed Sabri and his older brother Ghulam Farid Sabri was trained by their father, Inayat Hussain Sabri. Their first recording of "Mera Koi Nahi Hai Tere Siwa" (There Is No One for Me but You) was released in 1958, and they gained prominence throughout the 1970s. They were the first qawwals to gain recognition in the Western world, by performing at New York's Carnegie Hall in 1975. The pair seems to have an endless number of hits, including "Tajdar E Haram" (King of the House of God), "Bhar Do Jholi Meri" (Fulfill My Needs, Muhammad), and "Khwaja ki Deewani" (Lover of Khawaja). Their music has been reprised multiple times by modern-day singers, including Atif Aslam and Adnan Sami. The Sabri family continued the qawwali tradition, most recently with Ghulam's son, Amjad Fareed Sabri until his passing in 2016.

(continued)

(continued)

- **Abdul Aziz Mian:** Born in Uttar Pradesh, India, and later residing in Pakistan, Abdul Aziz Mian is also considered to be one of the great qawwals of all time. After learning to play the harmonium at the age of 10, he later trained musically at Data Ganj Baksh School of Lahore and was a student of the great Ustad Abdul Wahid Khan. Mian was most renowned for his unconventional raspy voice, and he was often compared to another qawwali legend, the Sabri Brothers. The songs that Mian is best known for are "Nabi Ya Nabi Nabi" [Prophet (Muhammad), Oh Prophet (Muhammad)], and "Main Sharaabi" (I'm a Drunkard). He passed in December 2000 at 58 years of age, but his legacy is carried on by his eight qawwal sons.

- **Abida Parveen:** Known as the queen of Sufi music, Abida Parveen is an anomaly, considering that her medium is a male-dominated one. Also hailing from Pakistan, she is a singer, teacher, and painter who also plays the harmonium and sitar. She gained tutelage from her father, Ustad Ghulam Haider, and became the musical heir over her two brothers. Parveen gained popularity throughout the 1980s and '90s and still continues to make new music. She regularly makes appearances on Pakistan's smash hit television show *Coke Studio,* collaborating with other musicians.

- **Rahat Fateh Ali Khan:** You should know that the tradition of qawwali is alive and well today. Rahat Fateh Ali Khan is famously known to be the nephew of the great Nusrat Fateh Ali Khan. His father, Farrukh Fateh Ali Khan, regularly sang alongside Nusrat Fateh Ali Khan and his troupe of qawwals. Khan, revered by many for his timeless voice, has paid great homage to his late uncle, with reprised versions of his classics. His most famous rendition came from the *Coke Studio* (see Chapter 16) hit "Afreen Afreen" (Beautiful, Beautiful). Rahat himself has made a name for himself by singing many Bollywood hits, such as "Teri Meri" (Yours and Mine), from the movie *Bodyguard,* "O re Piya" (Oh, My Beloved), from the movie *Aaja Nachle* (Come Let's Dance), and "Bol Na Halke Halke" (Speak Softly), from the movie *Jhoom Barabar Jhoom* (colloquial, Dance Your Heart Out).

Chapter **10**

Mixing It Up with Other Musical Genres: Pop, Rock, and Rap

different music movement was rumbling within the youth of India as the 20th century came to a close. Bollywood's musical influences range far and wide, but musical styles from the West almost inevitably find their way into the Indian mainstream, often through the Bollywood medium. Such has been the case for genres such as rock, pop, and rap music.

Of course, these different genres have rarely been adopted as is. Bollywood has a knack for taking various styles and adapting them for the Indian movie-going public. Such is also the case for these three genres, which we discuss in this chapter.

Discovering Rock Music's Influence in Bollywood

As rock bands such as The Beatles and Led Zeppelin took the Western world by storm, Indian musicians began to take note. The 1950s and 1960s saw a thriving record industry in India, with a noted prevalence of not only indigenous Indian

music but also music from famous Western musicians. As more and more people heard the sounds of rock and roll, Bollywood began to take note as well.

Bhaskar Menon, an Indian record executive who worked for the British-based record label EMI, handled operations in Indian and ensured that Western artists received playtime in India. He also kept an eye out for local talents, which lead to the emergence of Mumbai-based (then Bombay) the Mystiks and Chennai-based (then Madras) Beat-X. These bands were heavily influenced by Western rock and roll while singing in their respective dialects and touching upon issues that were relatable to their fellow Indians.

The emergence of amateur rock bands across India eventually became so popular that Bollywood executives soon began implementing these influences into their film's musical scores. The next section dives deeper on how that came to be.

Bollywood loves rock and roll

Many communities throughout India saw an emergence of amateur bands who took inspiration from of the Mystiks and Beat-X. Given that are more than 1,500 languages spoken in India, you can only imagine how many different bands across India brought forth rock music to the masses. Eventually, Bollywood caught on to this trend and began adopting many of the same sounds in its films:

>> **1960s:** Rock and roll made its first appearance in Bollywood films. As the stars began adopting fashion reminiscent of Western rock stars, the songs took on decidedly more rock and roll notes. Songs like "Jaan Pehechan Ho" (Let's Know Each Other) and "Dum Maro Dum" (Take a Puff) introduced Bollywood audiences to a more metal and electric sound.

>> **1970s:** Even more rock-inspired compositions from Bollywood musicians, with songs like "O Saathi Re" (Oh My Beloved) and "Aye Naujawan Hai Sab Kuchh Yahan" (Everything Is Lively Here) topped the nation's music charts.

Although underground rock musicians continued to grow the Hindi rock scene, Bollywood ventured into the psychedelic rock and disco genres more and more in the late 1970s and 1980s. Much like rock and roll, disco influences came abroad from the West. (We discuss disco and psychedelic rock in Chapter 8).

Getting psycho with Raga Rock

Raga is the term used to describe the melodic structure of classical Indian music, and so the term *Raga Rock* was fittingly coined as the influence of Western rock continued to blend within Indian subcultures. The use of Indian instruments,

mainly the *tabla* (dual hand drums) and *sitar* (stringed instrument), helped popularize this new subgenre of music. The likes of popular Bengali sitar player, Ravi Shankar, helped Raga Rock gain international attention.

Raga Rock came back to the West and was incorporated by several American Rock bands. Here are a few songs that caught on to the popular trend.

>> "Eight Miles High" — The Byrds

>> "Paint It Black" — The Rolling Stones

>> "Bus Stop" — The Hollies

>> "Within You Without You" — The Beatles

>> "Love You To" — The Beatles

The acculturation of American rock and Indian instrumentals was a wonderful phenomenon during this era as Western audiences were introduced to Indian influences for the first time. As the likes of Ravi Shankar and other notable Indian musicians gained international acclaim, rock was continuing to evolve within India.

Evolution of Hindi rock

In recent years, rock music has made a resurgence in Bollywood films. Movies like *Rockstar* and *Ae Dil Hai Mushkil* (The Heart Is Difficult) not only focus on rock and roll artists but also include a number of rock and roll songs in their soundtracks. Tracks like "Nadaan Parinde" (Innocent Bird) from *Rockstar* and "Bulleya" from *Ae Dil Hai Mushkil* lean heavily into the rock and roll sound and were hits at the time of their release. Other movies use the angst and pain of rock music to convey emotions in films. Tracks like "Bekhayali" (Without Thinking) from *Kabir Singh* and "Bhula Dena" (Forget Me) from *Aashiqui 2* are heartfelt ballads belted to rock music, delivering the hurt of the movies' characters to the audience.

REMEMBER

Bollywood loves to borrow from other industries. The influence of the Pakistani rock scene especially has become more apparent in recent years. We talk more specifically about Pakistan's own entertainment industry and influences to Bollywood in Chapter 16.

As Pakistani rock bands such as Junoon, a Sufi rock band, and Strings, a hard rock band, gained international recognition, Bollywood composers remade some of their biggest hits for films. Strings even co-wrote and produced the title song "Zinda" (Alive) from the Bollywood movie with the same name. Hits from Junoon (refer to Figure 10-1 to see Junoon performing at the MTV–Indian music awards in Bombay in December 2003) such as "Garaj Baras" (Thunder and Rain) and "Sayonee" (Soulmate) have also been remade for Bollywood movies.

PROMINENT ROCK SONGS IN BOLLYWOOD

As pop music and other music genres continue to evolve in Bollywood, rock has found its place and is here to stay. Here is our list of Bollywood rock songs through the ages, for you to become better acquainted with this category:

"O Saathi Re" (Oh, My Beloved): Sung in Kishore Kumar's inimitable voice, this 1978 song is a heartfelt ballad highlighting the power of love. Portrayed by Amitabh Bachchan on-screen (you can read about his legacy in Chapter 4), this song became the love ballad for an entire generation of lovers and continues to be a popular song even now.

"O Meri Jaan" (Oh, My Love): This song was featured in the popular 2007 film *Life in a Metro*, whose soundtrack consists almost entirely of rock songs. Perhaps the most memorable of the songs from the movie, this song is another heartfelt love ballad featuring vocals from Bollywood playback singer KK. Featuring soaring vocals and heavy-hitting drums, this song with its accompanying soundtrack is regarded by many as one of the quintessential rock albums to emerge from Bollywood.

"Saadda Haq" (Our Right): Composed by legendary Indian musician A. R. Rahman, this track became the anthem for Indian youth upon its release in 2011. Coincidentally, it's also a youth anthem in the film in which it appears, *Rockstar*. Sung onscreen by actor Ranbir Kapoor (you can read about him in Chapter 6), the song speaks to the troubled and struggling youth of India with decidedly rock musical themes: hard drums, electric guitar solos, and a raspy chorus.

REMEMBER

Although each country has its own entertainment industries, Pakistani music is often a place for discovering music for Bollywood films. Refer to Chapter 3 for more on how Pakistan was formerly a part of India before Partition.

Indian Music Pops Off

Though Bollywood dominated the music scene in India for many decades, the introduction of channels via television and the Internet in the 1990s helped proliferate and advance the careers of several pop artists. Even though these artists often enjoyed short-term success, their mark on Bollywood and the Indian music scene is undeniable. Eventually, the pop genre that created a wave in India came to be known as *Indipop*, a term still used today to describe this genre.

CULTURAL WISDOM

Bollywood's music scene differs from most other music industries in the way it presents artists and songs (flip to Chapter 7). Indian listeners stay faithful to individual songs more so than any single artist. Often, that means an artist develops a sound or becomes known for a particular type of track (like a sad love ballad) and is called on to sing in only that genre. That's what made it difficult for pop singers in India in the 1990s and beyond to find continued success — they often had one or two hit songs before moving on to Bollywood in order to make more money and gain fame. However, a move to Bollywood meant that their songs often became more famous than they themselves did as the singer.

SUBCONTINENT'S POP BEGINS IN PAKISTAN

Pop music in the subcontinent actually started in India's neighboring country, Pakistan, after the countries split in 1947. The first truly pop hit was Ahmed Rushdi's 1966 classic "Ko Ko Korina." The song inspired a new generation of jazzy, upbeat music across the subcontinent, though it wasn't until the 1980s that two pop artists gained a true foothold. With Biddu Appaiah behind production, that artist was Nazia and Zohaib Hassan, a sibling duo with an addictive pop sound that would sell millions of records (check out Chapter 8 for more about Biddu Appaiah and the Hassans).

Still, the Hassan siblings, though pioneers of the music scene in India, were Pakistani singers. In India proper, the music industry continued to be dominated by Bollywood. Filmi songs were the ones receiving the most airtime and playtime, because the consumption of media was dominated by the movie theater scene in the 1980s and early 1990s. It wasn't until the late 1990s that a few music-devoted television channels would create a wave of pop music that would take the country by storm.

Pop music is definitely in Bollywood to stay. The advent of new mediums such as YouTube and SoundCloud have increased the number of independent musical artists showcasing their work publicly in India. That increased exposure allows these artists to gain popularity quickly, and the most popular ones almost inevitably graduate to the big screen at some point. As the world becomes more and more connected, Bollywood has begun incorporating any and every musical style that's popular around the world.

This section explores incredible pop talent dispersed throughout India that ultimately influenced Bollywood to start creating pop songs and even work with many of these artists.

Recognizing famous Indi-pop singers

India began discovering other artists alongside their Indipop sound. Another find of Biddu Appaiah was the super popular Alisha Chinai who found commercial acclaim with her hit "Made In India." Her success ultimately lead to the discovery of more pop sensations in India. The rise of pop duo Colonial Cousins featured a fusion sound of old-school Indian musical techniques and more modern, upbeat pop tracks. Their eponymous album, released in 1996, broke many album records and sold millions of copies in India. The duo consisted of singer Hariharan and singer-composer Lesle Lewis, both of whom went on to have illustrious solo careers. Hariharan in particular became a household Bollywood name, often collaborating with renowned composer A. R. Rahman.

Bhangra was another musical genre that couldn't escape the pop revolution. One of the most recognizable stars to emerge from India, Daler Mehndi, an Indian recording artist, producer, and more, (see him in Figure 10-2) combined Bhangra music with fun, poppy notes to create a brand-new style of music that was catchy and addictive.

He quickly became one of the most popular artists of not just the Indipop era — but of all time. Even today, Bhangra's music and classic songs, such as "Tunak Tunak Tun" (referring to the sound made by the tumbi instrument), remain wildly popular and are remixed often around the world. Here are a few other songs from Mehndi that were specifically for Bollywood movies. "Na Na Na Na Na Re" from the film *Mrityudatta* (Angel of Death) and "Kudiyan Shaher Diyan" (Oh My, These City Girls).

>> "Na Na Na Na Na Re" from *Mrityudatta* (Angel of Death)

>> "Kudiyan Shaher Diyan" (These City Girls) from *Arjun Pandit*

>> "Nach Baby Nach Kudi" (This Baby Girl Will Dance) from *Khauff* (Awe)

>> "Rang De Basanti" from *Rang De Basanti* (Paint It Yellow)

FIGURE 10-2:
Daler Mehndi
performing
in 2008.

Dinodia Photos/Alamy Stock Photo

Other pop singers stuck to a more conventional pop sound. Maqsood Mahmood Ali (or, as he is commonly referred to, Lucky Ali) was one such singer in the 1990s. His debut album, *Sunoh* (Listen), won several awards in the late 1990s and launched his popularity quickly. Known for his soft voice that was never formally trained and powerful lyrics, Lucky Ali became a major figure during the Indipop era. He went on to be featured as a playback singer in a number of Bollywood films, with songs like "Ek Pal Ka Jeena" (One Second of Life) going down as some of the most iconic and famous in Bollywood history.

Still other pop stars were finding ways to emerge into the limelight. Shantanu Mukherjee, popularly referred to as Shaan, exploded onto the Indian pop scene by remixing old classics by Biddu Appaiah and R. D. Burman (to read more about these composers, check out Chapter 8). Gaining fame for his remixes of familiar sounds, Shaan became a popular playback singer in Bollywood as well, lending his voice to many of the top actors of the 2000s with the following songs:

- » "Chand Sifarish" (If the Moon Spoke For Me) from *Fanaa* (Destroyed)

- » "Kuch To Hua Hai" (Something Has Happened) from *Kal Ho Naa Ho* (Tomorrow May Never Come)

- » "Rock N Roll Soniye" (Rock N Roll My Beloved) from *Kabhi Alvida Naa Kehna* (Never Say Goodbye)

MTV INDIA INSPIRES INDIPOP

By 1996, one channel was turning the music industry on its head. By dedicating almost all its airtime to showcasing artists and their music videos, MTV was gaining a loyal following internationally. In 1996, MTV turned its eye on India and launched MTV India in the same year (see the pop band Junoon performing at MTV India in Figure 10-1). Almost overnight, pop music was reborn in India, as viewers saw videos from artists who would never make it to the Bollywood screen. Other, similar channels, such as Channel V India, also helped to popularize Indian pop music, or Indipop. Alisha Chinai, another Biddu Appaiah find, became a pop star who fans called "India's Madonna." India finally had its own homegrown pop star, and others would surely follow in her footsteps.

As the popularity of Chinai (see the following figure of her performing during the 2007 Bollywood Music and Fashion Awards in Atlantic City, New Jersey) surged after her mega hit "Made in India," music lovers in India began to discover other artists who had achieved a lesser degree of stardom to date. Almost single-handedly, MTV introduced a genre to the Indian mainstream audience, showcasing talent that had gone underappreciated in the early part of the 1990s.

REUTERS/Alamy Stock Photo

MTV India continues to be a popular television channel in India, though its programming has changed drastically since its inception. Similar to the MTV channel in the United States, far more programming now revolves around reality television than music. However, MTV India still notably produces some of the most recognizable talent in India; many video jockeys, or VJs, from MTV India have gone on to become famous Bollywood actors and actresses. Among this list are popular actors Amrita Arora, Ayushmann Khurrana, and Rhea Chakraborty.

The beauty of pop is that it can incorporate nearly every genre under the sun. Indipop is no different; as if we haven't covered enough types of singers in this genre already, here's one more: folk music. Falguni Pathak mastered the fusion of traditional folk music, often from religious ceremonies, into popular, upbeat songs. Especially famous within the Gujarati community in India, Pathak's songs remain extremely popular today and are used during celebratory occasions. She also leveraged her popularity for a stint in Bollywood, appearing as a playback singer in several movies.

We fully explore all things folk music in and out of Bollywood in Chapter 11. See that chapter to understand folk beyond music in India, including its own dance forms and online fandom.

Although Indipop was a genre outside Bollywood initially, the singers who popularized the genre eventually found a way into Bollywood, often as playback singers. The impact of Indipop on the landscape of Bollywood is undeniable; aside from singers lending their voices to Bollywood actors, the sound of Indipop influenced Bollywood soundtracks for decades, and continue today.

Keeping pop popular in Bollywood

As the stars of the 1990s paved the way for new talent, Bollywood began to integrate pop music into its soundtracks more and more often. Solidifying the wide popularity of the genre, many of today's Indian pop stars, including Sonu Nigam and Adnan Sami, find themselves with featured songs in Bollywood movies.

Sonu Nigam

Perhaps no pop star has broken the barrier between independent artistry and Bollywood crossover more so than Sonu Nigam. A talented vocalist, Nigam began performing covers of classic Bollywood songs at a very young age. Over the course of the 2000s to today, Nigam has released five studio albums while also recording countless independent solo tracks and hundreds of Bollywood film songs.

He gained a reputation as one of the greatest Indian singers of all time, and inspired a new wave of artists as he proved that singers can have solo careers while also lending their talents and voices to the Bollywood screen.

Another reason Nigam (you can see him in Figure 10-3 performing in Hamburg in 2007) inspired such a wide variety of artists in India was his ability to release music in a multitude of languages. Having recorded in more than 10 languages, Nigam inspired a generation of musicians from all over India and was able to reach a much wider fan base than many of the artists before him. As such, Bollywood was also introduced to a new wave of artists who didn't always perform in Hindi, and the industry was diversified as a result. Nigam's impact on the industry cannot be overstated — aside from being one of the most popular and sought-after playback singers in Bollywood history, his versatility inspired a new generation of artists who continue today to influence the Bollywood landscape.

FIGURE 10-3:
Sonu Nigam.

Panther Media GmbH/Alamy Stock Photo

CULTURAL WISDOM

One particular trend in Bollywood that even Nigam has participated in is remixing old school tracks with an updated, more dance-centric beat. This trend has produced some of the biggest hits of the past decade, as a new wave of audiences unfamiliar with classic Bollywood has been able to reconnect with these remixes. Sometimes, artists even remix their own songs! For example, music legend A. R. Rahman produced the pop number "Humma Humma" for the 1995 film *Bombay*, and remixed it for a modern audience in the 2017 blockbuster *OK Jaanu* (OK, Darling), aptly naming the new version "The Humma Song."

Adnan Sami

Of course, plenty of pop artists have produced original music and gained popularity since the initial Indipop wave. Notably, Adnan Sami became a pop sensation during the early 2000s, even recording an album with music legend Asha Bhosle. His original songs gained a huge following in not only India but also neighboring Pakistan, and he would eventually follow the path of many before him by singing playback in Bollywood. His popularity would remain high throughout the 2000s, and has continued to be a popular playback singer for Bollywood films in recent years.

Punjabi gets popping

Another genre that has found a home in modern Bollywood is that of Punjabi pop music. Artists like Guru Randhawa, Yo Yo Honey Singh, and Baadshah continue to produce hits in the modern era. Often, Bollywood music directors have taken to bringing these artists and their popular hits into their movies, and incorporating the very same songs with a slightly different melody. For example, Guru Randhawa's extremely popular 2017 solo hit "High-Rated Gabru" (High-Rated Guy) was adopted the following year in the movie *Nawabzaade* (Prince's Son).

Though the music was changed slightly, the song was nearly identical to the hit from the previous year. This method of incorporation is common for many pop artists in the modern era. As their solo songs and videos gain views and followings, Bollywood continues to bring them to the Indian big screen. To read more about Punjabi music and dance styles, turn to Chapter 11.

Busting a Rhyme: Bollywood and Rap

One musical genre that simply seemed to elude Bollywood was rap. The genre for the most part wasn't taken seriously and was scarcely used for comedic purposes with such songs like "Love Rap" from the film *Krantiveer* (Brave Revolutionary). The following section examines the journey rap music has made in Bollywood, from being featured more regularly in Bollywood soundtracks throughout the 2000s to its meteoric underground rise culminating in a film circling around the genre itself.

RAP MAKES ITS FIRST APPEARANCE IN INDIA: BABA SEHGAL

While many artists were fusing classical Indian music and pop during the 1990s, other singers were taking a decidedly more Western approach and finding success. Baba Sehgal, an Indian rapper, started to make waves in the early 1990s. Often regarded as India's first rap star, Sehgal was one of the biggest stars of the 1990s Indipop wave, garnering plenty of airtime on MTV India. His catchy lyrics and eccentric style endeared him to audiences across the country, and he single-handedly brought a new genre to the Indian music landscape.

Sehgal used his fame as a pop singer to make his mark on the Bollywood landscape as well, serving as a music director on films like *Bhoot Uncle* (Ghost Uncle) and *Nalaik* (Naughty) and as an actor in a few films, including his debut film, *Miss 420.* Thus, rap had finally found its way to Bollywood. A colorful character, Sehgal continues to appear on television and game shows.

Sehgal's success led to other Indian rappers trying their hand at the music industry as well. New artists such as Panjabi MC began to fuse rap with other cultural music. Panjabi MC fused bhangra music from his Punjabi roots (which you can learn more about in Chapter 11) along with hip-hop, and exploded onto the international scene in 1997 with his worldwide hit "Mundian To Bach Ke" (Beware of the Boys). The sound of hip-hop and bhangra mixing became popular in India and abroad, and Bollywood again took note. A new generation of artists would soon emerge and take this genre to new heights, and eventually become a mainstay on the Bollywood scene.

Rap: Appearing in Bollywood movies

Aside from Baba Sehgal (see the nearby sidebar), other artists also began to appear in Bollywood movies, starting in 2011. Many Punjabi artists began to gain popularity and be featured in Bollywood films. Many of these artists also included rap samplings in their songs, and derived their melodies from hip–hop–style electronic beats.

>> **Yo Yo Honey Singh:** This particular pioneer of this brand of music, originally a Hindi and Punjabi rapper and musician, began to make songs for Bollywood in the early 2010s and earned fame with his hit "Angreji Beat" (English Beat) in the film *Cocktail.* The success of the song led to further features in Bollywood films, and Yo Yo Honey Singh quickly became a household name in the Bollywood music scene.

>> **Badshah:** A former member of Singh's rap group, Badshah is one such artist. He quickly made a name for himself by working on several Bollywood soundtracks for films such as *Humpty Sharma* (Humpty Sharma's Bride) and *Khoobsurat* (Beautiful), but he truly outdid himself when his hit "DJ Waley Babu" (DJ Boss Man) released in 2015, becoming one of the most sought after Indian rappers. Badshah has since worked in tons of Bollywood movie songs and is usually given a featured track, many of which become extremely popular. His song "Tareefan" even earned him a Best Playback Singer nomination at the Filmfare Awards in 2018 (refer to Chapter 15).

Besides the mainstream artists showcasing their rap abilities to Bollywood viewers, the popularity of rap music in India led to a wave of underground artists all over the country as well. Similar to the rap world of the United States, some of these rap artists garnered a more modest local following, while others exploded onto the national stage and gained a loyal following both in India and abroad. Some of these rappers garnered enough recognition to prompt a Bollywood movie based on their lives, the first-ever Bollywood movie using rap music as the subject of its plot.

Making its debut: Bollywood's first rap film

In the late 2010s, rap artists such as Divine and Naezy emerged from Bombay's underground hip-hop scene, eventually gaining enough popularity to have their tracks featured in Bollywood movies as well. Naezy's hit song "Birju" appeared in the 2015 movie *Hey Bro,* with the video for the song featuring household Bollywood actors, including Amitabh Bachchan, Govinda, Hrithik Roshan, Akshay Kumar, and Ranveer Singh. Anytime a music video can feature that kind of combined talent, the film industry at large takes notice. And Bollywood did just that, rocketing Naezy to fame in 2019 with a biopic of his own.

Then in 2019, the film *Gully Boy,* directed by Zoya Akhtar and executive-produced by American rapper Nas, took the Bollywood industry by storm. Based on the real-life journeys of Divine and Naezy, the movie brought to the forefront the underground rap scene in Bombay. Starring superstar actor Ranveer Singh (you can read about his emergence in Chapter 6) as a fictionalized version of Naezy, the movie not only proved to be one of the most commercially successful movies of 2019 but also won a record 13 Filmfare Awards. Suddenly rap, a musical genre that had been ignored in India for decades, was being celebrated and given a new spotlight. Divine and Naezy contributed to the soundtrack for the movie, and their song "Mere Gully Mein" (On My Street) became a huge hit.

The success of *Gully Boy* holds special cultural significance because it opens the doors for new rap artists to be showcased in movies. As the rap music scene in India emerges from its underground roots, it looks to incorporate into the Bollywood mainstream and entertain generations to come.

Chapter **11**

Noticing Folk Music In and Out of Bollywood

The rich culture of the Punjabi people shines through in various forms in Bollywood film and music. This chapter explores the history of this region, the music that is passed from generation to generation, and its profound effect on Bollywood and the international diaspora.

The Punjab region was split during the 1947 Partition between India and Pakistan, and the northern region of Punjab still remains the cultural center of India. Throughout history, the Punjab region has been the target of many invasions, because of both its fertile soil and its role as the gateway to the Indian subcontinent. This rich and storied history lends itself to many tales of bravery, honor, and love. Chapter 3 discusses Partition in greater detail.

CULTURAL WISDOM

The Punjab region has a rich variety of languages, religions, and cultures, and art and music are no different. Punjabi folk music is perhaps the most recognized and celebrated folk music from the subcontinent, and its reach has spread across international borders. Though the music has evolved over time, the sound and traditions of Punjabi music remain extremely recognizable.

Recognizing the Traditions of the Punjab Region

Punjabi folk music, which has been a tradition passed down through generations, is any music that originates from the Punjab regions of Pakistan and India. Using a diverse set of styles with traditional Punjabi instruments, it's used in a variety of life milestones to celebrate, grieve, and remember. During Punjabi births, weddings, deaths, and other momentous life events, Punjabi folk music often commemorates the event. Even festivals, fairs, and religious ceremonies are often alive with the sound of folk music.

CULTURAL
WISDOM

Punjab refers to the geographic region, split across India and Pakistan. The people of the region are *Punjabis,* and their primary language is *Punjabi.* As such, the music is referred to as either music of Punjab or Punjabi music. The main religions of the Indian Punjab region are Sikhism and Hinduism. The main religion of the Pakistani Punjab region is Islam.

As Punjabi music continues to evolve, the region's history and lore are preserved through this folk music. Each region of Punjab boasts its own variety of folk music and songs, but they're all unmistakably connected by their common heritage and use of instruments native to the Punjab state. The melodies of the songs are also often preserved, as new musicians continue to honor previously composed songs, simply adding their own twist and lyrics to the melodies.

To completely understand how this music has profoundly affected Bollywood, you first need a basic understanding of the music. These sections delve deeper into where Punjabi folk music came from and the instruments the musicians commonly use.

Identifying the roots of Punjabi folk music

The influence of the Punjabi folk poems and songs that inspire Bollywood movies and songs can't be understated; the Punjabi tradition has permeated Bollywood film culture at every level.

CULTURAL
WISDOM

The music of Punjab has become a cultural symbol for the region. In fact, the music, songs, and artists of the region are more closely associated with their home state than is any other demographic.

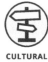

REMEMBER

Punjabi folk music can best be split into three distinct themes:

>> **Love:** Within the love-themed Punjabi folk songs are the region's famous romance stories. In particular, the love stories of Heer-Ranjha (names of the lovers), Sohni-Mahiwal, and Mirza-Sahiban appear across various areas of

Indian culture, including Bollywood. For example, Heer-Ranjha has been made into a movie more than ten times, with famous actors like Anil Kapoor and Sridevi reprising the title roles (refer to Chapter 4). The tragic tale also inspires popular Bollywood music, such as the song "Heer," from the Shah Rukh Khan blockbuster *Jab Tak Hai Jaan* (As Long As I Live).

>> **Heroism:** Punjab has a rich history of heroes who stood up to higher powers like the Mughal and British Empires. The inspirational tales about the likes of Dulla Bhatti, Jagga Jatt, Udham Singh, and Bhagat Singh are embedded within Punjabi music, and also became adapted as Bollywood feature films — with the most notable one being *The Legend of Bhagat Singh.*

>> **Religion:** Religion and spirituality are highly revered within Punjab. Although each of Punjab's religions (Sikhism, Islam, and Hinduism) have their own practices and teachings, they also have their own influences on the music. Sikh singers use the two instruments known as the *dhad* and *sarangi* whilst singing hymns from the *gurbani* (book consisting of hymns written by Sikh scholars). Muslim Punjabis would sing in the style of qawwalis and nasheeds, while Hindu's stylized their songs in the form of Bhajans. For more on qawwalis and nasheeds, check out Chapter 9.

The songs within each genre become even more specific and directly embody the lifestyles and struggles of Punjabi people. The songs therefore often deal with more hard-hitting topics such as the Indian caste system, colorism, religious differences, and even substance abuse in the region.

CULTURAL WISDOM

Because the songs are sung during important festivals throughout the year, the songs, festivals, and Punjabi culture have become synonymous. For example, during the change-of-season festivals Lohri and Maghi, men commonly dance *bhangra* and women dance *giddha* — both traditional Punjabi folk songs and dances. You can read more about them in the section, "Getting Down: Dance Traditions of Punjab," later in this chapter. The new-year festival Vaisakhi, which is also closely related to the Punjab region is especially celebrated by Sikhs from the region.

Identifying the unique instruments

Traditional Punjabi music relies on similarly traditional instruments, many of which influence Punjabi music in Bollywood films. Although more than 80 unique instruments are identified as part of the Punjabi folk music tradition, some of these instruments have fallen out of popularity and use as music evolved, and musicians chose not to learn to play the older instruments. Violence within the Punjab region during the late 1980s also led to a crucial loss of knowledge, as festivals and concerts were deemed too dangerous for a time because of political tensions.

Some instruments are extremely important to, and popular for, the continuation of Punjabi folk music traditions. They're used for various celebrations that keep the tradition alive and encourage people to learn and master these instruments:

>> **Dhol/dholak:** A *dhol* is essentially a double-sided drum made of mango wood that is played with two curved sticks. A *dholak* is simply a smaller version of the dhol that can be played with bare hands; it's used predominantly by women in small religious and wedding gatherings. Dhols, which are prominent in bhangra music and on festive occasions, are slung across the musician's shoulders or neck. Figure 11-1 shows professional dhol players perform during the entrance of a South Asian wedding.

>> **Chimta:** A *chimta* resembles extremely long tongs made of metal with a ring on one end, and sometimes they can have seven or more rings/jingles along each edge. As the musician dances, they hold the two arms of the chimta and periodically clap them together, thereby creating a metallic sound similar to that of small cymbals. The ring further adds to the sound combinations because it too creates a metallic sound when struck against an arm of the chimta.

>> **Kato:** An extremely unique instrument, the *kato* is a stick with what appears to be the head of a squirrel at its top. As the musician pulls a string that hangs from the squirrel's mouth, the head is jerked backward to create a sharp clicking noise. Additionally, the "squirrel" also sometimes has bells attached that jingle as the instrument is shaken. A singularly interesting instrument, the *kanjari* is often used in bhangra dance routines.

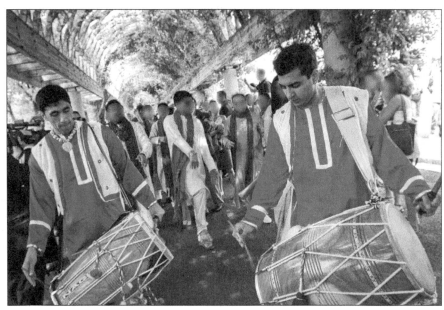

FIGURE 11-1: Professional dhol players Vivek Bhatia (left) and Rishi Bawa (right).

Source: Silk Events DJs

RECOGNIZABLE PUNJABI FOLK SONGS IN BOLLYWOOD

With it's incredibly recognizable and upbeat tunes, Punjabi folk songs have been a popular choice of music fit for parties of multiple occasions. Bollywood too has picked up on the popular music trend by implementing it into film scores over the years. Here are a few notable songs that can give you a taste of the many flavors of Punjabi music:

- **"Ambarsariya" (One From Amritsar):** Featured in the 2013 film *Fukrey* (Slackers), this folk song became extremely popular upon its release and went on to win the award for Best Punjabi Song in a Hindi Film at the Punjabi Music Awards, hosted by the Punjabi television network PTC in 2014. The song, which follows a traditional Punjabi folk melody, is sung in the style of a woman speaking to a young man from Amritsar.

- **"Layi Vi Na Gayee" (You Didn't Love Me):** This song, featured in the popular 2003 film *Chalte Chalte* (On the Way) and starring Shah Rukh Khan and Rani Mukerji, is a powerful love ballad sung by famous singer Sukhwinder Singh. Featuring traditional Punjabi folk sounds, the song is reminiscent of the lovelorn songs written about famous Punjabi love stories, like *Heer-Ranjha*.

- **"Lodi" (Festival of Lohri):** Released 36 years after his death and being one of the last compositions by legendary music composer Madan Mohan, this song from the movie *Veer-Zaara* accompanies a picturesque celebration during the annual Lohri festival in Punjab, marking the end of the winter solstice. Picturized on Shah Rukh Khan, Preity Zinta, Amitabh Bachchan, and Hema Malini, the song includes traditional Punjabi folk sounds and celebrates the Punjabi tradition and culture ecstatically.

These unique instruments help to give Punjabi folk music its distinct sound, rhythm, and recognizability. Its rich history and cultural attachment endears it to not only the Punjabi general population but also a wide range of audiences across the globe. You can note the influence of this genre in Bollywood because it appears in a number of famous songs over the years.

Getting Down: Dance Traditions of Punjab

Punjab is also famed for its many cultural dances. Accompanying the folk music are a number of different variations of dances. Some Punjabi dances, such as jhumar, are typically performed only by men in Punjab. Other forms of traditional dance,

such as bhangra, are now performed in arrangements featuring both men and women. These choreographed dances represent various aspects of Punjabi culture, originating from storytelling about the farmers, warriors, and lovers of the region.

The famed and energetic dance steps have blended perfectly with the more upbeat choreographies featured in Bollywood films. Here we dive deeper and see how Punjabis have influenced Bollywood with their world-renown moves.

It's all in the bounce

The Partition of India and Pakistan deeply affected the Punjab region, perhaps more so than any other region on the subcontinent. The state was essentially split in half, separating an Indian Punjab from the Pakistani Punjab. Cultural hubs such as Lahore and Amritsar resided on both sides of the new border, and both sides felt a newfound sense of urgency to preserve as much Punjabi culture as possible. Even though bhangra predates Partition, it was the time following Partition where bhangra became a prominent form of dance.

CULTURAL WISDOM

Because of its often exciting choreography, bhangra dancing became the banner dance of Punjabi culture. Rooted in the farming culture of the region, bhangra originated in the form of dance moves that farmers performed while harvesting their crops. By choreographing their movements and adding music to their harvesting work, the farmers made their chores more exciting and fun. Bhangra also is performed at festivals and is closely associated with spring harvest festivals in Punjab.

Recognizing bhangra as the energetic dance steps that mirror the beats of a dhol drum is easy. The dances include various kicks, leaps, and even stunts as the dancers perform in choreographed symphony. Dancers of traditional Bhangra perform in a circle, and often other instruments, such as a chimta or a kato (refer to earlier section, "Identifying the unique instruments," in this chapter). Figure 11-2 shows some bhangra dancing from Bhangra Empire, a California-based organization focused on representing and sharing Punjabi culture at the international level.

The traditional circle dance of bhangra would eventually give way to a more free-form variety of the dance. The evolution of the dance included the same energy and types of movements, but added in more intricate formations to make it more of a show than a traditional dance. This evolution helped to spur on the popularity of bhangra and make it a worldwide phenomenon in more recent years. As bhangra fever spread worldwide, Bollywood also started to notice and began incorporating the songs and dance into its movies. Here are some of the more notable songs that feature bhangra in their choreography:

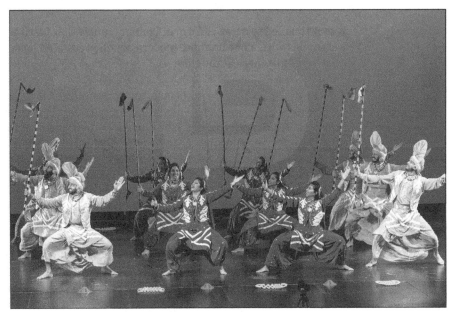

Source: Bhangra Empire

>> "Morni Baanke" (Like a Peacock) from *Badhaai Ho* (Congratulations There)

>> "Nagada Nagada Baja" (The Kettledrum Started Beating) from *Jab We Met* (When We Met)

>> "Bhangra Paale" (Colloquial for Let's Dance) from *Karan Arjun*

>> "No. 1 Punjabi" from *Chori Chori Chupke Chupke* (Secretly and Stealthily)

Bhangra's evolution, from folk to hip-hop

Bhangra music traditionally consisted of similar melodies arranged with specific instruments in mind. The dhol and chimta were featured prominently in the music, and the rhythmic dances that accompanied the songs were choreographed to mirror the movements of farmers from the region. After Partition and into the end of the 20th century, bhangra music began to spread to other parts of the world.

The Indian diaspora was most notable in the 1970s, as Indians flocked to English suburbs in Britain. As they migrated, Indians brought their traditions, music, and dances along with them. As a new generation of musicians and listeners emerged far from the traditional folk music of India, they also began to be influenced by the rock music of the West. The confluence of sounds and instruments in England

at that time led to a newer form of bhangra music that fused traditional melodies and sounds with a newer, more modern sound predicated on popular music in the Western hemisphere at the time.

Though it was evolving and people were listening to it, bhangra music didn't truly become popular in England until the 1980s. Bands such as Alaap and Heera became quite popular during this time, and their rock-infused bhangra songs created a new genre of music that the first-generation youth of the time could identify with. Just as they were the product of two cultures (English and Indian), so too was the music that these bands were releasing. Other artists, such as Malkit Singh, were also releasing popular tracks, such as his "Gur Nalon Ishq Mitha," which has since been remixed and used multiple times by DJs — and even by Bollywood musicians.

The 1990s and early 2000s saw another evolution in bhangra music, as DJs such as Bally Sagoo and Panjabi MC began to remix traditional Punjabi folk tracks with hip hop and dance music to create yet another new sound. It was also during this time, however, that folk artists began to push back against this new trend. What resulted was a clear divergence in bhangra music: Some artists took on the mantle of creating more traditional Punjabi folk music, and others adopted a more modern, fusion approach to Punjabi music. Both types of artists continue to thrive and influence music in Bollywood.

Artists such as Jazzy B, Sukshinder Shinda, Harbhajan Mann, Hans Raj Hans, and Diljit Dosanjh continue to keep the traditional folk music alive. Dosanjh, in particular, has had a profound impact on Punjabi music in the mainstream and has sung for and appeared in Bollywood movies. On the other side, artists such as Yo Yo Honey Singh, Badshah, and Guru Randhawa make more pop-infused bhangra music and are often featured on Bollywood soundtracks. Both of these subgenres of bhangra music continue to be extremely popular on the subcontinent as well as on the diaspora, and their influence can be found in a number of Bollywood tracks over the past few decades. Here are a few to check out:

>> "Angrezi Beat" (English Beat) by Yo Yo Honey Singh from *Cocktail*

>> "Suit Suit" by Guru Randawa from *Hindi Medium*

>> "Sadda Move" (My Move) by Diljit Dosanjh from *Raabta* (Connection)

Spotlighting the women of Punjab

Though bhangra can be and is often now co-ed, Punjabi women have long held their own step with the aforementioned dance, giddha. A popular folk dance as energetic as bhangra, giddha is considered derived from the ancient ring dance

that was performed in pre-Partition Punjab. For decades, the women of Punjab have embraced this vibrant and rhythmic dance style, performing on not only the subcontinent but also all around the world for festivals or weddings or any other special occasion.

As the giddha style has grown in popularity, so has its unique fashion. Both the giddha and bhangra styles showcase men and women in bright, vibrant colors. Traditionally, a form of Shalwar kameez, a South Asian pant and top, is worn. (We discuss South Asian fashion in more depth in Chapter 7.) What differentiates the bhangra and giddha fashion is typically the gold embroidery, neon colors, and wider bottoms. Women often wear additional jewelry and sport fabric on their heads. Braiding is a common hairstyle, to complete the traditional look.

Choreographing Bhangra within Bollywood

Traditional bhangra is still performed on stages around the world. The UK, United States, and Canada all have large Punjab-descended populations who keep alive the tradition of bhangra and other folk dances from Punjab. Colleges and professional organizations even hold bhangra competitions, where teams from different regions compete with their own choreography. In this way, the dance moves that have been passed down from decades continue, even today, to be in the limelight for South Asians. However, it isn't just bhangra that is performed at these competitions.

In recent times too there has been an influx of Bollywood films that feature songs with heavy-set bhangra choreography. The influence that bhangra continues to have in Bollywood songs is second to none.

Appreciating dance

One thing that people from the Indian subcontinent appreciate is a good, choreographed dance, and Bollywood doesn't let them down. Nearly every Bollywood movie has at least one dance number where the main actor is surrounded by a flock of backup dancers performing a number of intricate dance moves. In fact, a choreographed dance number or two is perhaps one of the most recognizable features of all films emanating from the South Asian subcontinent. Dance numbers and endless songs have become a staple of Bollywood and other South Asian film industries.

This lively tradition of appreciating dance — and often Bollywood dancing — doesn't stop at movies and music videos. With the advent of technology making the recording and uploading videos of amateur dance performances easier, dancing has made its own way into the mainstream, in a couple of ways:

>> **Celebrations:** South Asians enjoy dancing on nearly every occasion. Weddings and graduations are definite showcases of dancers performing to popular tracks, most often from Bollywood. These can often be a mix of several different dance traditions, from bhangra to hip-hop and even to traditional Indian kathak dances. Figure 11-3 show attendees at a wedding in Massachusetts performing a choreographed bhangra routine with *khunda,* decorative bamboo sticks maneuvered in various ways during a bhangra routine.

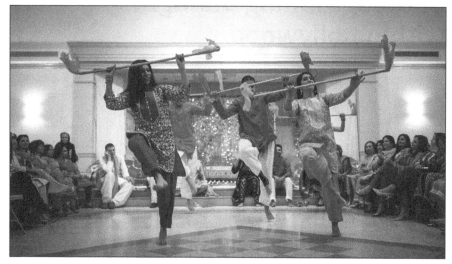

FIGURE 11-3:
Celebrating
at a wedding
with a bhangra
routine.

Source: Meryum Khan

>> **Dance studios:** Some people have opened up dance studios to teach various different types of South Asian dance styles, and some studios have taken it a step further and turned it into a workout. Because most of these dances are lively and energetic, another use for the choreography has found its way into the mainstream. Similar to Zumba, South Asian–influenced dance routines are often used as group workout classes in many cities across the world. In fact, BollyX was founded as a Bollywood-inspired dance fitness program, with many bhangra routines incorporated into the routines.

DANCERS GARNERING BOLLYWOOD'S ATTENTION

Both traditional and contemporary fusion dance styles have found their way to the mainstream. Popular social media accounts, like BollyShake, catalog the seemingly never-ending barrage of South Asian dance performances and help solo dancers gain worldwide recognition. Some dancers, such as Shivani Bhagwan and Chaya Kumar, have gained international recognition for their original choreographies to well-known South Asian songs.

Bhagwan and Kumar founded BhangraFunk and BollyFunk together, and continue to amass millions of views online for their original choreographies and instructional videos. The rising popularity of these fusion-style dances have necessarily attracted Bollywood's attention, and many of these dancers have begun appearing in mainstream Bollywood songs.

A culture of competing

As dancers around the world create their own original choreography and are showcased online, friendly competition has emerged throughout various mediums. Colleges around the United States and Canada routinely hold cultural shows or dance competitions in which teams from all over North America compete to show off their skills. Some competitions feature only bhangra dance groups, and others focus on Bollywood-style pop dancing. Still other competitions invite dance groups of all genres, as long as they're paying homage to South Asian music and dance traditions.

CULTURAL WISDOM

Some of these dance groups gain even more popularity after winning competitions. Groups like Bhangra Empire have even been asked to perform bhangra at NBA halftime shows and the White House. The popularity of cultural dances from the South Asian subcontinent, with Bollywood adapting more bhangra style, has now begun to transcend the South Asian community. Former performers like Manpreet Toor, Naina Batra, and Joya Nandy Kazi have amassed hundreds of thousands of followers on social media platforms after gaining popularity from dance competitions.

This new wave of dancers, musicians, and creators haven't gone unnoticed in Bollywood. The 2011 Bollywood movie *Dirty Picture* became so popular that the song's singer and composer, legendary Bollywood composer Bappi Lahiri (whom you can read more about in Chapter 8) appeared at their Los Angeles studio to record a video for the dance! As these artists and their popularity grow, they are sure to be included before long in Bollywood's music scene.

Chapter **12**

Painting the Town, Bollywood Style

For many fans, the highlight of Bollywood films comes from the dance sequences. Over time, Bollywood has developed its own, signature style of dancing, drawing inspiration from other regions as well as its own. By melding dance forms that encompass everything from classical Indian art forms to Arab techniques, Bollywood has infected viewers with moves that keep their eyes locked on screens.

Dance emerged in Bollywood films as early as the 1950s, as choreographers began experimenting with larger groups of dancers and taking inspiration from folk dances (see Chapter 11). In the 1970s, disco dancing came on the Bollywood dance scene, in addition to other classical, semiclassical, and folk steps. And now Bollywood dance is heavily influenced by Western culture, with many dances incorporating hip-hop moves.

This chapter gives you a taste of the evolving Bollywood dance stage with a special emphasis on the actors and choreographers known for their impeccable and legendary footwork. In addition, the chapter covers some of the most iconic songs made famous by a particular dance step or choreography.

Tapping Along to Indian Dance Styles

Even though dance is prevalent on the entire subcontinent, dance is treasured deeply in India. The country features a variety of dance styles ranging from classical to folk, all originating in different parts of the country with local culture and tradition baked into each. It's no wonder Bollywood has become as known for its dance as its music and films given the cherished place these dance forms hold in the country. These sections take a closer look at these traditions.

HISTORICALLY SPEAKING WITH CLASSIC DANCES

Classical dancing can be seen in every flavor of Indian dance, with more than eight distinct styles — two of which are

- **Bharatanatyam:** Considered one of the oldest dance styles in India and hailing from the South Indian region, Bharatanatyam is a religious art form that originated in Hindu temples, relying heavily on sophisticated hand gestures, facial expressions, and particular body movements for its spiritual storytelling. In a traditional setting, the Bharatanatyam dancer is typically a solo female dancer who is accompanied alongside by musicians who assist with her performance. One Bollywood choreographer who regularly used elements of Bharatanatyam in her routines was the late legend Saroj Khan. Bharatanatyam steps are featured in numerous Bollywood songs, including the infamous "Dola Re" in the film *Devdas,* featuring two dance queens: Madhuri Dixit and Aishwarya Rai Bachchan. The following figure shows Dixit (left) and Bachchan dancing to the song "Dola Re," featuring Bharatnatayam and Kathak dance steps.

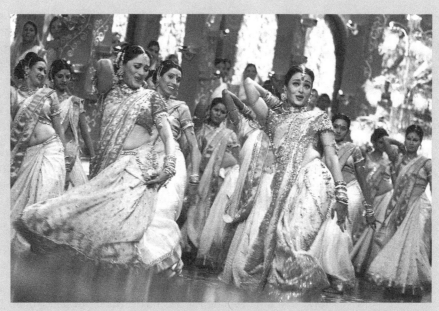

- **Kathak:** Kathak dance from northern India is similar to the Bharatanatyam origins as a medium used for ancient mythological storytelling. Kathak was also used heavily under the Muslim rule as an interpretive dance form for ghazals (refer to Chapter 9). The style of Kathak involves intricate and rhythmic footwork that's coupled with more graceful hand gestures and facial expressions. The dance medium was hugely popular during the Mughal era of India, as depicted in Mughal-era Bollywood films such as *Mughal-E-Azam* (The Great Mughal) and *Bajirao Mastani*. Other famous songs that incorporate Kathak styles are featured in the film *Devdas* in addition to the song "O Re Piya" (Oh, My Beloved) from the movie *Aaja Nachle* (Come Dance).

Looking to the Tribes for Folk Dance

Folk dancing and theatre both hold a significant place in many rural areas of India, with a higher emphasis placed on village communities. India has dozens of folk dance styles, each representing an ethnic group in India with its own flavor embedded. Here are a few that permeate Bollywood:

>> **Bhangra:** Among the most popular is bhangra, which has permeated everything from Bollywood films to wedding routines — and even to cultural events across the world, such as "Bollywood in the Park" in Los Angeles, an event that often consists of nonstop bhangra dancing.

The dance style itself mimics the physical harvesting styles of Punjabi farmers when they wanted to complete their agricultural chores in a more light-hearted way. Bhangra is an energetic style of dance that incorporates strenuous jumps and hops that would make any spectator get up out of their own seat and "bust a move." Bhangra has been incorporated several times into Bollywood films such as *Veer-Zaara* and *Kabhi Khushi Kabhie Gham*. For more on bhangra styles in Bollywood, check out Chapter 11.

» **Raas/Garba:** Turning to the state of Gujarat in India, you discover two famous folk dance styles, dandiya raas and garba, referred to jointly as raas/garba. The term *garba* itself comes from the Sanskrit word for *womb,* and it's traditionally performed around a clay lantern with a light inside. You can recognize garba today by the colorful, embroidered three-piece outfits worn by both male and female dancers. As mentioned, modern garba is influenced heavily by *dandiya raas,* a folk dance form involving two wooden sticks that someone clicks together in quick movements, with either their own pair or a partner's.

The combination of garba and dandiya raas has led to a high-energy dance style that can be spotted all around the world. The dance is most traditionally celebrated during Navaratri, a Gujurati celebration lasting nine nights. Both styles have grown so popular that more than 20 universities in the United States have competitions. Garba is also highly popular in the United Kingdom, and Gujurati communities there hold their own popular garba nights. Here are some famous Bollywood songs with garba/raas front and center, listed along with the films in which they appear and the year:

- "Udi Udi Jaye" (Flying Away) from *Raees* (Rich)

- "Nagada Sang Dhol" (Drums Are Beating) from *Ram-Leela*

- "Dholi Taro Dhol Baaje" (Drummer's Drum Is Beating) from *Hum Dil De Chuke Sanam* (I've Given My Heart Away, Darling)

- "Radha Kaise Na Jale" (How Can Radha Not Be Jealous?) from *Lagaan* (Tax)

- "Disco Dandia" from *Love, Love, Love*

Getting to Know the Famous Choreographers

Of course, Bollywood dance didn't just emerge overnight. Throughout history, numerous choreographers have been dedicated to the craft. In fact, these choreo-graphers are held in such high regard that in Bollywood they're often considered

dance directors. Their role is integral to a film's success, with entire awards at Bollywood awards shows dedicated to choreography. Often, the most expensive part of producing a Bollywood film is the dancing itself, with a heavy investment in designing the set, hiring hundreds of dancers, and teaching choreography. Here we discuss the people who have been integral to directing dance in Bollywood.

Popping with the king of Bollywood dance

Quite possibly one of the biggest dance innovators of India, Prabhu Deva is considered to be the Michael Jackson of India. Deva initially drew inspiration from his father, who was also a choreographer for South Indian films, and began learning a few traditional dance styles, including Bharatanatyam. Unlike other choreographers of his time, Deva was drawn by Western dance styles — specifically, that of Michael Jackson. He began incorporating the King of Pop's steps in his dance routines, eventually making appearances of his own in front of the camera. After spending several years choreographing and dancing for Kollywood (see Chapter 16), he transitioned to lead actor roles.

Deva's second acting role, in the 1994 film *Kadhalan* (Loverboy) is the one that launched him to superstardom. The film was mostly known for its A. R. Rahman-directed music — specifically, "Urvasi Urvasi" (a female name) and "Muqabala" (Challenge) — and the scintillating dance moves shown off by Deva. The songs grew to be even more popular after they were dubbed in Hindi, solidifying Deva's place as a top dancer.

CULTURAL WISDOM

The "Muqabala" song itself has a rich history, originating in Kollywood (the Tamil language -ollywood). To read more about Tamil songs, including this one, turn to Chapter 17.

Deva continued to make dance cameos, doing so once alongside the incredibly talented Madhuri Dixit in "Kay Sera Sera" from the film *Pukar* (The Call) all while still choreographing both Kollywood and Bollywood films. Soon after, he began directing films too, including the likes of *Wanted, Rowdy Rathore, Singh Is Bliing,* and *Dabangg 3* (Fearless 3).

CULTURAL WISDOM

Most Internet users are familiar with Deva, whether they know it or not, because he was featured in the famous viral video "Benny Lava." The uploader of the video adds to Deva's Tamil song "Kalluri Vaanil" (Touching the Heart of Girl) some English subtitles that comedically match the phonetic sound of the Tamil lyrics. Many felt that the video was made in good fun, but many others unfortunately felt that the culture was being mocked.

Emulating MJ and beyond

There seems to be a recurring theme among Bollywood choreographers whose love for dance begins with the great Michael Jackson. Here we discuss two more choreographers who are inspired by Jackson:

Farah Khan

Despite having no experience, Farah Khan made it her life's mission to pursue a dance career, after watching Michael Jackson's "Thriller" music video while attending college. She was so moved that she taught herself how to dance and then started her own dance group in college. Her big break came when she became the choreographer for the 1992 film *Jo Jeeta Wohi Sikandar* (Whoever Wins Will Be King), and she hasn't looked back.

She went on to work on many films including Shah Rukh Khan, such as *Dilwale Dulhania Le Jayenge* (The Big-Hearted Will Take the Bride), *Dil To Pagal Hai* (The Heart Is Crazy), and *Dil Se..* (From the Heart). Farah set a new high bar for the industry when she collaborated with newcomer actor Hrithik Roshan on the song "Ek Pal Ka Jeena" (One Second of Life), from the movie *Kaho Naa . . . Pyaar Hai* (Say It . . . You're in Love). This dance number immortalized Roshan, and it's still revered for being the best-choreographed dance number in Bollywood history.

CULTURAL WISDOM

"Ek Pal Ka Jeena" was so popular that in Season 2 of *America's Got Talent,* a 23-year-old Chicago native named Kashif Memon received a unanimous yes from the judges as he entertained the audience with his take on the song. Memon emulated the exact dance routine and turned himself into one of the favorite contestants of the season.

Farah's success led to not only more choreography work but also a directorial debut, starting with *Main Hoon Na* (I Am Here). The film was a tremendous success, and was followed by *Om Shanti Om* (Universal Sound for Peace), 2007. To this day, Khan is considered one of India's top choreographers — she spends her time making appearances on dance shows like *Dance India Dance* and *Bigg Boss* as a judge and mentor. She was hired as a choreographer (see Figure 12-1 shows Hrithik Roshan in a dance jump) on the production for one of Bollywood's most famous films, *Kabhi Khushi Kabhie Gham* (Sometimes Happy, Sometimes Sad).

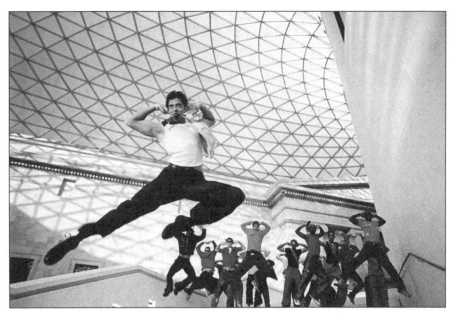

AF archive/Alamy Stock Photo

FIGURE 12-1: Hrithik Roshan in *Kabhi Khushi Kabhie Gham.*

Remo D'Souza

A self-taught dancer who emulated Jackson's steps, Remo D'Souza's first choreography venture came in the film *Bollywood Dreams,* and he followed it up as a dancer in the 1997 hit *Pardes* (Foreign Land). Unlike the aforementioned choreographers, D'Souza gained his popularity from serving as a mentor and judge for the dance show *Dance India Dance.* He continued appearing on other dance shows, such as *Jhalak Dikhhla Jaa* (Give Me a Glimpse of Yours), *Dance Plus,* and *Bigg Boss,* all while providing the choreography for Bollywood films. Here are some of his notable choreography in films:

» *Dhoom* (Blast)

» *Singh Is Kinng*

» *Student of the Year*

» *Krrish 3*

» *Bajrangi Bhaijaan* (Brother Bajrangi)

» *Bajirao Mastani*

D'Souza has also directed several movies, such as *ABCD: Anybody Can Dance, A Flying Jatt,* and *Street Dancer 3D.*

Getting energetic and making history

While some choreographers were using legends like Michael Jackson as inspiration, still others within the Bollywood industry were carving out names for themselves with their own unique styles. Two of the most famous trailblazers in Bollywood choreography became famous for their upbeat, energetic dance moves.

Ganesh Acharya

Known for his highly energetic and fun dance numbers, Ganesh Acharya embarked on a dance career at a relatively young age. His father, who was also a choreographer, passed away early in his life and so the family faced financial setbacks. His sister also happened to be a dancer, and after studying under her wing as well as involving himself in a dance group, Acharya choreographed his first film *Anaam* (Anonymous) in 1992. Acharya picked up momentum and choreographed several films during the 1990s, and he was often paired up alongside actors Govinda and Madhuri Dixit. Some of their more memorable collaborations were Govinda's "Bade Miyan Chote Miyan" (Big Mister, Little Mister) and Madhuri's "Badi Mushkil" (Big Trouble).

Acharya had a huge year in 2006, winning the 2007 Filmfare Best Choreography award for the song "Beedi" (Cigarette), from the movie *Omkara* (Hindi adaptation of Shakespeare's *Othello*), 2006, as well as working for blockbusters like *Lage Raho Munna Bhai* (Keep at It, Munna Bro) and *Rang De Basanti* (Shade of Yellow). Other films that Acharya is known for choreographing are *Agneepath* (Path of Fire), *Bajirao Mastani,* and *Simmba.*

Saroj Khan

Saroj Khan was the first woman choreographer in Bollywood history. She began her career in film as a background dancer for several years, before opening her own dance studio in Dubai, where she was able to further her craft. Khan's dance style specialized in Kathak and Bharatnatyam, and you would often see these influences in her dance routines. After becoming an assistant, she was moved to head choreographer for years to come. Sarjo didn't reach critical acclaim until she choreographed "Hawa Hawaii" (Wind from Hawaii) for the film *Mr. India,* and then began getting paired with Madhuri Dixit and creating iconic numbers such as "Ek Do Teen" (One Two Three), "Dhak Dhak Karne Laga" (My Heart Is Beating Fast), and "Choli Ke Peeche" (What's Behind Your Blouse?).

When Aishwarya Rai Bachchan rose to prominence as an actress, Saroj began collaborating with her on hits like "Nimbooda" (Lemon or Lime) and "Barso Re" (Please Rain). Saroj's most iconic routine came from "Dola Re Rola" in 2002, for the film *Devdas* (refer to Figure 12-1). She continued her legendary career well into the 2010s before passing away from cardiac arrest in July 2020.

Dancing Their Way to Center Stage

It's only natural that an industry so heavily involved in dance would foster world-class talent. Many actors created legacies and careers from their dancing abilities, and some even got their foot in the door as background dancers. Here are a few actors of the dance legends in Bollywood:

» **Madhuri Dixit:** It's nearly impossible to discuss Bollywood dancing without mentioning Dixit's name. Her Bollywood legacy is making a career out of her memorable dance numbers. Her ability to tell a story by way of adorable facial expressions and pick up any classical or modern tempo made her unlike any other dancer or actress throughout the 1990s. To find out more about Dixit's acting career, flip to Chapter 5.

» **Hrithik Roshan:** Search online for the term *best Bollywood dancer of all time*, and Roshan's name is likely to come up. He's the man who revolutionized dancing in mainstream Bollywood forever. Considered to be a chameleon of sorts when it comes to his acting prowess, Roshan (see him in Figure 12-1) is no different as a dancer, because he's able to fully assume any dance style and step given to him. His debut to the industry in 2000 was through a film that put this dancing ability, literally, at center stage, immediately winning fans over and wanting more. To find out more about Roshan's acting career, turn to Chapter 5.

» **Shahid Kapoor:** This heartthrob is one of the few with an unconventional path to acting stardom. Kapoor got his start as a backup dancer and never stopped hustling until he was front and center on the big screen. If you look closely, you can catch him assisting in the background behind Aishwarya Rai Bachchan in the song "Kahin Aag Lage Lag Jaaye" (If A Fire Sparks, Let It Burn) from the movie *Taal* (Rhythm). He brings an unmatched combination of energy, power, and grace to his routines, without seemingly ever breaking a sweat. Read more about him in Chapter 5.

» **Aishwarya Rai Bachchan:** Considered by many to be the "most beautiful woman in the world," the title could also apply to Bachchan's elegant dancing. The camera absolutely loves capturing her elegance and unworldly charm when she's onscreen, especially when she's dancing (refer to the sidebar, "Historically speaking with classic dances," in this chapter). This beauty queen is a sight to behold as she's able to hit all the right angles and the most intricate steps, ranging from classical ballads to sexy cabaret numbers. Read more about her career in Chapter 5.

» **Govinda:** This comedy actor, among the earliest known for having a signature dance style, oozed charm and charisma unlike anyone else whenever he was seen busting a move. Many fans loved him solely for the hilarity of his hip movements and facial expressions. Although most of his dances were masked

by comedy with a tinge of sleaze, Govinda was highly entertaining to watch, especially given that his technical proficiency was also remarkably ahead of his time, making him one of the most popular stars of the 1990s. Check out Chapter 4 for more about his acting career.

>> **Tiger Shroff:** If you combined Sylvester Stallone's character Rambo with the aforementioned Hrithik Roshan, the result would be actor-and-dancer Tiger Shroff. This specimen can master the most athletic hip-hop and pop-and-lock routines while finding ways to incorporate his grandmaster skills in martial arts. Shroff's abilities as a martial artist, combined with his dancing prowess, have made him one of the rising newcomers to the dance floor. Refer to Chapter 6 for more.

>> **Deepika Padukone:** The modern-day beauty queen of Bollywood is also renowned for high-energy dance numbers (see Figure 12–2). As one of the taller actresses in Bollywood history, she used her lengthiness to her advantage in order to accentuate certain poses, moves, and steps. Padukone's statuesque beauty and grace, like watching a Michelangelo sculpture come to life, continues to mesmerize audiences whenever she hits the dance floor, as Bollywood continues to cast her for classic timepieces that allow her to win over audiences in elegant dance routines. Read more about Padukone's career in Chapter 6.

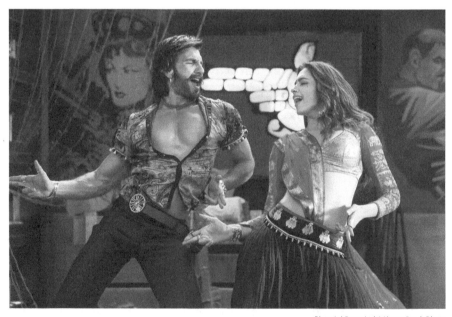

FIGURE 12-2:
Bollywood couple Ranveer Singh and Deepika Padukone dancing in their film *Ram Leela*.

Pictorial Press Ltd / Alamy Stock Photo

OUR TEN FAVORITE DANCE NUMBERS IN BOLLYWOOD HISTORY

Bollywood has certainly had iconic dance numbers. The top ten list we present here gives you the essence of each era of Bollywood. When you turn to YouTube to consume these videos, there's no doubt you'll see a plethora of related songs that fulfill your Bollywood boogie needs, all worthy of being viewed and acknowledged:

- **"Ek Pal Ka Jeena" (One Second of Life):** Worldwide audiences witnessed newcomer Hrithik Roshan become an instant star who took Bollywood by storm with this hit from the movie *Kaho Naa . . . Pyaar Hai* (Say It . . . You're in Love). With the help of choreography mastermind Farah Khan, Roshan's fluid and waterlike movements, coupled with his effortless footwork, set newfound prerequisites for actors in India.

- **"Choli Ke Peeche" (What's Behind Your Blouse?):** Madhuri Dixit is another actress whose many songs are worthy of being on this list, but this particular hit of hers from the movie *Khal Nayak* (Villain) is a prime example that best showcases her dancing abilities, acting, facial expressions, and charisma. It's difficult to watch this nearly nine-minute spectacle and resist the urge to dance.

- **"Pyar Kiya To Darna Kya (Why Be Afraid If You've Loved?")**: This ballad features one of Bollywood's greatest actresses, Madhubala, who shockingly wasn't actually considered to be a great dancer. Even though she allegedly gained assistance from a dance double, her performance is still a sight to behold. Madhubala plays a courtesan dancer who performs a riveting Kathak solo and then proceeds to bravely proclaim her love to Prince Saleem (Dilip Kumar), despite the danger that might be inflicted on her by the disapproving King Akbar (Prithviraj Kapoor). One of the best showcases of Kathak dancing on the big screen, this was the inspiration for future Bollywood dance numbers, such as "Kaahe Ched" (Why Does He Tease Me) and "Mohe Range Do Laal" (Color Me Red).

- **"Malhari" (colloquial, Happiness):** Typically, dance numbers in Bollywood don't mesh well with the more rough-and-tumble characters. However, this choreography, by Ganesh Acharya, brilliantly matches the tough, masculine characteristics of Bajirao and his warriors in this rowdy and energetic routine, resulting in its becoming one of the most popular songs of the past decade. Singh's raging and iconic performance further popularized him and solidified his rank as India's premiere actor.

- **"Dola Re Dola" (Sway and Sway):** Choreographed by the late dance legend Saroj Khan, Madhuri Dixit and Aishwariya Rai Bachchan were pitted against one another in the style of a friendly dance-off, giving fans a showdown between two of Bollywood's best dancing actresses. The song featured elements of Kathak and Bharatnatyam and ended up being one of the highlights of the film — as well as a career highlight for everyone involved in its production.

(continued)

(continued)

- **"Muqabala" (Challenge):** Alongside the funky lyrics, eccentric wardrobes, and fun-filled special effects, "Muqabala" proved to be highly entertaining video that also benefited from never-before-seen choreography. From the quick-footed pop-and-lock routines to the memorable moments, such as Prabhu Deva making a cowboy hat move with his dancing pelvis, this song oozes incredible amounts of swagger, thanks to Deva's performance and the choreography of Raju Sundaram.

- **"Chaiyya Chaiyya" (In the Shade):** Quite possibly Shah Rukh Khan's most memorable hit from the 1990s, the video for "Chaiyya Chaiyya" was unlike any other. Choreographed by Farah Khan, the entire song takes place atop a moving train as Khan dances alongside actress Malaika Arora. The catchy song, which reached a cult-like following, is regarded as one of greatest in history, making numerous appearances in both Eastern and Western pop culture. A remix version of the song was featured in the closing credits of Denzel Washington's film *Inside Man.*

- **"Nimbooda" (Lemon or Lime):** A coming-out party of sorts for the great Aishwarya Rai Bachchan, this song showcased her full dancing capabilities to the world. The lyrics serve as a fun double entendre about picking and choosing lemons from the fields while Nandini (Rai) catches the attention of Vanraj (Ajay Devgn). Saroj Khan's choreography is highly intricate yet fast-paced and once again contains elements of both Kathak and Bharatnatyam.

- **"Tu Cheez Badi Hai" (colloquial, You're a Wonderful Babe):** Nothing screams early 1990s Bollywood more than nonstop hip-thrusting. This classic from the film *Mohra* (Pawn) was popular because of the interesting wardrobe choices and provocative dance routine. The song features actors Raveena Tandon and Akshay Kumar dawning faux dreadlocks and do-rags while proceeding to pelvic-thrust at one another and into the camera.

- **"Nagada Sang Dhol" (Drums Are Beating):** A dance number proving that Deepika Padukone is a world-class dancer capable of picking up different styles, this song from Ram-Leela was the film's most popular hit. Similar to how "Nimbooda" is a song that elevated Aishwarya Rai Bachchan, this number did the same for Padukone, as she was also reported to have faced swelling in her legs and feet caused by the rigorous routine and shoot schedule.

Adding Bollywood Dance to Your Repertoire

Much like its musical history (which we discuss in Chapter 7), dance in Bollywood has evolved over time as the industry continues to globalize and adopt more Western influences. Dance groups became more prevalent from the 1960s onward,

as jazz, disco, cabaret, and contemporary styles begin seeping their way into films. Modern-day Bollywood dance is the result of many years of collaboration with different Western styles, eventually becoming its own bold and outspoken style of dance. Actors who have innovated their own styles include the likes of Govinda and Salman Khan.

REMEMBER

You can start to master Bollywood dancing, ranging from classical to folk and everything else fused along the way. Here are some people or organizations to search for, all of which host trainings and classes for learning:

>> `bfunkdance.com`: BFunk, a combination encompassing Bollywood and bhangra with funk has been providing dance education in classes and workshops in cities across the United States. The routines are known for fusing traditional Bollywood styles with hip-hop, though Dandiya, giddha, classical, and others are sprinkled throughout.

>> `joyakazi.com`: Joya Kazi is a classically trained choreographer whose techniques and choreography you can see in Mindy Kaling's Netflix series *Never Have I Ever*. Featured in press all around the world, Kazi offers not only virtual trainings but also bookings for performances at an event. Kazi has also been among the dance crews at famous Bollywood awards shows, such as the IIFA Awards in 2014. Read more about Bollywood awards in Chapter 15.

>> `bhangraempire.com`: Bhangra Empire is a northern California-based organization that has been focused since 2006 on bringing bhangra to mainstream audiences. The group is composed of students and working professionals who have a passion for representing Punjabi culture at an international level, having performed at the White House, at a Golden State Warriors game, and even on *America's Got Talent*.

>> `amitpateldanceproject.com`: Amit Patel is a professional dancer, choreographer, and teacher whose focus is on fusing his culture through various disciplines of dance. A pioneer of "Indian contemporary," Patel is most famously known for his rebellious pieces in heels, known as Bollywood heels, which challenges the norms of sexual identity in dance.

>> `bollyheels.com`: Founded by Swarali Karulkar, a dance movement therapist and choreographer, Bollyheels is an empowering class series fusing traditional Bollywood dance with commercial heels. The very East meets West motif of the classes is representative of the effect Bollywood dance has had on all parts of the world.

>> `afrodesi.com`: AfroDesi is a fusion form of dancing that aims to push cultural literacy via dance. The organization celebrates the intersection of African and Indian dance styles, drawing their parallel influences and cultures to form a unique art dance. To read more about Africa's love of Bollywood and Indian dancing, turn to Chapter 13.

4

Bollywood Goes Global

Meet the fans of Bollywood inside and outside of India.

Discover which Hollywood stars have found themselves in Bollywood over the years.

Understand Bollywood's global impact with major international audiences from Europe to Africa.

Find out more about the various award shows that celebrate and push Bollywood entertainment forward.

Peek inside the TV industry often inspired by what's happening on the Bollywood big screen.

Chapter **13**

Leading Box Office Revenue Worldwide

ndian culture truly began traversing the globe in the 1970s and 1980s as more and more people from the Indian subcontinent migrated around the world. These migrants took their culture, food, dress, and love of Bollywood with them. Though Bollywood's global influence was gradual at first, in recent years Bollywood has come onto the global scene in true Bollywood fashion — with a bang!

Many regions around the world now regularly show Bollywood films, and Bollywood stars are stars only in India no longer. This chapter covers some of the areas around the world where Bollywood is most popular, from the "test market" of the Middle East, to the shared values of West Africa, to the adopted filming locations of Europe, and even the popularity among Western artists and audiences.

Movies such as *Lagaan* (Tax) and Danny Boyle's *Slumdog Millionaire* were among the select moments when the United States took note of Bollywood films. *Lagaan*, starring actor Aamir Khan (see Chapter 5), is about villagers who play a game of cricket against their British colonizers, in the hope of lessening their agricultural taxes. It was nominated for Best Foreign Language Film at the 2002 Oscars. Even though *Slumdog Millionaire* wasn't produced by a Bollywood studio, it won Best Picture at the 2009 Oscars and showcased a feel-good movie that featured several

Bollywood-esque scenes, dances, and even actors, such as Anil Kapoor and Irrfan Khan. (We discuss them in greater detail in Chapters 4 and 5.)

In what may have seemed like the first time that many people in the United States were taking note of Bollywood influences, you'd be surprised to know that the rest of the world has admired the industry for years. Bollywood movies are filmed worldwide, have been released in multiple markets throughout several continents, and have gained millions of followers across global markets. In fact, in 2017, box office revenue outside India for Bollywood films grew to $367 million, nearly tripling overseas revenue from years past. This chapter takes a closer look at Bollywood's worldwide phenomenon.

Representing Bollywood Culture around the Globe

You may be surprised to discover that Bollywood fandom isn't limited to the Indian subcontinent, but is rather a worldwide phenomenon that continues to grow larger by the day. For one, the South Asian diaspora at large has a huge percentage of people who are avid Bolly-watchers.

Although the United States, Middle East, and United Kingdom top the charts for revenue brought into Indian films from overseas, Bollywood fans are present all around the globe, including Russia, Africa, Europe, China, and more, which we discuss in greater detail in these sections. Given that these movies are released in public theaters, local residents also have the opportunity to watch them just as often as anyone else. Seeing how certain aspects of Bollywood affect various demographics is also interesting.

INSPIRING SOVIET RUSSIA

During the Soviet days of Russia, Hollywood films were typically banned. As a result, Bollywood provided an alternative source of entertainment — especially given that Bollywood films weren't deemed to be political or controversial. With the influx of Bollywood movies in the early 1950s, the Soviet Union public found India to be a sort of phoenix rising from the ashes as India bounced back from the turmoil of the Partition (a topic we cover extensively in Chapter 3) and fought for independence. The Soviet Union's general population, still reeling from the carnage of World War II, found the whimsical dream world of Bollywood to be a welcome reprieve as they began return to their normal lives.

Testing success in the Middle East and North Africa

The MENA (Middle East and North Africa) region has long been one of the top three regions outside India to watch Bollywood and feed industry revenue. In 2014, 35 channels showed Bollywood and Indian content in the region, with more and more being dubbed in Arabic. Some viewers prefer these movies over Hollywood or native Arabic films, praising their mix of comedy, action, and romance.

In Arab-speaking Egypt alone, the love of Bollywood has been present for decades. Cinema houses in the '80s and '90s showed the latest Bollywood films — so much so that Egypt's ministry of culture enacted restrictions that made it nearly impossible for Indian films to be profitable in an effort to boost Egypt's local film industry. Still, Egyptian homes continued to watch Bollywood films on television and do so now via streaming services. By 2019, the Arab Gulf region emerged as a top overseas market for Bollywood films, to the point that film creators would release the latest movies in the gulf on Thursdays to test audience response before releasing them in other box offices.

Sharing values with West Africa and beyond

Although India and West Africa are very different in their histories and local traditions, their cultures share several similarities. Furthermore, because many African countries are home to conservative Muslims, the early era of Bollywood appealed to this region as the Muslim population felt that Bollywood movies did a great job of maintaining the modesty of their movies' subject matter.

As West Africa and India shared cultural identifiers such as arranged marriages, caste barriers, close familial ties, and ideals of morality, many West Africans identified with many of the themes and characters in Bollywood movies. This is in direct contract with Hollywood films, which showed a much more westernized and liberal world than the one West Africans were used to. The Muslim majority population further appreciated that Bollywood depicted women in modest dress with no nudity or love scenes. Bollywood was therefore perceived to be rich in culture, modest in its values, and quite independent of western ideas.

In recent years, as Bollywood films have become more violent and sexually explicit, their popularity has started to drop in West Africa because many movie-goers feel Bollywood has become more westernized. Since Bollywood reached its

peak in West Africa from the 1950s through the 1970s, the likes of actors Amitabh Bachchan and his famous playback singing partner (and former actor), Kishore Kumar remain popular. (Refer to Chapter 4 for more about these actors.)

CULTURAL WISDOM

Bollywood cinema has great prevalence in many areas beyond West Africa. While we cover North Africa's love for Bollywood in the preceding section, another region full of Bollywood love is South Africa. In fact, South Africa has a vibrant Indian community, called *Indian South Africans*, that have helped bring the Hindi film world to the area.

Filming in the UK and Western Europe

Bollywood's impact on Western Europe dates back several decades, and can generally be attributed to the success of the movie *Aan* (Pride), which was the first Indian movie to enjoy a worldwide release. In the UK especially, Aan popularized the actress Nimmi and her costar, actor Dilip Kumar (refer to Chapter 3). Thanks in part to the film's popularity there, England became a regularly recurring location for filming Bollywood movies.

The most popular Bollywood actor in the UK is Shah Rukh Khan (see Chapter 5 for more on his legacy) because he filmed many movies throughout the 1990s and 2000s throughout Western Europe, including the Netherlands, France, Scandinavia, and Germany. The majority of his blockbusters ended up faring well in these countries, and had a big hand in increasing Bollywood's presence on the continent. His celebrity in the UK especially is tremendous, and he remains a wildly popular figure there (Figure 13-1 shows him at the premiere of *Ra One* in London in 2011). Thanks to him, famous actresses like Katrina Kaif (check out Chapter 5) often are discovered in Europe before making waves in Bollywood; Kaif herself was discovered during a talent search in London by Indian filmmaker Kaizad Gustad.

TIP

To get a look at Bollywood's love for England, check out these movies filmed in London:

>> *Dilwale Dulhania Le Jayenge* (The Big-Hearted Will Take the Bride)

>> *Baghban* (Gardener)

>> *Aashiq Banaya Aapne* (You Have Made Me Your Lover)

>> *Namastey London* (Hello, London)

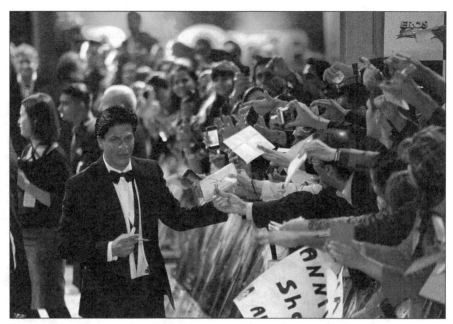

FIGURE 13-1:
Shah Rukh
Khan signs
autographs
for fans.

Growing popularity in China

Although China hasn't historically been a market for Indian movies — after all, the Indian community in China is relatively small — things began to change in the 2010s. In 2017, a Deloitte India report showed that the film *Secret Superstar* reaped nearly $120 million in China alone. That same year, *Dangal*, featuring Aamir Khan (see Chapter 5), became the highest-grossing non-Hollywood foreign movie of all time in China. The film was both dubbed and subtitled for the Chinese audience. Beyond the films, a growing community of Bollywood fans of Chinese descent love and appreciate Indian films (Figure 13-2 shows Aishwarya Rai Bachchan and her husband, Abhishek Bachchan meeting with their fans in Macau, China, during the tenth International India Film Academy (IIFA) weekend in 2009), and some even learn to speak Hindi. Chapter 7 spotlights one Chinese contestant on the music show *Indian Idol* and the mark he's made.

Roller-coastering through South America

Bollywood's presence in Latin America and South America recently has grown in popularity. Although Latin America first fell for Bollywood in the 1970s, after films such as *Mother India* and *Mera Naam Joker* (My Name Is Joker) screened there, further growth continued when the industry began filming some scenes in the region, such as the 2006 film *Dhoom 2*, shot in Rio De Janeiro. In the franchise's

next film, *Dhoom 3*, Peru's pop sensation Mia Mont sung the Spanish version of the title track, which grew in popularity in both countries. Peru itself has emerged as home to many fans of Shah Rukh Khan. (See Chapter 5 for more on Khan.)

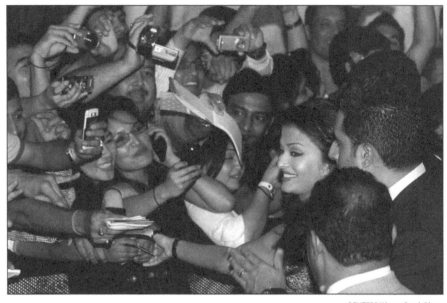

FIGURE 13-2: Aishwarya Rai Bachchan and her husband, Abhishek Bachchan, meet with their fans in Macau, China.

In 2015, a play in Lima, Peru, was inspired by Khan's 1995 hit *Dilwale Dulhania Le Jayenge* (The Big-Hearted Will Take the Bride"]), featuring Spanish dialogue and Hindi songs. The 2011 film *Ladies vs. Ricky Bahl* was even remade in Spanish for the Colombian market — which, funnily enough, was originally inspired by the Hollywood film *John Tucker Must Die*. Around that same time frame, Brazilian actress Bruna Abdullah started making appearances in Bollywood. Born in Brazil to a father of Lebanese descent and mother of Italian-Portuguese ancestry, she moved to Mumbai to grow her career.

TIP

To see Abdullah in action on the Bollywood big screen, check her out in these films:

>> *Grand Masti* (Grand Fun)

>> I Hate Luv Storys (No translation necessary!)

>> *Jai Ho* (Let There Be Victory)

Streaming everywhere

Beyond the cinema, streaming platforms have helped Bollywood appear on screens everywhere — in people's homes and on their phones. You can watch Bollywood films on Netflix or Amazon Prime. In 2018, Netflix CEO Reed Hastings shared that the company's next 100 million subscribers will come primarily from growth in India. Netflix has nearly 500 Hindi films, and Amazon Prime has hundreds.

Considering the Western Influence

Bollywood has become more and more popular in the West, and more and more movie industries and film professionals highly respect Bollywood. However, you may be surprised to see many actors from Hollywood who have also decided to dip their toes in the Bolly-waters. The opportunity to collaborate on these Hindi films provides the opportunity to expand not only their fan base, but also their portfolio of work. In return, Bollywood has also welcomed foreign artists into its fold for collaborations, performances, and adaptations. The spread of Bollywood in the Western world today continues through these collaborations and with the advent of social media. The following sections share more about these influences.

American actors adopt Bollywood

Several of Hollywood's A-list have showcased their talent on the Indian silver screen:

» *Kambakkht Ishq* (**Incredible Love**): Director Sabbir Khan's 2009 flick in particular managed to feature, surprisingly, a handful of Hollywood icons. The most notable cameos in the movie are actress and model Denise Richards and the legendary Sylvester Stallone, both playing themselves. In the film, Akshay Kumar ends up proposing to Denise Richards and is shown to have a brief relationship with her, whereas Sylvester Stallone debuts (naturally, in a fight scene) and saves actresses Kareena Kapoor and Amrita Arora from a group of thugs. The film also has cameos of actors Brandon Routh and Holly Valance as themselves.

» **Will Smith:** Let us tell you all about how Will Smith's life got flipped upside-down! That's right — in a more recent collaboration that was highly publicized on Instagram and YouTube, the former *Fresh Prince of Bel-Air* star made it a personal goal to work in a Bollywood movie. For his onscreen debut, he was featured in the song "The Jawaani Song" (The Youthful Song) from the movie *Student of the Year 2* in 2019, which, unfortunately, didn't do well with critics. During his time in India, Smith met other Bollywood celebrities (Figure 13-3

shows him with Akshay Kumar during a promotional event for *Rustam* in 2016) — most notably, superstar Ranveer Singh (see Chapter 6), who taught Smith how to do his signature pelvic thrust from his 2013 song "Tattad Tattad," which doesn't have a translation because it's an onomatopoeia. After all was said and done, Smith was basically the new Fresh Prince of Bollywood.

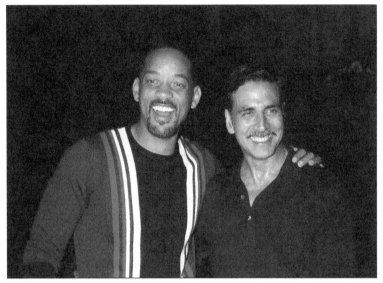

FIGURE 13-3: Will Smith with Bollywood actor Akshay Kumar.

STR/Getty Images

>> **Sir Ben Kingsley:** Kingsley is regarded as one of the more revered actors of today — and he too is no stranger to Bollywood. It just so happens that he was featured in a film with one of the greatest Bollywood actors ever, Amitabh Bachchan, in the 2010 movie *Teen Patti* (Three Cards). He plays the world's greatest living mathematician and has several scenes with Bachchan. (You can read more about Bachchan in Chapter 4.) Kingsley is best-known for starring in several Hollywood films, such as *Schindler's List* (1993), *The Tale of Sweeney Todd* (1997), and as Mohandas Gandhi in *Gandhi* (1982).

Aside from the silver screen, Hollywood actors have been spotted mingling with Bollywood's elite during several other moments in Bollywood history. At the 2014 IIFA Awards in Tampa Bay, Florida, actors John Travolta and Kevin Spacey were in attendance and were even featured several times throughout the evening. At one point, actors Shahid Kapoor and Farhan Akhtar gathered with several other Bollywood personalities to take a cellphone selfie with Spacey. During other points of the evening, Travolta danced onstage on two occasions, once alongside actor Hrithik Roshan and actress Priyanka Chopra (see Figure 13-4).

FIGURE 13-4:
John Travolta
dances with
Indian actress
Priyanka
Chopra.

FOREIGN TALENT MAKING THEIR MARK IN BOLLYWOOD

Outside of American presence in the industry, a range of foreign talent has tapped into the Indian film scene and can be seen in Bollywood flicks. Here are just a few examples:

- **Bárbara Mori in *Kites*:** The Uruguayan-born Mexican actress Bárbara Mori is most popular for her role as the main character in one of the most successful *telenovelas* of all time. Because of her success, director Rakesh Roshan approached her to act opposite his son, famous actor Hrithik, to play Natasha/Linda in his 2010 feature film *Kites*.

- **Toby Stephens in *Mangal Pandey: The Rising*:** The English actor Toby Stephens has worked on stage, television, and film, including in the stage and film versions of *A Midsummer Night's Dream* and *Unfinished Business*, respectively. He was also cast to play Captain William Gordon in Ketan Mehta's film *Mangal Pandey*, starring Aamir Khan.

- **Clive Standen in *Namastey London*, 2007:** The British actor Clive Standen, best-known for his role as Bryan Mills on NBC's *Taken*, plays Katrina Kaif's boyfriend, Charles Brown, in the film, *Namastey London*, which also features actors Akshay Kumar and Rishi Kapoor.

Musical collaborations

Given that Bollywood's staple is music production, many artists from across the world have also collaborated with the brightest stars of Bollywood's music scene.

>> **Singh Is Kinng:** In this 2008 film, the title song features a collaboration with the one-and-only Snoop Dogg. He collaborated with the lead actor, Akshay Kumar (refer to Chapter 5), as well as Britain's hip-hop and bhangra fusion band, RDB (an abbreviation of *r*hythm, *d*hol, and *b*ass). Throughout the song, Snoop does what he does best, by rapping choruses about all things Punjabi and masala and donning a Sikh turban and seated atop a throne alongside Akshay Kumar. This movie ended up as a superhit worldwide.

>> **Blue:** Kumar went on to collaborate with another popular American singer for this feature film. That individual was none other than Australian pop star Kylie Minogue. The collaboration led to the song "Chiggy Wiggy," a carefree and catchy song featuring singers Sonu Nigam and Suzanne D'Mello. The soundtrack to this film, which was composed by the legendary A. R. Rahman, was received with positive reviews and thought to be a wonderful mix of genres.

A few years later, another hip-hop star took center stage to try to make a name for himself in this brand-new market. Singer, songwriter, and hip-hop artist Akon decided to leave his comfort zone and sing the hit song "Chammak Challo" (colloquial for Flashy Girl) in India's superhero movie, *Ra One*. Unlike Snoop Dogg, Akon took on the challenge of singing a great portion of the song in Hindi, despite not knowing how to speak the language. The song was dubbed as the main trademark of *Ra One's* publicity and marketing campaign, and ended up becoming the most downloaded and viewed song of the year. Despite the movie's not faring too well at the box office, "Chammak Challo" was a huge hit, and Akon (Figure 13-5 shows Akon performing with Shah Rukh Khan and German tennis player Boris Becker in London in 2011) was even nominated for Best Male Playback Singer for the song at the 2012 Filmfare Awards the following year.

It seems like rappers are on to something when it comes to collaborating with Bollywood. When the opportunity presented itself in 2019, rapper Nas was billed as executive producer of Zoya Akhtar's *Gully Boy* (Ally Boy). Though Nas didn't make an appearance in the film, he was mentioned several times throughout the movie. In one scene, Murad, played by Ranveer Singh, is shown rapping seven bars of Nas's song "N.Y. State of Mind" to a tourist. (You can read more about this film and the rap scene in Bollywood in Chapter 10.) Nas did, however, collaborate and produce a song alongside Ranveer Singh and the Indian-based rappers Divine and Naezy (whom *Gully Boy* was inspired by) — "NY Se Mumbai" (From New York to Mumbai).

PA Images/Alamy Stock Photo

The Janice Miller effect and social media

Love for Bollywood has taken many forms, with some folks going as far as learning the Hindi language just to further enjoy the content beyond using subtitles. Social media has opened the world to Bollywood.

Even before Instagram and TikTok existed, Bollywood has inspired creatives near and far. One of the most popular is San Francisco-born Janice Miller, who sings professionally in several South Asian languages, including Urdu, Punjabi, and Hindi, even though she can't speak any of them. Miller's love of Bollywood began after she moved to Ghana in 1989. (You can find out more about Bollywood's presence in Ghana in the section, "Sharing values with West Africa and beyond," earlier in this chapter.)

REMEMBER

Punjabi music comes from the traditions of the Punjab region of the Indian subcontinent. This form of folk, which is covered extensively in Chapter 11, is notable for its accompanying dance techniques, often including wrist movements.

Miller returned to America, where she quickly become a sought-after cover artist. Most of her fame came in Pakistani communities, and her first major concert was a performance at the Pakistan Day Parade in New York City in 1992. (Chapter 16

discusses more about Pakistan's presence in Bollywood.) In 2005, then Pakistani president Pervez Musharraf invited Miller to perform at a private party in the country's capital of Islamabad. Miller even ended up living in Pakistan for a year, with some people dubbing her the "eighth wonder of the world."

On social media, you can find everything from Instagram pages, such as @the_desi_cowboy, a novelty account run by a white boy who has a penchant for Bollywood pop songs. The Instagrammer hasn't revealed his name, but describes himself as a 2020 Harvard graduate. He uploads everything, including videos of people lip-syncing Bollywood songs to comedic remakes of Bollywood scenes.

Turn to the TikTok app and you'll find hundreds of users from across the world taking the Sadi Gali Hurt Wrist Challenge. In this challenge, one person pretends to have hurt their wrist but then begins dancing with a group to "Sadi Gali" (Our Alley), a Punjabi song that was later featured in the 2011 film *Tanu Weds Manu*.

Chapter **14**

Bollywood Fans Grow in the Masses

Bollywood fans are loyal, and sometimes to a fault. They love everything Bollywood. For instance, to show how devoted Bollywood fans are, consider this: Classic Bollywood actor Amitabh Bachchan (refer to Chapter 4) has amassed more than 40 million followers on Twitter alone, and as this book is being written, he'll soon be one of the Amazon Alexa voices. His fans and other Bollywood fans have praised, created fan pages for, and even dedicated their careers to learning and appreciating their favorite Bollywood heroes.

This chapter takes a closer look at all the different ways that Bollywood has permeated other media platforms. From serving as the subject matter for traditional games, to being the focus of various television shows, to driving its fans into a frenzy, Bollywood has covered all the bases in India and in the South Asian diaspora. Even if you don't watch Bollywood movies, chances are you'll come across Bollywood content through any one of these alternative sources.

Loving the Bollywood Culture

The Indian diaspora has spread widely throughout the world, ranging from parts of Africa, Europe, Russia, Southeast Asia, and, of course, Canada and the United States. Unlike their parents, the first-generation South Asians of those countries

didn't grow up in their ancestral homes; they're often seen latching onto Bollywood as an avenue to become versed in their culture and heritage. Across the board, South Asians are typically proud of their culture and love to immerse themselves in it, including numerous games and activities that revolve around Bollywood themes, which make for some fun parties. The following sections discuss several ways that Bollywood fans have embraced Bollywood and made it part of their fun.

Celebrating Bollywood with games and music parties

Bollywood is so revered that it has inspired countless fun and interactive games, played by many people who grew up in India and South Asia. Bollywood serves as a common bridge, uniting people in the Indian subcontinent as well as the South Asian diaspora through activities like these games.

CULTURAL WISDOM

A game that Indians and Pakistanis are particularly fond of is *Antakshari* (the game of the ending letter). In this musical game, two opposing teams typically sing songs to one another; however, each song begins with the consonant that the previous teams' song ended on. The game continues until one team is unable to come up with a song with the appropriate starting consonant.

Another adored pastime among South Asians is the music party, which is similar to a jam session except that the songs aren't improvised and created on the spot. Instead, they're famous songs, hailing from across South Asia and sung typically in their entirety. As you can already imagine, Bollywood songs are usually an easy go-to! Party-goers typically take turns singing songs and playing instruments (if available). This session, which is more popular among the older generation, can potentially last until the wee hours of the morning.

CULTURAL WISDOM

A popular form of the music party is a pre-wedding event commonly referred to as a *dholki* in Hindi. The event celebrates the new couple with elder women of the community, or *aunties*, singing wedding-themed songs in unison, whereas younger women often dance along. The name of the event is derived from the two-sided drum called a *dholak*, which is played by a designated aunty at each event.

More memes, please

The expertise of the youth has always been the Internet, tech, and social media. Memes are a terrific way for the younger generation to tap into Bollywood roots.

BOLLYWOOD-INSPIRED INSTAGRAM PAGES TO FOLLOW

To get a taste of the Bollywood fandom for yourself, or perhaps even join in as this book turns you into a fan, we suggest the following pages:

- **@bollywille:** This delightful page is equal parts nostalgia and hilarity; Bollywille takes iconic scenes and stills from the Indian silver screen to create incredibly hysterical memes.

- **@bollyshake:** This page truly honors and showcases the illustrious dance tradition of South Asian culture and Bollywood. With millions of videos being uploaded weekly on social media, Bollyshake started reposting a sample and highlighting originally choreographed dance videos to famous Bollywood songs from amateur talent across the world. As the page draws closer to a million followers, it has become one of the more standard pages to follow and be featured on if you're a Bollywood fan.

- **@desistandard:** This podcast is about all things South Asian media, as the hosts (who are the authors of this book!) help break down the themes, trends, and content of South Asian entertainment — and give insight into how it has affected them as first-generation kids growing up outside South Asia (see the following figure). The page goes beyond core Bollywood to influences that the industry has had from Pakistan and beyond.

Permission of Desi Standard Time

(continued)

(continued)

- **@instantbollywood:** This page has literally everything you would want to know, and probably don't even need to know, about Bollywood actors, dancers, producers, and more. With more than 6 million followers, this page ensures that you're never out of the loop on what's happening.

- **@bfunk:** This page has had many evolutions, from BhangraFunk (we tell you about this folk dance style in Chapter 11) and BollyFunk to ultimately bfunk to encompass it all. As a page dedicated to unique dances choreographed by instructors Shivani Bhagwan and Chaya Kumar, this account takes your fandom to the next level, by inspiring you to get off your feet and dance along with your favorite Bollywood beats.

A *meme* is a picture stemming from various pop culture references with a specific and contextualized caption relating to the photo. Memes are mostly for humorous purposes and have flourished wildly over the past ten years as they're shared person-to-person via social media, email, and text messaging.

Bollywood memes are especially interesting. For example, though the meme pics may ultimately hail from the subcontinent (given that they're images of Bollywood stars), the context of the caption and how it's used with the picture can fit in with any society or a culture.

We've also seen the reversal instead with American pop culture figureheads whose voices are dubbed over with Bollywood-inspired music, dialogue, or captions. One of the more popular memes is a collection of various Donald Trump speeches spliced together with the 2000 song "Nimbooda" (Lemon), dubbed so it looks like Trump is singing legendary actress Aishwarya Rai Bachchan's part. Ultimately, Bollywood memes (or any Internet meme, for that matter) are as successful as they are because it can bridge the gap between any two cultures, or even generations.

Spinning Off: TV Shows Discuss More about Their Beloved Bollywood

Unlike Hollywood, which defines the great film and television industry in the United States, Bollywood primarily refers only to the film industry in India, and that too only the films made in Mumbai. Indian TV shows or dramas are an entity of their own, with little if any crossover of talent. That said, some Indian shows have been created by and for Bollywood, allowing discussion, celebration, and more of this huge industry. These sections examine some of the more popular shows.

Koffee with Karan

Filmmaker, gossiper, controversial, and *exclusive* are just a few terms that describe the infamous Karan Johar. The one and only son of the late film producer Yash Johar has cemented himself as one of the top directors in Bollywood with many blockbusters, but over the years, Karan (refer to Chapter 2) has become infamously known more for his flamboyant personality and shocking antics. His larger than life reputation is fueled by his hit television talk show, *Koffee with Karan,* where he sits down with Bollywood's most elite and brightest stars and openly discuss details regarding not only movies and their acting chops but also their personal lives.

Koffee with Karan, which airs on Star World India, has completed six seasons over 15 years — and it doesn't look to be slowing down. To get a feel for it, think of it as Oprah Winfrey meets Howard Stern. *Koffee with Karan* has the mainstream and presentational panache of Oprah Winfrey's talk show and similarly can catapult any young and budding star into fame. Though it may not necessarily be as R-rated as the subject matter Howard Stern is notorious for, it's similar in the sense that the content Karan Johar dabbles in is racy and controversial within an intimate setting, because he has no live studio audience.

The guests featured on the show are usually A-list actors, actresses, and directors. Karan ends to host two or three at a time and on rare occasions might host a one-on-one chat. The show usually starts with him asking the more generic questions "How are you?" and "What's new?" as a way to get guests going. Not long after, he may casually pepper guests (and sometimes blindside them) with questions circling around the tabloids, paparazzi, or anything that would be considered more intimate, like details about their sex lives or their true opinions on other Bollywood stars. For the most part, guests are expected to be put on the spot, so to speak.

The guests are usually good sports who are enthusiastic about being on the show and partaking in whatever games Karan has in store for them. Often guests flip the tables and pressure the host with invasive questions, poking fun at him throughout in return. All in all, as a result, the show has always done well with ratings and is many a Bollywood fan's go-to guilty pleasure.

The show is no stranger to controversy, given the topics and on-air probing by Karan. It's a habit of his to simultaneously host guests who have some distinct association with one another. In one of the more popular episodes, actresses Deepika Padukone and Sonam Kapoor (read about them both in Chapter 6) were guests on one episode, and both were publicly known to have had romantic relationships with actor Ranbir Kapoor. With the help of Johar, both actresses had berated him throughout the episode, much to the dismay of his famous parents, Neetu Singh and Rishi Kapoor (see more in Chapter 4), which was a dream for the

tabloids. In another episode, actress Kangana Ranaut made it a point to call out Karan for giving her a hard time throughout her career for being an outsider and for constantly perpetuating the culture of nepotism within Bollywood.

Kapil Sharma Show

In the past few years, Kapil Sharmahas has knocked down the door to Indian TV in his own right with *The Kapil Sharma Show,* which is more than just a talk show — it's also a sketch comedy show. After winning *The Great Indian Laughter Challenge* in 2017 and six seasons of Sony's *Comedy Circus,* Sharmahas has ascended to new-found heights. He has not only cohosted the 60th Filmfare Awards in 2015 with Karan Johar but also acted and produced a few Bollywood movies, such as the 2015 *Kis Kisko Pyaar Karoon* (Whom Should I Love?) and the 2017 film *Firangi* (Foreigner).

The Kapil Sharma Show is recorded in front of a fairly large studio audience in Mumbai that includes a variety of other comedians who regularly help Kapil host his show. The first half of the show solely involves Kapil's monologue, followed by comedy skits alongside his fellow comedians; the second half of the show consists of Kapil interviewing famous Indian celebrities and personalities.

The Kapil Sharma Show is renowned more for its slapstick and off-the-wall humor. During the skits, the comedians come fully costumed and exaggerated sound effects, which are an Indian comedy staple, are played throughout moments of the show. The guests chat in a hearty and lighthearted dialogue with Kapil that includes an interactive Q&A with the live audience.

All India Bakchod

Not all comedians take kindly to the antics of Bollywood. One troupe of comedians that have gained popularity in recent years by satirizing and parodying Bollywood is the group *All India Bakchod (AIB).* (*Bakchod* means "baseless chatter," which is colloquial for "nonsense.") Led by comedians Tanmay Bhat and Gursimran Khamba, the duo started circling the comedy scene in the late 2000s. They first launched *AIB* as a pop culture comedy podcast, and they were later joined by fellow comedians Rohan Joshi and Ashish Shakya, whom Bhat befriended during his days in the Mumbai comedy scene. Thanks to their quick wit and commentary, they transformed *AIB* to the next level and began writing shows, producing comedy sketches, and releasing parody songs, all via their YouTube channel. They even created branded content for corporate clients.

AIB is best known for its satirical social commentary regarding Bollywood's nepotism, patriarchy, films, and songs. The show is best known for a few content types, such as these:

- >> "Honest Indian" series
- >> Their parody "Every Bollywood Party Song," starring the late actor Irrfan Khan
- >> "Creepy Qawwali," which expanded on men and their sleazy attempts at courting women

AIB also produced the "Roast of Ranveer Singh and Arjun Kapoor" in 2015, which featured other prominent comedians and was hosted by Karan Johar. Several other Indian celebrities were in attendance, demonstrating just how much *AIB* pushes the envelope when it comes to vulgarity in their content.

As you can imagine, anytime the envelope is pushed, it leads to some sort of pushback. *AIB* has been quite controversial, and even criticized, for its indecency and crude humor. Traditionally in Bollywood, comedy is clean and steers away from topics regarding promiscuity and sex, which is what *AIB* specializes in. Many people, however, have come to the group's defense, proclaiming that suppressing them is a way to suppress artistic expression.

More recently, *AIB* has been on a hiatus of sorts because of negative press, including some sexual harassment charges. Since then, the pair posted infrequently on YouTube, but did use the channel to promote their film *Chintu Ka Birthday* (Chintu's Birthday).

Recognizing When Fandom Turns into Obsession

Imitation is the finest form of flattery, and some fans take this flattery quite far. In fact, some have even emulated their favorite Bollywood scenes and songs from over the years in the form of wedding dances, skits, song parody videos, and even cosplay, whenever appropriate.

This fandom has gone to extremes as well. For example, the one-and-only Shah Rukh Khan (refer to Chapter 5) has a fan who has covered every inch of his home with pictures of King Khan. After actress Aishwarya Rai (who has been cited by media as "the most beautiful woman in the world") married actor Abhishek Bachchan, one fan sued her for allegedly causing him mental distress. Meanwhile, a fan of the present-day actor Aditya Roy Kapur (see Chapter 6) waited outside Kapur's home for nearly six days to try to meet him. Clearly, Bollywood celebrities are loved by their fans, sometimes to alarming degrees.

These sections identify situations where fans turned into fanatics because of their devotion to Bollywood.

Banning TikTok in India

With the advancement of social media, fans have been able to showcase just how obsessed they are with Bollywood, and no other platform saw as much of a Bollywood obsession as TikTok did. Those parodies were highly entertaining, with a wide array of performances and talents from slapstick comedy to downright dramatic (though still funny).

TikTok is a video-sharing social network that emerged in 2014. Owned by Chinese company ByteDance, the platform allows for short-form vies ranging from dance to comedy to education to everything in between. Each video can be anywhere from three seconds to one minute long.

In fact, TikTok saw approximately 600 million downloads from India alone, as fans showcased creative ways to lip-sync songs and famous movie dialogues as well as thousands of original skits. Figure 14-1 shows Indian American Ashley R. Singh who has amassed hundreds of thousands of followers on TikTok. She creates humorous videos ranging from poking fun at the people of Bollywood to living out her Bollywood fantasies.

FIGURE 14-1: Ashley R. Singh's TikTok.

Permission of Ashley R Singh

One reason that TikTok caught on internationally is the sheer entertainment value that Indian TikToks provide. Many people worldwide heard about them, and the only way they could be viewed was to download the app. Some TikToks became so popular that many people from around the world began emulating them, which exposed people to more Bollywood songs and scenes as well as to new talent, such as dancers, musicians, and DJs. For the moment, India has banned TikTok, but Bollywood fans will always find new and inventive ways to share their love for the industry across borders.

Majoring in Kapoorology

The Kapoor family has a heavily revered lineage, and the line of movie stars the family has produced spans multiple generations. Trying to keep up with who's who can be quite confusing, especially given that they have six generations worth of talent — so far.

To ensure that the legend of the Kapoor family remain intact throughout time, certain enthusiastic Bollywood fans have gone as far as to call themselves "Kapoorologists" when it comes to all things regarding the Kapoor family. The study of the Kapoor family entails documenting every member, how they're connected, and their contributions to the industry. Truly, the Bollywood fandom knows how to reach a fever pitch when it comes to showing their devotion to their favorite celebrities.

REMEMBER

You can see the Kapoor family lineage all across Bollywood, on screen and off. To read more about the Kapoors, turn to Chapter 2.

Chapter **15**

Grabbing Trophies: The Award Shows

Numerous entertainment outlets on television and the Internet continue to fuel the masses obsessed with Bollywood. You may wonder what turns actors and actresses into stars in the first place. Their chiseled good looks, daring fashion choices, and charming personalities can continue to garner the attention of the public for years to come. But, as with any entertainment industry, the obsession must begin with admiring their body of work.

Like other industries from across the globe, Bollywood also thrives on its annual awards shows. There are two main components to celebrating Bollywood cinema:

» The first is awarding those who brought the most popular movies of the year to life.

» The second element is honoring the films and stars of years past.

To keep the events entertaining, performances of the year's most popular movie songs break up the evening's accolades. Even though playback singers actually sing the songs on the movie soundtracks, the actors and actresses from the movie actually perform them onscreen. (Read Chapter 7 to find out about this unique concept.) Bollywood's overall aesthetic also veers toward vibrancy and visual stimulation, and so the performances are no different. With ample dancers, pyrotechnics, and colors, you can't look away from the action.

In this chapter, you walk down the red carpet and find out (drum roll, please!) who wins the trophy at the various awards shows. We also give you a tour of the wide array of South Asian film festivals that celebrate South Asian cinematic efforts, even outside of Bollywood.

Reaching for the Stars: India's Version of the Oscars

"And the Oscar goes to. . . ." Whoever ends up hearing this phrase is undoubtedly forever immortalized. The Oscars are known as one of the biggest nights in the United States as it commemorates the on- and off-screen talent that brought the biggest films of the year to life. The sights and sounds of the Academy Awards are forever embedded into American pop culture.

India is no different. Although it may not have the Academy Awards, it has a few storied awards shows that, in their own right, fit the bill of being dubbed Bollywood's version of the Oscars. Collectively, in their own way, the shows seek to commemorate, expand, and push the genres of Bollywood.

These sections examine the three most prominent awards shows in India, each bringing a different flare, level of respect, and location for celebration. These three — Filmfare Awards, IIFA Awards, and National Film Awards — most closely resemble the Academy Awards in the United States.

Finding Fame with the Filmfare Awards

Introduced to the Indian landscape in 1954, the Filmfare Awards were named after *Filmfare* magazine, a subsidiary of The Times Group. Every year, the magazine polled readers to choose the winners of select categories observing the artistic and technical excellence of Bollywood. Upon their inception, the awards consisted of only five categories, but now have expanded to almost 30. Unlike other awards shows, some of the more "Bollywood-esque" categories may include

>> **Best Choreography** recognizes the best dance choreography for a film's hit song.

>> **Best Action** calls attention to the best sequences consisting of fight scenes, car chases, stunts, or sport scenes.

>> **Best Playback Singer (Male and Female)** awards a singer for his or her contributions to a film's musical score.

The Filmfare Awards, which receive the most mainstream attention and so are considered to be the Academy Awards of India, are the pinnacle of recognition within the Bollywood industry. Similar to the Academy Awards, between award presentations the Filmfare Awards host live performances from the some of the nominees (Figure 15-1 shows Shah Rukh Khan and Alia Bhatt dancing onstage at the 2016 Filmfare Awards). Artists can become bona fide stars overnight after receiving an award and join the ranks of so many legends that came before them.

FIGURE 15-1: Shah Rukh Khan and Alia Bhatt dancing.

Dinodia Photos/Alamy Stock Photo

Here are some of the more notable feats in the history of the Filmfare Awards:

>> **Dilip Kumar and Shah Rukh Khan:** These two actors are tied for most Best Actor wins with eight apiece.

>> **A. R. Rahman** has won Best Music Director ten times, and at one point won the award four consecutive years between 2007–2010.

>> **Singer Nazia Hassan** remains the youngest-ever Filmfare Awards winner, at 16 years old. Hassan won Best Female Playback Singer in 1981.

>> **Gully Boy:** In 2020, this film surpassed both *Devdas* (2002) and *Black* (2006) as the movie that has won the most (13) Filmfare Awards.

Gully Boy is among the more recent Bollywood productions, gaining particular attention for moving the industry into rap culture. To find out more about this film and its musical ties, turn to Chapter 10.

Going international with the IIFA Awards

In recent years, the IIFA Awards (pronounced "EYE-fuh"), hosted by the International Indian Film Academy, have been considered to match the level of grandeur and notability to the Filmfare Awards. They've developed a reputation for bringing a different flare to celebrating Bollywood.

Given their inception in the year 2000, the IIFA Awards celebrate Bollywood with an emphasis on being bigger, brighter, and more extravagant. The IIFA Awards typically occur during the summer months (scheduled anytime from May to September) and are hosted in a different international city each year. (Past cities have included London, Singapore, Johannesburg, Amsterdam, Tampa, Toronto, and Madrid.) IIFA focuses more on jam-packing the event with performances and having a higher attendance. By comparison, the Filmfare Awards (which we discuss in the previous section) are considered to be a more classic awards show given its lengthy history and always being held in India.

American actor Gregory Peck, one of the most popular film stars from the 1940s to 1960s, was a guest of honor at the Filmfare Awards in 1954. To read more about Hollywood's presence in Bollywood, flip to Chapter 13.

The various host cities not only showcase Bollywood's international reach but also provide the opportunity to grab the attention of locals of the attending countries. For example in 2014, the 15th IIFA Awards were hosted at Raymond James Stadium in Tampa, Florida. IIFA took advantage of the fact that the awards were in the United States and extended an invite to some of Hollywood's most elite. Legendary Hollywood actor John Travolta was invited to dance onstage on two occasions during the show, once alongside Bollywood's elite dancer Hrithik Roshan and the other with actress Priyanka Chopra. During another segment, Hollywood actors performed the lungi dance with Bollywood actors Shahid Kapoor and Deepika Padukone, and also proceeded to take selfies with several Bollywood celebrities — paying homage by doing their own version of the iconic celebrity selfie taken by Ellen DeGeneres at the 2014 Academy Awards. Naturally, Travolta's participation garnered much attention by media outlets in both India and the United States.

REMEMBER

Many of the actors mentioned here made their way to performing at the IIFA Awards due to their successful careers in Bollywood, whether as actors, dancers, or both. To read more about their work, turn to Chapter 5.

Getting presidential with the National Film Awards

The National Film Awards, also introduced in 1954, have been around for as long as the Filmfare Awards and are administered by the International Film Festival of India. Taking place in New Delhi, the awards are presented firsthand by the president of India. Participating entries in the awards show aren't limited to Bollywood; rather, this ceremony honors Indian films made on a national scale. As a result, many critics actually consider this to be the most elite awards show in India.

With the intention of honoring genre-pushing films throughout India, the National Film Awards are free of commercial and mainstream distractions that awards shows like Filmfare or IIFA might attract. For example, no live performances or sketches are performed by delegated hosts and popular Indian personalities. Instead, the ceremony takes place at the Vigyan Bhavan, a New Delhi-based convention center that's exclusive to the Indian government. Jurors are delegated by the directorate of film festivals in India, and the rules and regulations for entry are considered to be stricter than for other awards shows.

Given its national scale, this awards show is meant to encourage and further the arts and culture throughout India. Although artists from other film industries within India are nominated, Bollywood's Amitabh Bachchan remains the artist with the most awards won, for Best Actor, with four wins.

Identifying Other Prominent Awards Shows

Given that Bollywood is the world's largest film industry, a number of awards shows match the volume of output. In this section, we discuss three awards shows that are second-tier, although they're prominent enough to discuss.

Coming and going with Zee Cine

Stemming from the Indian conglomerate known as the Zee Group (also known as Essel Group), the Zee Cine awards first made their debut in 1997. For the first couple of years, the awards took place in Mumbai. From 2004 onward, however, they took place internationally, in locations such as Macau, Dubai, London, Kuala Lumpur, Mauritius, and Singapore.

The Zee Cine Awards has had a bit more of a tumultuous history. As a company, the Zee Group has experienced financial trouble over several years, which led to a sporadic cancellation of the awards show. Nonetheless, it's still considered to be one of the bigger shows that celebrates Bollywood, with many A-listers attending.

Reaching for the Stardust

One of the staple magazine subscriptions covering Bollywood news and gossip is known as *Stardust* magazine. With its first issue released in 1971, the magazine made a name for itself over its tabloid journalism, and it temporarily expanded its reach with the initial Stardust Awards in 2004, until the final award show in 2016.

Given the prominence of *Stardust* magazine, the awards show naturally became another notable event. Like other awards, the show featured live performances and notable awards such as Best Actor, but Stardust was unique because it had awards culminating on a grander scale and timeline, such as these:

>> Best Artist of the Millennium

>> Best Director of the Millennium

>> Best Singer of the Millennium

>> Star of the Century

Given these awards' grand time frame, many trophies were given posthumously to artists such as Nargis (Best Female Artist of the Millennium), Mohammed Rafi (Best Singer of the Millennium), and Raj Kapoor (Best Director of the Millennium).

Starring in the STAR Guild Awards

Now known as the Producers Guild Film Awards, the STAR Guild Awards were given by the Producers Guild of India, from 2004 to 2016. Its former president, Amit Khanna, was the creator of the event. He also happens to be a triple winner at the National Film Awards and is the founder of Reliance Entertainment. Members of the guild were responsible for voting for the nominees and eventual winners

of the award. Similar to the Filmfare Awards, the event would typically take place within India.

What was unique about the STAR Guild Awards is that they honored not only those in Indian film but also in television. Here are some of the categories specific to Indian television:

>> Best Drama Series

>> Best Comedy Series

>> Best Nonfiction Series

Aside from television, here are a couple of unique categories pertaining to Bollywood:

>> **Entertainer of the Year** honors an actor or actress who had the best all-around previous year in the opinion of the Producers' Guild.

>> **Jodi (Couple) of the Year** honors the year's best onscreen duo.

CULTURAL WISDOM

One staple of this awards show is the trophy awarded to the winners: a 22-karat statuette composed of gold harvested from some of India's most revered landmarks — the Ajanta Caves and Ellora Caves.

GOING OUT OF INDIA: INTERNATIONAL SOUTH ASIAN FILM FESTIVALS

As Bollywood continues to produce new movies annually, it also continues to inspire film enthusiasts near and afar. Whether they're inspired by the Bollywood genre or not, members of the South Asian community have spread far and wide globally, paving their own paths in storytelling through the lens of film. As a result, a number of South Asian film festivals happen worldwide, honoring the amateur filmmakers of tomorrow — whether they're Indian natives or people from the overall South Asian diaspora.

South Asian International Film Festival

The United States has a large South Asian population — a large influx had migrated after the passing of the Immigration Act of 1965. For the most part, the diaspora has dominated in several disciplines and professions, but has never been quite as prominent in entertainment and media. That situation started to change with the first generation

(continued)

(continued)

of South Asian Americans. This diaspora started drawing inspiration from the unique upbringing and American influences, culture, and heritage — and, as a result, we saw many immersing themselves in the art of storytelling and filmmaking in the hope of sharing their experience with the rest of the United States.

Even though many South Asian Americans started committing to the arts, there was still a shortage of representation in the media. To further inspire arts and entertainment from within, the South Asian International Film Festival was founded. Established at the turn of the millennium in New York City, independent filmmaking was showcased by the exhibition of films from India, Pakistan, Bangladesh, Nepal, Sri Lanka, and the Indian diaspora.

The festival, which lasts from three to seven days, gives amateur filmmakers an opportunity to kick-start their careers by networking with other artists; to witness and enjoy other South Asian films; and to harness enough attention and acclaim to secure additional work in the industry.

Product of Culture's South Asian Film Festival of America

It's not always easy to create a project from scratch, especially if it's your first time. For that reason, Product of Culture was born. This nonprofit organization hosts pop-ups and mixers in New York City and Los Angeles with the intent of assisting South Asian creatives in their professional development while also celebrating their South Asian heritage.

A staple of Product of Culture is the South Asian Film Festival of America (SAFFA), which screens numerous short films, web series, and music videos. The films in this festival are directed by South Asian Americans and topically revolve around the South Asian diasporic experience. Though the featured bodies of work may showcase influences from either Bollywood or Hollywood, some pieces are able to fuse both influences in order to better tell the artists' story. With filmmakers and musicians participating from all across the United States, this festival is an inspiring way to network with other South Asian American creatives while also fostering potential breakout talent. The following figure shows the hosts of the South Asian Film Festival of America (SAFFA) Archana Jain (mid left) and Monika Sharma (right) with festival goers in 2019.

Tasveer South Asian Film Festival

This Seattle-based organization was inspired by the events of September 11, 2001, as a result of the festival organizers feeling that South Asians were unnecessarily scrutinized and misrepresented in the media. As a result, Tasveer, which means "picture," was born. It has become a catalyst in educating and furthering the dialogue for South Asian Americans in the Great Pacific Northwest. With the film festival occurring every October, Tasveer celebrates the diaspora by creating a space to have prolonged conversations with attendees about each film's sociopolitical themes.

Nepal America International Film Festival (NAIFF)

Nepal is a country in South Asia, located within the Himalayas and nestled between India, Bangladesh, and China. Often, it's overshadowed by its South Asian counterparts (India, Pakistan, and Bangladesh), and so this film festival started in 2017 to inspire emerging filmmakers of Nepali background to push their own stories. This Maryland-based festival features Nepali creatives from around the world seeking to educate attendees and globally unite Nepali creatives. The festival screens documentaries, feature-length films, shorts, and animations.

(continued)

(continued)

South Asian Film Festival of Montreal (SAFFM)

This Canadian-based film festival, introduced in 2016, offers films set within the Indian subcontinent and diaspora communities from across the world. The films, which are subtitled in both English and French, take place at the Kabir Centre in Montreal. Like the aforementioned festivals, the various themes in the films are discussed in a question-and-answer-style segment, usually with the director and lead actor.

Mosaic International South Asian Film Festival (MISAFF)

Based in Mississauga, Ontario, the Mosaic Film Festival has screened many renowned films over the years. Some of those films include the long-form version of Sharmeen Obaid Chinoy's Oscar-winning film *Saving Face*, and the hit film *Zinda Bhaag* (Run for Your Life), which went on to become Pakistan's entry into the Academy Awards. Started in 2012, the Mosaic International Film Festival has quickly become Canada's premiere film festival.

5

From Neighboring Industries to the Diaspora

Tour the subcontinent and the other film industries of the area.

Discover the obsession over dramas in Pakistani entertainment.

Get to know all the -ollywoods of the subcontinent, with industries in Bangladesh, South India, and more.

Expand your watch list with Tamil language films and songs.

Recognize Bollywood's reach in other industries such as Hollywood.

Check out the International Films featuring or influenced by the South Asian diaspora.

Spot which Bollywood actors and actresses have made their way to talk about their work on Hollywood talk shows.

Chapter **16**

Taking From and Giving To Lollywood

Whenever any country is divided by political lines, one of the often-forgotten effects among the chaos is the division of arts within the country. Such was the case with the Indian subcontinent after Partition in 1947 (read more about Partition in Chapter 3), as both the artistic hubs and the artists themselves throughout the unified India were forced to choose one country or another. The two cities that had produced most of the film and music before Partition, Bombay (now Mumbai) and Lahore, became premier destinations for artists on either side of the border.

A similar industry was burgeoning in Pakistan, in the cultural hub of Lahore. Though Pakistani films were made initially in present-day Dhaka, Bangladesh, all efforts were shifted to Lahore in 1971 after Pakistan split into the two states. Over time, the Pakistani film industry came to be known as Lollywood, following a similar naming pattern as Bollywood did (for being based in Bombay). Though in terms of popularity and cultural significance, Lollywood pales in comparison to Bollywood, the industry continues to produce music, film, and artists that influence Bollywood and the South Asian film industry at large.

Lollywood is now experiencing a resurgence. Partition-era artists like Noor Jehan (whom we also discuss in Chapter 3) carried the industry in its early years after Partition. However, in the 1980s and 1990s, Lollywood became almost an afterthought, hardly remaining relevant. An industry that at one time produced tens of movies a year was down to single-digit productions in any given year.

However, a new wave of artists in the 2000s have begun to revive the industry while also moving production to Pakistan's biggest and most populous city, Karachi. The resurgence has led to more exposure for artists within Pakistan and has brought Pakistan's film and music industry back into the international spotlight. In this chapter, we examine some of the notable talent and art to emerge from Lollywood and how Bollywood continues to borrow from its neighboring industry even today.

Influencing Bollywood Soundtracks: Pakistan's Musical Talent

Lollywood has produced some increasingly iconic artists on the international stage over the past decade or so. Because Lollywood is a much smaller industry than Bollywood, it lacks the reach and support needed to evolve and produce as much talent. Nevertheless, Lollywood has carved out its own name in the South Asian film industry, which the following sections discuss. In fact, Bollywood borrows from Pakistani artists more than many people know.

Because of the political friction between the two countries, collaborations are kept to a minimum. Yet some artists are so talented and influential that they transcend these restrictions and find their way into the Bollywood sphere. In particular, Pakistan's musicians have become recognized on a global level, and in many ways have surpassed some of their Indian counterparts.

Including Pakistani culture in Bollywood

Art forms reside in Pakistan and have influenced entire generations of artists and media consumers and continue to do so, particularly in the two art forms that have influenced Bollywood.

Ghazals: A form of sung poetry

One art form that became a staple of Pakistani culture and, in particular, Indian Muslims before Partition was that of the ghazal.

LOLLYWOOD OVERCOMING CHALLENGES

Despite Lollywood being smaller than Bollywood, it has overcome obstacles and made significant contributions to Bollywood. This list describes the obstacles that have affected the lack of talent within Pakistan:

- **The departure of artists from the country after finding success:** As Bollywood remains a global powerhouse, many artists from Pakistan exit the Lollywood industry and seek bigger, higher-paying roles in Bollywood. This leads to much of the premier talent feeding into the production machine that is Bollywood, but leaving behind a lack of star power in Lollywood and Pakistan at large.

- **Conservative leadership under the country's sixth president:** During General Muhammad Zia-ul-Haq's time in office (1978–1988), new taxes were levied on the film industry, and most cinemas in Lahore were shut down. Further taxes on consumer's viewing films decreased cinema attendance. Pakistani television (PTV) even stopped playing music videos as only patriotic songs were allowed to be on broadcast.

As awareness of these problems and more grew and as tensions between the countries made border-hopping more restrictive, artists began to make their mark on the international stage by remaining in Pakistan. In doing so, they're also able to preserve some of the rich artistic history that Pakistan carries, including musical forms that are native to the country.

CULTURAL WISDOM

A *ghazal is* a form of poetry that is often sung as an ode. Ghazals are often pain-filled songs written about unrequited love or as devotional ballads. Though originating in the Arab states as far back as the seventh century, ghazals made their way to the Indian subcontinent with the spread of Islam and the Persian empire.

Particularly, the ghazal form came to be associated with Sufi mystics, who would perform the ghazals as a spiritual tribute. Poets performing ghazals in Urdu, a language largely concentrated Pakistan, existed as far back as the 13th century.

Muslim poets had a hand in furthering the popularity of the humble ghazal. Renowned poets such as Jalal ad-Din Muhammad Rumi (referred to popularly as simply Rumi) gained recognition far and wide, helping to push forward the art of ghazals. Centuries later, a poet by the name of Muhammad Iqbal would play a major role in creating the Muslim independent state that is now Pakistan. Throughout history, ghazals have played an integral part in spreading knowledge, culture, and stories. Refer to Chapter 9 for more about the presence of ghazals in Bollywood.

Qawwali: A form of devotional singing

Another ancient form of music made popular in films by Pakistani artists is that of qawwali.

CULTURAL WISDOM

Qawwali is a form of devotional singing specific to Sufi Muslims. Originally performed at religious occasions and shrines, qawwali music gained worldwide notoriety in the late 1990s, thanks to the popularity of artists such as the Sabri Brothers and Nusrat Fateh Ali Khan.

Qawwali performances are instantly recognizable, with a main singer (the *ustad*, or "teacher") seated in the middle and surrounded by a few other singers and musicians. The songs are typically devotional pieces about love or religion, and each song can go on for as long as 30 minutes.

No singer has had as much of an influence on qawwali music as the late Nusrat Fateh Ali Khan. With fans all over the world, including U.S. presidents, Khan brought qawwali to the masses and popularized this type of music. What was once a religious occurrence became a staple of concerts and even began to appear in Bollywood films. Before Khan's death, a number of his songs had found their way into Bollywood soundtracks. Though some of the songs were recorded differently to give them wider appeal, Khan often provided the playback and music for many of the songs. Other artists now keep alive Khan's legacy and the tradition of qawwali; Khan's nephew Rahat Fateh Ali Khan is now one of the most recognized and accomplished singers in Bollywood. We discuss qawwali and its influence on Bollywood more in Chapter 9.

Rocking Pakistani-style

One of the more popular movements to come out of Pakistan has been its rock music hysteria. The craze began in the 1980s with Vital Signs and was then followed up by 1990's bands like *Junoon* (Obsession) and Strings. These rock bands served as the voice for an angsty generation that was fed up by prime minister Muhammad Zia-ul-Haq's conservative rule and banning of Western ideas and influences. The rock music craze from Pakistan grew wildly popular and also captured the attention of fans and industries within the subcontinent at large, including Bollywood.

The Hindi film industry not only borrowed the songs and other musical influences that the Pakistani rock scene had to offer, but it also took on the stars themselves. As a result, musicians such as Atif Aslam, Fawad Khan, and Ali Zafar were able to further their careers by expanding their fanbases in Bollywood. However, as the popularity of Pakistani music grew more widespread, these musicians would hardly be the last to transcend borders and make an indent in Bollywood, among other outlets.

Rockin' Out to Music Franchises So Good They're International

Rock artists continued to gain fame, and singers such as Atif Aslam, who started with Pakistani rock band *Jal* (Water) made the jump to Bollywood in order to reach a wider audience. However, Pakistan's rich musical heritage included several other genres, although they're often overlooked outside of Pakistan. Artists from other genres, such as pop and even qawwali, tried to jump ship and leave for Bollywood or other industries that would give them more fame and money. This further created a hole in the Pakistani music industry because talent couldn't be retained.

This situation changed in the late 2000s, as television programs devoted to showcasing musical talent from Pakistan took off. The following sections discuss two of the most successful in not only Pakistan but also the world.

Drinking it in: Coke Studio

No television program has had an effect on a country quite like the one that *Coke Studio* has had on Pakistan. A simple show that combines emerging and established musical artists with a live studio band to record popular and original songs, the show resonated with the Pakistani public in a way that few television programs ever had.

The show (see Figure 16-1 of Pakistani rock musician Omran Shafique playing guitar during his tenure on the house band on *Coke Studio*) was initially produced by Vital Signs member Rohail Hyatt, and was subsequently helmed by the members of Strings and another Pakistani rock band *Noori* (Light). However, the rock influence of its producers didn't stop the show from branching out into various other genres. The show was extremely successful in showcasing new talent across all forms of music, and even took on the task of reintroducing traditional music genres, like Sufi music and qawwali, to a younger generation. The show was an instant success both commercially and critically; it's now the longest-running annual television program in Pakistan.

With 13 seasons under its belt, *Coke Studio* shows no signs of slowing down or stopping anytime soon. Its success and cultural impact in Pakistan have prompted a number of spin-offs in other countries, making the show an international franchise. MTV India produces the *Coke Studio India* television show, which is also successful and features many of the playback singers and songs from Bollywood. Noting the success of the format that *Coke Studio* popularized, other television shows began to pop up with similar formats in an attempt to further showcase musicians and new music.

FIGURE 16-1:
Omran
Shafique plays
guitar at *Coke
Studio*.

Finding treasures: Nescafé Basement

Following the success of *Coke Studio*, show runners looked to create similar musical programs for television in Pakistan. One such offshoot that has recently found a lot of success is *Nescafé Basement*, a show that focuses on underground artists throughout Pakistan. The show is produced by another Pakistani rock veteran, Zulfiqar "Xulfi" Khan, from the rock group Entity Paradigm. The show initially toured college campuses around Pakistan and searched for young, hopeful musicians. Khan then mentored 15 of the best to create a new band for the show.

Following the success of the show, other bands have also begun to perform on the show. One such band, *Soch* (Thought) has gained widespread popularity for its song "Bol Hu" (Say Hu), which was also featured in the Bollywood movie *Malang* (Wanderer) soundtrack, remade as "Ho Ja Mast Malang Tu" (Become A Carefree Wanderer).

Soch had previously also recorded a song for a Bollywood movie; the original track "Awari" (Homeless) was included in the Bollywood movie *Ek Villain* (One Villain), and included vocals from another Pakistani artist who found fame from *Coke Studio*, Momina Mustehsan.

FAMOUS PAKISTANI SONGS IN BOLLYWOOD

Pakistani musical artists are being featured in Bollywood movies more and more. As they continue to gain global followings and widespread popularity, Bollywood is taking it upon itself to include some of their works in its films. This trend isn't altogether new, because Bollywood has definitely borrowed music and movies from other industries. Here are some of the most famous Pakistani songs that are heard in Bollywood movies:

- **"Aadat" (Habit), *Kalyug* (Modern Era):** Sung by perhaps Pakistan's most famous modern-day singer, Atif Aslam, the song "Aadat" is a remake of the song "Woh Lamhe" (Those Times), which was performed by Atif Aslam's band, *Jal* (River), and initially catapulted him to stardom. This would become the first of many songs that Atif lends his voice to in Bollywood, and it launched his career as an international superstar.

- **"Sayonee" (Soulmate), *Sayonee:*** Adapted with more modern sounds for the 2020 version, "Sayonee" is a classic and the most famous of Pakistani rock band Junoon's hits. Upon its initial release in 1997, the song became an overnight sensation that swept across the subcontinent and catapulted Junoon to fame. The original song remains popular even now, as is evidenced by its adaptation into a modern version for a film of the same name in 2020.

- **"Loye Loye" (Come Here), Yaraana (Friendship):** Perhaps no other Pakistani artist has been remade for Bollywood more notably than the King of qawwali himself, Ustad Nusrat Fateh Ali Khan. This classic hit, which he debuted in 1990 and endures as one of his best songs, was remade for the 1995 film *Yaarana* (Friendship), which starred Anil Kapoor and Madhuri Dixit. The adapted version featured female vocals by Kavita Krishnamurthy, but the song was instantly recognizable as the classic Khan hit. Another song included in this soundtrack, titled "Mera Piya Ghar Aaya" (My Beloved Has Come Home), is another Fateh Ali Khan hit that was remade.

Crossing Over: Lollywood Impacting Bollywood

The significance of Pakistan's music industry on its neighboring India and Bollywood is undeniable. However, music isn't the only artistic aspect that transferred to India. As the Lollywood industry seeks to reestablish itself and gain more popularity, it also produces stars with worldwide recognition and serious talent.

As with the music industry, these talented stars often look outside Pakistan in order to make more money and gain more recognition. Of course, there is no better industry in the world to be in, in terms of popularity, than Bollywood itself. As a result, a number of successful Pakistani artists have found their way into the Bollywood mainstream.

This transition hasn't always been easy, however. It's important to note that the politics between the two countries remain prohibitive. Indeed, it has been less than a century since the two countries split. Many of the ill effects of splitting a country persist today, not only as a narrative in Bollywood films but also as headlines when the Lollywood and Bollywood industries aim to collaborate. This next section shows how that has played out in films produced by Bollywood as well as the newer trend of Lollywood being casted for Bollywood productions.

Indo-Pak relations, as told through Bollywood

As the wounds of Partition continue to heal, Bollywood has shown many differing viewpoints of the struggle and identity crisis that Pakistani, Indian, and Bangladeshi people often feel. Because many current South Asians can trace their roots to sometimes all three of these modern-day countries, it can often be difficult to identify with a national identity from any one of them, particularly in the international diaspora.

Bollywood has touched on an array of issues that still remain a hot topic within the region in varying ways. The most prominent is definitely centered around Partition. Some of these productions include

>> *Kalank* (**Stain**): Kalank uses Partition as a backdrop to other events that are occurring in the film.

>> *Gadar: Ek Prem Katha* (**Rebellion: A Love Story**): *Gaddar* more heavily involve the events of Partition and how it affected peoples' lives.

>> *The Legend of Bhagat Singh:* *The Legend of Bhagat Singh* covered important events and people leading up to Partition.

In many of these movies, Muslims and/or Pakistanis are often shown as antagonists, which has led Pakistan to ban certain movies over the years.

Partition wasn't the end of the quarrels between India and Pakistan. Still, other movies showcase the ongoing disputes and political situations between the

two countries. Movies like *Fiza* and *Mission Kashmir* focus on terrorism and the disputed province of Kashmir. The two countries also bumped heads in 1971 as East Pakistan (known today as Bangladesh) gained its independence. A huge blockbuster movie, *Border*, was released in 1997 and showcases this conflict. Though the movie had an antiwar message, it again depicted Pakistan in an antagonistic light, causing dissent from people across the border from Mumbai.

Finally, some movies simply highlight the unfortunate circumstances that can occur because of the political disputes between the two countries. Perhaps one of the most famous is *Veer-Zaara*, which tells the tale of two lovers from either side of the border and their struggle to settle peacefully with one another. Though Pakistan in the movie is again shown as the bad guy, so to speak, the movie carries a poignant message in its ending about the shared values and cultures of the two countries, preaching unity.

Pakistani actors crossing the border

As soon as musical artists from Pakistan began to achieve greater success in Bollywood, a precedent was set for other artists as well. Atif Aslam and Ali Zafar were household names before moving over to Bollywood and achieving major success. Ali Zafar, who gained fame as a singer, was even able to secure lead acting roles in successful films such as *Mere Brother Ki Dulhan* (My Brother's Bride). At the same time, actors from Pakistani drama serials were gaining fame and recognition across the subcontinent. Though Lollywood continues to be a small industry with only a few productions a year, the Pakistani television drama segment is huge, with many of the dramas becoming beloved all across the subcontinent.

The popularity of some of the actors in these drama serials sets the stage for more talent moving across borders. Two actors in particular, Mahira Khan and Fawad Khan (no relation), found stardom in the superhit Pakistani drama series *Humsafar* (Lifelong Partner), in which both had starring roles. Fawad Khan first made the leap to Bollywood in 2014, appearing in *Khoobsurat* (Beautiful) alongside Sonam Kapoor. The role earned him a Filmfare Award for Best Male Debut and launched him into the public eye of Bollywood.

Khan appeared in a few other roles — notably, his Best Supporting Actor performance in *Kapoor and Sons*, for which he received critical praise as well. However, his casting in the Karan Johar-directed *Ae Dil Hai Mushkil* (The Heart's Affairs Are Difficult) was met with serious backlash because Pakistan and India were again enduring political turmoil in 2016. In fact, soon after the movie's release, Pakistani actors were temporarily banned from appearing in Bollywood films.

Mahira Khan also had a controversial foray into Bollywood, though for different reasons. Following the temporary ban against Pakistani actors, Mahira Khan's Bollywood debut was made in the 2017 film *Raees*, opposite none other than Shah Rukh Khan. Though the film was a box office success, Mahira faced criticism from both sides of the border. Conservative groups in India asked for her scenes in the movie to be deleted because of her Pakistani heritage, and conservative groups in Pakistan criticized her for appearing in a Bollywood film with more liberal clothing than Pakistani media is accustomed to. To date, *Raees* (Rich) has been Mahira Khan's only Bollywood film (see Figure 16-2) — and who can blame her, after the ruckus that even a single film caused?

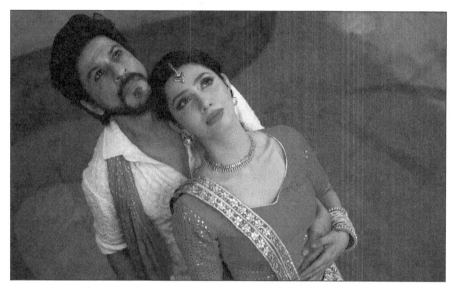

FIGURE 16-2: Mahira Khan, acting alongside Shah Rukh Khan.

AF archive/Alamy Stock Photo

Though Pakistan and India have a shared history and similar cultures, the two countries have distinct entertainment industries. Though Bollywood reigns supreme in terms of film, Pakistan has etched out a fantastic reputation for its television drama serials. The music of both countries continues to thrive, and in many cases what's popular in one is also popular in the other. It remains to be seen how the industries of both countries continue to intertwine and produce content for the Indian subcontinent at large.

TEN PAKISTANI DRAMAS WORTH THE DRAMA

Pakistani drama serials are all the rage in not only Pakistan but also across the subcontinent. The intricate storylines, distinct camerawork, and legendary performances of many of these serials earn them a special place in the hearts of South Asians. A common stereotype within the South Asian community is watching one of these dramas on TV while enjoying the family meal — this book's authors may or may not have had such an experience growing up! If drama is something you crave, this list of ten of our picks for Pakistani dramas is worth your time to read:

- *Dastaan* **(The Tale):** Starring Fawad Khan and Sanam Baloch, and based on the novel *Bano,* by Razia Butt, *Dastaan* tells the story of two lovers separated by the events of Partition. A love story that examines more than just its characters' individual stories, this 2010 drama serial is widely regarded as one of the best of all time in Pakistan.

- *Humsafar* **(Life Partner):** The 2011 drama serial that launched the careers of Fawad Khan and Mahira Khan, *Humsafar* may be the most popular Pakistani drama of all time. A tale of love, devotion, betrayal, and forgiveness, this serial really does cover the full range of human emotion. It's a must-see series for any fledgling Pakistani drama fan.

- *Akhri Station* **(Final Destination):** A somewhat different Pakistani drama than most, *Akhri Station* deals with such hard-hitting topics as mental health, depression, and misogyny in the Pakistani community. Lighthearted at times and poignant throughout, this 2018 drama definitely deserves a viewing. This drama stars actress Sanam Saeed and actor Mikaal Zulfiqar.

- *Zindagi Gulzar Hai* **(Life Is a Poem):** Another drama starring Fawad Khan, this 2012 drama also starred popular actresses Samina Peerzada and Sanam Saeed. Though the star power alone could have catapulted this drama to the top, the story and backdrop of Pakistan–India relations served to make this drama an instant classic.

- *Meray Paas Tum Ho* **(I Have You at My Side):** One of the more recent additions to Director Nadeem Baig's collection of work, *Meray Paas Tum Ho* features a memorable title song, excellent performances by popular actors Humayun Saeed and Ayeza Khan, and an engaging storyline centering around infidelity in marriage. The 2019 serial was met with criticism from some feminists within Pakistan for its portrayal of women in marriages, and it deserves a viewing if only to engage in the conversations around it.

(continued)

(continued)

- ***Diyar-E-Dil* (Valley of the Heart):** A 2015 family drama featuring an ensemble cast, this short-but-sensational drama follows a family through its trials and tribulations over multiple generations. The drama was highly rated at the time of its release and gathered a large following. With standout performances from nearly all its cast, this serial is still worthy of viewing today. This ensemble cast includes the likes of actress Maya Ali, and actors Abid Sher Ali and Osman Khalid Butt.

- ***Khuda Ki Basti* (God's Colony):** One of the oldest and most successful Pakistani dramas, *Khuda Ki Basti* is often credited as the 1969 drama serial that established the genre. The show was so good, in fact, that it was re-telecast five later in 1974, upon the direction of Pakistan's prime minister at the time!

- ***Alif* (A):** Another recent drama to make waves, *Alif* gained widespread positive attention for its direction, cinematography, and writing in 2019. The story of two individuals overcoming past trials and tribulations, *Alif* is based on a novel by Umera Ahmad, who is known for having written a number of novels that have been adapted into Pakistani dramas. This series stars actor Hamza Ali Abbasi and actress Sajal Aly.

- ***Aunn Zara* (Character's Names):** Not all Pakistani dramas have to be serious, and this 2013 romantic comedy serial proved just that. With a relatively low budget and an unknown cast, this smart and lighthearted serial was based off the novel "Hisaar-e-Mohabbat" (Fort of Love) written by Faiza Iftikhar, and also encouraged a new generation to watch a genre normally reserved for more mature audiences.

- ***Jackson Heights:*** Another lighthearted drama serial, *Jackson Heights* resonated with many South Asian audiences living abroad, particularly in the United States. Centered on six Pakistanis living in the Jackson Heights neighborhood of Queens, New York, the 2014 show features an ensemble cast that navigates the nuanced life of South Asian immigrant families in the western world.

Chapter **17**

Examining South India's Bollywood

The ascension of Bollywood in India and on the international stage often leaves other Indian film industries out of the spotlight. However, Bollywood often draws its inspiration from a number of these regional industries. Although the main difference between each of these industries is their unique languages and location, each individual industry in India maintains its own style and distinct characteristics.

Many of these regional film studios date back well before Partition (which we discuss in Chapter 3), and before Bollywood's rise to become the top film industry in the country. Some of these studios have even rivaled Bollywood's output in recent years. Many of them serve as inspiration for — or even outright copy material from — Bollywood films. Many of the artists involved in each industry often cross over into Bollywood as well; professionals, ranging from music composers, singers, actors, and directors from the South Indian film industry have made their way into Bollywood at some point.

Today these parallel industries continue to produce talent and content at a remarkable rate. The film industries that we discuss in this chapter are still very much part of the national conversation in India and often have a profound effect on Bollywood and other media forms within the country.

The tale of South Asian "-ollywoods" doesn't end here. Although a discussion of other industries is beyond the scope of this book, they're alive and well on the subcontinent, including Dhallywood; the Bangladeshi film industry in Dhaka, Bangladesh; as well as the Nepali Kollywood, produced mainly in Kathmandu, Nepal. That said, the Nepali Kollywood often takes influence from Bollywood, creating similarly styled films and songs.

A Tale of Two Tollywoods

The common trend with naming film industries around the world is simply changing the *H* in *Hollywood* to correlate with the first letter of whichever city the industry resides in, or the language that the movies are produced in. Bollywood, for example, received its moniker from being based in Bombay. So, what happens when two film industries in close proximity are both characterized by something that starts with the same letter? Apparently, they're given the same name!

That's the case with Tollywood, the film industry emanating from India's Tollygunge region, as well as Tollywood, the Telugu-language film industry. Both of these film industries, which the following sections discuss, have a storied past and a vivacious following today. Each has been important in its national influence in separate ways, and each has also seen important characters in their rise and development that shaped cinema in India as a whole.

Here's a clearer picture of this region: Western Bengal is a state in Eastern India between the Himalayas and the Bay of Bengal. It's capital is Kolkata (formerly Calcutta), where the Bengali film industry of Tollywood is based. The Bengali language is often spoken here and in Bangladesh. Meanwhile, the Telugu-language Tollywood is for the film industry based in Telangana and Andhra Pradesh, both Southern states in India.

The Tollywood of Bengal

With a population of more than 90 million inhabitants, West Bengal is one of the largest states in India by population. Residing on the west side of the Bay of Bengal, West Bengal was also once the center of the Indian film industry. Because the industry is headquartered in the Tollygunge region of South Kolkata, the industry has been dubbed Tollywood as a portmanteau (blend) of *Tolly*gunge and Holly*wood* for almost a century. Many of the most important Indian movies of all time have come from this region and industry, with some of the earliest works inspiring even Western filmmakers.

The most famous Bengali Tollywood filmmaker of all time is the late Satyajit Ray (Figure 17-1 shows Ray behind the scenes in 1955 for his film *Pather Panchali*). Ray was a pioneer of Indian cinema, often writing, directing, composing, and editing his movies — talk about creative control! His debut film, *Pather Panchali* (Song of the Little Road), is the first in his famed *Apu Trilogy*, gaining him instant recognition and success as a filmmaker. The film would go on to win the Best Human Document award at the famous Cannes Film Festival in 1955 and would win a number of other international film awards in the same year. Interestingly enough, Ray made *Pather Panchali* with no studio funding and mostly with amateur cast and crew. The success of the film eventually lead to more resources for Ray in the second two installments of the trilogy, and by the time *The World of Apu* hit theaters, Ray was a household name.

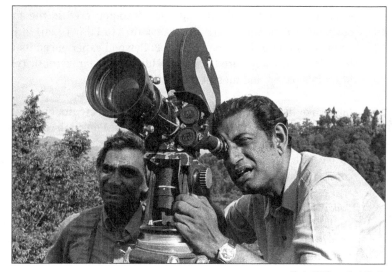

FIGURE 17-1: Bengali writer, director, composer, and editor Satyajit Ray.

Photo 12/Alamy Stock Photo

Ray's pioneering efforts brought international attention to the Tollywood film industry. His unique style and dedication to showcasing emotion led to the rise of parallel cinema, which originated in Bengali Tollywood and was characterized by real, natural takes on socioeconomic conditions in India. It was a significant film culture movement in India during the 1950s and 1960s, apart from the mainstream Indian film industry.

The golden age of Tollywood coincided with Bollywood's, during the 1950s and 1960s (Chapter 3 discusses Bollywood's Golden Age in greater detail). It was during this time that many of its most famous movies, actors, and actresses were emerging. Artists like Utpal Dutt and Sharmila Tagore defined this period of Bengali cinema and would influence artists for many decades. Actress Aparna

Sen, who was a household name during Bengali Tollywood's heyday, also took up directing films starting in the 1980s and created many award-winning films.

Today, the Bengali Tollywood industry continues to produce acclaimed content. Many of its directors and actors have spent some time in Bollywood as well. Bollywood movies like *Kahaani* (Story) and *Piku* feature Bengali directors and stories. Both of these movies were commercial and critical hits, cementing talent from the Bengali Tollywood industry as some of the most important for Indian cinema's future.

Telugu cinema, another Tollywood

India's other Tollywood, originating from the state of Telangana, features movies made in the native Telugu language. Headquartered in the aptly named neighborhood of *Film Nagar* (literally translating to Film Town) in Hyderabad, Telugu cinema also dates back well before Bollywood experienced its meteoric rise after Partition. With some productions dating back as far as 1909, Telugu cinema is one of India's oldest and most impactful film industries.

REMEMBER

Much like the other Tollywood, Telugu cinema credits one man with putting the industry on the map, so to speak. Ragupathi Venkaiah, commonly referred to as the father of Telegu cinema, made numerous short films at the beginning of the 20th century. He would eventually make films with sound, or *talkies*, as they were commonly referred to.

REMEMBER

Talkies or *talking pictures* are informal terms for films that incorporated actual audible dialogue, rather than the subtitle-like text plates what were formerly used. The terms emerged in the 1920s and 1930s to help distinguish sound films from silent films.

Many of the early Telugu-language films were epic or religious in nature. Though the industry has diversified over time, and movies of all different genres are now made in Telugu cinema, a large portion of India's fantasy- and mythology-driven movies originate in Tollywood.

REMEMBER

Telugu cinema is now regarded as some of the most groundbreaking and creative cinema in India. Telugu Tollywood directors like Ram Gopal Verma are brought into Bollywood to make movies in their distinct perspective. Taking things a step further, Bollywood often remakes Telugu-language films into Hindi versions rather than simply dub the language for the film. Additionally, the effects and cinematography work of Telugu films are some of the most advanced in India; the continued creativity and development by Telugu filmmakers continues to help Bollywood thrive as they adopt the Telugu storylines and advanced technology.

Remaking culture — from Tollywood to Bollywood

One of Bollywood's most striking characteristics is its willingness to borrow from other film industries. In fact, many Bollywood movies have been shown to be direct remakes of foreign films. (Hollywood movies are regularly adapted for Bollywood audiences, with hardly any credit given to the original motion picture that the Bollywood film plagiarizes.) This practice of remaking movies is taken to a different level within India, however. Many Bollywood movies are direct remakes of Tollywood films. Some of these movies, like *Ready*, aren't even given new names when remade in a different language.

Over time, this practice has become almost second nature for Bollywood. Today, hundreds of movies that originated in the Tollywood industries have been remade into Bollywood movies. Bear in mind that these aren't simple dubbings — the movies are completely remade with new casts, new dialogue, new songs, and, often, new directors. The continued practice of remaking Tollywood films is a double-edged sword: Though the remade movies take away from the revenue and fame of the original movies, they help to spread the storytelling and originality of the Tollywood filmmakers. Bollywood owes a certain debt of gratitude to its neighboring industries for their heavy influence on its productions.

Tapping into Tamil Cinema: Kollywood

If Bengali and Telugu language cinemas are the younger siblings to Bollywood, Tamil cinema is the distant, equally talented cousin. With an extensive worldwide reach, Tamil cinema has grown to become one of India's largest film industries. Tamil cinema is mainly produced out of the Kodambakkam neighborhood of Chennai in India. Following the normal nomenclature rules of film industries in India, Tamil cinema is therefore referred to as Kollywood, combining *Kodambakkam* with *Hollywood*. Tamil cinema has gained particular recognition for gaining viewership internationally and for using the Tamil diaspora in areas like Southeast Asia to establish new, more widespread distribution areas.

CULTURAL WISDOM

The Tamil language is spoken by more than 70 million people. It's the official language of not only the Indian Tamil Nadu state, but also the nations of Singapore and Sri Lanka.

Even though Kollywood itself is full of its own film productions, some of its most famously known works come from its music. From notable music videos to famous musicians, Kollywood served many hits that grew its reputation in the subcontinent and beyond.

A secondary hub for Hindi cinema

Kollywood has as much crossover with Bollywood as any other Indian film industry. Many Tamil movies are remade into Hindi movies, giving Kollywood the classification of a secondary hub for Bollywood.

Directors such as Mani Ratnam have forged their paths through Kollywood and directed movies for Bollywood as well. Some of the most well-known Bollywood movies, such as *Saathiya* (Companion), which was completely remade, and *Bombay*, which was dubbed, were Ratnam productions in Tamil that found their way to the Bollywood big screen. Some remakes even feature the original actors in them; for example, the Tamil movie *Minnale* (Lightning) was remade with the same main actor, R. Madhavan, and director, Gautham Menon, into the Bollywood hit *Rehna Hai Tere Dil Mein* (Need to Stay in Your Heart).

The success of Tamil movies has led to a vivacious industry not only in India but also abroad. With more than 5,000 Tamil-language movies made to-date, the industry continues to grow and cater to a worldwide Tamil-speaking audience. In fact, Kollywood has inspired other independent film studios around the world where the Tamil diaspora is present.

The Kollywood industry is also known for feeding Bollywood with musical inspiration, and some of Bollywood's most famous songs are Tamil remakes in Hindi. Sometimes, listeners have no idea of the song's origin; at other times, some Tamil is retained in the new song, paying homage to the original soundtrack. Here are some famous Bollywood songs that were originally in Tamil:

>> **"Muqabala" (Fight):** Composed by A. R. Rahman, this Kollywood song weaves lyrics in English and Tamil, courtesy of lyricist Vaali. The film was dubbed in Hindi and released as "Humse Hai Muqabala" while the song was remade as "Muqabala Muqabala." The soundtrack alone sold two million album units in India.

>> **"Kannalane" (My Darling):** This Tamil song based on the Sufi art form qawwali (read more about qawwali music in Chapter 9) is by K. S. Chitra. The song went on to win the Tamil Nadu State Film Award for Best Female Playback and was almost simultaneously remade in Urdu by lyricist Mehboob to create the Bollywood version, called "Kehna Hi Kya" (What is There to Say). The Hindi version was not only on *The Guardian*'s list of "1000 Songs Everyone Must Hear" but was sampled in 2009 by American singer Ciara for her song "Turntables," featuring Chris Brown.

>> **"Nenji Nile Nenji Nile" (Rebirth):** This 1998 song features famous singers Sistla Janaki, Sujatha Mohan, and Hariharan, all of whom have sung in Hindi and Tamil, among other languages. The song was remade in Hindi to "Jiya Jale" (The Heart Burns) for the famous Bollywood film *Dil Se..* (From the Heart).

Kollywood's greatest gift to Bollywood: A. R. Rahman

One man hailing from Madras (now Chennai) has done more for Bollywood than perhaps any other individual: A. R. Rahman (whom we mention in Chapter 7) is a true one-man powerhouse in composing music for Tamil- and Hindi-language films. Getting his start alongside the famed Tamil director Mani Ratnam in movies like *Roja* (Rose) and *Bombay*, Rahman was quickly hailed as a musical genius and even began to gain recognition internationally for his work. Figure 17-2 shows Rahman singing a song during a live concert in Calcutta in 2003 in front of nearly 50,000 people. Rahman also won a National Film Award for Best Music Direction for *Roja*, which was his first film. Chapter 15 discusses the Bollywood Award Shows.

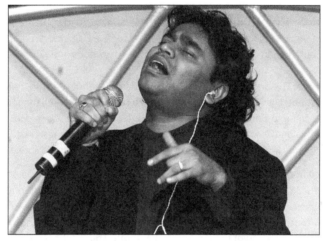

FIGURE 17-2: Indian composer, musician, singer, and music producer A. R. Rahman.

REUTERS/Alamy Stock Photo

Another South Indian director, Ram Gopal Verma, brought on Rahman to compose the soundtrack for his Bollywood film *Rangeela* (Colorful), marking Rahman's debut in Bollywood. The music for *Rangeela* was a huge hit, landing Rahman Best Music honors that year at the Filmfare Awards. He followed up this success with compositions for hit movies such as *Dil Se..* (From the Heart . . .) and *Taal* (Rhythm) and never look back. The success of the soundtracks from these two movies was astronomical, with songs like "Chaiyya Chaiyya" (In the Shade) from *Dil Se.*, and "Taal Se Taal" (Match My Rhythm) from *Taal* — still regarded as some of the most famous and influential songs ever to appear in Bollywood movies.

Rahman's illustrious career has spanned three decades, and he has already established himself as one of the most influential people in the world, let alone Bollywood. Rahman has won an astounding number of awards, including two Academy Awards, two Grammy Awards, a British Academy of Film and Theatre Arts (BAFTA) Award, a Golden Globe, and 15 Filmfare Awards. His accomplishments and contributions to Indian cinema are truly astonishing, and he continues to compose for Kollywood and Bollywood.

FAMOUS SOUTH INDIAN REMAKES IN BOLLYWOOD

Simply because Bollywood has remade other industries' movies doesn't mean that they should be avoided. Thanks to the extensive resources, funding, and production value that Bollywood provides, many of these remakes end up being as good as, if not better than, their originals. Here are our picks for five Bollywood remakes, originally from South Indian film industries, like the two Tollywoods and Kollywood:

- *Wanted:* The original Telegu film was made by legendary South Indian film personality Prabhu Deva. It was so popular that he remade it in Tamil the following year and then came to Bollywood and remade it again in Hindi as *Wanted* in 2009. Starring actor Salman Khan as an undercover cop dealing with gangsters, this movie had a fresh story line and memorable dialogue that audiences absolutely loved.

- *Ghajini:* *Ghajini* takes remakes to a new level. The original *Ghajini* is a 2005 Tamil-language film whose plot borrows heavily from the 2000 Christopher Nolan thriller *Memento*. Upon the Tamil film's excellent run at the box office, the film's director, A. R. Murugadoss, teamed up with Bollywood legend Aamir Khan to release a Bollywood version of the film in 2018. Starring Khan in the lead role, the movie was a close remake of the Tamil original and broke numerous box office records upon its release.

- *Nayak: The Real Hero*: Another successful Tamil film remake that was injected with star power in Bollywood, *Nayak* was a remake by director Shankar Shanmugam of his own Tamil-language film *Mudhalvan* (Leader). With Bollywood actors Anil Kapoor and Rani Mukherji as headliners in this 2001 Bollywood film, *Nayak* was a critical success and has gained a significant cult following over the years. The movie is another example of South Indian cinema's propensity to create original storylines that resonated with audiences regardless of their language preference.

Chapter **18**
Reaching Hollywood: Bollywood's Impact

The globalization of Bollywood has been absolutely phenomenal. Expanding into multiple markets all across the globe (Russia, China, Africa, Europe, Middle East, North America), Bollywood has taken inspiration and influences from other markets and industries, and the same has happened from Bollywood as well. Although Bollywood is always trying to push the envelope within its own narratives and keep up with the current times, for the most part it still has the global reputation of creating long-winded, romantic musicals with a heightened and colorful take on reality.

Danny Boyle's *Slumdog Millionaire* may have been the most popular movie to expose Western audiences to Bollywood's style of storytelling, production, and talent (such as Irrfan Khan or Anil Kapoor). Bollywood has been collaborating and embedding itself into Hollywood's mainstream for several decades.

It's also worth examining the effect that both Hollywood and Bollywood have had on the South Asian diaspora in the United States and the lucky few who have emerged as stars and spokespeople of this diasporic narrative. For more info specifically on Bollywood's global impact, turn to Chapter 13.

Recognizing Bollywood Actors in Popular Hollywood Media

You may be more familiar with all things Bollywood than you think. Although in recent years an increased influx of talent from Hindi cinema has broken through the barriers to Hollywood, Bollywood stars have been dabbling in Hollywood-related projects for decades, some of whom you might have already seen on the small and silver screens.

Hindi film stars have been able to transcend Bollywood and showcase their talents to Western audiences by way of TV and film. Some of the more publicized and standout names that come to mind are Irrfan Khan, Priyanka Chopra, and Anil Kapoor. To read more about their contributions to Hollywood, check out Chapter 21. Meanwhile, several Bollywood actors' work flew under the radar and wasn't as publicized as the aforementioned stars. We discuss them in the following sections.

Leaving a legacy: The late Irrfan Khan

Few Bollywood stars have broken through barriers and landed roles in both American television and film, other than Irrfan Khan, who received acclaim from fans and critics alike during his time in Hollywood.

Originally, Khan was a cricket prodigy whose parents ran a tire business. He was selected to partake in an elite 23 and under cricket tournament, but unfortunately had to back out because he couldn't afford the travel expenses. Citing Rajesh Khanna as his favorite Bollywood actor and muse, Khan followed in the footsteps of Khanna, with the help of his theater actor uncle, and joined Delhi's National School of Drama. For more about him, keep reading.

Focusing on his early career

Though Khan began his career with a small role in the 1987 Oscar-nominated *Salaam Bombay!*, it took some time until he was being regularly cast or recognized for his body of work. His first accolade was a Filmfare Award for Best Villain for his role in *Haasil* (Result), and then he maintained that momentum by winning the approval of his critics as the lead in *Rog* (Malady). Khan wasn't considered a commercial Bollywood actor; however, he was well regarded as a master of his craft. His style and prestige allowed him to gain notice from filmmakers abroad.

Khan was cast alongside Tabassum Fatima Hashmi, known as Tabu, and American actor Kal Penn and made his international debut in the highly successful 2006

English film *The Namesake.* Figure 18-1 shows a scene from that movie, which exposed Khan to International audiences and eventually helped him land the role of a police inspector in *Slumdog Millionaire.*

AA Film Archive/Alamy Stock Photo

Looking at his international roles

These international roles catapulted Khan into the international mainstream and grabbed the attention of more casual Bollywood lovers as well. He followed up his momentum by starring alongside Shah Rukh Khan in Bollywood's 2009 film *Billu,* which was well received. He continued to appease audiences at home in movies like *Paan Singh Tomar, Gunday* (Outlaws), and *Hindi Medium,* and abroad in *The Amazing Spider-Man, Life of Pi,* and *Jurassic World.* Khan added more hardware to his collection with Filmfare, National, and Asian Film awards. Unfortunately, as the world began to become more and more familiar with Khan's artistry, he was taken from the world too soon when he passed away in 2020.

Examining the Khan contradiction

Khan was considered a contrarian in the Hindi film industry because his characters and films of choice had more depth and relevance than your average Bollywood flick. Though these films weren't as commercially successful as the others, he took pride in choosing meaningful roles with substantial narratives, earning the respect of his contemporaries along the way. Khan had a relatable and warmhearted

presence on-screen, perhaps in part because of his humble beginnings, which also translated to his personality in real life.

Many have described Khan's performances to be as though you were watching your best friend on-screen, who was seemingly finding moments to wink at you throughout the film. Though in real life Khan kept a low profile from the public eye, he instilled not only a sense of familiarity and ease with his onscreen presence but also a reassurance of the film's credibility. Much like his idol, Rajesh Khanna, who was considered Bollywood's first superstar, Khan achieved that same level of superstardom by being the first Bollywood actor of his kind to find true, substantial success outside Bollywood.

Sweeping audiences off their feet: Dimple Kapadia

In 1973, actress Dimple Kapadia made her Bollywood debut in *Bobby*. Throughout the 1970s, she was known mainly for her beauty and sex appeal; however, when she returned to Bollywood in the 1980s, she gained critical success with her wide range of roles. Known for her standout performances in movies such as *Dil Chahta Hai* (The Heart Wants), *Dabangg* (Fearless), and *Cocktail*. Kapadia also started appearing in English-language films, such as *Being Cyrus* and *Finding Fanny*.

Kapadia proved that she was a versatile actor, and so she caught the attention of the infamous Christopher Nolan, who cast her for the role of Priya in his 2020 hit *Tenet*. (Figure 18-2 shows Kapadia walking alongside John David Washington in *Tenet*.) Critics favored her performance and her tremendous on-screen presence. To read more about Kapadia and other actresses of her time who were pushing boundaries, check out Chapter 4.

Shining in unconventional roles: Om Puri

Om Puri, an acting savant, made a reputation for taking on roles of varying range throughout his career. His Bollywood filmography includes *Disco Dancer*, *Arohan*, The Ascent, *Gupt: The Hidden Truth*, and *Agneepath* (Path of Fire). Alongside his fellow Delhi National School of Drama classmate Naseeruddin Shah, Puri also found work abroad, acting in British and American film alongside several notable Hollywood actors. Some of those include *City of Joy*, with Patrick Swayze; *Wolf*, alongside Jack Nicholson; and *Charlie Wilson's War*, costarring with Tom Hanks and Julia Roberts. Unfortunately, Puri passed away in 2017 from a heart attack.

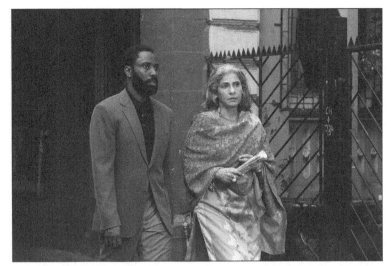

FIGURE 18-2:
Dimple
Kapadia, with
John David
Washington.

PictureLux/Alamy Stock Photo

Recognizing other actors who made the transition

Other actors have made appearances in Hollywood. Here's a sampling:

>> **Tabussum Fatima Hashimi:** Better known as Tabu, she made a name for herself in several critically acclaimed Bollywood films in the 1990s and 2000s. Also known for being one of the taller actresses at the time, her highly regarded bodies of Bollywood work include films such as *Vijaypath* (Path of Victory), *Maachis* (Matchsticks), *Virasat* (Inheritance), and *Haider*. Tabu's (you can see her in Figure 18-1) ability to excel in more unconventional Bollywood films allowed her to flourish overseas as she has made appearances in movies like *The Namesake* and *Life of Pi*. For more on Tabu's career, check out Chapter 5.

>> **Naseeruddin Shah:** An award-winning and popular actor in India, Shah appeared in the Hollywood movie *The League of Extraordinary Gentlemen*.

CULTURAL
WISDOM

Shah was invited to audition for the role of Albus Dumbledore when the *Harry Potter* franchise was in search of a new Dumbledore after the death of Richard Harris. For reasons unknown, Shah turned down the offer.

>> **Nargis Fakhri:** She made the jump into Hollywood in *Spy* alongside Melissa McCarthy.

>> **Shabana Azmi:** Her work includes *City of Joy,* and *Son of the Pink Panther*.

TIP

For other Bollywood stars who made the jump into Hollywood waters, check out Chapter 21.

BOLLYWOOD-STYLE AMERICAN MOVIES

The filmmaking style of Bollywood is, needless to say, much different from films made in Hollywood. Though Hollywood prides itself on the raw, gritty, and struggling tales of outcasts and the marginalized, Bollywood has typically showcased colorful, multigenre stories of the beautiful and glamorous. It should be noted, though, that these are generalizations of each industry, and though Hollywood too also produces movies that serve as complete escapes from reality, the Hindi film cinema too has done a commendable job of producing movies with a more indie-film feel that touch on societal issues.

The global success of *Slumdog Millionaire* is what caused Hollywood's elite to take a good, hard look at Bollywood. Though *Slumdog Millionaire* isn't considered a Bollywood movie, it had the plot twists, songs, and romantic themes similar to one. Once these concepts are blended with the elements of Western cinema (darker themes, depiction of the underworld, and poverty), you have a film that highly resonates within the diaspora while exposing new cultures and ideas to a wider audience.

When these types of Bollywood-style American films have the right professionals working behind them, the films can potentially become critical and commercial successes. The 2014 Steven Spielberg-produced *The Hundred-Foot Journey* follows the story of a culinary prodigy, Hassan (played by Indian American actor Manish Dayal) as he and his family establish an Indian diner in France after being displaced from their homeland in India. The diner starts a turf war of sorts with Madame Mallory (Helen Mirren), a neighboring restaurant proprietor, until the two end up collaborating on their talents and Hassan becomes Mallory's protege.

The story also follows the budding romance between the protagonist Hassan and Marguerite (Charlotte Le Bon). The film has remnants of an underdog story while incorporating romance and social dialogue. Along with appearances from established Bollywood stars (Om Puri and Juhi Chawla) and a soundtrack produced by the great A. R. Rahman, the film touches on Bollywood's cinematic themes while still appeasing American and diaspora audiences with a grounded plot that anyone can relate to.

Moving from Acting to Talking with Talk Shows

Everyone loves their celebrities, and what better way to become familiar with the rich-and-beautiful than by way of the magic of talk shows? Several Bollywood stars have made appearances on popular U.S. talk shows over the years to promote their films and relevant projects at the time. Given their superstardom overseas, these different hosts take this opportunity to discover more about the stars as well as the culture and industry they hail from.

Ellen DeGeneres

Ellen DeGeneres features a who's who of celebrities on her daytime talk show. No doubt an appearance on her show can make someone a household American name, and few Bollywood stars have been lucky enough to be graced on the show. The likes of Priyanka Chopra and Deepika Padukone have both been guests, with Chopra appearing three times and Padukone appearing once.

Chopra's first appearance was to promote her ABC show, *Quantico*, followed by an episode where she discusses her marriage ceremony with American singer Nick Jonas. Padukone's first appearance on American talk shows was on Ellen's show, when she was promoting her movie alongside Vin Diesel, *XXX: The Return of Xander Cage.*

CULTURAL WISDOM

Padukone was also a guest on *The James Corden Show* with Vin Diesel and taught the host how to perform the famous lungi dance from her hit movie, *Chennai Express.*

Jimmy Fallon

To host *The Tonight Show* on NBC means you've reached the pinnacle of comedy and stamped yourself as a Hollywood icon. As a result, it's truly a dream come true for someone to be featured as a guest on the show, and Chopra has been lucky enough to be featured on the show five times. From discussing her forthcoming films to her highly publicized wedding with Nick Jonas, Chopra has also played interactive games alongside Fallon, such as bobbing for apples and a wing eating contest, all of which have gone viral on YouTube.

Oprah Winfrey

Oprah Winfrey was the original queen of daytime with *The Oprah Winfrey Show* — and her show is still considered to be the echelon of daytime television. Winfrey was one of the first to feature a Bollywood star on American television, in the mid-2000s, with the great Aishwarya Rai Bachchan. On her first appearance, Bachchan wasn't married yet to her future husband, Abhishek Bachchan, and appeared on the show with Winfrey billing her as the most beautiful woman in the world. In her initial appearance, Bachchan answered several questions about her upbringing as an Indian woman, which was then followed by Rai's assisting Winfrey in donning a traditional Indian dress, the sari. For more about traditional Indian's women clothing and other costumes appearing in Bollywood flicks, check out Chapter 7.

Aishwarya Rai made her second appearance on Winfrey's show in 2009, alongside her husband, Abhishek. At the time, their union was considered to be the biggest wedding in India, and it was met with heavy publicity, so much so that Winfrey had to invite her from overseas to chat about it! Winfrey followed up this meeting by paying a visit to the Bachchans in India three years later and met several of Bollywood's elite for her special, "Oprah's Next Chapter: India Episode."

David Letterman

Proving to be a trailblazer for the likes of Priyanka Chopra and Deepika Padukone, Aishwarya Rai also paid a visit to *The Late Show with David Letterman* in 2005. Letterman had also billed Rai as the most beautiful woman in the world as she came on the show to promote her film *Bride and Prejudice*. The interview was memorable not just because it was the first time a notable Bollywood star was on a major late night American talk show but also for the witty comebacks and digs she exchanged with Letterman.

REMEMBER

As Letterman passed the torch to Stephen Colbert and retired from late night, he moved to Netflix and started his new show, *My Next Guest Needs No Introduction*, in 2018. After two successful seasons, Letterman featured King Khan himself, Shah Rukh Khan, which was met by worldwide excitement and hype. Letterman visited Khan's home in India and chatted with him about his career and his upbringing, and then asked what the day-to-day life of someone of Khan's stature and caliber looks like. This episode still remains one of Letterman's most popular.

TEN INTERNATIONAL INDIAN MOVIES THAT GIVE A TASTE OF THE DIASPORA

The hybrid formula of blending Hollywood with Bollywood is a recipe that's only continuing to evolve as time goes on. From highlighting established Bollywood stars to giving new-and-hungry stars their big break, these Indian-American films have given South Asian communities abroad the narrative and recognition they've been yearning for.

- ***Slumdog Millionaire:*** Hands down, the 2008 *Slumdog Millionaire* is widely regarded as the most recognized and successful international Indian film of all time. It was inspired by the novel *Q & A*, by Indian author Vikas Swarup, which tells the story of a boy from the Mumbai slums who suspiciously wins India's version of *Who Wants to Be a Millionaire,* leading to accusations of cheating. This film showcased Bollywood stars such as Irrfan Khan and Anil Kapoor to international audiences and introduced British Indian actors Dev Patel and Freida Pinto, who continued successful acting careers following the film.

- ***American Desi:*** This 2001 comedy touched heavily on the identity crisis that many diasporic communities worldwide face. The tale of the film's protagonist, Kris (played by actor Deep Katdare), is about how he doesn't associate with his Indian heritage, though that all quickly changes after he falls for a girl by the name of Nina (Purva Bedi).

- ***Monsoon Wedding:*** The spectacle that is an Indian wedding was expounded on internationally, thanks to director Mira Nair's 2001 movie *Monsoon Wedding*. The plot circles around the arranged marriage of the Verma family's daughter, Aditi. The film was well received by audiences for capturing the ensuing chaos and expenses that come with organizing large Indian weddings, along with the baggage that comes with family reunions.

- ***Bend It Like Beckham:*** Despite her parents' disapproval of her playing soccer, 18-year-old Jess, played by British actress Parminder Nagra, bends their rules and restrictions to finds ways to play, along with the help of her friend, Jules, played by actress Keira Knightley. This film touches on the traditional gender norms of Indian culture and empowered women to live their lives and pursue their own careers and ambitions.

- ***The Namesake:*** Another classic featuring the greats, actor Irrfan Khan and director Mira Nair, this film is also a coming-of-age story that examines and appreciates one's cultural heritage, American values, and healthy dialogue between children and parents. The film (refer to the section, "Focusing on his early career," earlier in this chapter) touches on issues of dating, marriage, and family values, ultimately unifying the two cultures.

(continued)

(continued)

- ***Bride and Prejudice:*** Banking on the international rise of actress Aishwarya Rai Bachchan (read about her legacy in Chapter 5), *Bride and Prejudice* was one of the first international Indian films that featured a megastar from Bollywood. For the most part, audience and critics liked the 2004 film; the film gave viewers cross-cultural dialogue in regard to marriage and other heritages and backgrounds.

- ***Dude, Where's the Party?:*** Kal Penn leads the way again, this time in a comedic and lighthearted portrayal of Indian Americans navigating through life. This film, unlike others on the list, wasn't critically acclaimed but nonetheless provides much needed mind-numbing entertainment.

- ***The Tiger Hunter:*** Set in 1979 Chicago, the movie follows the adventures of Sami, played by Indian-American actor Danny Pudi. The film is a lighthearted take on early Indian immigrants and their struggles assimilating into the United States. The film marks the debut of Muslim American director Lena Khan and also features actors Jon Heder, Rizwan Manji, and Canadian-Indian actress Karen David. The film was well received by critics and is available for streaming on Netflix.

- ***Outsourced:*** Though the other movies in this list had to do with Indians assimilating into Western cultures, this 2006 movie examines the journey of Todd (Josh Hamilton) and his move to India. The film did decently well within film festivals; however, it didn't fare well at the box office.

- **The Problem with Apu:** This 2017 documentary was written by American Indian comedian Hari Kondabolu, discussing how *The Simpsons* character Apu (voiced by Hank Azaria) was for a period the only mainstream representation that South Asian Americans had on U.S. television. The movie hones in on bullying and how South Asians were perceived in the United States as a result of the negative stereotypes. The documentary was met with positive responses and resulted in Azaria no longer voicing the character.

Crossing Over: Hollywood in India

As the worldwide and Western popularity of Bollywood grew, Hollywood stars began to dabble in Hindi cinema projects. Stars and icons from both U.S. music and television have collaborated with the brightest of Bollywood over the years. Here we take a brief overview on the stars behind Tinseltown's small and silver screens that took the leap overseas.

Appearing in Bollywood movies

Surprisingly, a fair share of A-list Hollywood actors have mingled with the best and brightest of Bollywood. From films, awards shows, and friendly cameos, the stars of Tinseltown are quite familiar with the presence and value that Bollywood brings to world cinema, and an opportunity for a collaboration is never to be taken lightly. American actors like Will Smith, Sylvester Stallone, Denise Richards, and Sir Ben Kingsley have made appearances on the Hindi silver screen. For more on these stars and their contributions, check out Chapter 15. This section addresses a couple others.

Annabelle Wallis

Stars from Hollywood's small screen have also worked with Bollywood talent. Popular English actress Annabelle Wallis is known for her roles in *Peaky Blinders*, *Annabelle,* and *The Mummy*. After being sent to make a Bollywood film in her initial years as an actress, she starred alongside Amitabh Bachchan and Karan Sharma in the film *Dil Jo Bhi Kahey. . .* (What the Heart Says). The film didn't do well, unfortunately, but luckily for Wallis she was able to land work eventually back home!

Sarah Thompson

Sarah Thompson had a steady career making appearances in *Boston Public, Angel, 7th Heaven,* and *Malibu's Most Wanted*. In 2010 she was cast as Ranbir Kapoor's American girlfriend in Prakash Jha's *Raajneeti* (Politics). Despite neither of these Bollywood films doing well critically or commercially, it's still interesting to see just how much of an option it is for Hollywood stars to potentially take up work in Bollywood.

Collaborating on cross-cultural comedy

A lot of the first-generation diaspora relied heavily on Bollywood as a way to become familiar with their own identity and heritage. One example is Lilly Singh. Toronto-based Singh was a YouTube star who produced Bollywood parodies and comedy sketches that circled around her upbringing as an Indian Canadian.

Her quick-witted content and hilarious impressions of her parents made her one of the highest-paid and most successful YouTubers of all time. She then moved to NBC and took over Carson Daly's slot and became the host of *A Little Late with Lilly Singh*. She continues to create Bollywood-related content on her social media and features several South Asian American celebrities as well as other POC talent.

Eyeing South Asian Contributions to Hollywood Films

Not only have more South Asian Americans started to find careers in show business, but more are beginning to be recognized for their contributions in the field. Whether they're captivating the hearts of millions in front of the camera or creating magic behind the scenes, South Asians are bringing a much needed breath of fresh air to storytelling and entertainment in Hollywood. Here we examine the people behind and in front of the cameras who have made an impact.

Identifying notable people behind the scenes

Though actors and actresses are often the faces of stories told on film, there are a number of South Asian directors and filmmakers who don't appear on the big screen but are responsible for films making the big screen. Here are a few of the most notable and influential South Asian filmmakers making waves in Hollywood.

M. Night Shyamalan

One of the first Indian American directors to make a splash into the American mainstream was Manoj Nelliyattu Shyamalan ("sham-uh-lam"), also known as M. Night Shyamalan. After directing and working on lesser-known projects, Shyamalan scored big by directing the 1999 hit *The Sixth Sense*, receiving international recognition. The film was nominated six times at the Academy Awards and was soon followed up by his next sci-fi horror blockbuster, *Signs*.

Though his next array of films was either critically unsuccessful or met with mixed reviews, they were still commercially successful because of his ability to draw large audiences as well as A-list talent. Shyamalan (see Figure 18-3) has created his own legacy in horror and sci-fi genres and is considered to be a stand-out talent with his eccentric directing and cinematography styles. His most recent films were *Split* and *Glass*, which featured the likes of actors James McAvoy, Anya Taylor-Joy, Samuel L. Jackson, and Bruce Willis, who also starred in *The Sixth Sense*.

Mira Nair

Listed several times as the director of a few of the films mentioned in this chapter's earlier sidebar "Ten Indian international films that give a taste of the diaspora," Mira Nair has been working in film since the 1980s, directing documentaries and co-writing the 1987 Oscar-nominated *Salaam Bombay!*. When she transitioned to directing, her films were centered around diaspora characters who dealt with their American and Indian cultures clashing. Those films are

FIGURE 18-3:
M. Night
Shyamalan,
during the
making of
The Sixth Sense.

AF archive/Alamy Stock Photo

>> ***Mississippi Masala:*** This love story between an Indian American and a Ugandan American in the United States stars Denzel Washington and Roshan Seth.

>> ***Monsoon Wedding:*** Delhi-based Aditi Verma deals with her arranged marriage to Houston local Hemant Rai and all the chaos associated with planning an Indian wedding.

>> ***The Namesake:*** The Ganguli parents and their son, Gogol, struggle to balance Indian traditions with their newfound American culture.

Nair is a gem and considered to be the pride of Indian representation in cinema that includes Oscar, Golden Globe, and BAFTA nominations. Nair has been praised for unapologetically sticking to her roots, and pushing for diversity and inclusion in her filmmaking.

Sharmeen Obaid-Chinoy

Another woman who has made a name for herself is the incomparable Sharmeen Obaid-Chinoy. Hailing from Karachi, Pakistan, Chinoy has won two Oscars and six Emmy awards for her notable documentaries *Saving Face*, and *A Girl in the River: The Price of Forgiveness*. Her documentaries have revolved around the mistreatment and inequality of women in South Asian and Middle Eastern countries. In 2012 she was included in *TIME* magazine's list of the 100 Most Influential People in the World.

Making space in the industry: Prominent diaspora actors in Hollywood

A handful of actors of South Asian descent are continuing to make their mark in Hollywood. We take a closer look at these individuals in these sections.

Riz Ahmed

The British-Pakistani actor Riz Ahmed has starred in several films, such as *Four Lions*, *Nightcrawler*, *Rogue One*, and *Venom*, but was most notably recognized for starring on HBO's hit miniseries *The Night Of*, a show about a Pakistani-American college student accused of murdering a girl in New York. The show touched upon preconceived notions of Muslims living in a post-9/11 world, something that Ahmed (see Figure 18-4, which shows him during the filming of *Rogue One*) has been vocally passionate about in his craft.

FIGURE 18-4: Riz Ahmed during the filming of *Rogue One*.

AF archive/Alamy Stock Photo

The actor has gone on record saying that he would rather be poor than take roles that further perpetuate stereotypes of brown people in a negative light. Ahmed is also a rapper, going by the stage name Riz MC, where he continues the narrative of living as a Muslim in the free world as well as his Pakistani upbringing and culture.

Utkarsh Ambudkar

An American actor, rapper, and singer, Utkarsh Ambudkar's range of talents helped him gain stardom with his role of Donald in *Pitch Perfect*. He has been in a

variety of on-screen and voiceover roles, from Pizza in *The Muppets* to a small role on *The Simpsons*. He worked alongside the legendary Mindy Kaling in *The Mindy Project*, and has taken on many roles, big and small, in film and TV.

Fun fact: Maaz Ali, one of the authors of this book, acted as Utkarsh's double for a driving scene in a Netflix production.

Aziz Ansari

Aziz Ansari won Best Standup at HBO's US Comedy Arts Festival. His stand-up typically circled around stories from his personal life, which resonated with many. He grabbed the nation's attention with his role as Tom Haverford on NBC's *Parks and Recreation*. After the success of that show, Ansari produced his own show on Netflix, titled *Master of None*, which was met with critical acclaim. The show won Ansari the award for Best Actor in a Comedy at the Golden Globes, making him the first Asian-American to do it. He also wrote a book in 2015, titled *Modern Romance: An Investigation*, which was also well received.

Manish Dayal

Manish Dayal hails from an Indian Gujarati family in South Carolina. Dayal headed to New York in the late 2000s to focus his career on film and television. After landing a few national commercials for the likes of McDonald's and Domino's, Dayal booked a few roles on short-lived shows such as AMC's *Rubicon* and NBC's *Outsourced*. From there, he was cast as Raj in the third and fourth seasons of the CW's *90210*, and then got his big break in *The Hundred-Foot Journey*, which found critical and commercial success. He now plays Dr. Devon Pravesh on the Fox medical drama *The Resident*. In a short time, Dayal has shown tremendous promise as a leading man who still has a bright future ahead of him.

Jameela Alia Jamil

Jameela Alia Jamil, a British actress of both Indian and Pakistani descent, has worked as an actress, radio presenter, model, writer, and activist. First discovered at 22 years old while teaching English in London, she's held a number of prominent roles with her first major series regular in the American fantasy comedy *The Good Place*. She has gone on to hold a number of voiceover and on-screen acting roles, including the Netflix production *Jurassic World Camp Cretaceous* alongside another rising South Asian actress, Bengali Pakistani American Kausar Mohammed. Other roles of Jamil's include the TV series *DuckTales*, *Animaniacs*, and *Harley Quinn*.

Mindy Kaling

When it comes to South Asian Americans being in the limelight, many turn their attention to the one and only Mindy Kaling. She attended Dartmouth College for playwriting and became an intern for Conan O'Brien during her sophomore year. (Refer to Figure 18-5, which shows her at the 2016 *Vanity Fair* Oscar party.) From there she landed the iconic role of Kelly Kapoor on the superhit NBC comedy *The Office*, also working as a writer and executive producer on the show. In 2012, she made the move to Fox and starred in *The Mindy Project*, where she also served as the writer and producer, furthering herself as an unstoppable force in Hollywood.

FIGURE 18-5: Indian American actress, comedian, writer, producer, and director Mindy Kaling.

REUTERS/Alamy Stock Photo

CULTURAL WISDOM

Kaling is beloved by her fans and contemporaries alike for breaking South Asian stereotypes and being a role model for young girls everywhere. Recently, Kaling has gone on to produce the Netflix hit *Never Have I Ever*, and worked in films such as *Wreck-It-Ralph*, *Inside Out*; and *Oceans 8*. She also directed and produced *Late Night*. In addition, she has given fans more insight into her personal life, by authoring two books: *Is Everyone Hanging Out Without Me? (and Other Concerns)* and *Why Not Me?*

Hasan Minhaj

When it comes to South Asian American media personalities, no one, arguably, has been as red-hot as American Indian comedian Hasan Minhaj. He gained national attention for sharing his upbringing by detailing his encounters of prejudice and racism as a first-generation Indian American in his Netflix special, *Homecoming King*. He first served as a correspondent on *The Daily Show* before hosting his own political satire show on Netflix, *Patriot Act with Hasan Minhaj*.

CULTURAL WISDOM

With a role on Season two of Apple TV's *The Morning Show*, Minhaj has been the voice of the South Asia diaspora in the West. He has received several awards for his work, including a *GQ India*'s International Man of the Year award with the likes of Bollywood actors Aamir Khan and Ranveer Singh present. Figure 18-6 shows Minhaj performing at the White House Correspondents' Association dinner in Washington in 2017.

FIGURE 18-6:
Hasan Minhaj.

REUTERS/Alamy Stock Photo

Kumail Nanjiani

A readily seen actor who continues to appear on film and television for his comedic roles is Kumail Nanjiani. The Pakistan-born actor rose to fame by playing the role of Dinesh in the HBO comedy hit *Silicon Valley*. In 2017, Nanjiani starred in and co-wrote *The Big Sick*, which depicted his personal life and relationship with his real wife. Though the film did incredibly well commercially and critically, it was met with controversy from the South Asian community over how elder Pakistani characters in the film were depicted. Nonetheless, Nanjiani was still nominated for Best Original Screenplay at the Academy Awards, among other awards.

He also "broke the Internet" when he uploaded a shirtless picture of himself sporting his newly sculpted muscles and announcing that he was joining the cast of Marvel's *The Eternals*, slated for release in 2021.

Dev Patel

Meanwhile, the one-and-only Dev Patel captured the hearts of millions with his film debut as Jamal Malik in *Slumdog Millionaire* and continues to do so today. With hits like *The Best Exotic Marigold Hotel* and *Lion*, Patel is an Oscar-worthy actor who

still has a bright future ahead of him. This British-born prodigy is regarded as a national treasure who is highly beloved by his South Asian community back home and abroad.

Kal Penn

Kal Penn had audiences in stitches with his iconic role as Kumar in the *Harold and Kumar* film series. Born into a New Jersey-based Indian Gujurati household, Penn traveled cross-country to study film at UCLA, after which he landed small parts in films such as *American Desi* and *Van Wilder*. Following his rise to fame from *Harold & Kumar Go to White Castle*, Penn landed a small role as a terrorist on the Fox show *24*, which made him rethink his choice of roles. Penn has gone on record to say that his role in *24* didn't sit well with him politically, and he recognized the problem with further instilling negative stereotypes of brown people.

CULTURAL
WISDOM

Penn had a newfound purpose and decided to not only become more politically active but also to choose roles that elevated his South Asian community and background shortly after the release of *The Namesake*, in which Penn's performance was especially praised. As he continued to pick up movie and television roles, Penn stayed politically active and most recently started a show titled *Kal Penn Approves This Message*, which covered political topics as well as the 2020 presidential election.

Russell Peters

By the early 2000s, South Asians had started making their way into Western pop culture. One of them was Indian-Canadian comedian Russell Peters, who began his career under the wing of comic legend George Carlin and eventually gained tremendous popularity after his set from the Canadian show *Comedy Now!* went viral. Specializing in impersonating accents and sharing anecdotes about his father, Peters is a trailblazer for South Asian comedians and paved the way for many after him. The most popular anecdote was of his father who would discipline his brothers by saying, "Somebody gonna get a hurt real bad" in order for them to start behaving better. Peters was the first comedian to have a Netflix special and has made several appearances on television and film.

Naomi Scott

Naomi Scott is another actress with a bright future ahead. Born to an Indian Gujarati mother and an English father, Scott reached critical acclaim for her roles in *Terra Nova*, and *Lemonade Mouth*, while showcasing her singing talents on YouTube during her downtime. Her first big role was that of the Pink Ranger in the *Power Rangers* film in 2017 (Figure 18-7 shows Scott as the Pink Ranger in that film), followed by *Aladdin*, where she played the lead as Princess Jasmine.

Scott was recently in the 2019 rebooted action comedy *Charlie's Angels* alongside the likes of Kristen Stewart and Elizabeth Banks. Scott has proven to be a capable actress, and it will be exciting to see where her future projects take her.

Moviestore Collection Ltd/Alamy Stock Photo

FIGURE 18-7: English actress Naomi Scott (left) in *Power Rangers.*

Hannah Simone

Sharing the limelight alongside Mindy Kaling on Fox was actress Hannah Simone. The British Canadian, who is the daughter of an Indian father and a German-Italian-Greek Cypriot mother, began working as a fashion model and later hosted several music shows in her 20s. After picking up small television roles, Simone was cast as the best friend, Cece, in the Fox hit comedy *New Girl.*

6

The Parts of Tens

IN THIS PART . . .

Check out ten movies to watch if you're new to Bollywood for a good primer.

Make time for the ten must-see films starring Shah Rukh Khan, the king of Bollywood.

Find out about the ten Bollywood actors who transitioned to Hollywood.

Chapter **19**

Ten Movies to Watch If You're New to Bollywood

For any new fan of Bollywood, having a starting point is important. This chapter discusses ten must-watch Bollywood movies that we identify as some of the best for exposing you to the Bollywood culture.

For a closer look at some of the movies on this list, check out our podcast, *Desi Standard Time*. Refer to the Cheat Sheet at www.dummies.com by searching for "Bollywood For Dummies Cheat Sheet" for more information.

Whether you're new to Bollywood or a long-term fan, understand that these ten movies aren't the greatest Bollywood movies ever made — we're just sharing our list to give you an overview of some great films. And you may notice that none of these movies features Shah Rukh Khan, often deemed the "King of Bollywood." Khan's legacy is so monumental that we dedicate Chapter 20 to ten of his masterpieces. (Chapter 5 discusses Khan's legacy in greater detail.)

Furthermore, we provide this list to give you a taste of the films that were both critically and commercially acclaimed and had a lasting cultural impact that's still discussed today. For each movie, we give you a rough synopsis and then describe the significant themes, the main actors, any notable songs, and its legacy today.

TIP

When you're ready to watch these films, you can find many of them on streaming platforms, such as Netflix and Amazon Prime.

Sholay: Burning Down the Competition

The 1975 movie *Sholay* (Embers) is widely regarded as the greatest Bollywood film of all time. The story revolves around two small-time thieves — Veeru, played by Dharmendra, and Jai, played by Amitabh Bachchan — who are hired to capture the notorious outlaw Gabbar Singh. Actresses Hema Malini and Jaya Bhaduri play, respectively, the love interests of Dharmendra and Bachchan, who are shown in Figure 19-1. (You can read more about all these actors in Chapter 4.)

FIGURE 19-1: Dharmendra (left) and Amitabh Bachchan (right), from a scene in *Sholay*.

Dinodia Photos/Alamy Stock Photo

Sholay features a mix of action, romance, and comedy. Given its genre-pushing plot, early critics rated the movie harshly because they felt that some of the featured themes were excessive — specifically, the use of violence. As a result, the film was considered a flop during the first two weeks of its release. The character dialogues and musical score, however, proved to be immensely popular, and movie-goers reversed the fate of *Sholay* by word of mouth, which led to its tremendous commercial success.

Sholay is solely responsible for turning Amitabh Bachchan into a superstar, and for revolutionizing the antagonist in Hindi films with Singh, played by Amjad Khan, who also become a superstar, thanks to this role. This movie is best known for its character dialogues and scenes (especially Singh's), which were parodied and highly embedded into Indian pop culture. In 2013, *Filmfare* magazine named Singh as the greatest Indian villain of all time. As far as the music, here are some notable hits of the film, composed by the legendary R.D. Burman — you can read more about him in Chapter 8:

» "Yeh Dosti" (This Friendship)

» "Haa Jab Tak Hain Jaan" (Yes, As Long As I Live)

» "Mehbooba Mehbooba" (Girlfriend, Girlfriend)

The set life and chemistry occurring between the stars was a tabloid's dream come true and another reason that the movie is quite popular. Numerous gossip publications followed Dhamendra's attempts to court his future wife, Hema Malini, throughout the film's shooting. He was eventually successful, and the pair bore six children, three of whom went on to become Bollywood stars: Sunny Deol, Bobby Deol, and Esha Deol. Simultaneously, Bachchan also developed a real-life relationship with his onscreen flame, Jaya Bhaduri. The pair tied the knot in 1973, four months before the beginning of shooting, and delayed production because Jaya became pregnant with their first child, Shweta. By the time the film was released, Jaya was pregnant with their son, future star Abhishek Bachchan (refer to Chapter 5).

Mother India: Flag-Bearing a Country

In the iconic film *Mother India,* director Mehboob Khan sought to return his home country's narrative to its rightful owners: his fellow Indian people. This 1957 film, widely considered a cinematic masterpiece, was included in *TIME* magazine's list of the Best Bollywood Classics in 2010. The story follows Radha (played by Nargis, which we discuss in Chapter 3) on her journey as a woman and a mother of two boys (played by Sunil Dutt and Rajendra Kumar) who's governed by a power-hungry moneylender, Lala (played by Kanhaiya Lal). Her husband in the film is played by Raaj Kumar (see them both in Figure 19-2). This nationalistic, feel-good movie also pushed by leaps and bounds the idea of feminism and the independent woman.

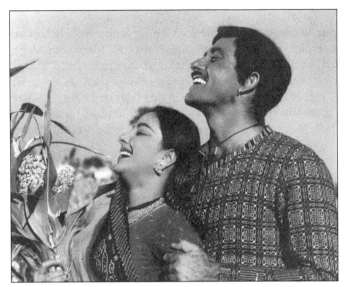

FIGURE 19-2:
Actress Nargis,
with Raaj
Kumar, in
Mother India.

A budding romance ensued between actress Nargis and her onscreen son, played by Dutt (refer to Chapter 3). During the movie, Radha (Nargis) runs between burning haystacks in search of her son, Birju, who has hidden among them. The actors performed their own stunts, and on one particularly windy day, the flaming haystacks burned out of control. Nargis was entrapped in a ring of a real-life fire, and Dutt rushed in with a blanket and rescued her. The incident hospitalized Dutt with burns on his face and body, and Nargis helped nurse him back to health. The relationship built from this stunt-gone-wrong ended with the pair falling in love and marrying in March of 1958 five months after the film released in October of 1957. In the film's best interest, the couple waited to marry to prevent a poor reaction from the public to an onscreen mother-and-son pair marrying in real life shortly after the film's release.

Amar Akbar Anthony: Marinating in "Masala"

With a superstar-studded ensemble and a compelling plot, *Amar Akbar Anthony* hit the silver screen in early 1977 and added more themes to the masala film recipe. (*Masala films* are movies that combine a number of different genres into one entertaining movie). With colorful performances, memorable dialogues, and a wildly popular soundtrack, the film is a staple of every Bollywood enthusiast's

movie collection. The plot follows the struggle, and quest for revenge, of Kishanlal (played by Pran Sikand) against his ungrateful crime boss, Robert (played by Jeevan).

Through a series of unfortunate events, Kishanlal's sons are adopted by families of varying religious backgrounds — a Hindu policeman, a Muslim tailor, and a Christian minister. Each child assumes his new family's religion and is named accordingly: The eldest son becomes a police inspector named Amar Khanna; the middle child owns a liquor bar and is named Anthony Gonsalves; and the youngest becomes a qawwali singer (to read more about qawwali, refer to Chapter 9) and is named Akbar Ilahabadi. The family reunites as the plot unfolds, with the brothers learning their mother is still alive and then avenging their father by taking down Robert and his henchmen.

Bachchan's performance as Anthony Gonsalves outshines that of his costars. The character is named after popular composer (and mentor of one of the film's musical directors) Pyarelal Sharma. Immortalized as an iconic character in Bollywood cinema, he was most popular for his self-titled song, "My Name Is Anthony Gonsalves," and his memorable dialogues, such as the advice he bestows on himself in a mirror after getting drunk and beaten up by his nemesis, Zebisco (Yusuf Khan).

Dil Chahta Hai: The First Coming of Age

At the turn of the millennium, Bollywood had long since shifted away from action-packed machismo films and started catering movies to the more whimsical, hopeless-romantic archetypes. In line with this genre, Farhan Akhtar, the son of Javed Akhtar, made his directorial debut in this coming-of-age movie, a first in Bollywood. The movie follows the friendship of the three childhood besties Akash (Aamir Khan), Sameer (Saif Ali Khan), and Sid (Akshaye Khanna) as they navigate life after college and together encounter love, heartbreak, and adulthood (Figure 19-3 shows the cast of *Dil Chahta Hai* (The Heart Wants), at a news conference for the film's premiere in 2001). The film also stars Preity Zinta, Dimple Kapadia, and Sonali Kulkarni. (We discuss many of these actors in Chapter 5.)

The critically acclaimed *Dil Chahta Hai* nabbed the award for Best Hindi Feature Film at the 2001 National Film Awards and was the Critics' Award for Best Film at the Filmfare Awards the same year. The film was especially popular with the younger demographic not only throughout India but also in diasporic communities throughout the world (check out Chapter 13). Fans felt that the movie was a realistic and down-to-earth depiction of the struggles young people face in their formative adult years and was a nice change of pace from the more grander

themes that Bollywood typically puts forward. Technically speaking, *Dil Chahta Hai* forged its reputation for having fresh and quick-witted dialogue that caught the attention of critics. Music director Shankar Ehsaan Loy topped off the movie with a phenomenal soundtrack to match, and won the award for Best Music Director four times that year — at Filmfare, International Indian Film Academy Awards (IIFA), Zee Cine, and Screen — we describe all in Chapter 15.

FIGURE 19-3: From left to right: Sonali Kulkarni, Akshaye Khanna, Preity Zinta, and Aamir Khan.

REUTERS/Alamy Stock Photo

Hum Aapke Hain Koun . . .! Topping the Charts

Sholay was the reigning all-time highest-grossing movie until *Hum Aapke Hain Koun . . . !* (Who Am I to You. . . !) debuted in 1994. The 1990s shifted viewers away from the action-packed masala films and toward contemporary romance. *Hum Aapke Hain Koun . . . !* is a fun-filled family event that reinstated family values, romance, and the celebration of Indian weddings.

Salman Khan and Madhuri Dixit (we tell you more about their start in Chapter 5) had worked together in several films before *Hum Aapke Hain Koun . . . !* and were quickly stealing the hearts of the nation's viewers with films such as *Saajan* (Beloved) and *Dil Tera Aashiq* (Heart Is Your Lover). Unlike those movies,

Hum Aapke Hain Koun . . . ! started a trend in Indian cinema by centering the plot around weddings and family drama.

The plot centers around family ties and the highs and lows of marriage, and especially highlights Indian weddings, with a soundtrack to match. The soundtrack to *Hum Aapke Hain Koun . . . !* went on to become a cultural juggernaut, and to this day is a staple of South Asian wedding playlists. Here are some of those hits:

>> "Joote Do Paise Lo" (Give the Shoes, Take the Money)

>> "Didi Tera Dewar Deewana" (Sister, Your Brother-in-Law Is Crazy)

>> "Maye Ni Maye" (Mother, Oh, Mother)

>> "Pehla Pehla Pyaar" (It's My First Love)

Lagaan: Vying for the Oscars

This 225-minute-long spectacle will have you fully immersed in the compelling story revolving around Bhuvan (Aamir Khan) rallying his village against British occupiers in a game of cricket in order to repeal a land tax (see him in Figure 19-4). Directed by Ashutosh Gowariker, this film — the flagship and debut film from Aamir Khan Productions — features newcomer Gracy Singh as well as British actors Rachel Shelly and Paul Blackthorne. The film was wildly successful, due largely in part to its feel-good nationalistic storyline as well as its incorporation of the age-old tale of the underdog overcoming the odds, which moved audiences worldwide.

FIGURE 19-4: Aamir Khan in *Lagaan*.

RGR Collection/Alamy Stock Photo

The storyline of *Lagaan* (Taxation) steers away from the typical Bollywood style of revolving the plotline around romance. The David-versus-Goliath theme as a result resonated with international audiences, catching the eye of even critics in the United States. (We tell you more about the global impact of *Lagaan* in Chapter 13.) *Lagaan* went on to become the third Bollywood film in history nominated for the Best Foreign Language Film award at the 2002 Academy Awards. When it came to the awards back home, *Lagaan* dominated by winning eight Filmfare Awards, eight National Awards, and nine IIFA Awards.

Bombay: So Good That We Must Dub

Unlike other entries on this list, *Bombay* was originally a Kollywood-produced film, a Tamil-based film industry (see Chapter 17) set in Chennai, Tamil-Nadu, India. Not only is *Bombay* considered to have one of the best-ever movie soundtracks, courtesy of composer A.R. Rahman, but the movie's message of union is also incredibly potent because it depicted the turmoil between protesting Muslims and Hindu nationalists — better known as the Bombay Riots of 1992. The movie became a huge success and won two critics' awards at the Hindi Filmfare Awards and four awards at the Filmfare Awards South.

The film portrays Shekhar (Tamil actor Arvind Swami), a Hindu boy who falls in love with Shaila (Manisha Koirala), a Muslim girl. Shekhar proposes his interest in Shaila to her father, Basheer (a Tamil actor named Kitty), who forcefully refuses. As a result, Shekhar and Shaila leave for Bombay, where they marry and conceive twin boys. The pair instill both Hindu and Muslim values in their children. As they encounter the Bombay riots of December 1992, the family struggles to survive, summoning a visit from the parents of both Shekhar and Shaila. Both Hindu and Muslim families are forced to live together and keep one another safe from danger. The film culminates in a powerfully moving scene, where the protagonists and religious leaders stand together, holding hands in unison as they successfully stop a riot.

Gully Boy: Hip-Hop Hooray

We now direct your attention to 2019 and director Zoya Akhtar's monster smash hit *Gully Boy* (Alley Boy). This one-of-a-kind movie showcases and highlights Mumbai's newer-yet-popular underground rap scene, following the journey of Murad (Ranveer Singh) and his rise in the hip-hop ranks under his stage name, Gully Boy. The film also stars Alia Bhatt as Murad's love interest, Safeena

(Figure 19-5 shows both at the trailer launch of *Gully Boy* in 2019), as well as the rock-star-like debut of Siddhant Chaturvedi, who plays the role of Murad's mentor, MC Sher (Lion). American rapper and hip-hop legend Nas is billed as the film's executive producer. (We tell you more about Singh and Bhatt's start in the industry in Chapter 6.)

FIGURE 19-5:
Alia Bhatt and
Ranveer Singh.

ZUMA Press, Inc./Alamy Stock Photo

Gully Boy was a critical darling and was commercially acclaimed for showcasing youthful, spunky, and marginalized characters perfecting their artistry in the music style most parallel to them. *Gully Boy* does an astounding job of not only expanding on hip-hop's cultural history but also giving a platform to India's own underground scene and highlighting actual rap artists, like Divine and Naezy.

As you can probably already imagine, the film's soundtrack was astoundingly popular and highly original. Here's a list of other popular hits from the movie:

» "Doori" (Distance)

» "Sher Aaya Sher" (A Lion Is Coming)

» "Mere Gully Mein" (In My Alley)

» "Kab Se Kab Tak" (Until When)

Mughal-E-Azam: India's Prince Charming

The 1960s were the latter part of Bollywood's golden age, and no movie was more popular than *Mughal-E-Azam* (The Great Mughal). It's a tale about Prince Saleem (Dilip Kumar) and his adoration of court dancer Anarkali (actress Madhubala, shown with him in the movie still in Figure 19-6), much to the disapproval of his father, Emperor Akbar (Prithviraj Kapoor) (refer to Chapter 3). The feud between father and son in this film leads to a war and the imprisonment of Anarkali. This 16th century period piece, which also has a popular musical score, is widely regarded as one of the most iconic Bollywood movies of all time.

FIGURE 19-6: Madhubala and Dilip Kumar.

Sterling Investment Corporation/Alamy Stock Photo

The film was based on the 1922 play *Anarkali* written by the Urdu poet and dramatist Syed Imtiaz Ali Taj. Though the characters and plot depicted in *Mughal-E-Azam* were based on real people and events, the poem and movie definitely add some embellishments and changes. The movie was revered for its depiction of a "casteless" love story (in this case, between a courtesan and a prince), religious tolerance between Muslims and Hindus, and technically for its highly sophisticated and poetic dialogues. The movie has withstood the test of time and even inspired these modern movies:

Mughal-E-Azam won Best Picture in both the Filmfare Awards and National Film Awards (both described in Chapter 15). Given the film's immense popularity and critical acclaim, it was re-released in color on November 12, 2004.

Munna Bhai M.B.B.S.: Faking It 'til We Make It!

This comedy, starring Sanjay Dutt, was the first installment of the Munna Bhai series, was a mega-blockbuster, and viewers far and wide heavily favored it. The story follows Dutt's character, Munna Bhai (an adoring way of calling someone a brother), a lovable don of the underworld, and his attempt to pretend to be what his father had wanted him to be — a doctor. His father, Shri Prasad (played by his real-life father, Sunil Dutt), sees his dream shattered in front of him on several accounts, leading to several comedic sequences.

The film touches on not only the popular desire parents have for their progeny to work in lucrative professions but also the inflicted pressure to succeed. Though Munna is attending medical school to exact revenge on Asthana for outing him in front of his disappointed father, his charm and wit are infectious to not only his classmates but also his patients.

Munna Bhai M.B.B.S. (also a play on the Indian medical degree of the same initials, that stands for Bachelor of Medicine and Bachelor of Surgery) won four Filmfare and IIFA awards, and one National Film Award. The second installment in the franchise, *Lage Raho Munna Bhai* (Keep at It, Munna Bro!), was released in 2006, and there were talks of a third installment rumored to be released in 2022.

Chapter **20**

Ten Must-Watch Shah Rukh Khan Films

F ew personalities in the world are quite like Shah Rukh Khan. One of the most popular celebrities on the planet, he has amassed a huge following both on the Indian subcontinent and around the world. Coming from humble beginnings, Khan's rise to fame was truly astronomical. (Check out Chapter 5 for more about Khan's career trajectory and accomplishments.)

Because of Khan's illustrious career, we can recommend an endless list of his movies to become acquainted with him. This chapter focuses on ten of his most memorable and iconic roles. As Khan hit his peak in the 1990s, romantic films seemed to be the biggest blockbusters, and as a result, most of his iconic films feature him playing a romantic hero — each role being iconic in its own, unique way.

The movies in this chapter serve as a fantastic starter pack for understanding the Khan fanaticism. Each has a memorable Khan character and the films themselves are also some of the most iconic in Bollywood.

TIP

When you're ready to watch these films, you can find most of them streaming on platforms such as Netflix and Amazon Prime.

Baazigar: The Antihero Role

Viewed by many as Khan's breakthrough role, *Baazigar* (Gambler) polarized India by introducing a vengeful and violent protagonist named Vicky Malhotra, played by Khan, who evokes both hatred and adoration from audiences.

**CULTURAL
WISDOM**

This antihero role turned traditional Bollywood hero roles on their head, creating a much more complex character that conflicted audiences.

Marketed as a crime thriller, *Baazigar* was a commercial and critical success. The film drew large crowds upon its release and earned Khan his second Filmfare Award, this time for Best Actor. (He also won the Best Debut award the preceding year.) The film was nominated for ten awards and won four. Actresses Shilpa Shetty Kundra and Kajol played the lead female roles in the film, with Kajol and Khan's chemistry creating a popular new couple for the silver screen.

The film, which catapulted Khan into stardom, is widely considered one of the best Bollywood films of all time. An iconic soundtrack helped solidify this movie, with both the title song and "Yeh Kaali Kaali Aankhein" (These Dark, Dark Eyes) becoming extremely popular. Both the movie and the soundtrack remain mainstays in the Bollywood conversation today and demand any new fan's attention as a must-see Khan film.

Dilwale Dulhania Le Jaayenge: Landscapes of Love

Marking the beginning of Khan's reign over the 1990s romantic film genre, *Dilwale Duhania Le Jaayenge* — or *DDLJ*, as it's commonly referred to — is one of his most memorable films. As a talkative young man with charming pick-up lines, a carefree attitude, and a willingness to go to any length for love, Khan won over audiences worldwide with this film.

**CULTURAL
WISDOM**

Many Bollywood films have alliterative titles that are often four or more words long. Particularly, Khan films in the 1990s followed this nomenclature pattern, and audiences eventually began to refer to his movies with acronyms for the names. Movies like *Dilwale Dulhania Le Jaayenge* were shortened to *DDLJ*, and *Kuch Kuch Hota Hai* to *KKHH*. This trend has persisted to this day, and many of these iconic films are referred to by their acronyms rather than by their full titles.

Kajol was cast as the female lead in the film, and the chemistry she and Khan shared in *Baazigar* translated once again to the screen in *DDLJ*. The film was also the directorial debut of Aditya Chopra, the son of legendary film director and producer Yash Chopra. The final product turned into the highest-grossing film of 1995 and one of the most memorable Bollywood films of all time.

The film centers on two young Indian travelers in Europe on vacation. Khan and Kajol end up separated from their other friends, and romance ensues. However, as in many other Bollywood movies, a problem arises when Kajol's family disapproves of the couple's relationship, wishing instead to marry her to a family friend. What ensues becomes a classic tale of romance and redemption, with Khan firmly cementing himself as a romantic star to be reckoned with.

Though the soundtrack for the film was wildly popular, one song in particular became synonymous with the film and persists as one of the most iconic songs in Bollywood history: "Tujhe Dekha Toh Yeh Jaana Sanam" (Once I Saw You, I Knew) features a love-ridden Kajol running into Khan's outstretched arms in a moment of pure bliss that had audiences cheering for more. The song remains a classic; its opening scene is one of the most memorable in Bollywood history.

Dil to Pagal Hai: The Master of Triangles

Khan, aside from being a romantic star in the 1990s, became known for another common characteristic in his films: being part of a love triangle. Starring female stars Madhuri Dixit and Karishma Kapoor, *Dil To Pagal Hai* (The Heart Is Crazy) is the story of two dancers (Dixit and Kapoor) vying for the love of their choreographer, played by Khan. To add to the complexity of the situation, Akshay Kumar also stars in the film, in a supporting role as one of Dixit's love interests.

The movie was extremely successful both commercially and critically, winning eight awards at the Filmfare Awards, including Best Film, Best Actor, Best Actress, and Best Supporting Actress. Directed by legendary director (and frequent collaborator with Khan) Yash Johar, this was the third film in which Chopra cast Khan in the 1990s. Because the film centered around a dance troupe, the soundtrack was also a big hit with audiences with songs like these gaining widespread popularity:

>> **"Le Gayi" (Took It Away):** Sung by Asha Bhosle and Udit Narayan

>> **"Bholi Si Surat" (An Innocent Face):** Sung by Lata Mangeshkar and Narayan

>> **"Koi Ladki Hai" (There Is a Girl):** Sung by Mangeshkar and Narayan

The film's convoluted love triangle, Khan's charismatic and confident character, and the film's memorable dance numbers led to this movie's earning a spot as one of Khan's best and most famous films. (You can read more about music in Bollywood in Chapter 7.)

Kuch Kuch Hota Hai: The All-Time Classic

Though it's difficult to choose which Khan movies to watch, in many people's eyes, *Kuch Kuch Hota Hai* (Something Happens) is a quintessential Khan movi. Starring Rani Mukerji and Kajol as female leads, the story of an unrequited college romance finding new life after adulthood remains a classic recommendation for any new Bollywood fan.

REMEMBER

The directorial debut of Karan Johar, the son of producer Yash Johar, *Kuch Kuch Hota Hai* was another Khan film featuring a love triangle. With heartfelt performances by all actors within the film, the movie evoked an emotional response from audiences that remains memorable to this day. Often regarded as the climax of Khan and Kajol's onscreen chemistry, the movie has an intricate plot that spans multiple decades and generations.

The film broke multiple box office records and was the highest-grossing film of 1998. The soundtrack for the film was equally memorable and successful in sales. Each of the songs from the soundtrack became a huge hit, and the soundtrack as a whole is one of the most successful of all time. These are some of the most popular tracks from the film:

>> "Kuch Kuch Hota Hai" (Something Happens)

>> "Koi Mil Gaya" (I've Found Someone)

>> "Ladki Badi Anjaani Hai" (That Girl Is Mysterious)

Kabhi Khushi Kabhie Gham: The Star-Studded Family Film

Featuring a star-studded cast alongside Khan, *Kabhi Khushi Kabhie Gham* (Sometimes Happiness, Sometimes Sadness) is one of his most famous Bollywood films. Often shortened to *K3G*, the film features big-time acting names, such as Amitabh

and Jaya Bachchan, Kajol, Kareena Kapoor, Rani Mukerji, and Hrithik Roshan. Directed by Karan Johar, coming off his success with *Kuch Kuch Hota Hai*, the film was guaranteed to be successful.

A family drama broaching issues such as adoption, social class, and family hierarchies, *K3G* is beloved for the iconic dialogue delivered by each actor. Despite its length (the movie clocks in at 3½ hours!), it maintains a good pace and leaves audiences laughing, crying, and cheering throughout.

One of the most commercially successful Bollywood films, *K3G* firmly cemented Johar as one of Bollywood's premier directors — and further enhanced Khan's position atop the Bollywood industry. The film earned Khan another Best Actor nomination at the 2002 Filmfare Awards and won five awards in total. *K3G* is definitely one Bollywood movie that pulls at the heartstrings and is well worth the marathon viewing session.

TIP
Chapter 15 discusses all about Bollywood Award Shows in greater detail.

Devdas: Tragedy Strikes

A film that has been remade more than ten times, *Devdas* is also a classic Bengali romance novel, written by Sarat Chandra Chatterjee. (Chapter 17 discusses the cinema of West Bengal in greater detail.) Perhaps no iteration of the movie has become more famous than this 2002 classic featuring director Sanjay Leela Bhansali's intricate set and costume design, fantastic choreography, and epic musical sequences — and, of course, Khan's epic performance. The film is often considered one of the most beautiful films ever shot.

Starring alongside Khan are female greats Madhuri Dixit and Aishwarya Rai Bachchan. One memorable scene features the song "Dola Re Dola" (Sway and Move), which showcases both actresses in a dance number that has become iconic.

The movie itself is a tragic tale of forbidden love between Khan and Rai Bachchan's characters. The lovers' separation drives Khan to spend all his days at brothels, drinking away his pain (see Figure 20-1), until eventually his bad habits bring him to death's door.

FIGURE 20-1:
Khan, in his
iconic role in
Devdas.

Mohabbatein: Living in a Dream World

A film that took Bollywood's obsession with forbidden love to new heights, *Mohabbatein* (Love Stories) was the first to pair legendary actor Amitabh Bachchan with Khan. The movie centers on three young boys at a private school in India; Khan encouraged their individual love stories because his was left unfinished.

Featuring powerhouse performances from the two main actors (see Figure 20-2) and from Aishwarya Rai Bachchan, the film helped launch the careers of six other actors as it wove memorable love stories for each of the couples.

REMEMBER

Though *Mohabbatein* notches another level of success for Khan in the early 2000s, the film served as a resurgence for Amitabh Bachchan. After Bachchan had no commercially successful film appearances for several years, this film relaunched his career as an older actor appearing in supporting roles. (You can read about Bachchan's legacy in Chapter 4.) The film was a critical and commercial success, becoming the highest-grossing Bollywood film worldwide the year of its release.

The film features some of Khan's most memorable quotes. The emotional plot of the film also features excellent musical accompaniment, with tracks like "Humko Humise Chura Lo" (Steal Me from Myself) and "Aankhein Khuli" (Eyes Open) becoming chart-toppers at the time of their release.

Kal Ho Naa Ho: The Tear-Jerker

Karan Johar's collaborative efforts with King Khan already provide two of the classic entries in this chapter, and *Kal Ho Naa Ho* (Tomorrow May Never Come) delivers the third. An emotional roller-coaster with extremely memorable characters and multiple storylines, *Kal Ho Naa Ho* is a smart, witty, heart-wrenching tale that explores themes such as friendship, unrequited love, family conflicts, and grief.

Khan plays a happy-go-lucky transplant to New York who quickly befriends a neighboring family dealing with multiple issues. Preity Zinta, Jaya Bachchan, and Saif Ali Khan also star in the film, giving exceptional depth to their characters — particularly in powerful scenes throughout the film. In fact, all three took home Filmfare Awards for their performances.

The film, which went on to become the highest-grossing film that year, won eight total Filmfare Awards. The soundtrack was also a big hit, with many of the songs topping charts for months after the movie's release and winning numerous awards. They include

>> "Pretty Woman"

>> "It's the Time to Disco"

>> "Kal Ho Naa Ho" (Tomorrow May Never Come)

The film was shot primarily on location in New York City, and it became iconic for its depiction of famous landmarks — a few memorable scenes show the Brooklyn Bridge in the background. The movie was extremely popular with Indians living abroad, particularly in the United States, because they recognized many of the set locations.

Swades: Yearning for Home

After making waves with *Lagaan* (Taxation), starring Aamir Khan, director Ashutosh Gowariker tried his hand at making another classic, with Khan as a lead. Gowariker proved to be successful when their collaborative efforts led to the making of *Swades* (Motherland), a poignant tale of a nonresident Indian returning to the homeland for a brief period and learning to assimilate with the people of his home village.

Departing from his usual loverboy roles, Khan delivered a powerful performance as a NASA program manager, living a comfortable life in the United States, who is suddenly uprooted when he must visit his childhood nanny in India. Hoping to bring her back with him to the United States so that she can live out her final years in leisure, he is surprised to find out that she lives a comfortable life in her quaint home village in India. The rest of the movie dives deeper into themes of cultural identity, poverty, the caste system in India, and rural life.

Veer-Zaara: A Tale of Two Nations

An epic film that uses the persisting tensions of India and Pakistan as a backdrop (refer to Chapter 3), *Veer-Zaara* is the heartfelt tale of star-crossed lovers (Veer and Zaara) learning how political divides can cause rifts in personal relationships as well. Khan plays an Indian air force pilot who falls in love with a Pakistani woman, played by Preity Zinta, whose family is well-connected in Pakistani politics. After a series of unfortunate events, Khan is wrongly imprisoned in Pakistan and the two lovers are separated (see Figure 20-3). A young human rights lawyer, played by Rani Mukerji, enters the picture and takes on Khan's case, hoping to free him from prison after many years.

The film also stars Amitabh Bachchan, Hema Malini, and Manoj Bajpai in supporting roles, and the movie's subject matter and political nature make it a particularly hard-hitting. The film's climax includes one of Khan's most iconic monologues, wherein he recites a poem recognizing and celebrating the similarities between

the two quarreling countries and asking for unity between their people. The scene, along with his performance throughout the film, helped elevate this film to an all-time classic.

Source: Alamy

FIGURE 20-3:
Khan
embracing
Preity Zinta in
Veer-Zaara.

The soundtrack to the film is also regarded as an all-time classic because it featured original compositions created by the late Madan Mohan in the 1970s that were finalized and released by his son, Sanjeev Kohli, for the film, and it also includes legendary singer Lata Mangeshkar on nearly every track after she took a short hiatus from playback singing. Three of the film's most memorable songs include

» "Tere Liye" (For You)

» "Do Pal" (Two Moments)

» "Main Yahann Hoon" (I Am Right Here)

Chapter **21**

Ten Bollywood Actors Who Transitioned to Hollywood

Although the formula for creating a successful Bollywood movie may be quite different from the one required for Hollywood, including different storylines, genres, and production styles, the two industries are connected in their desire for actors who have years of training under their belts. Bollywood requires a mastery of a particular discipline, but that doesn't mean that these actors can't dabble to films of other places. So, what about Hollywood?

Well, it has happened — and multiple times! In this chapter, we discuss Bollywood stars who have immersed themselves in the American mainstream throughout history. You may even recognize some of these stars on the list, from either seeing their blockbuster Hollywood films or reading about their Bollywood careers in this book. You may not even have an idea that they have made their way to Hollywood. We list them here in alphabetical order by last name.

Amitabh Bachchan

Amitabh Bachchan is one of the most popular actors (if not *the* most popular actor) in the history of Bollywood. (Refer to Chapter 4 for more on him.) Bachchan is a bona fide superstar of Bollywood — he dominated the Bollywood box office in the 1970s and 1980s before taking a short hiatus in the '90s and ultimately making a comeback in the 2000s.

Bachchan's debut in Hollywood included a small part in Baz Luhrmann's *The Great Gatsby* in 2013. In a scene alongside Leonardo DiCaprio and Tobey Maguire, Bachchan played the role of a gambler and close acquaintance of Jay Gatsby's. In interviews, Bachchan contends that he still hasn't made his Hollywood debut and that his role in *The Great Gatsby* was instead "just a friendly gesture."

Aishwarya Rai Bachchan

Amitabh Bachchan's daughter-in-law, Aishwarya Rai Bachchan, is no stranger to Hollywood, either. (Check out Chapter 2 for more about the Bachchan family.) Nicknamed Ash, Rai quickly won the approval of audiences and critics alike in the 1999 films *Hum Dil De Chuke Sanam* (I Have Given My Heart Away, Darling) and *Taal* (Rhythm), the 2000 movie *Mohabbatein* (Love Stories), and the 2002 movie *Devdas*.

Then in 2004, Rai began dabbling outside of Bollywood. She played the role of Lalita Bakshi in the 2004 film *Bride and Prejudice*, which was loosely based on the 1813 Jane Austen novel *Pride and Prejudice*. She later made an appearance on *Late Show with David Letterman* to promote the movie. Her interview with the late-night legend quickly went viral among Bollywood fans as the chat showcased Rai's quick wit and charm. Following her success from *Bride and Prejudice*, Rai went on to work in the British Film *Provoked* in 2006 and then co-starred in 2009 with Steve Martin in *The Pink Panther 2*.

Priyanka Chopra

One of the more recent successful and famous transitions was none other than Priyanka Chopra. Before her Bollywood career began, Chopra made a name for herself by competing in several beauty pageants, which culminated in her crowning

as Miss World in 2000. As a result, she began to take on multiple film roles and quickly gained the nation's admiration with a number of hits (refer to Chapter 5).

After donning the new nickname Piggy Chops, Chopra continued to excel in critically acclaimed Bollywood roles, in films such as the 2008 *Fashion*, the 2012 *Agneepath* (Path of Fire), and the 2012 *Barfi*. Perhaps you can say that Chopra had reached a crossroads in her career and then decided to make a splash in Hollywood, starting with her music career. Her first collaboration was with American rapper will.i.am., on her song "In My City," which was the intro theme of *NFL Thursday Night Football* during the 2012 season. She later created the video "Exotic" with the help of singer-songwriter Pitbull. As Chopra continued making connections within Hollywood, she continued starring in 2015 hit Bollywood films, such as *Dil Dhadakne Dho* (Let the Heart Beat) and *Bajirao Mastani*.

After finding musical success in the States, Chopra then jumped into American television on the hit ABC Show *Quantico*, playing the role of Alex Parrish. Slowly, Chopra mingled more and more with Hollywood's elite, which not only helped her acting career but also made her a tabloid darling — she and Nick Jonas married in December 2018. Chopra has continued acting in Hollywood, including roles in the films *Baywatch* and *Isn't It Romantic*.

Anil Kapoor

Another Bollywood star laid familiar groundwork — none other than the ever-so-loveable, and seemingly age-defying, Anil Kapoor. Kapoor began his Bollywood career in the 1980s (refer to Chapter 4) and starred in many blockbusters, such as 1987's *Mr. India*, *Beta*, *Judaai*, *Taal* (Rhythm), and *Race*, and alongside Priyanka Chopra herself in 2015 in *Dil Dhadakne Dho*.

After proving to be a mainstay of the Bollywood industry for more than two decades, Kapoor set his sights on his first international feature with Danny Boyle's Oscar-winning film *Slumdog Millionaire*, playing the role of Prem Kumar, the game-show host of India's fictional version of *Who Wants to Be a Millionaire?* Kapoor was admired for his performance and, as a result, started appearing on several American talk shows and mingling with Hollywood's elite. Ultimately, his role in *Slumdog Millionaire* allowed him to land the role of Omar Hassan, the president of the fictional country of Kamistan, in the eighth season of the FOX hit series *24*, which was met with rave reviews. Kapoor also got in touch with his comedic side and went on to voice himself, in his reprised role from *Slumdog Millionaire*, in a 2016 episode of *Family Guy*.

Shashi Kapoor

Shashi Kapoor's commanding presence was a force to be reckoned with throughout the 1960s and 1970s — even while sharing the screen with some of the all-time Bollywood greats. The famed youngest son of Prithviraj Kapoor, a pioneer of Indian theatre, Kapoor had married Jennifer Kendal, the English stage manager of Prithvi Theatre, and the pair acted together in several movies produced by Merchant Ivory Productions. For a refresher on Kapoor, check out the section in Chapter 4.

Kapoor, who has a resounding history starring in English films, was known to be Bollywood's first international star. He had roles in films such as *Shakespeare Wallah*, *Bombay Talkie*, *The Householder*, *A Matter of Innocence*, and *The Deceivers*. When Kapoor passed away in 2017, he was mourned by not only Bollywood but also Hollywood.

Irrfan Khan

The late, legendary Irrfan Khan made a name for himself in Bollywood for always going against the grain in selecting his movies. His debut came in 1988 with the Oscar-nominated *Salaam Bombay!*, and he went on to work on critically acclaimed films, in breakout roles such as *Haasil* (Achieved) and *Maqbool* (Favorite).

Khan's legacy of taking on unique roles continued as he began acting outside Bollywood. He gained international exposure with his 2006 performance in *The Namesake*, playing the father of Nikhil (Hollywood actor Kal Penn). Perhaps Khan's willingness, unlike most actors in Bollywood, to immerse himself in genres that were grounded in realism allowed him to easily transition and find success in English-speaking films. In 2008, Khan was featured in *New York, I Love You,* which featured an all-star cast, including the likes of Hollywood stars Natalie Portman, Bradley Cooper, Shia LaBeouf, and Orlando Bloom. In that same year, Khan truly made his presence felt with his performance as a corrupt policeman in *Slumdog Millionaire,* which won Best Picture at the 2009 Academy Awards.

Khan continued making movies overseas in Bollywood, with hits like the *Billu Barber*, *Lunchbox*, *Haider*, and *Piku*, but at the same was dominating Hollywood with blockbusters. Here are some of those hits:

>> *The Life of Pi*

>> *The Amazing Spider-Man*

>> *Jurassic World*

>> *The Jungle Book*

Given that Khan was a regular in not only Hollywood hits but also Bollywood, to this day he is regarded as a powerfully compelling actor who can do a great deal of storytelling using only his eyes. Unfortunately, Khan passed away in 2020 from a neuroendocrine tumor. His legacy was fondly reflected on by celebrities across the world.

Anupam Kher

From as early as 1984, Anupam Kher has sustained a long and illustrious career in Bollywood as a result of his well-known comedic roles. Racking up eight Filmfare Awards and two National Film Awards (see Chapter 15), Kher has starred in Bolly-wood hits such as the 1994 *Hum Aapke Hain Koun . . . !* (What Am I to You . . . !), *Dilwale* Dulhania *Le Jayenge* (The Big-Hearted Will Take the Bride), *Kuch Kuch Hota Hai* (Something Happens), *Kaho Naa . . . Pyaar Hai* (Say . . . That It's Love), and *Veer–Zaara*.

At the turn of the millennium, Kher started dabbling internationally with his first film, in 2002, outside of India, in *Bend It Like Beckham*. He proceeded to work on other English and American films, such as *Bride and Prejudice* and the Oscar-nominated *Silver Linings Playbook*. His most notable role was in Kumail Nanjiani's 2017 flick *The Big Sick*, where Kher played the role of the protagonist's father, Azmat. Over the course of his career, Kher has been featured in more than 500 films worldwide. Though he doesn't appear now in as many films as he once did, he still works on films to this day.

Deepika Padukone

Known now as the reigning queen of Bollywood, Deepika Padukone is still an unstoppable force in Bollywood. From her 2007 memorable debut in *Om Shanti Om* to her powerful portrayal of an acid attack survivor in *Chhapaak* (Splash), Padukone has seemingly done it all in her career. For a deep dive into her career, check out Chapter 6.

In 2017, Padukone made her way to the American silver screen by starring opposite Vin Diesel in *XXX: Return of Xander Cage*, making this her official Hollywood debut. Even though the movie received disappointing reviews, Padukone fans

nonetheless thought her performance was a breath of a fresh air in a movie that, unfortunately, couldn't hold up its end of the deal. The role also led to many interviews, including on *Access Hollywood* and *The Ellen DeGeneres Show.*

Amrish Puri

One of the more recognized faces (and eyes, even more so) in Bollywood history is the late, great Amrish Puri. Puri started acting at the Prithvi Theatre and later transitioned to film around the age of 40. Puri made a career out of playing villains and intimidating father figures in Bollywood, thanks largely in part to his trademark eyes. Since the 1970s, Puri used his infamous glare to either instill fear or provide comedic relief to audiences worldwide. He starred in mostly certified hits and blockbusters playing the aforementioned roles, but perhaps his most iconic role was Mogambo in *Mr. India*. His line "Mogambo, khush hua" ("Mogambo is happy"), one of the most famous lines in Bollywood history, is still referred to in pop culture.

Thanks to his menacing look, and perhaps a catalyst to his future role as Mogambo, Puri was cast as Mola Ram alongside Harrison Ford in Steven Spielberg's *Indiana Jones and the Temple of Doom*, marking his Hollywood debut. The same menacing expression that made him famous in India was also what helped him garner rave reviews in his first American film. Sadly, Puri passed away in 2005. Given that he was a part of numerous iconic and hit films, Puri is still remembered fondly and is much beloved by members of several film industries within India and overseas.

Naseeruddin Shah

Despite having a successful career in Bollywood and India, Naseeruddin Shah may be one of the more underrated actors in history. He was similar to Irrfan Khan in the sense that Shah's legacy and style were more understated, especially, in retrospect, in comparison to the rest of Bollywood's more vivacious nature. Shah has won three National Film Awards as well as three Filmfare Awards, and has been a part of critical darlings as well as blockbuster hits, including *Masoom* (Innocent), *Karma*, *Mohra* (Pawn), *Maqbool* (Favorite), and *Krrish*.

Shah started with the Merchant Ivory Productions title *The Perfect Murder* in 1988. In 2003, he played the role of Captain Nemo, opposite the star power of Sean Connery in *The League of Extraordinary Gentlemen*. Two years later Shah starred in *The Great New Wonderful* as Avi, alongside Maggie Gyllenhaal and Jim Gaffigan. He then followed up with the role of Akbar in Aasif Mandvi's independent comedy *Today's Special* in 2009.

Index

Numbers

3 Idiots, 16

A

A (*Alif*), 246
"Aadat" (Habit), 241
Aaja Nachle (Come Dance), 158, 187
Aan (Pride), 50, 204
"Aap Jaisa Koi" (Someone Like You), 137, 143
Aashiq Banaya Aapne (You Have Made Me Your Lover), 204
Aashiqui 2 (Romance 2), 161
Abraham, John, 88–89
Academy Award, 46
accessibility, 123–124
Acharya, Ganesh, 192
Acid (*Tezaab*), 64
action stars, 84
Ae Dil Hai Mushkil (The Heart's Affairs Are Difficult), 161, 243
Affair (*Silsila*), 73
"Afreen Afreen" (Beautiful, Beautiful), 158
AfroDesi, 197
Agneepath (Path of Fire), 192
Ahmed, Riz, 268
Ahuja, Govinda, 83–84
AIB (All India Bakchod), 218–219
Akhri Station (Final Destination), 245
Akhtar, Farhan, 281
Akhtar, Javed, 58–59, 127
Akon, 210
Alam Ara (Ornament of the World), 148

Alcoholic (*Sharaabi*), 140
Ali, Maqsood Mahmood, 165
Alif (A), 246
Alive ("Zinda"), 161
All India Bakchod (AIB), 218–219
Alley Boy (*Gully Boy*), 115, 171, 210, 226, 284–285
Aman, Zeenat, 76
Amar Akbar Anthony, 60, 62, 155, 280–281
Amateur (*Anari*), 47
"Ambarsariya" (One From Amritsar), 177
Ambudkar, Utkarsh, 268–269
American Desi, 263
Anaam (Anonymous), 192
Anand, Dev, 49
Anari (Amateur), 47
Angel of Death (*Mrityudatta*), 164
"Angrezi Beat" (English Beat), 170, 180
Ansari, Aziz, 269
Antakshari, 214
Appaiah, Biddu, 136–137
Apu Trilogy, 249
Armaan (Desire), 140
As Long As I Live (*Jab Tak Hai Jaan*), 175
As You Have Stolen This Heart ("Chura Liya Hai Tumne Jo Dil Ko"), 142
Aslam, Atif, 238, 241, 243
Aunn Zara, 246
aunties, 214
Aur Pyar Ho Gaya (And Love Happened), 157
Awaara (The Vagabond), 46
awards, 17, 223–232
 Filmfare Awards, 224–226

IIFA Awards, 226–227
international South Asian film festivals, 229–232
National Film Awards, 227
STAR Guild Awards, 228–229
Stardust, 228
Zee Cine awards, 228
Awe (*Khauff*), 164
"Aye Naujawan Hai Sab Kuchh Yahan" (Everything Is Lively Here), 160
"Azeem O Shaan Shahenshah," 129
Azmi, Shabana, 75–76, 260

B

Baazigar (Gambler), 290
Babi, Parveen, 74
Babul (Father's House), 48
Bachchan, Abhishek, 27–28, 85
Bachchan, Aishwarya Rai, 15, 94–95, 186
 dancing, 193
 overview, 27–28
 transitioning to Hollywood, 300
Bachchan, Amitabh, 11, 16, 61–63
 overview, 25–27
 singing, 126
 transitioning to Hollywood, 300
Bachchan, Jaya, 25–27
Bachchan family, 9, 25–28
"Bade Miyan Chote Miyan" (Big Mister, Little Mister), 192
Badhaai Ho (Congratulations There), 179
"Badi Mushkil" (Big Trouble), 192

playback singer for, 126

popularity in UK, 204

Khan, Sharmila, 32

Khan, Yusuf. *See* Kumar, Dilip

Khan, Zayed, 38

Khan family

Contemporary Bollywood (1990s and 2000s), 79–83

overview, 28–32

Khanna, Amit, 228

Khanna, Rajesh, 52

Khanna, Vinod, 69

Khauff (Awe), 164

Kher, Anupam, 303

Khoobsurat (Beautiful), 73, 171, 243

Khuda Ki Basti (God's Colony), 246

khunda, 182

"Khwaja ki Deewani" (Lover of Khawaja), 157

King of Bollywood, 11

King of the House of God ("Tajdar E Haram"), 157

Kingsley, Ben, 208

kissing

1990s and 2000s films, 11

songs minimizing, 121

Kites, 209

"Ko Ko Korina," 163

Koffee with Karan, 217–218

"Koi Jane Koi na Jane" (Some Know and Some Don't), 157

"Koi Ladki Hai" (There Is a Girl), 291

"Koi Mil Gaya" (I've Found Someone), 292

Koirala, Manisha, 96

Kollywood, 189, 251–254

koti, 132

Kranti (Revolution), 63

Krantiveer (Brave Revolutionary), 169

Krrish 3, 191

"Kuch Kuch Hota Hai" (Something Happens), 165, 292

Kuch Kuch Hota Hai (Something Happens), 79, 150, 292

Kudalkar, Laxmikant, 145

"Kudiyan Shaher Diyan" (Oh My, These City Girls), 164

Kumar, Akshay, 84

Kumar, Chaya, 183

Kumar, Dilip, 31, 50–51, 225

Kumar, Kishore, 39–40, 51, 126, 127

L

"Ladki Badi Anjaani Hai" (That Girl Is Mysterious), 292

Lagaan (Tax), 188, 201, 283–284

Lage Raho Munna Bhai (Keep at It, Munna Bro!), 192, 287

Lahiri, Bappi, 125, 126, 138–140

Lahore, Pakistan, 44

Laila Majnu (Laila and The Madman), 60, 152

The Late Show with David Letterman, 262

"Layi Vi Na Gayee" (You Didn't Love Me), 177

"Le Gayi" (Took It Away), 291

Leader (*Mudhalvan*), 254

The Legend of Bhagat Singh, 175, 242

lehenga, 131

Lemon or Lime ("Nimbooda"), 192, 196

Let There Be Victory (*Jai Ho*), 206

Let's Dance ("Bhangra Paale"), 179

Let's Know Each Other ("Jaan Pehechan Ho"), 160

Letterman, David, 262

Lewis, Lesle, 164

Life Is a Poem (*Zindagi Gulzar Hai*), 245

Lifelong Partner (*Humsafar*), 243, 245

Lightning (*Minnale*), 252

Like a Peacock ("Morni Baanke"), 179

A Lion Is Coming ("Sher Aaya Sher"), 285

lip-syncing, 126

Little King (*Chhote Nawab*), 145

locations, video, 127–129

"Lodi" (Festival of Lohri), 177

Lollywood, 44, 138, 235–246

impacting Bollywood, 241–244

music franchises, 239–240

overview, 236–238

Pakistani dramas, 245–246

love, 174–175

Love, Love, Love, 188

And Love Happened (*Aur Pyar Ho Gaya*), 157

Love Stories (*Mohabbatein*), 294–295

Lover of Khawaja ("Khwaja ki Deewani"), 157

Loverboy (*Kadhalan*), 189

Loy, Shankar Ehsaan, 282

Loyal Servant (*Namak Halaal*), 140

"Loye Loye" (Come Here), 241

lungi, 132

lyricists, 127

M

machismo male archetype, 67–69

Madhubala, 53–54

About the Authors

Maaz Ali is an Indian and Pakistani entertainer including acting, sketch comedy, and dancing. Born and raised in California, Maaz's love for the entertainment industry comes from his family: His mother hails from Mumbai, India (formerly Bombay) and his father Rahim Yar Khan from Pakistan. This blend of cultures of the subcontinent led to a childhood full of family nights spent watching Bollywood films, hosting Pakistani music nights, and endless dance choreographing. On-screen, look for him in short films, TV spots, and music videos. Among his favorites is the role of lead actor and dancer in "Circles" by Tesla Boys, which was selected and featured at the 2017 SXSW Film Festival.

Off-screen you can find him performing and hosting South Asian cultural events, the next wedding you're invited to, or even South Asian film festivals. Outside acting, Maaz keeps busy hosting a podcast along with the other authors of this book called Desi Standard Time. You can find Maaz on Instagram at @maazyali.

Maaz Khan is an attorney and finance professional who seeks adventure and thrill away from his daytime corporate life in the exciting world of Bollywood cinema. A graduate of the University of Georgia with a degree in microbiology, Maaz crushed his parents' dreams of seeing him become a doctor, disappointing them immensely by becoming a lawyer instead. After practicing for four years at firms in Philadelphia and Los Angeles, he moved on to the world of finance and private equity in New York, and even lived abroad in Dubai for a year.

Despite spending an exorbitant amount of time studying and working as a cog in America's corporate wheel, Maaz will always make time for a three-hour Bollywood movie. An avid fan since he was a child, Maaz has an uncanny knowledge of Bollywood films, actors, and actresses. It was this addiction to the industry that eventually brought him together with Maaz Ali and Anum Hussain on their South Asian–focused podcast Desi Standard Time. You can find Maaz on Instagram at @TheMaazlim.

Anum Hussain is a writer, marketer, and entrepreneur with an obsession with results-driven storytelling. Her career has taken her from newsrooms to software companies to everything in between, always focused on creating digital content that adds value to the world. She is the co-founder and CEO at Below the Fold, a media company helping you discover stories you aren't hearing anywhere else.

Anum was born and raised in New Hampshire and spent ten years in Boston before finally migrating west and settling in California. Her family and friends know her as the "tiny dancer," as she can be spotted on any dance floor performing with uncontrollable enthusiasm to the latest Bollywood or bhangra hit. She even brought this love for dance with her while getting her MBA at MIT Sloan School of Management, hosting the institution's South Asian Cultural Function,

and choreographing the many dances her classmates performed. This very love for dancing first bonded her to her husband Maaz Ali, at a Bollywood dance class in Los Angeles. It's also what introduced her to Maaz Khan, during a dance practice for an upcoming friend's wedding. You can find Anum online at @anum on Twitter and @anumaunty on Instagram.

About Their Podcast

All three authors of this book host and produce Desi Standard Time, a top-ranking podcast on all things South Asian media. The hosts, Maaz Ali and Maaz Khan, cover topics from long-standing themes in Bollywood to cultural history of Pakistani music to the impact all the above has on the South Asian diaspora. Their work has led to hosting multiple South Asian events from fashion shows to charity events to social media takeovers for massive Bollywood-centric accounts. You can find out more and follow their work at www.instagram.com/desistandard.

Dedication

Maaz Ali: I dedicate this book to my parents, who from a young age instilled a love for the artistry that is Bollywood. To my older siblings, for always urging me to push the bounds of my comfort zone and to my Bay Area boys, who keep the Indian uncle in me forever alive. To the establishment that once was Naz 8 Cinemas in Fremont California for cultivating 25 years' worth of memories and serving as a means of escape for my family and friends. To my nephews and nieces for wearing their culture so proudly, and also to my cat, Meowdhuri Dixit, named after Bollywood icon Madhuri Dixit.

Maaz Khan: I dedicate this book to my parents, for keeping the South Asian and Bollywood culture alive in our home and getting me addicted to it from an early age. To my siblings and cousins, with whom the infamous Bollywood Bracket Challenges have become a family tradition. To this author team's dear friend Humna Kalota, for pushing us to begin our podcast, starting us on the path that ultimately led to this book. And finally to my friend Shantha, for forever being my go-to encyclopedia of Bollywood knowledge and gossip.

Anum Hussain: I dedicate this book to the woman who first brought me into the *Dummies* world, Laura Fitton. Laura took a bet on my writing ability and social media expertise early in my career, bringing me on to co-author the third edition of *Twitter For Dummies.* Also to my in-laws, who along with my husband Maaz Ali and friend Maaz Khan, continue to introduce me to more content, knowledge, and hilarious humans core to the magic that is Bollywood.

Authors' Acknowledgments

Maaz Ali: Thank you to Steve, Chad, and the team at Wiley Publishing that worked on making this book possible. Thank you to my author team: my wife, Anum Hussain who was patient with me and helped me evolve as a writer during this process, and my dear friend, Maaz Khan, for taking on this book with me as we continued our passion of exploring every aspect of South Asian media. Thank you to our friends who helped contribute visuals and to ever editor involved in ensuring this book was an enjoyable read for all.

Maaz Khan: Thank you to Steve, Chad, and the team at Wiley Publishing for helping us make this dream a reality. A very special thank you to my co-authors Maaz Ali and Anum Hussain, who have somehow put up with me through not one but two massive projects now. And thank you to our friends, family, and podcast supporters, without whom we wouldn't have been able to share our love of Bollywood with the world.

Anum Hussain: A special thank you to Steven Hayes, who has become my *Dummies* family since 2015 when I first worked on *Twitter For Dummies,* and will be, at the time of this publishing, be celebrating 25 years at Wiley Publishing. Thank you to Vicki Adang, who helped me take the word vomit that was our original Table of Contents and focus it to the core subject matter valuable for our readers. Thank you to the many editors involved in this project and were patient with us as we described and detailed the nuances required for this book. And finally, thank you to Joy Batra for jumping on the occasion to help ensure every page was combed through for accuracy.

Publisher's Acknowledgments

Executive Editor: Steven Hayes

Project Editor: Chad R. Sievers

Copy Editor: Becky Whitney

Technical Editor: Joy Batra

Production Editor: Mohammed Zafar Ali

Cover Image: © Zonda/Shutterstock